AS IT WAS:

A Common Thread

Dean – Because I know
your sister, Edna, I know
I like you – maybe thats'
what our common thread will
be, – Until we meet –
Enjoy!

 Happy
ROBERTA A. BEUTE Trails

Roberta A. Beute

ISBN: 978-1-7162-8398-7 (sc)
ISBN: 978-1-7162-9083-1 (hc)
ISBN: 978-1-7162-8397-0 (e)

Library of Congress Control Number: 2021900492

Photographs on front and back cover by Dean Hellinger. The house on the front cover was owned and built by Earl Jones. He was a homesteader who worked in Choteau County, Montana as a carpenter (now Toole and Liberty Counties). The land is currently farmed by Stan McCarter. The picture is taken north of Devon looking northeast with East Butte of the Sweet Grass Hills in the background. The back cover is taken in the same area of Montana looking northeast at East and Sharkstooth Buttes of the Sweet Grass Hills.

Lulu Publishing Services rev. date: 02/04/2021

DEDICATION

To the Indigenous peoples, the pioneers, politicians, military, entrepreneurs, and settlers who have arrived in North America and found their way to Montana and stayed. Montana is beautiful and harsh and each person who arrived and stayed for more than four years has felt this ambiguity. It develops a certain character. Some of these characters marginalized lives are brought to life in these pages from the scant recordings left as a record of their journey. Some of their family members remain in Montana and have shared stories and made trails of their own.

This book is dedicated to these people who made a footprint in hopes someone would discover what they had seen or accomplished in their journey through Montana.

EPIGRAPH

"I am enough of an artist to draw freely upon my imagination. Imagination is more important than knowledge. Knowledge is limited. Imagination encircles the world."

Albert Einstein

CONTENTS

ACKNOWLEDGEMENTS

Grateful acknowledgement to my husband, Albert E. Beute, for his patience and encouragement of this project. To Quasar, Infinity, Robin, and Victor Thompson for their interest and enthusiasm. To my children for their fierce independence, honesty, and perspectives from another generation who grew up in rural Montana, left, and came back to raise their families in Big Sky country.

To the library staffs in Great Falls, Havre, Shelby, and Sun River. To the Great Falls Genealogy Society, Larry Spicer, Jan Thomson, and all the volunteers who offer their services to anyone who seeks to know more about the past generations. To Jennifer Richmond, Museum Specialist Archivist, St Joseph, Michigan, and Laura Tretter at Montana Historical Society for leaving no stone unturned in their search and research. Your help and suggestions made a world of difference in resolution of the hide-and-seek game of non-fiction.

To everyone who gave permission to share stories of their families and experiences on the pages of this writing. You have all made the journey a joy and inspiration so these precious moments will not be lost over time. To Debbie Jeppeson for bringing horses back into my life at her "Walkers On Water" ranch in Sun Prairie. To Eva McDunn for her tireless and informative work at the Great Falls Library. Eva simplified my search for rare and unusual books and journals. Yes, it's her job and everyone at the Great Falls Library is efficient and enthusiastically 'help', but Eva made it look easy and fun.

Samantha French at Blaine County Museum and Ashley Verity at Hill County Library. You lovely ladies brought me to Pamela Morris,

Chas E. Morris's granddaughter, and an entirely new horizon to explore.

To Hope Good and her Lifestyle's Magazine for direction and encouragement. Those magazines are a wonderful source of pictures and stories about Montana business's and people. They cover the entire State and there is never an issue where I don't find a story about someone who has influenced my life in Montana. My classmates, family, and friends. Your influences helped me write this book.

Fanny Hofer, Corliss Branch, Dicky Thompson, Marilyn Holt. You ladies have shared endless hours laughing and teaching me. To my mother and brother who taught me patience, tolerance, and laughter, all good medicine.

<div align="right">

Thank you,
Roberta A. Beute

</div>

INTRODUCTION

History can often be a lugubrious journey as we individually make our trail through life. This book is a collection of individuals and events as they created a nation that continues to evolve. From its discovery, North America evokes interest and excitement in its journey to become the 'New World': ever revealing new potentials of vast resources and unexplored geography. This book uncovers some of the characters who opened trails leading to the interior of the continent identifying and exposing resources along their paths.

History can be remarkable, delightful, and interesting when considering individuals made and recorded it. A collection of facts and artifacts can be found about who influenced, and how Montana became a part of the United States if the time is taken to look and explore.

Change does not just happen. It is often a modification or refashioning of events that transition or transfigure over time and environmental influences. The influences are often hastened by humans and nature. The trail is chronicled in layers of earth and heredity. The path to discovery of Montana descended simultaneously from four directions and culminated at the 49th Parallel on the International boundary between the United States and Canada.

A trio of mountains known as the Sweet Grass Hills lies along this path. These islands on the prairie were witness to several events leaving untold stories of peoples and places that effectively contributed to the establishment of Montana.

People who make history are not only prodigious folks, but often ordinary people like you or me. You will find many of these people

named and outed for some of their memorable characteristic actions and words. Pieces of the tapestry of life that weaves a story. A collection of memoirs, short stories, and facts about men and women who clamored to North America and left a trail. It is not exhaustive research nor all-inclusive of people and places. It is a unique collection of less known facts about some well-known people who ventured into the unknown. It also chronicles some of the journey the indigenous peoples and animals made as change happened on the North American continent.

Spelling of names is a juxtapose position when researching people and places. There was not spellcheck and people from different places spell names differently according to their ethnicity. The best-known example I can give on this subject is that Charlie Russell's first best horse, Monty, is spelled this way in his own words in his book. Others have spelled it Monte. Charlie was a common name in the late 1800's and early 1900's. Initials, middle names, nicknames, and different spellings such as 'Charley' are used in this writing attempting to keep the characters defined.

An earnest attempt was made by the Author to present facts and stories about and by the people in the story as they related it: if they did. It would be wonderful if we all wrote more, especially about our own thoughts and lives. It seems that these threads of thought are all that remains once we depart from this world. It's possible to leave some record of a life in photographs and art. All these media are a piece of a life's puzzle. These are the pieces placed together in this writing. Enjoy yourself as you read, "As It Was; a common thread".

PART I

TREATIES AND TERRITORY

Exploration, Exploitation, Disinformation

CHAPTER 1

UNTAPPED RESOURCES

Montana has been called the last best place, big sky country, the land of the shining mountains, and countless other romantic sobriquets. Each phrase is an attempt to capture what Montana is simply and exquisitely. Montana is all of this, and at times, none of these. A fickle conundrum fitting these descriptions one day only to begin the next morning with a violent gale and a glorious sunrise. Then there are the days when snow softly piles on everything, coating the landscape with fresh white crystals. The serene appearance of the dazzling white expanse does not appear to threaten life yet this icy blanket on the backs of animals renders them unable to breath. Beneath the frozen facade turned casket, they succumbed to a certain death.

It was the last place to define its northern boundary after the Revolutionary and Civil Wars. Montana and Canada are separated by latitude 49° north. This 1,300-mile expanse of international boundary is the longest continuous curved line between nations in the world. The forty-ninth parallel appeared on several sixteenth-century maps, suggesting a northern boundary between what would become the United States and Canada. This boundary was not designated as such until 1846 when the Oregon Treaty was ratified. Oregon Territory included western Montana to the Rocky Mountain front at that time. Commissioners of the Treaty of Utrecht had suggested the forty-ninth parallel as the southern boundary for Hudson Bay Company trappers and explorers. This continuous curved line ran "from the Lake of the

1

Woods to the Pacific Coast". The Peace of Utrecht was one of the great international settlements in history. Representatives from all major European nations met to discuss peace terms in Utrecht, Netherlands, in January of 1712. The conference was called to put an end to the French and Indian War, also known as Queen Anne's War or the War of Spanish Succession. The final agreement was signed April 11, 1713. Peace of Utrecht made many changes in the map of Europe and attempted to balance power in Europe and North America. Great Britain had the key role as arbiter helping increase England's colonial and commercial power over the newly discovered continent of North America. France ceded Nova Scotia, Newfoundland, and Hudson Bay Territory to Great Britain. Not realizing the expanse of the land west of the Great Lakes or the untapped resources, this concession by France would later be challenged. The major flaw in the agreement was that the country parceled out in North America had not yet been explored. The agreement was never ratified.

In 1762, during the Seven Years War, France secretly ceded New Orleans and the vast region west of the Mississippi to her ally, Spain. The French and Indian War left England master of Canada by 1765. Americans began a revolution in 1775. The revolution ended October 19, 1781, leaving Britain irate at the loss of their taxable wards of state, yet in control of the seas. The dispute was over undefined properties and taxation without representation.

Verendreys, a group of Native Americans, Métis, and French trappers, had secured entrepreneurship with the British-owned Hudson Bay Company (HBC) in 1741. This group of trapper explorers had ventured into the Dakotas, and possibly to Montana, that same year. This is known because in 1913 a group of schoolchildren in Pierre, South Dakota, found a small lead plate buried in the hills just outside the city. The plate reads: "In the twenty-sixth year of the reign of Louis XV, the most illustrious lord, The Lord Marquis of Beauharnois being Viceroy, 1741, Peter Gaultier de Laverendrye placed this." The Verendreys had secured their entrepreneurship by peaceful agreements with HBC and had planned more expeditions west of where they placed the lead plate. Louis XV, scheming with the Viceroy of Canada, Lord Marquis of

Beauharnois, revoked the land grants, preventing the Verendrey family from carrying on further exploration in the Territories of Louisiana and Oregon. This act presumed that the Verendrey family and their entourage would exploit and claim the lands explored for their home country. Louis XV was unsure of traders who had married Indians. He suspected they would claim lands for Spain or England. If a trapper married an Indian, the couple and their children would be considered Métis. At the time, Britain and France were skeptic of the growing population of Métis. These Indigenous Peoples had knowledge of the terrain and the ability to adapt to the climate. The bond of marriage gave the trappers friendship with the Indians, which was advantageous for physical safety and trade.

Historic events have considerable importance; however, a single accounting of the event is always incomplete. The journey to establish the United States started with one such event that happened in 1492. A class of third graders at Valleyview Elementary in Oneonta, New York, and their teacher, Ken Sider, sought to correct disinformation about Christopher Columbus.

Columbus was the Italian who borrowed funds from King Ferdinand of Spain for his voyage around the world across the uncharted ocean. Columbus did not reach North America's shores on either of his voyages in 1492 or 1493. Instead, one of the shipmates, Ponce de León, a Spanish explorer on the Columbus voyages, found the shores of Florida on April 3, 1513. He claimed the land he set foot on for his homeland, Spain.

The third-grade students were working on a math problem that stated, "Columbus was in America in 1492." The cover of the *Math in Focus* workbook published by Marshal Cavendish Education said it is a "world class program" and a "consistent top performer in international studies." The students wrote the publishers. "There was a math problem that said Columbus was in America in 1492. (We have proof.) We know that is not true." The error was found on page 52 of the workbook. After three form letters from the publishers of the math workbook and a petition posted on change.org, the students wrote once again, saying: "We think they are ignoring us because we are kids." On the posting they stated that "kids deserve to know the truth about history and

Columbus." Kudos to these young scholars and to their teacher who aided their approach and supported their quest to right a perceived wrong.

The workbook publishers finally replied: "people can use the words [Americas] and [America] in different ways." However, the publishers agreed to change the textbook and adjust the language for clarity. "Columbus never landed in the United States of America."

This writing is a continuation of discovery and exploration of North America and other parts of the world. Certainly, it is not a total history, but it enough to give a flavor of how and who came to Montana and some of what was found when they arrived. Montana was a three-sided state. The north border is a thirty-foot-wide space of what is called "no-man's-land" because it is a buffer between nations. Identifying this boundary by surveyance did not happen until the late nineteenth century. Just as the Rio Grande River divides two nations—Mexico and the United States—the no-man's-land at the forty-ninth parallel divides the United States from Canada. The wind and wildlife know no borders.

Twenty-eight years after Ponce de León found Florida; Charles V of Spain appointed Hernando de Soto as governor of the unexplored interior of southeastern North America. De Soto's voyage to explore the New World landed him on the shore of the mouth of the Mississippi River. He claimed all adjacent lands whose water drained through the mouth of the great river for Spain. De Soto landed on the west bank, and as governor of the unexplored southeastern interior, he attempted to construct vessels that would carry his party to the eastern banks of the great river. Once ferried across, de Soto and his men found only thickets and bogs, along with insects and animals that wished to consume them. De Soto returned to Spain disillusioned of his political appointment and despised by his crew. He died, depressed, on his return home in 1542.

Spain consolidated her dominion over the southern portion of the New World by converting Indians to Christianity. The conversion continued as the Spanish explorers moved north and west, meeting resistance from the established Native Americans they encountered. A French explorer named Jean Ribault led an expedition up the mouth of

the St. Johns River in Florida in April of 1562. From there he entered the uncharted territory of the mainland and led his expedition to South Carolina, where in 1564 he was killed during the Spanish-French dispute for control over Florida. René de Laudonniere followed Ribault to North America, but once he entered the mouth of the Johns River he moved inland and established Fort Caroline. In 1565, Pedro Menéndez de Avilés, a Spanish explorer, founded St. Augustine. He named the settlement for St. Augustine's Day, the day he first sighted Florida. St. Augustine is located not far from Fort Caroline and was the first established settlement in what would become the United States.

Prior to 1534 the English Reformation movement began introducing Protestantism. Spain, France, and Britain's religion was Catholicism. This made the religious conversions somewhat similar regardless of which nation was staking claim, but problems arose with communication and application. None of the native Indian tribes in North America were familiar with Spanish, English, French, or religion, and the same was true of language in reverse. Trappers, traders, and Indians were largely infidels unfamiliar with capital and merchandising. These concepts had not been considered by the politicians and rulers of the day. After the continent was discovered by Europeans, many of the immigrants arriving in the New World came to the shores of North America partially to escape the politics and religion of their native countries.

A young Réne La Sallé, the son of a wealthy French entrepreneur, joined his brother, who was serving as a priest at the Seminary of St. Sulpice in Montréal in 1667. France, Spain, Italy, and Great Britain began settling New France and Canada through religion and agriculture. La Sallé purchased property through the Seminary at Lachine, where he worked his land for a brief time. Being an entrepreneur by birthright, he observed the fur trade industry in the spring during planting season. French fur agents (known as *wood runners*) and Indians would arrive in the neighboring cities with tales of abundant wildlife and fabulous furs to be gained near a great river that ran southwest. La Salle thought three things about the stories he was hearing: First, hunting, trapping, and exploring sounded like a lot more fun than farming. Second, the

furs industry was booming in Europe. Third, it was possible this great river that ran southwest would lead to a shorter, more direct shipping route to China.

The territory of New France and New England consisted of five colonies in 1712. Canada, Québec, Trois-Rivières, Montréal, and Hudson's Bay territory which included Acadia in the northeast, Plaisance on the Island of Newfoundland, Louisiana, and the Canadian prairies to the Gulf of Mexico including all the Great Lakes of North America. This claim was problematic with DeSoto's claim of *all of the lands that drained into the Mississippi River for Spain*" and LaSalle's belief that he could hunt and trap throughout the territory and claim new lands through adjacent waterways for France. LaSalle suffered from entitlement and an inability to use the tools of the day for exploration and mapping. He was not a good people person and was unable to navigate, therefore, woefully equipped to do either of the tasks he contemplated and then attempted to complete. There were some sparse written reports and reasonably accurate maps of a portion of North America that were available written by Groseilliers and Radisson prior to Hudson Bay Company's establishment May 2, 1670. There would have been no way for LaSalle to access that information as it was not until Radisson handed maps and reports to the King of England that there was any such record available.

The Spanish explorers began bringing horses to the New World in the 1600's to expedite exploration and settlement of the newfound continent. This asset enabled the Spanish explorers to cover territory at an aggressive pace given that the area they were exploring did not have the extreme mountains and forests that the northeast portion of North America's landscape contains. Horses of French and English breeding arrived on the northern Great Plains in the late 1700's via Hudson Bay Company coureurs de bois. These explorers traveled as much as possible by waterway and/or by foot and only brought what horses were necessary for survival. Larger numbers of horses would have slowed movement providing rest and feed for the animals. The terrain in the rocky forested northeast slowed the pace of the parties and the seasons necessitated efficiency in all aspects of the journey.

The pair of Coureurs de bois responsible for the formation of Hudson Bay Company, Médard Chouart des Groseilliers (1618–1696), and Pierre-Esprit Radisson (1636/1640–1710), became the first white men to venture inland establishing friendly trade with Indians. Hudson Bay Company opened Canada to settlers by setting up trade relations with indigenous tribes of North America. Groseilliers was the older of this pair and had married the widow Helène Martin, daughter of Abraham Martin, whose land surrounded Quebec City, Canada. Helène died in 1651. Médard had worked as a lay helper at the Jesuit missions in the Huron region near Simcoe County, Ontario. The Iroquois Indians had destroyed the Huron missions in the 1640's forcing people further west. Groseillier had moved to the Lake Superior region of New France where he worked to establish trade with the Indians.

In 1653 Médard Groseillier established himself at Trois- Rivières where he married the widowed maternal half-sister of Pierre-Esprit Radisson. This marriage produced three children: Jean Baptiste, Marguérite, and Marie-Antoinette. Marguérite Hayet, (sometimes spelled Hayot), may have arrived with Pierre- Esprit Radisson and his two sisters, Élisabeth and Françoise, in 1651 when they emigrated from France to Canada. All three women were reported living together in Trois-Rivières in 1651.

Radisson was much younger than Groseilliers. Shortly after his arrival he was with a hunting party that was attacked by the Iroquois Indians. Radisson was taken hostage and tortured, eventually escaping after almost two years of heinous treatment. He was a wild spirit who wrote in his journal: *"It was my destiny to discover many wild nations, I would not strive against that destiny ... For my own part, I will venture, choosing to die like a man than live like a beggar."* Following his escape from the Iroquois he was captured a second time and joined a local Mohawk family near Schenectady in what is now New York State. In both of his captivities Radisson continued his enthusiastic curiosity and ability to adapt making him one of the most notable fur traders of his era.

Médard Groseillier was sent west to Huron lands when the Governor of Trois-Rivières was killed in a skirmish with the Iroquois Indians.

Guillaume Guillemot had been made Governor to establish peace with the Indians. After Guillemot's demise in 1652 it was thought perhaps Groseilliers might begin a peaceful trade association with the Sioux, Pottawatomi, Winnebago, Fox, and Iroquois Indians as he was bilingual and knew the habits of the Indians. Groseillier began his voyage to the Huron lands in 1654. It took two years with Groseilliers and his men returning in August of 1656 with furs weighing 14 to 15 thousand kilos. When Médard made his second trip inland, Pierre-Esprit Radisson had returned from captivity with the Indians. Groseillier and Radisson traveled west with a party of men of their choosing to the far end of Lake Superior and wintered in what is now known as Wisconsin. The King of France had offered to appoint a party of men for the expedition, however, Radisson scoffed at the offer choosing to pick men he trusted could handle what he knew to be a difficult dangerous journey.

While Radisson had been captive to the Indians from 1652-1654, peace had been made between the French and the Iroquois largely due to Groseilliers leadership. The area at the far end of Lake Superior had Sioux, Winnebago, and Fox Indians who had not yet established trading relationships with either the French, Spanish, or British. Wintering in this area, Radisson and Groseilliers gained the respect of the Indians encountered by offering gifts and tools that were helpful for survival in the harsh northern winter. They were rewarded with furs and returned to Trois-Rivières with an impressive load of furs and a civil understanding with the Indians encountered around Lake Superior.

In 1657 Radisson accompanied a Jesuit missionary party to Marie-de-Gannenta. This mission had been established in 1656 near what is now Syracuse, New York. This began written accounts by Radisson of his life as explorer, entrepreneur, and ombudsman who, along with his brother-in-law Groseilliers, compelled France and England to establish boundaries for North America's fur trade. In 1664 Radisson traveled to Boston then on to England as the King had summoned him. He was made an offer to defect from France and become a Coureurs de bois for Britain. Comfortable with his own capacity to adapt, but cautious of being hampered by inexperienced and woefully equipped government appointee's, Radisson audaciously told the King what he could do

with his offer then promptly returned to Canada to set out on another adventure. What was left to the King were detailed maps and journals siting valuable accounts of territories and Indian customs encountered by Radisson when he was a captive of the Indians.

In 1668 and 1669 Groseilliers and Radisson went on an extensive inland trip feeling confident they could manage an expedition without the intrusion or finance from another government as both men were loyal to France and the Marquis d'Argenson, governor of the Colony of New France. That loyalty was compromised when the two men returned with the largest caches of furs ever to reach the market. The governor refused to allow Radisson and Groseilliers full payment for their cargo, taxing them because they had taken more than one year's time, the length of their permit, for the expedition. Additionally, many furs were confiscated leaving them with substantially less money than what they had earned or were anticipating for their labor. The pair went to England to barter the remainder of their cache. This number of furs and the tenacity and astuteness of the men brought the King to the realization that England needed to gain control over New France and Canada territory if they were to capture the fur industry.

Fur trade became the primary industry of French colonies in North America once the Voyageurs and Coureurs de bois began exploring inland and setting up trade posts. Prior to the appearance of entrepreneurship reaching the indigenous natives on the continent, the Indians engaged in limited trading with neighboring tribes for goods they could not acquire themselves. They hunted, fished, and procured fruit, herbs, and edible vegetations which were gathered in season then dried and stored for winter months. Radisson and Groseilliers were among the first Coureurs de bois to introduce the Indians to trade or exchange of goods for furs. They began the complex building of networks and alliances. This was not an easy task as it required speaking many different dialects and hours of collaborating with different tribes demonstrating new methods of procuring furs and utilizing the tools brought by the Coureurs. The French traders began, as these two, trading high quality French goods. Knives, pans, blankets, fishing poles and hooks, beads, and other useful items. For the Indians to see

the value of the items they had to be shown how the items were used in everyday life.

Radisson and Groseilliers had been highly insulted with their treatment from the French after their successful venture into the unexplored regions of New France. On returning from their next expedition, they defected to England and became the first employees of Hudson Bay Company formed by King Charles II May 2, 1670. HBC formed by Charter of monopoly over the region drained by all rivers and streams flowing into Hudson Bay in North America. The new land was named after Prince Rupert, the first governor of **Ruperts Land**. There had been tensions growing between France and England, not entirely over the fur trade in North America, but also over religion and slave trade. English Reformation and Martin Luther's Protestantism dividing the beliefs of the English was creating extreme tension in Europe. France was holding firmly to Catholicism. Slavery was another contentious subject between the two nations and tobacco was becoming an issue as the consumption of both countries, and addiction to the product by their inhabitants, was causing irregularity in supply and demand.

Radisson married the daughter of Sir John Kirke 1n 1672. His wife's father, Gervase Kirke of Hudson Bay Company, owned a considerable part of the northeastern region of North America. Following the formation of Hudson Bay Company, Groseilliers was delayed on his return to Canada from England. When he did return, he retired from his Coureurs de bois adventures and his son, Jean-Baptisté Des Groseilliers, began working with his uncle. Radisson had no moral or patriotic compass where his cousin wished to remain loyal to France. Unhampered by religion, his zest for life would not allow Radisson to work within the boundaries of one employer. He left Hudson Bay Company and began trading with France after only two years. This angered Great Britain. They took away the citizenship of both Radisson and Jean-Baptiste Des Groseilliers.

France was frustrated with Radisson for not bringing his wife with him when he returned to France to defect from England. They had hoped by working with Radisson for a better market price for his

goods they could gain some of the land his wife's father controlled. Unbeknownst to the French, his wife had died, and he had remarried a French-Protestant Gideon. His ambition and imagination took him back to England where he persuaded Hudson Bay Company to pay he and his nephew to become naturalized citizens of Great Britain.

Radisson married one more time before he died leaving a widow in England where he had returned to live out his life. For all the money he earned from Hudson Bay Company, Radisson left a will for his wife Elizabeth when he died. The will was probated. The Company gave her six pounds for the entire estate, presumably to bury her husband, and that is the last information this author found of record of the whereabouts of Radisson and his wife Elizabeth.

Radisson had been severely tortured by the Indians when he was captured as a teenager. One of the slighter atrocities done to him was to have his fingernails pulled off while strung by his wrists from a pole. While he was elevated, bleeding and in incredible pain, his captors ordered him to sing. Radisson wrote about the experience in the report he gave to the King of England. He described how it was difficult to bring out a sound that resembled a note as he had not sung before. Charged with the task, he found that he could sing and in doing so he could forget about everything else that was happening to him and he could sing. This knowledge and ability served him well throughout his lifetime and most probably shocked and awed many of his would-be enemies disarming and charming them.

CHAPTER 2

MALODOROUS ENTITLEMENT

The drainage basin of Hudson Bay constitutes 1.5 million square miles comprising over one-third of the area of modern-day Canada and stretches into north central United States. The formation of Hudson Bay Company's exclusive control of Rupert's Land would eventually become Canada's largest land purchase in the 19th century.

While Groseillier, Radisson, and Jean-Baptisté Groseillier were working hard at making peace with the Indians and establishing friendly fur trade, René-Robert Cavelier Sieur de LaSallé was mucking up the works from north to south. At his request he was released from the Society of Jesus citing *"moral weakness"* March 27, 1667. He was required to reject his father's legacy when he joined the Jesuit's and accepted the land in Canada his brother afforded him when he came as a prospective colonist. He began issuing land grants on his property with the intent of setting up a village. He did try to learn the languages of the native Iroquois Indians in Lachine. Apart from this gesture he appeared to have no interest in owning or working the land or generating a relationship with Indigenous Peoples.

LaSallé began building ships financed with the help of his merchant father in France. His first 10-ton single decked brigantine was lost in Lake Ontario January 8, 1679. The second ship was the Le Griffon, a seven-cannon, 45-ton ship which he launched on the upper Niagara River August 7, 1679. LaSalle sailed Le Griffon up Lake Erie through Lake Michigan, Lake Huron on to Green Bay, Wisconsin. Le Griffon

left Wisconsin for Niagara with a load of furs and was never seen again. LaSalle and his men managed to get into canoes and traveled down the western shore of Lake Michigan around the southern end to the mouth of the St. Joseph River where they landed. The crew built a Fort they named Miami in January of 1680. Currently this is St. Joseph, Michigan. There they waited for another party that was crossing the Lower Michigan peninsula on foot.

The party on foot was led by a French officer named Alphonse de Tonti. After meeting up with LaSallé's entourage, Tonti remained in Michigan where he engaged in numerous scandals and disreputable activities before he was eventually dismissed from his post as commandant. He died before he could receive another appointment or return to France. This type of leadership and decisions made by LaSallé made him extremely unpopular with his charges. He returned to France and found a newly appointed Governor, Count 'Frontenac, known to have entrepreneurial interests. LaSallé proceeded to recruit Governor 'Frontenac's financial support for further exploration of the New World for a share in the fame and profits.

LaSallé found the Iroquois and Illinois Indians had become savagely hostile to the French upon his return from Europe. During his absence, his men turned on him. When he ordered them to fight off the Indians while maintaining the camp he was rebuffed. With this new threat, LaSallé pressed upon 'Frontenac to finance the building of more forts to protect his investments in the New World fur trade and further explorations of the great river. With the additional funds he was able to pay his men more thus keeping enough men to continue the route south.

LaSallé continued his exploration southward establishing forts providing outlets for expanded fur trade and convenient retreats. Somehow, he managed to turn the Illinois Indians against the Iroquois. This began an era of fighting amongst all tribes in North America while the furs were being harvested from every living creature captured and killed by the Indians, trappers, traders, and military. The education of competition and greed followed throughout the settling of the New World. For LaSallés' part, he finally traveled the entire Mississippi Valley, through hostile Indians and diverse terrain. Rene-Robert LaSallé

reached the mouth of the Mississippi April 9, 1682. He promptly named the territory he had traveled Louisiana and claimed it in its entirety for France. This port would have theoretically given France control of the fur trade all the way up the Mississippi Valley and on into Canada.

From the mouth of the Mississippi River, LaSallé returned to France to deliver the information and maps to Count 'Frontenac and to gather a population for establishing a French port and trading post at the mouth of the Mississippi River. This port would give France control of the fur trade in North America. The demand for beaver pelts was great but the animals were only available in the northern regions of the continent. Gaining control of the southern port would put France in charge of agricultural products exported through the New Orleans port, such as grains, cotton, and tobacco. In 1684 LaSalle sailed from France with 4 ships and 400 people. He mistakenly took Matagorda Bay for the Mouth of the Mississippi River and two of his ships wrecked and the remaining two were plagued by Indian attacks and internal dissension. LaSallé was eventually killed by his own men.

LaSalle had never married. His family suffered greatly when he abdicated from the Seminary then continued his attempts of discovery on money sponsored by Count 'Frontenac. Each of his exploits ended in embarrassment for his family and failure or death for his charges. The provocations this single person ignited amongst all Indian tribes and Nations on the North American Continent caused a prolonged rift that has never really healed. He was not alone in his malevolence, but he left a scar on the United States as big as the mighty river he untenably asserted to explore for France.

In 1691, a Spanish naval expedition went to look for LaSallé's two sunken ships. The Spaniards, using their own maps and navigation systems, found the fatal error LaSallé had made directing two of his ships to certain disaster landing at Matagorda Bay instead of the mouth of the Mississippi.

In 1998, the flagship of French explorer Rene-Robert Cavelier, Sieur de LaSallé, was discovered in the Gulf of Mexico near the Texas coast. The ship, L'Aimable, ran aground February 29, 1685, and was partially exposed under 20 feet of water still holding a vast array of artifacts.

Clive Cussler discovered the wreck February 25, 1998. Three hundred and twelve years and 361 days after its final sail. This story was reported in the Great Falls Tribune.

Matagorda County in Texas is a census designated place located near the mouth of the Colorado River on the Upper Texas coast in the United States. This primarily tourist town was established in 1827 and boasts of a population of 503 in the 2010 Census. It is a commercial and recreational fishing destination and is listed #1 in the Nation by the North American Audubon Society denoting 234 distinct species of birds. Located at the end of State Highway 60, which runs over the Intracoastal Waterway and south to the Gulf of Mexico, it is the third oldest town in Texas. Matagorda was established when Stephen F. Austin obtained permission from the Mexican government to build a town to protect incoming settlers (1827). Commercial and recreational fishing and world class kayaking waters bring tourists to this tiny village once mistaken by an experienced French naval explorer, LaSallé, as the gateway to America.

LaSalle's claim of the mouth of the Mississippi for France was one of the contributing factors for Spanish succession from the New Territory at the Treaty of Utrecht. The division of powers in the New World were unaware of the vast area and diverse topography of North America. While the European nations leadership could negotiate agreements among their established governments and territory, they were woefully equipped to manage a country unexplored and unmapped with a vast body of water separating the continents. Europeans who had made their way to the North American continent had often left their native countries fleeing religious oppression and political discord. The lack of established boundaries, laws, and leadership exacerbated by English, French, and Spanish finance and trade, set the stage for the American Revolution.

A remarkable fact of the founding of the Nation that would become the United States is there was no consideration of the Indigenous Peoples who for centuries had lived in relative harmony sustaining on the natural resources in tribal territories. Not until the Europeans arrived with capitalistic goals and dominate aspirations did the Indians

become aggressive savages. This haughty invasion of other cultures who were unable to communicate with comprehensiveness would doubtlessly cause anger and distrust to the natural population of North America. Yet, the invasion of these aliens continued.

Henry Hudson, a Dutchman, had twice attempted to find a shorter passage to the Far East by going west, once it was discovered that the world was round, financed by merchants of the Dutch East India Company. Both expeditions ended in failure. Hired by English merchants, Henry Hudson made a third voyage into the unknown. The third time was the charm for this Dutchman finding Manhattan and Hudson Bay in 1609. Perhaps it was luck, or fate, or divine intervention that the Dutch should land on the east coast where the land was partially submerged in water. This was a problem the Dutch had dealt with. Turning a bog into productive soil is a capital skill of the Dutch. This northeast corner of the United States included what is now New York, New Jersey, Pennsylvania, Maryland, Connecticut, and Delaware forming the colony of New Netherlands. The first major group of settlers to arrive at New Netherlands were French speaking Belgians. A group of 30 Protestant families came fleeing oppression in their own country in 1624.

As Hudson was exploring in unknown territory, he did not have settlers aboard the Half Moon. The men who disembarked on the mainland knew of the fur trade to the north of their landing. They began a route to Montreal securing furs along their way. This brought another country of trappers into the fur trade industry. The Dutch encountered Mahican and Mohawk Indians who were at war with the French, English, and Spanish trappers. This began what was known as the *Beaver Wars* or *Iroquois War* in Europe and the northern regions of North America in and around the Saint Lawrence River Valley. The Iroquois, armed by the Dutch and English, were pitted against the Algonquians. The Algonquian speaking tribes and Hurons were backed by the French, their chief trading partners. Unaware of the reason for the fighting, the Dutch became involved in the fight on the losing side.

Henry Hudson died in 1611 when his crew mutinied setting him adrift on a small lifeboat in the Canadian Artic. His luck ran out. In

his defense, Dutchmen are fiercely stubborn and do not take orders well. Even Hollands' Navy crews were malcontent defying tactics laid out by their command. Netherlands was experiencing disagreements with England, France and Spain on the mainland of Europe and the Dutch people were experiencing political and religious divergence with the Catholics, Protestant's, and William the Silent' s Calvinistic *house of Orange*. Stadtholders, the Dutch term for a chief executive officer of the provinces that formed a union leading to establishment of the Netherlands, were heritors of the colonies and counties. It became important that leaders have son(s) to keep land holdings in family lines. The larger the land holdings, the greater the role in forming governments. Females were not considered heir apparent.

Religious friction in Europe had begun in 1566 with the Prince of Orange, William the Silent, attempting to liberate the Calvinist Dutch from the Catholic Spaniards starting the *Eighty Years' War*. The son of a wealthy family in Utrecht, Paulus Buys, decided to support William the Silent. Buys had studied law and worked as a lawyer for the court of Holland. He became a well-paid pensionary whose task was to advise the city council on legal affairs and serve as the representative of Leiden at the estates of the colony of Holland. Later he became '*hoogheemraad*' (the chief official) of the Dutch constitutional body for the security of dikes and tracts of reclaimed lowlands (polder) against the sea and the rivers. In 1572 he was appointed as land's advocate of Holland before Calvinists took the county. As representative, he vetoed raising taxes at the estates general of the Netherlands in Brussels. He had to flee from the Netherlands because of this negative vote which prevented increasing the enrichment of the Roman Catholic Spanish garrison in the counties of Zeeland, Leiden, and Holland. Paulus Buys became the head of the rebel *Raad van State* (one of the constitutional bodies of the Netherlands).

As *Raad van State*, Buys became the rebel leader of the Protestantism conversion which transpired when, as curator of the university, he went to England in 1575 to try to convince Elizabeth I of England to ally with the Prince of Orange. Elizabeth I refused. As leader of the inundations, Buys opened the dikes to let the water of the sea in during the *siege of*

Leiden drowning the Spanish cannons causing the Spanish to lift their Siege in 1574. He was also the leader of the reconstruction of Leiden starting with a successful appeal to the Prince of Orange to establish Leiden University.

The *Pacification of Ghent* declared the northern and southern provinces of the Low Countries put aside their religious difference and unite in revolt against the Spanish *Habsburgs*. This was the first major expression of the Netherlands' national self-consciousness. The *Treaty of Ghent* took place November 8, 1576. Paulus Buys was one of the founders of the *Union of Utrecht* in 1579. This Union ended the *Union of Brussels*.

In 1648 *Peace of Münster* closed the flourishing port of Antwerp to all foreign trade and other ports in what is now the Netherlands. France ceded Northern Brabant, Zeeland, and the region east of the Meuse River to the Dutch Republic making it a part of the Spanish Netherlands (also known as the United Provinces). United Provinces also included Artois in the northern part of France, portions of Hainaut, plus Luxembourg and Flanders in Belgium. This mercilessly carved region was in the unfortunate position of being a buffer between Protestant and Roman Catholic religion resulting in more than eighty years of constant warfare. The Dutch won their independence from Spain at the expense of their fleet. They were depleted of capital and leadership.

The Prince of Orange died of smallpox in 1650 at the age of twenty-four leaving a son (too young to inherit) heir to this beleaguering Habsburg dynasty. Dutch merchant fleets had been trafficking in on Britain's trade in the Americas. The colonies began practicing limited forms of self-governance and merchants soon learned to operate outside British law. Those who escaped religious persecution in England demanded the freedom to worship according to their faith. Each colony had a written Charter between the colony and the King of England or Parliament. A colonial Legislature was elected by property holdings. At this time women could not own property making the Legislature exclusive for men stating, **"the ruler is fully autonomous within his own domain"**.

English Commonwealth sent a diplomatic delegation headed by Oliver St John to The Hague in March of 1651 on the pretense of negotiating an alliance combining the two republics into a single diplomatic and commercial Protestant federation. Dutch republicans, Cornelis de Graeff and Johan de Witt, were sent to end the influence of the aristocratic house of Orange's hold on the Netherlands. The Dutch were not fully prepared for the Commonwealth's successful passage of the **Navigation Act of 1651**. The Act restricting all imports to be delivered by English ships, or by ships of the country of origin of the goods being imported. The Act intended to cripple the freight trade of which Dutch commerce depended. It required that the Dutch would only be able to import butter and cheese, produce of Holland, to England and her colonies. The act further stipulated that salt-fish and fish-oil could only be imported or exported from Commonwealth territories in English vessels. This action only increased tensions between Netherlands and England. This began the first *Anglo-Dutch War* between the two countries leaving both exhausted with seriously impeded shipping abilities. England called for negotiations but not before the Dutch *Battle of Goodwin Sands* 1652. Netherlands conducted a full-scale amphibious operation with the Dutch troops landing on English soil. The Dutch were victorious capturing two English ships and destroying major units of the Royal Navy in its own lair.

A bit of foresight passed to Johan De Witt by his father, Jacob DeWitt – a prominent figure in the stormy dissention of Holland's political life and ardent supporter of the Republic against the hereditary stadtholders of the house of Orange. Suggesting to his son that; '*he might insert a secret clause in the alliance agreement combining the two republics into a single diplomatic and commercial Protestant federation*' negotiated in the Hague in March of 1651. Jan De Witt had taken his father's suggestion and inserted the clause in the *Treaty of Westminster*.

Spain, Britain, and France were all sinking further into debt trying to sustain their mainland religion and fight territorial trade battles amongst each other and the Indians on a continent an ocean away. New France, New England, New Netherlands, and Spain were all competing for colonial trade while the colonies were at war with the native inhabitants

of their newfound country. As the colonists and settlers sought freedom from their mother countries, the Native Americans fought to keep the freedom and resources they had always known. Louis XIV was nominally an ally of the Dutch splitting the British fleets attention with threats from both French and Dutch Navy. Britain had engaged France in a four-day battle in Nord Foreland (North Sea) which resulted in the loss of seventeen French ships. The county of Artois and large southern portions of Hainaut were taken by France in 1659.

A decade of peace had followed the first *Anglo-Dutch War*. The Dutch Republic used this time re-establishing finances with the leadership of Johan De Witt. De Witt began by reducing the rate of interest on all debt while restoring monetary reserves making it possible for swift construction and outfitting of a powerful naval force. With his own monies, and the able backing of Michael de Ruyter, the Dutch republicans were able to create order out of chaos. Michael de Ruyter, a naval hero of the *Anglo-Dutch* wars, was made commander of the Admiralty of Amsterdam.

The second *Anglo-Dutch* war was colonial in nature. In 1664 English aggression resulted in the acquisition by naval expeditions of the New Netherlands colony in North America and of the isles of Tobago and St Eustatius in the Caribbean. Cabo Corso and other Dutch trading posts in West Africa were conquered by English men-of-war. The colonies protested to the dissembling Charles II. Thereupon, De Ruyter was sent with a squadron to the African coast and on to the West Indies. When the English heard of the Dutch retaliation, war was declared in the spring of 1665.

There were four Anglo-Dutch wars. Some historians will say six, others eight, but not all these battles were Dutch. They all involved England, but England was being heavily resisted by France and Spain as well as Holland. England had enjoyed control over the seas early in the colonial settlement of North America. Governors were appointed by the King of the mother country of the colony and had almost complete authority – in theory. The legislature controlled the salary of the governor and often used this influence to keep the governors in line with colonial wishes. The first Colonial legislature was the

Virginia House of Burgesses established in 1619. Pilgrims, landing at Plymouth Rock in 1620, drafted the Mayflower compact declaring that they would rule themselves. The Anglo-Dutch wars were keeping the mother countries busy with internal dissension and financially strapped. (Plymouth Rock is in present day Massachusetts.)

The Dutch had their way in the *Treaty of Westminster* enforcing the '*secret clause*' that Johan de Witt had inserted in this agreement. When the French defeated the Dutch in the Mediterranean, the Dutch and English formed an alliance with the Prince of Orange, William III, (who was just four years old), marriage to Mary Stuart Princess Royal, the daughter of King Charles I. Mary Stuart was closely related to Johan de Witt through his mother. Ironically, William III became the King of England when James II was dethroned during the Glorious Revolution which ended England's move toward absolutism.

September 7, 1664 the British took possession of New Netherlands. This action was happening at the end of the First Anglo-Dutch War. Following the *Battle of Goodwin Sands* and the *Cromwell arbitration agreement* (which reviewed the hidden clause inserted in the *Westminster Treaty*) Britain traded the British colony of Suriname to Holland for New Netherlands with the *Treaty of Breda* in 1667. This was the atmosphere at sea affecting continents in their development of trade. These never-ending wars did not compare to the devastation that was taking place inland. Protestants fought Catholicism. The Holy Roman Empire fought France against the Habsburgs of Spain. German royalty was against the emperor and each other(s). Swedes, Danes, Russian, Dutch, and Swiss were all dragged into the rivalries because of commercial interests. Many countries of Europe were on the brink of bankruptcy.

What happened to the North American Continent during the French and Indian Wars, American Revolution, and the Civil War was happening to Europe in the mid 1600's. Until the matters of religion, politics, and commercial interests were identified and defined. Fighting continued. Resentment continues amongst countries. At the turn of the century Spain lost control when Charles II died naming Philip, duc d'Anjou of France his successor (Philip V). In 1602 the *Dutch East India Company* was founded. This company flourished and survived for two

centuries giving Holland a upper hand in commerce. It was this spice trade that roused the Dutch so violently when the British captured the trading posts in the second *Anglo-Dutch War*. This trade was so valuable to Holland that they were willing to give up New Netherlands, North America in trade for Suriname. New Netherlands settlers and traders were not happy being pawns in the political wars of their mother land effectively making them a part of New England.

1567-1574 saw the rule of Holland under the Duke of Alba of Spain. The Duke began a reign of terror slaughtering all suspected of heresy. This opened wounds that had been developing amongst the Catholic, Protestants, Calvinists, and Jews. The Netherlands ceded from Spain over both political and religious issues and practiced certain forms of tolerance towards people of other religions opening its borders to religious dissenters from elsewhere. This friction with Spain gave English merchants the advantage of trade in Spanish markets from which the Dutch were excluded. Persecution and discrimination of native Catholics became pronounced throughout Europe resulting in cataclysmic devolution on the terra firma of Europe.

A series of peace treaties ended this calamitous period of European history. Named after the Westphalia area of north-western Germany, *Peace of Westphalia* ended the prospect of a Roman Catholic reconquest of Europe and solidified Protestantism in the world. The wars fought during this period of European history were said to have caused the deaths of approximately eight million people. What began when the Austrian Habsburgs attempted imposing Roman Catholicism on Protestant subjects in Bohemia, resulted in a century of horror for mainland Europe including the Swedes, Danes, Poles, Swiss, Russians, Germans, and Czechs. Fighting largely took place on German soil. It reduced the country to desolation as hordes of mercenaries, left unpaid by their masters, lived off the land. Rape, pillage, and famine stalked the countryside as armies marched about, plundering towns, villages, and farms as they went.

'*We live like animals, eating bark and grass*', says an entry in a family Bible from a village on the Danube River where few family names inhabited the hamlet (*Swabian*). '*No one could have imagined that anything*

like this would have happened to us. Many people say that there is no God ...'. The horrors became a part of everyday life. When the wars ended, the mercenaries and their wives complained their livelihood was gone.

Wenceslas Hollar, a prolific and accomplished Bohemian graphic artist of the 17th century, recorded devastation in the war zone in engravings. Starvation reached such a point in the Rhineland that there were cases of cannibalism. Hollar spent much of his adult life in England. Dutch, French, and the Habsburgs were dragged or dived into this fight over commercial interests. Rivalries played a part, as did religion and power politics. The increasingly crazed Wallenstein (*Bohemian Military Commander*) grew so sensitive to the constant noise that he had all the dogs, cats, and cockerels killed in every town he entered.

Albrecht von Wallenstein was orphaned at age 13. He was supported by an uncle who sent him to Protestant grammar school in Poland and to the Protestant University in Altdorf, Germany, east of Nuremberg. Born September 24, 1583 in Hermanice, Czech Republic, Wallenstein was seemingly not beholding to any religion or country. He was married twice and killed in battle by an English officer February 25, 1634 at age 50 in Cheb, Czech Republic. Wallenstein was said to be blinded by his belief in astrological prognostications which some believe contributed to his erratic behavior.

As the turn of the century approached, Spain began to encourage black slaves from North American colonies to come to Spanish Florida as a refuge. King Charles II issued a royal decree freeing all slaves who fled to Spanish Florida and accepted Catholic conversion and baptism. St. Augustine received many runaway slaves. Spanish Louisiana had a substantial number of blacks from Haiti (a French colony) because of greater freedoms in the first legally sanctioned free black settlement in present-day United States. Spain's *Law of Coartación* resulted in a large population of free black people in Spanish America. This manipulation of slaves and slave trade by Charles II before his death escalated the friction in the American colonies by imposing decretory forcing settlers to redirect the way they did business. Combining such incommodious laws and increased financial demands through taxation was setting the mood for a revolution.

REFASHIONED NATIONS

Utrecht Netherlands seems an unlikely place for the world to unite in 1712. Perhaps because the Dutch were accepting of all religious beliefs, or possibly because of their dominance in the spice trade, but most likely because the Dutch had a University in Utrecht where René Descartes taught *"Cartesian"* physics around 1635. Cartography is mapmaking technology. Holland had the best maps in the world at the turn of the 16th and 17th centuries. For unknown reasons, the maps were not shared or distributed for many years with some ending up in Austria with a collector years later. When the Age of Exploration began Dutch maritime trade expanded their discovery to the western coasts of North and South America continuing from Portugal around Africa into the Pacific Ocean. Maps were crucially important to the flow of information and decerning property lines especially on detached continents which had not been explored in their entirety. The small country of Holland cast a large footprint in the 1700's.

Treaty of Westphalia had given the Netherlands independence from Spain changing to rule by Bourbon France for six years. British and Dutch troops occupied the country jointly for another seven years. In 1713 the *Treaties of Utrecht* passed the inheritance of the Spanish Netherlands to the Holy Roman emperor. This conference was a series of individual agreements, some of them were commercial, some were not sanctioned. Britain was the arbiter as their part of foreign policy was to make peace in Europe by establishing a balance of power. Even

though the conference was held on Dutch territory, the influence on the outcome of Spanish Netherlands was insignificant. The rivalry between France and Britain had international dimensions in the scramble for overseas territories, wealth, and influence. Attempting to balance power in Europe and North America the *French and Indian War* and *Queen Anne's War* ceased. The hostilities between France and Spain over the *Holy Roman Empire* and Catholicism continued until 1720 ending with the *War of the Spanish Succession*. This agreement returned the mouth of the Mississippi to France.

All of Europe was weary of the debts the *Hundred Years War* had incurred, the taxations that would be required to finance repair. Commercial devaluation of furs from Hudson Bay Company in North America would have to come from outside of Europe. Britain aggressively sought, and was awarded, the sole right to import black slaves into America for 30 years. France was required to acknowledge the Protestant Succession in England, Austria, Milan, Naples, and the Spanish Netherlands. This admission significantly contributed to the establishment of the Episcopal Church of England and churches of similar faith in communion with it influencing North American emigrants.

France ceded its claims to the Hudson Bay Company territories in Rupert's Land, Newfoundland, Nova Scotia, and Acadia to Britain. The island of Saint Kitts was also ceded in its entirety to Britain. France retained its pre-war North American possessions including Prince Edward Island and Cape Breton Island. Final agreements were reached and the conference that closed April 11, 1713 leaving the commissioners suggested southern boundary for Hudson Bay Company trappers and explorers; *"a line due west from the northwestern point of the Lake of the Woods to the Mississippi"*. Again, the description and location of the international boundary between Canada and United States lacked the insightfulness of an accurate map and therefore left undefined. The point of *Lake of the Woods* where the 49° parallel continued west to the Pacific Ocean was not identified until *Pierre Gaultier de Varennes, Sieur de la Vérendrye* explored the inland of Canada to Winnipeg Manitoba.

The colonies in North America became the jewel in the crown of Britain since they were awarded the Spanish Netherlands, most of

Canada, all of Hudson Bay Territory, and all thirteen colonies. Britain assigned a governor to oversee the colonies and began raising taxes on both imports and export goods to and from the continent. Since the lands of Europe were severely damaged from the wars, it was thought the British held property could make up the finances needed to rebuild their country. The colonists revolted in 1775 beginning with the *Boston Tea Party, Paul Revere's Ride,* and ended victorious for the United States October 19, 1781. This left Britain irate and in control of the seas.

War of the Spanish Succession put France in the import and export business at the mouth of the Mississippi in 1720. Beaver pelt trade took place in the north around the Great Lakes and west, but the colonists had built up a good wool and grain trade through the southern port and were not happy with the rise in prices to export and import. Spain's *Law of Coartación* had increased the free black population in the south and west coast of the continent. Blacks and Indians were each fighting for their market share. No one doing business through the port of New Orleans was happy with the changes that had taken place at The Hague in 1713.

Whatever the colonists were feeling on the North American continent had little to do with the ruling politics in the early 1700's. This was most probably the cause of the Revolution. Politics and finance are the two factors that seem to be the constant in shaping nations. The third crucial factor being religion or the lack thereof. Friction created by these surfactant elements continue to create heated disturbance around the world. Major factor's second to these elements in the 21st century are communication, education, and transportation. Nineteenth Century generations in North America had quite a breath-taking world to behold as none of these factors or elements were established, and yet they were all equally important to the final outcomes.

Despite The Hague being the messenger and host of the agreements reached in Utrecht Holland, the United States relationship with the Dutch has coexisted since pre-American Revolution. The American Revolution lasted six years starting in 1775 and ending October 19, 1781. John Adams, the United States first Vice President, and his wife Abigail Smith Adams, played a role in the success of the Revolution.

The stress and tension being separated from his closest consult and soulmate may have led to a major nervous breakdown John Adams suffered when he was removed from his position of sole head of peace treaty negotiations in August of 1791.

Without official status, John Adams traveled to the Dutch Republic in 1780 attempting to secure a loan from one of the few existing sympathetic republics for the American cause of increasing independence from France and Britain. The Dutch refused to meet with him. Two of Adam's sons were with him as he continued his negotiations with Dutch officials for a loan and became increasingly disappointed calling Amsterdam the "*leader of greedy pursuit for its own gain*". Adams purchased a house in *The Hague* when he was recognized as *de facto* Secretary of War. His two sons were given permission to leave Netherlands once negotiations began in 1782; John Quincy went with his father's secretary, Francis Dana, to Saint Petersburg as a French interpreter. A homesick Charles returned home with his father's friend, Benjamin Waterhouse. John Adams negotiated a loan of five million guilders and a treaty of amity and commerce with Holland. His house was purchased by the Netherlands and became the first American embassy on foreign soil.

John Adams wife, Abigail Smith Adams met John when she was 15 years old. They married October 25, 1764. Abigail's father preformed the ceremony in the North Parish Congregational Church in Weymouth, Massachusetts. If not for this remarkable woman, John Adams would have been a colorless blur of forgotten legal litigations in rural Massachusetts. Abigail was often sick as a child preventing her from attending school. This may have been a factor preventing her from receiving formal education. Regardless, her mother home schooled Abigail and her two sisters with their grandmother, Elizabeth Quincy, helping with reading, writing, and ciphering. The men of the Smith family had large libraries enabling the sisters to study English and French Literature. Somewhat of a bibliomaniac, Abigail Adams was said to have been the most erudite of all First Ladies. When she was growing up, she would read with friends to further her learning. She lamented the fact that females were rarely given the opportunity to have

a formal education in her era as she took responsibility for her family's financial matters and kept a constant flow of written communications to her husband, family, and friends. Most of her communications with her husband have been kept in the archives of American History documenting a story of a great love and strong leadership formed by the uniting of this pair of intellectuals'. John and Abigail Adams maintained a mutual emotional respect throughout their lives together exemplifying all the good a President and First Lady should employ as owners of the privileged office they are blessed to serve. Perhaps more amazing is the task for the First Lady to display such grace as the President is elected and the First Lady rises by conversion. Perhaps in the not so far future we shall see this role reversed.

Abigail Smith was born November 22, 1744 making her twenty years old when she married John. The first twelve years of their lives together as the John and Abigail Adams family, their numbers grew to seven with five children born healthy and the sixth girl stillborn in 1777. First born in 1765 was a girl. Second born in 1767 was a boy followed by another girl in 1768. In 1770 another son joined the family with another boy arriving in 1772. The family began their lives together at a small estate John's father had given him known as *Braintree*. John maintained his business in Boston while Abigail managed the farm and children when John was away. In 1768, Abigail and the children moved to Boston renting for one year. Abigail and the children moved to a larger house in 1770. In 1771 Abigail and the children moved back to *Braintree* to allow John to focus on his work. Equally distracted with his family at *Braintree*, Abigail and the children moved back to Boston where they resided in a large brick home on Queen Street. Boston was becoming unstable and the family moved back to the countryside estate in 1774 leaving John to do his work in Boston.

Abigail kept the responsibility for the family's financial matters, including investments, while caring for her children and keeping up her correspondence with her husband. Because of John's involvement with the Continental Congress and the Congress of Confederation in Philadelphia, he was kept away from Abigail and the children for extended periods of time. Even with the distance between, John sought

advice from his wife on all matters in his letters to her often apologizing for his weakness in decision making without her input. Abigail had the help of her sisters, mother, and grandmother in raising her children, which she did without complaint or neglect of duties. She accepted the role of wife and motherhood with elegance while watching other women in her family deal with their men and their alcoholism. When the revolutionary battles were taking place around the Massachusetts countryside, she became an eyewitness as she sat on a hill watching *Charlestown* burn and the *Battle of Bunker Hill* rage while tending her children.

Debt instruments issued to finance the Revolutionary War were given to Abigail by her uncle, Cotton Tufts. An original member of the Massachusetts Medical Society serving as a physician in Weymouth, he was a first cousin to John. These instruments were rewarded after Alexander Hamilton's *First Report on the Public Credit* following the War. They granted the holder federal payment at face value to holders of government securities. Abigail's financial acumen provided for the Adams family's wealth through the end of John's lifetime. During her tenure as First Second Lady and Second First Lady, Abigail Adams was an advocate of married woman's property rights and encouraged more opportunities, especially in education. In 1778 she wrote her husband; *"You need not be told how much female education is neglected, nor how fashionable it has been to ridicule female learning."* She urged her husband not to submit laws that were not in women's interest. She believed that women should not be content to be companions in their marriage and that husbands should not have unlimited powers in inheritance and finance. She believed slavery was evil but did not express an opinion on women's right to vote. She is said to have written that; *"All men would become tyrants if they could. Women will not hold themselves bound by any Laws in which we have no voice, or Representation."*

In 1784 Abigail Adams joined her husband in Paris France. She took her oldest daughter, Abigail (Nabby), and son, John Quincy, while her husband served in a diplomatic post. She was unhappy at first but soon became enamored with the fashions and arts Paris offered. When John was assigned as first U.S. Minister to the Court of St. James in

Britain, Abigail was reluctant but followed her husband to London. Her stay in London was disappointing after Paris. One bright spot was she was given the temporary guardianship of Thomas Jefferson's young daughter Mary. At one time clashing with Jefferson while in Boston, Abigail enjoyed the company of Mary in London and maintained a close relationship with her. When Mary Jefferson Eppers died, Abigail renewed correspondence with her father, Thomas Jefferson. This is yet another side of Abigail Smith Adams, the first First Lady to reside in the White House. She was not so enthralled with the Presidents House that she could not find a useful purpose for the unfinished East Room. The perfect place for hanging laundry.

Mrs. John Adams was the daughter and granddaughter of Ministers'. She had deep faith and was an active member of the Unitarian church. In her later years she lamented; *"When will Mankind be convinced that true Religion is from the Heart, between Man and his creator, and not the imposition of Man or creeds and tests?"* She died October 28, 1818 from typhoid fever. John Adams was born October 30, 1735 and died July 4, 1826. John and Abigail Adams shared the commonalities of Presidency, First Ladies, and parents of a President with George and Barbara Bush. John Adams was the first and only Federalist Party President.

In September of 1701, a *Grand Alliance* formed between *England, The United Provinces* and *Austria-Hungary.* This alliance led to the *"War of the Spanish Succession"* as a part of the agreements negotiated at Utrecht. The Treaty dealt with territories east and north of New Orleans. Spanish exploration of the continent was taking place on the west side of the Mississippi and north up the coast of the Pacific Ocean. The final agreement was signed, but not ratified, creating the Province of Louisiana and Oregon Territory. The area known as Hudson Bay Territory was governed by Great Britain including the New Netherlands since trade with Holland had been established in the *Treaty of Breda.* Boundaries were not clearly defined, a detail that hastened the outburst of the French Revolution.

While Europe was debating ownership and rule between countries and continents explorers in New France, New England, Louisiana, and Oregon continued with their struggles with Indigenous peoples who

were rapidly transitioning into a diverse collection of resistance to the haughty attitudes some of the trapper and traders exhibited. Although delighted with items obtained in trade, just as the furs were declining so did the quality of trade goods, particularly the British. The difference being that the value of the furs was increasing along with the decline in the numbers obtainable. The costs for expeditions inland increased as larger parties were required with more supplies with increased threats from competition for commodities. As the Couriers du bois and Hudson Bay trappers increased their trade with the Indians, they taught the Indians how to use trade items like knives, guns, kettles, spices, rope, needles, tobacco, horses, and liquor. The concept of wooden shelters, improved watercraft, and wearing apparel were introduced by early couriers. The building of trading posts and forts required increased cargo area on canoes that could navigate the smaller streams carrying building supplies. As the Indians learned from the Europeans, the explorers learned weather patterns, transportation corridors, cultural differences, and trapping techniques. The Indians had to answer to no one, but the explorers had to answer to their financier's. Money lenders expect returns; therefore, bookkeeping is necessary. With the money situation becoming desperate in Europe, North America colonies and territories were feeling the pinch as there were no banks or lending agencies in North America that were not governed by another country. Expeditions to the interior were, at first, sponsored by countries, but by 1720 a transition of sponsorship for expeditions and establishment of trade posts was becoming a company matter. Mother countries such as Britain, France, and Spain began to dispute with Hudson Bay Company and other conglomerates withholding money, confiscating goods for taxes, and failing to provide enough capitol for supplies and wages leaving the authorized harbinger '*holding the bag*'.

LaSalle's interest and exploration moving from the Great Lakes area to the mouth of the Mississippi, Hudson Bay, St. Lawrence River, Canada, and Quebec continued attracting French merchants long after LaSalle's demise. Coureurs de bois, Voyageurs, First Nation and Métis traders all relied on the fur trade to make a living in New France. French and British merchants began investing revenues forming coalitions to

finance fur traders as furs remained the primary industry in North America. Progress of mapping and securing territory inland continued. Spanish exploration on the western coastline continued moving north. Once reaching the mouth of the Columbia River they progressed up the river taking them into the heart of what is now Washington state. As Europeans crept toward the heart of North America, the Blackfeet, Cree, Sioux, Piegan, and Mandan Indians continued their lives with little discord or disease. From all accounts they were content to have *'enough'*. Perhaps their way of life appears Archaic to Historians, but they survived generations without periods of defecation as other nations and cultures have.

Following the *Treaty of Utrecht* many of the ranking military careers ended for young men who had fought valiantly for European countries. As in wars that would follow, these brave men returned home and found little waiting for them. This brought a new wave of entrepreneurs to the new world with an unsettled yearning to make something of themselves or, at the very least, find a place to call home. Many of these men were highly educated and experienced commanders knowing well how to lead and maintain composure in the face of danger. Qualities that were perfectly suited to lead expeditions into the unexplored interior of North America. One such Frenchman would find his way to the eastern borders of Montana and Alberta Canada. Pierre Gaultier de Varennes, Sieur de la Vérendrye returned to Canada in October of 1712 when his military career fizzled out. He was unaware of what was happening in the fur trade industry. When he left Canada to fight for France, fur trade was the premier industry in the world without competition as no other continent had the quantity or quality of beaver plews that North America provided. The first fur trade era belonging to the French from 1600 to1759 was followed by the British Era from 1760 to 1816. Vérendrye sold some of his property and borrowed against some scrimping out a living for his family of eight until around 1725. As his family matured, Pierre joined his brother in the fur trade industry. This partnership lead Vérendrye and his sons to the most important period of their lives. Their bravery and initiative led to a transportation corridor that spanned across half the North American continent.

CHAPTER 4

HUDSON BAY TO THE ROCKIES

Vérendryes were French nobility who secured entrepreneurship by peaceful agreement with Hudson Bay Company. Pierre Gaultier de Varennes, Sieur de la Vérendrye was born in 1685 and took part in border warfare during the Queen Ann War. He is thought to have been a member of the raiding party led against New England by Hertel de Rouville in 1704. This savage slaughter took place in Deerfield, Massachusetts. The French voyageurs burst into the little settlement and butchered, or carried off as prisoners, most of the inhabitants. Two years later la Vérendrye went to France and became a member of the French grenadiers engaged in destroying the armies of Louis XIV. Vérendrye was wounded and captured at the battle of Malplaquet in 1709. When he was released fifteen months later. He found himself too poor to maintain himself as an officer in France and so, returned to Canada.

Following his return to Canada, Pierre Gaultier de Varennes, Sieur de la Vérendrye (also known as Boumois) married Marie-Anne Du Sablé October 24, 1712. Vérendrye was engaged to Marie-Anne before his departure for France. Her father was Louis Dandonneau Du Sablé, a substantial landowner in Trois-Rivières. Louis endowed his daughter with 2,000 *livres,* (one *livre* was equal to the worth of one pound of silver), as well as land on Île Dupas and Île aux Vaches, located in Lac

35

Saint-Pierre. The couple made their residence on Île aux Vaches, where they lived obscurely for the next 15 years. They had six children – four sons and two daughters – and cleared a 38-acre farm. La Vérendrye had the revenue of the fief of Tremblay, inherited from his family, his ensign's pay, and the fur-trading post of La Gabelle founded by his father on the Rivière Saint-Maurice. La Vérendrye was granted permission to trade with the Indians at La Gabelle a few weeks every year by the acting governor of New France, Claude de Ramezay.

The combined revenue was not enough to fund an expedition west into the interior of New France in search of the Pacific Ocean. This idea was germinating in Vérendryes mind. A fortunate happenstance came in 1712 when Pierre's brother, Jacques-René, received command of the north post embracing a vast area north of Lake Superior at Thunder Bay. Jacques-René Vérendrye formed partnerships to continue fur trade in the area. They hired *engagés* (indentured employees) and borrowed money from various merchants for the purchase of trade goods. Pierre was taken into the partnership and acted as second in command becoming commander-in-chief in 1728. At last Pierre Sieur de la Vérendrye could engage his attention on exploring west in search of a route to the Far East. The fur trade era would belong to France for another thirty years before Britain claimed "***Ruperts Land***".

Information obtained by Jacques de Noyon in 1688 postulated the existence of a divide which could be reached via an eastward-flowing stream which would arrive at a high mountain which a party would need to ascend. There, at the summit, would be the head of a river flowing into the western sea. Noyon's data indicated that the western flow would lay in the latitudes of Lake Winnipeg.

Father Charlevoix, a Jesuit, had traveled as far as Mississippi country establishing a mission on Lake Pepin in Sioux country America. On his return he reported his theory that the trail might be made by way of the Missouri or perhaps farther north through the country of the Sioux west of Lake Superior. Either of these routes required travel among warlike Indian tribes who were as likely to turn on white intruders as they were already engaged in bloody struggles with neighboring tribes. A Cree chief named Pako had journeyed to Lake Winnipeg and the river system

surrounding it. The slave of an elderly chief named Vieux Crapaud described in sketchy fashion the land of the Mandan. Another Indian named Auchagah drew a map on a piece of bark that La Vérendrye composed a mind's eye picturing the inland of New France.

The first Vérendrye expedition party consisted of Pierre, three of his sons (Jean-Baptiste, Pierre, François), a nephew (Christophe Dufrost de La Jemerais), Indian Ochagach (guide), a Jesuit priest and 43 *engagés*. On June 8, 1731, the party set out to identify locations and build trading posts along the westward route always making the last post a base for further advancement. The route lay across rough country beyond Lake Superior. There were many long portages where the men had to carry their provisions and the heavy stores for trade. They disliked the hard work amplified by their superstitious fears of malignant fiends in the unknown lands who, they imagined, lay in hiding waiting to attack. Exhausted, the party reached Rainy Lake. From this lake the waters flowed westward. There was abundant fish and game, and the party was able to secure a rich store of furs. On the shore of Rainy Lake, the party constructed a trading-post naming it Fort St. Pierre. Other French voyageurs had preceded the Vérendryes to this point inland, but this was the first voyage of discovery for which there are any details.

Returning the following spring, La Vérendrye floated down Rainy River with his escort of an imposing array of fifty canoes, *engages,* and Indians to the Lake of the Woods. On a peninsula he built Fort St. Charles. It was an intimidating show of strength that included a watchtower, a chapel, and houses for the commandant and the priest. Vérendrye cleared some land and planted wheat. He was the pioneer of wheat production in the west. When winter was encroaching, La Vérendrye wished to move forward in his quest west but remained at Fort St. Charles waiting to receive consent from France and his trading partners in his fur trade monopoly profits. He had been financed one hundred percent on their outlay and was near paying it back. His oldest son, Jean-Baptiste Gaultier de la Vérendrye, was sent back to Rainy Lake to hurry canoes from Montreal which were bringing needed supplies. He also arranged that his fourth son, a lad of eighteen, should follow him in the next year on this glorious adventure of western discovery.

Upon Vérendryes return to Fort Saint-Charles with his youngest son in 1735, it was becoming evident that arrangements for trade were being impaired with merchants and traders going where they pleased leaving forts unprovided for. Vérendrye had armed the Indians of his command against the Sioux at Rainy Lake the previous year. With the temper of savages in the region always being uncertain, the party of Jean-Baptiste had been ambushed when they landed at Rainy Lake and the entire party was butchered. The tragedy saddened, but did not dishearten, Vérendryes exploration west. Now with his youngest son among the voyageurs, Vérendrye ventured west on the Winnipeg river. This was not the river Vérendrye had hoped to take him west, but whose main flow turned north as most rivers in inland Canada do. The group returned to camp on Lake Winnipeg.

Red River flows from the south into Lake Winnipeg near the mouth of the Winnipeg River. Vérendrye led his party south, up the Red River, to the Assiniboine River which flows into the Red River from the west. At this point he built a tiny fort called Fort Rouge. The name is preserved in a suburb of Winnipeg.

Here was Vérendrye, an ambitious genius whose passion for exploration was his life, caught in a place where the flowing waters tempted him west, yet the winter weather and short supplies were threatening. On the Assiniboine River near present Portage la Prairie in Manitoba, La Vérendryes party-built Fort La Reine. In the spring of 1737 Vérendrye made another long journey back to Montreal where he once again hoped to secure financing to continue west. He had but fourteen canoes, but each was laden with fabulous furs. He hoped the King of France or his merchant associates would appreciate the progress he had made and offer at least enough backing to afford his quest far enough west to see the vision of the great mountains, or perhaps the vast ocean leading to the Far East.

The last two decades of the French fur era saw a decline of beaver and an increase of animosity growing among the Indians and traders. Pierre Vérendrye returned to Montreal in hopes that he could secure financing for another expedition. He had observed that even though Hudson Bay Company was British owned, the British traders remained

simply that, traders. They didn't venture into the woods to explore the inland either by land or by river. There were no trails, no maps, no safe zones leading into the woods. The Indians Vérendrye met coming and going on his explorations took their furs to Hudson Bay and there they traded furs for goods which they carried with them on their long journey '*home*'. The English made no attempt to learn the languages, customs, or sources of the furs so abundantly provided them on the Bay. They wished to not trouble themselves with the labor when they were secure on the seashore waiting to buy goods already prepared for shipment for a slight sum then sell the '*ready for market goods*' for a huge profit. Every party Vérendrye met, going from, and returning to Montreal he urged not to make the long journey and encouraged the Indians to depend on the French voyageurs who came into their country.

A group of British and Scottish businessmen had begun to form in Montreal. This group became the Montrealer's' and began hiring French Traders to travel inland. Upon Vérendrye' s return to the city with his impressive cache of furs, Pierre pressed his associates enough to gain finance for another expedition west. The competition was increasing, and the Indians were becoming more agitated with the British. His journey to Fort la Reine was becoming well-traveled so making it to that inland point was less perilous yet as strenuous as ever. Reaching the Fort in the fall of 1738, October 16 Pierre Vérendrye assembled his party; two of his three surviving sons, Francois and Pierre, with a selected group of soldiers, voyageurs, *engages*, and Assiniboine Indian guides prepared to cross the well-beaten trail that led across the high land separating Red River country from the regions to the southwest.

From near where Manitoba is now situated the Vérendrye party set out on the 18th of October on their long march across the prairie. There had been reports of Indians who called themselves Mandan's dwelling in well-ordered villages on the banks of the great river. La Vérendrye hoped the river reported was an unknown stream, but found it to be the Missouri, a river already frequented by the French in its lower stretches where its waters join those of the Mississippi. The Mandan culture were said to be cultivating the soil instead of wandering as other tribes. Vérendrye expected that there were perhaps white men with the Indians

forming a civilization equal to that of Europe. It was a long march over the prairie made somewhat pleasant with glorious autumn weather. What we now call "*Indian Summer*" may have been what enchanted the Assiniboine guides as they continued at a relaxed pace regardless of Vérendrye's urging. The Assiniboine determined to take the party several miles off course to visit a village of their own tribe. When they finally resumed their journey, the entire village joined them. As the Assiniboine were a friendly tribe, La Vérendrye allowed them to follow and watched as these prairie savages showed a more developed sense of order and discipline than the tribes of the forest.

The prairie Assiniboine divided their tribe of more than six hundred into three columns with military precision. In front were the scouts looking out for any enemy and herds of buffalo; in center, well protected, the old and the lame, all those incapables of fighting; for the rear-guard, the young braves who were prepared to fight if necessary. When buffalo were seen, the most active of the fighters rushed to the front to aid in hemming in the game. Women and dogs carried the baggage. The men condescended bearing only their weapons.

Winter had begun when the party reached the Mandan village. Vérendrye thought the village appeared as an imposing settlement compared to anything encountered previously. The lodges were arranged in streets and squares and there was a surrounding palisade that was strong and well-built with a fifteen-foot-deep and wide ditch surrounding the entire settlement. Although he did not write in his report that he was grateful to have the six hundred well organized Assiniboine with his party, when he saluted the village with three volleys of musket fire and marched into this large well-ordered village under the French flag, it must have given him some added confidence. The Mandan's were unimpressed with the fanfare as the men in the encampment continued walking about naked and the women nearly so. This was not uncommon to the Indian villages of the day, but in the December weather it was surprising.

Pierre Gaultier de Varennes, Sieur de la Vérendrye was at once impressed and dismayed. The Mandan were skilled in dressing leather and cooked in earthen pottery of their own handicraft. They had

abundant cultivated crop stores in cave cellars which they cooked and served daily while the Vérendryes were at the encampment. Sieur Gauliter also reported that he believed them to be cunning traders as they "*duped*" the men "*out of their muskets, ammunition, kettles, and knives*". Vérendryes placed the metal plate on their way to the Mandan village. This marker was found by school children near Pierre South Dakota one hundred and seventy-five years after the historic expedition took place. Pierre South Dakota was not where the large Mandan Indian village was located. Farther northwest along the Missouri, the Mandan's had located west of Williston North Dakota. The site is now a Historic Landmark known as Fort Union. The location is a short distance from the Montana State border. This was the largest Indian encampment used for trade in the 1600 and 1700's. The southern and northern plains Indians brought their medicinal herb bundles and other goods to trade with the Mandan for their corn and seeds.

As a polyglot, Vérendrye was dismayed that he could not understand the Mandan language making coherent conversation impossible for him. He learned enough to discredit the tales his guides had relayed to him about peopled towns and white men in armor. Most importantly, he could not decern directions for the route west to the Rocky Mountains and on to the Great Sea. The weather had turned cold and he was ill. December 13, 1738 the Vérendrye expedition headed back to Fort La Reine leaving two men at the Mandan village to learn the Mandan language so in future they might act as interpreters. One of the men was his son, Pierre. Vérendrye wrote in his report: "*I have never endured such misery from illness and fatigue, as on that journey*".

The party reached Fort La Reine on February 11, 1739. Worn out and in ill health their leader resolved never to abandon his search for the route across the continent to the west. In 1740 Pierre Gaultier de Varennes, Sieur de la Vérendrye was in Montreal where he found a lawsuit had been brought against him by some impatient creditor. To his defense, instead of amassing great wealth from his exploration and negotiated trade agreements with the Indians, Vérendrye had accumulated a debt of forty thousand *livres*.

In the autumn of 1741 Sieur de la Vérendrye returned to Fort La

Reine where his son Pierre was waiting on his return from the Mandan village. La Vérendrye insisted that his two sons should give up this search for the western route to the Great Sea. Francois told his brother that *"to return west was a matter of life and death"*. Francois secured leave of Fort La Reine with a single canoe laden with trading goods. His brother, Pierre, claimed damages for the intrusion and went after Francois. There was a physical confrontation at Fort Michilimackinac where Francois was severely injured. Pierre apologized and attempted to make a deal to continue with his brother in the fur trade business, but the damage was done.

The brothers Vérendrye, Pierre and Francois, returned to Montreal and were unable to secure any financial compensation with their appeals to France as their military rank was that of junior cadet and there was no recognition of their personal sacrifice in the party with their father. They sank into obscurity. Francois was killed in the siege of Quebec in 1759. Pierre died by drowning when a ship laden with refugees was returning to France and wrecked on the St. Lawrence. He was among the refugees. By the time the brothers had returned to Montreal, Hudson Bay Company was attempting to rein in the French fur trade.

La Vérendrye expanded the frontiers of New France as far as Manitoba; in countless meetings with the Indians, he enshrined loyalty to the French monarchy among important new tribes. Along with the establishment of trade with the Indians and gathering peltries from the west, Vérendrye had gathered a substantial number of Indian slaves. In his memoir to Maurepas, minister de la marine in charge of the navy to Louis XV, in 1744, he wrote: *"Do the great number of people my enterprise provides with a living, the slaves it procures to the colony and the pelts which had previously gone to the English count for nothing?"*

The journey to the Mandan had left La Vérendrye physically exhausted and burdened with debt. In 1740 he returned to Montreal only to learn his wife, Marie-Anne, who had served him as attorney and procurator during his long absences, had died the previous September and was buried in Sainte-Anne's chapel of Notre-Dame church. Governor Beauharnois graciously lodged la Vérendrye and granted him the fur-trade monopoly of the posts he had founded beginning in June

1741. He continued a sizeable trade with the permits issued to him and was granted a captain's commission. As captain of Beauharnois guards, la Vérendrye settled down to a good life in the colony's fashionable society. He courted Esther Sayward (Sayer), widow of Pierre de Lestage, one of New France's great merchants. He was given an opportunity to make one more expedition west in pursuit of the discovery of the western sea in 1746. He died December 5, 1749. He had planned to leave for the west in 1750. Before he died, he received the cross of Saint-Louis. He left a small estate worth perhaps 4,000 *livres,* much of it consisting of articles of clothing and adornment. His estate was that of an impecunious nobleman.

Pierre Gaultier de Varennes, Sieur de la Vérendrye along with his sons, diverted much of the fur trade in Saskatchewan and Assiniboine areas from Hudson Bay to St. Lawrence as valiant sons of New France. They did all this quietly in the face of personal tragedies and unusual adversities while others were creating hate and discord across the continent.

The French fur trade era was nearing its end when Vérendrye died, and the British era was about to begin. Nobility in Europe had lived in damp castles with drafty fireplaces in the 1600's, but as exploration of the North American continent expanded the economy was shifting. Furs were the leading export crop of North America with Europeans finding comfort in adorning their heads with beaver hats and lighter furs for scarves, muffs, and trim on woolen garments. Hudson Bay Company began in London as a joint-stock organization in 1670. The Company was named for Hudson Bay, the main shipping port for fur trade in British North America. Formation of the Company gave Britain control of all commerce flowing through the Great Lakes region with HBC collecting taxes and keeping records of the fur industry by licensing traders doing business through this port.

With transportation corridors opening from all cardinal points progressing inland, disputes between the Indians, Spanish, French, and British became a chronic state of war. When furs were plentiful and easily obtained some of the nations formed allegiances. As furs became scarce all bets were off. Indians tribes began fighting each

other as well as the European invaders. Hudson Bay Company required their employees to be licensed and to map, keep accurate accounts of the names and numbers of persons in expeditions, numbers and kinds of furs, trade items, daily events and encounters and approximate values, all-inclusive of the expedition. It was important that the leaders of the expeditions be educated in many aspects of math, language, bookkeeping, and written recording.

As the fur export industry devolved a new culture was establishing itself in the northern regions of North America around the Great Lakes and Red River shores. Since the English Hudson Bay traders had enjoyed keeping themselves and their employees near the shipping ports where the Indians would bring furs to them for trade; the French courier de bois made progress in befriending the Indians and ambitiously built forts and trading posts (at first called House) inland, Hudson Bay Company began hiring Scots and Irish men who were honest, industrious, and used to the harsh weather conditions to travel inland. In competitive trade negotiations with the Indians, the British traders began diverting some of the French trade from competitors back to HBC. As these voyagers traversed inland and fraternized with the Indians, they began taking wives.

In the early phases of this evolution, HBC employs were reluctant to assume the expenses and troubles of supporting "country wives" and their children so they left the 'mothers' at the "House" with their children discouraging the lower rank employees from such relationships. HBC turned a blind eye to their officers taking Indian wives, but as the voyageurs, Coureurs de bois, fur traders, engagés, winterers (the wintering partners were also called "*hivernants*"), and provisioning freighters began wintering with the Indians more of these men married 'a la façon du pays', that is in accordance with the custom of the country without the benefit of clergy.

The men married not only for companionship and conjugal relations, but also to establish kinship with Indian tribes and form alliances advancing fur-trade. The offspring of these monogamous relationships produced mixed-blood children who were the embryonic beginnings of the historic Métis people. The children of these unions

frequently became voyageurs and employees of the fur companies as did their children. These progenies lived and remained in Indian country while the men who intermarried usually lost their status with HBC often giving up all ties to land ownership and officer status they may have had prior to this union. This snobbish exclusion of families of mixed races was a large factor in the treatment of Radisson, Groseilliers, and Pierre La Vérendrye when they cashed in their furs or attempted to get financed for their expeditions. The Indians preferred these unions as it often ensured continuous food supplies through the winter months. When the convergence of these cultures occurred in Montana in the 1800's, the plains Indians had not had the luxury of years of trade with Emigrants or Métis, although they did recognize the advantages of their women marrying into this *'new-breed'*. What was not understood or practiced by the Indians was monogamy.

As Vérendryes' had observed, the English traders did not venture inland, however, as forts were built and French voyageurs lost financial support, HBC began commandeering the posts staffing them with commissioned personages. Some of the appointees were officers of the British Military who were moved to these trading posts following the Revolutionary War. Others were young men who were given scholarships to attend schools in England studying math and navigational studies so they might lead expeditions further into Canada mapping routes and opening trade with the Indigenous peoples. When the twentieth century arrived and the World Wars raged in Europe, Canada began recruiting the Métis in the territorial Regiments sending them to England to train and support British troops in the fight. Many of these men returned to North America with English and other lineage wives. (Dumont; Hills Happenings)

CHAPTER 5

FREE SPIRIT

The War of Independence or Revolutionary War took place from 1775 to 1783. Vérendrye had traveled to the Hidatsa village and viewed the Rocky Mountains and returned to Montreal where he was laid to rest in 1749. Alexander Mackenzie had taken up Vérendryes quest to find a way from Winnipeg to the Pacific Ocean. In 1762 France secretly ceded New Orleans and the vast region west of the Mississippi to her ally Spain following the Colonies French and Indian War. The thirteen Colonies were transitory to statehood. George Washington was elected President of the United States in 1789 and a decade later Napoleon came to power in Europe causing Spain to return Louisiana territory to France by Treaty of San Ildefonso in 1801. Farmers from the colonies, now the United States, had not been happy with the grain, hogs, cattle, and produce export costs Spain had imposed and were happy to have France back in charge. Smugglers and colonial merchants had learned to operate outside British and Spanish law and the new young country would have to rein in illegal trade while building a parliamentary infrastructure.

As the century closed, a young David Thompson was learning the skills he would need to become a Hudson Bay Company employee. Thompson would find his way to Montana where few white men had been, and no one had mapped. Born April 30, 1770 David Thompson began his life in Westminster England. His father and Mother emigrated from Whales shortly before David was born then his father died when

he was two years old. His mother, unable to support David and his brother, placed her sons in a school known as the Grey Coat Hospital then disappeared from their lives. David lived and completed his formal education in Grey Coat Hospital graduating to secondary school, Grey Coat Mathematical. He showed a passion for numbers and was introduced to basic navigation skills in secondary school. Hudson Bay Company (HBC), the largest fur traders in the world at that time, had made requests to the school over the years for qualified men to work the North American fur trade. HBC approached the school with a request for four such men. David was fourteen years old and had completed his secondary school with honors. He was one of the two men the school had available who had completed school. His education had prepared him for the Royal Navy with algebra, trigonometry, geography, and navigation using practical astronomy. HBC commissioned him to a seven-year apprenticeship contract in the fur trade industry. Grey Coat Mathematical gave fourteen-year-old David Thompson a Hadley's quadrant when he left for Montreal Canada for a position with HBC on May 28, 1784.

His first assignment was personal secretary for Samuel Hearne, the Governor of Fort Churchill, Manitoba, Canadian Territory. David Thompson's secretarial job lasted only one year. Thompson was sent to trading posts along Lake Saskatchewan and South Saskatchewan River where he kept all the books for the posts calculating the value of furs and clerking the trading supplies. In 1786 David Thompson spent the winter at a Piegan Indian encampment along the Bow River near Calgary, Alberta. Only into his apprenticeship two years, at 16 years of age he was penetrating the North American wilderness learning customs and culture of the indigenous tribes.

By 1787 Thompson had worked at five trading posts: Fort Churchill, Lake Saskatchewan House, South Branch House, Manchester House, and Cumberland House. South Branch House was the only significant fur trading post on the South Saskatchewan River. In 1788, while at Cumberland House, David fell down a creek bank and severely broke his leg. The injury took two years to heal and during that time young Thompson refined his mathematical, astronomical, and surveying skills

under the tutelage of HBC surveyor, Philip Turnor. Possibly overzealous peering at the sun during his astrology lessons, David Thompson lost sight in his right eye during the time his broken leg was healing.

1790 he recorded his first navigational report. His passion to navigate, with one good eye and a permanent limp from his broken leg, kept Thompson on track with his apprenticeship. David Thompson became the first man to map the western portion of the 49th parallel and the interior of North America along the Missouri River where later Lewis and Clark traveled, and James J. Hill built a railroad. His maps would serve both the U.S. Boundary Commission and the Canadian Government.

David Thompson noted some of the changes he was encountering in the Kalispell and Salish Kootenai area. English trappers licensed with HBC began bringing liquor and blankets infected with disease, inadequate quality kettles, and poor-quality beads to trade with the Indians. Thompson did not approve of these tactics because he knew maintaining good relationships with the Indians would be the only way to continue peaceful trade. A group of British and Scottish businessmen began to hire French traders. These businessmen knew the friction that was building between the Indians and British trappers and began North West Company (NWC) in 1784, the first fur trading company to challenge HBC's monopoly. David Thompson left HBC in May of 1797 and began working for NWC. The Indians recognized the difference between HBC and Nor'westers by their dress and mannerisms and spent little time in converting their trade to the new company. The businessmen who started Northwest Company had recognized one other advantage the French trappers had secured during their expedition inland. Several of them had taken Indian wives. To accommodate the families, NWC licensure established a more sustained and respected relation with these traders.

Thompson Falls Montana is named after this explorer called *Koo-Koo-Sint* or *"Stargazer"* or *"the man who looks at stars"* by the various tribes of Indians he did business with. He established Kalispell House and other Trading Posts along the Rocky Mountain Front. The Piegan Indians were one of the first tribes in Canada assisting David

Thompson in establishing relationships with the Blackfoot, Blackfeet, and other tribes in central Montana. In his book, "**Sometimes Only Horses to Eat**", Carl W. Haywood outlines David Thompsons journey in the Thompson Falls area giving accurate dimensions of the building structures and other details of the landscape and people who were part of Thompsons entourage.

Thompson took a Métis wife, Charlotte Small. Charlotte was the daughter of Patrick Small one of the founders of NWC. This couple had 13 children, three were born when David was sent to map the geographic features of the country and identify locations of existing trading posts. Thompson took French trapper Rene Jessuame (guide and interpreter), Hugh McCrackan (an Irish free trader), and seven French-Canadian free traders on his expedition to explore and map into Mandan Indian Territory. This first trip to the Hidatsa village was in the winter of 1797-98. This village was the same village the Vérendryes' had visited and where Sacagawea (also known as Sacajawea) gave birth to her son on February 11, 1805.

In William Clarks' journal entry of October 13, 1805, he wrote:

"The wife of Shabono [sic] our interpreter we find reconciles [sic] all the Indians, as to our friendly intentions, a woman with a party of men is a token of peace."

The Lewis and Clark expedition were on their way west. On their return trip August 14, 1806, Charbonneau, Sacagawea, and their Métis son Pompy, remained at the village while the Corps of Discovery returned to St. Louis. It was in 1806 that David Thompson sought a route west of the mountains establishing trading forts on the Pacific slope. He commenced exploration west from Saskatchewan and Athabasca Rivers through passes over the Rocky Mountains from what is now Alberta into British Columbia. Charlotte Small Thompson and three of their young children accompanied David on this expedition.

Sacagawea was a full blood Shoshone Indian who was kidnapped as a child and traded or sold to French trapper, Charbonneau, when she was 13. She was still in her teens when she gave birth to her first child, Jean-Baptiste (Pompy). There were many instances where Sacagawea is mentioned in Captain Clark's journal because of her mature nature on

this physically challenging journey. She had learned how to use native plants for food and medicine and often contributed useful teas, salves, and seasonings as this young group of explorers traversed the banks of the Missouri River. There are numerous indications that Charbonneau was a course despicable paramour, but he was Sacagawea husband, an asset that prevented him from assaults from fellow journeymen. The entourage were not sorry that Charbonneau broke from the group on the return journey. The Lewis and Clark Landmark, Pompey's Pillar located in south central Montana along the Yellowstone River, was named by Captain William Clark for Sacagawea's son, Pomp.

Charlotte Small Thompson was a Métis. Her mother was a full blood Cree Indian and her father was English. She married when she was thirteen years old and traveled with her husband frequently taking their children with her, often pregnant, giving birth at encampments along the routes. The Thompson expeditions had families in the entourages and the children played important roles in procuring food and firewood along the journeys. In this way Charlotte was able to teach her children and spend time with her husband while he worked making his life somewhat richer and rewarding mentoring his children and learning from his wife the customs of the assorted Indian tribes he encountered on his expeditions. David and Charlotte had their marriage formalized 13 years after they united by commitment as was the custom at that time. They were married in a Scotch Presbyterian church in Montreal October 30, 1812. David Thompson died February 10, 1857 ending his 57 years with Charlotte.

With his limited schooling in algebra, trigonometry, geography, and the use of crude navigation tools in training for the Royal Navy, David Thompson entered the fur trade industry and mapped possibly more of the North American continent than any other individual ever has. With the Hadley's Quadrant, a simple double-mirrored navigational instrument given him upon graduation from formal school, he completed on the job training learning to calculate values of furs, keep accounts, and record and track supplies for the companies he worked for while managing the varied personnel who he met or were in his entourage. Unfortunately, he died not having completed his journals

for submission to the Canadian government, however, he journaled and most of his written daily accounts have been preserved. Because of his status as a Métis he was never a landowner, nor was his wife or descendants at that time. Legal actions are working their way through the courts today in an attempt to reconcile this disparity. Regardless of the aboriginal rights or the lack thereof, David Thompson was an esteemed individual to all who worked with him and knew him. His maps are incredibly accurate, especially considering the conditions and equipment he used. Simply amazing.

Back in the colonies the Revolutionary war was being fought and HBC commerce continued as the availability of furs declined and competition increased. The businessmen who started North West Company (NWC) in 1784 had found themselves in no-mans-land without financial support of a country and having no rules or regulation for business. What they did have was an understanding of the value of natural resources in the unsettled and unexplored regions of North America and the natural ports available in and around the Great Lakes region. They opened a new shipping port at Grand Portage, Minnesota, on Lake Superior. This strategic location, fifty miles southwest of Thunder Bay, Ontario, would allow delivery of furs hundreds of miles closer to the expanding trade from the area ranging between Calgary, Alberta, Canada to Great Falls, Montana. The entire territory to the west of Grand Portage to Oregon Territory was open for business and settlement.

Starting a new company gave NWC an opportunity to purchase larger cargo ships for export. There had been no need for HBC to improve their fleet of cargo ships as there was no competition. NWC began their business with French trappers who were friendly with the Indigenous peoples, took their quality trade goods to the Indians and packaged their furs with the help of the Indians then transported them to new ports. NWC also had the advantage of being independent from HBC licensure and English tax and restrictions of payment or report.

Native Americans, Indians, Métis, and Immigrants were continuing business as usual enjoying the spoils of war and the amenities offered west of the Mississippi where only the Jay Treaty of 1794 outlined

sketchy boundaries for settlement. In 1801, the third president of the United States, Thomas Jefferson, appointed Robert Livingston first United States Minister to France. Livingston's first assignment was to go to France and convince Napoleon that holding on to territory across the Atlantic was folly and a wise decision would be to sell the property to the United States. Livingston returned from France reporting his successful negotiations with a suggested amount he was reasonably sure it would take to purchase Louisiana and Oregon Territory from France. Jefferson sent Livingston with James Monroe returning to France with an offer of ten million dollars for the territory. Monroe was serving as envoy extraordinary and minister plenipotentiary authorizing him to offer fifty million francs (approximately $10,000,000.00) for territory at the mouth of the Mississippi, including the island of New Orleans. Monroe was asked to extend his duties to convincing the minister of Madrid, Charles Pinckney, to secure Spain's commitment of the cession of East and West Florida for the United States.

Livingston and Monroe met with Napoleon in Paris at a dinner party May 1, 1803 where final terms for the exchange were agreed upon. The amount of sixty million francs, plus another twenty million to settle claims against the land, which was about $15,000,000.00 was agreed upon. The French wine must have gone to the statesmen's heads, yet they knew regardless the consequences they had made an extraordinary land deal with Napoleon Bonaparte. It was their good fortune that Napoleon had never seen America and was only concerned about financing his own interests in conquering Europe.

GOOD THINKING

Western Montana to the Pacific coast was uncharted and undefined until the Jay Treaty became effective February 29, 1796. This agreement was never ratified. The Treaty guaranteed Indians, Métis, and fur traders unrestricted travel between Canada and the U.S. but left the southern and western boundary's undefined. It also left a broad definition of *fur traders.* Originally all fur traders were Hudson Bay Company licensed employees. Western Montana was a part of Oregon Territory. Congress established east of the Rocky Mountains a part of the District of Louisiana in 1804. When Jefferson purchased Louisiana Territory it included Oregon Territory through occupation and settlement. The District of Louisiana was established with the Pacific northwest kept as Oregon Territory. Congress changed the area of the Louisiana Purchase to Louisiana Territory. In 1812 the name was changed to Missouri Territory. The northern part of Missouri Territory was organized as Nebraska Territory and the division of Idaho and Montana formed Montana Territory in 1853.

By 1803 the third President of the United States of America, Thomas Jefferson, was about to enter his second presidential term. He was born (1743) and raised on a farm in Virginia. Jefferson attended College in Williamsburg studying law and became involved in politics as a scribe as his writing ability far outweighed his ability to speak. Thomas Jefferson's father, Peter, was a surveyor as his father before him had been. Peter Jefferson became a mapmaker in his later years and with

a group of co-workers, became a land speculator. John Meriwether was a neighbor and one of the men in the conglomerate investing in property in Virginia and North Carolina.

Thomas Jefferson's mother, Jane Randolph Jefferson, was born in England February 9, 1720 in a maritime village of Shadwell near the Tower of London according to a family Bible entry. Jane Randolph was the daughter of Isham Randolph. Jane Randolph's mother Jane, and Peter Jefferson were married October 3, 1739. Peter Jefferson was a mariner and planter born in Virginia. Jane moved to Virginia with her mother when she was about five. Jane Jefferson was of Anglican faith which was the identity the Church of England took following the English Reformation. Often referenced as *Episcopal* or *Episcopalian*, it is a hierarchical form of church governance in which the chief local authorities are called bishops.

Thomas Jefferson was close to his mother as a young lad and she greatly influenced his life. She liked to entertain; home schooled her girls (as was the custom at that time) and managed the family finances with precision. Thomas spent time with his father and his father's colleagues learning about surveying as he grew older and was not attending formal school.

Thomas Jefferson married the widow, Martha Wayles Skelton, in January of 1772. Martha had one child from her first marriage. Her son, John, died at age three the summer before she married Thomas Jefferson. Jefferson had his partly constructed mountaintop home, Monticello, when he married. Thomas and Martha spent their short-married life together at Monticello. Monticello remained unfinished when Martha passed away only ten years and eight months later. Together they had six children with only two daughters living to adulthood. Two daughters, Jane Randolph and Lucy Elizabeth, and an unnamed son died as infants. Lucy Elizabeth lived for two years, but Martha died only four months after Lucy's birth, September 6, 1782. Thomas Jefferson never married again and spent his two terms as President without a First Lady in the White House. Martha was the First Lady of Virginia as Thomas Jefferson served as Governor from 1779 to 1781. He had decided not to

run for Governor for a third term and left his post early leaving Virginia without a Governor for eight days.

Martha Wayles Skelton Jefferson was the daughter of John Wayles and Martha Eppers. Her first husband was Bathurst Skelton. John Wayles, Thomas Jefferson's father-in-law, was married three times. Martha Eppers was his first wife. His third wife was Elizabeth Lomax Skelton. All three of John Wayles wives died while they were married to John Wayles. His last wife, Elizabeth, died a little more than a year after her marriage to John on February 10, 1761. Elizabeth Lomax Skelton was the widow of Reuben Skelton when she married John Wayles. Reuben Skelton was the brother of Martha Wayles Skelton's first husband. Thomas Jefferson's father-in-law did not marry again after Elizabeth died, rather he took one of his slaves as "concubine". Elizabeth Hemings is said to have six children who grew to be adults. These six people (slaves) were the children of John Wayles and half-brothers and sisters to Martha Jefferson.

Jefferson was the principal author of the Constitution, and as Governor of Virginia he wrote a bill establishing religious freedom that was enacted in 1786. As leader of the Democratic Republican party, he sympathized with the revolutionary cause in France and championed the rights of states as opposed to centralized Government. Both of his Presidential terms were the result of a young country adjusting to democracy and free election. The first, in 1800, resulted with Alexander Hamilton urging the House of Representatives to settle the tie between Aaron Burr and Jefferson in favor of Thomas Jefferson. The second term uncovered a flaw in the Constitution. Jefferson had not made a provision for acquisitioning new land in his draft. Fortunately, by his second term he successfully acquired Louisiana Territory from Napoleon in 1803. The purchase of Louisiana Territory, his elimination of tax on whiskey, reducing the national debt by one-third, slashing army and navy expenditures, and cutting the budget made him extremely popular. He also sent a naval squadron to fight pirates harassing American commerce in the Mediterranean. The over expenditure for the territory purchase was soon overlooked and his other deeds well received making him wildly popular for the election of 1804. Before

being sworn in to his second term, Jefferson began grooming his private secretary, Meriwether Lewis, to head up a Corps of Engineers to explore the newly purchased territory.

Meriwether Lewis's parents, William Lewis and Lucy Meriwether were 35 and 17 when they married in 1768. He was Welsh and she was English. She was the eighth child of Thomas Meriwether and Elizabeth Thornton. William was the son of Robert and Jane Jefferson Lewis and first cousin to Thomas Jefferson. The family were proudly First Families of Virginia (FFV's), a strong cousin network of Old Virginia. William Lewis was a planter who served as Lieutenant in the Virginia militia during the revolutionary war. He died at age 43 crossing the Rivanna River during a flood in 1779. His horse drowned. William made it to shore and walked home soaked, but contracted pneumonia a few days later and died.

Meriwether was the third of four children born to William and Lucy, and the oldest son. He was barely five when his father died. The first five years of his life his father was away fighting the Revolutionary War. His mother managed 24 slaves and made sure the tobacco crop was planted, harvested, and gotten to market in the middle of a war zone, while caring for three small children at the Locust Hill plantation. Six months after William died, Meriwether's mother remarried. Captain John Marks was among several families of the "cousin network". At the end of the Revolution the Marks family moved to a frontier settlement in Georgia. Lucy and John had two children, a son, and a daughter. Both Marks children followed their mother's interest in medicinal plants becoming doctors in their maturity. When Lucy was 39 and Meriwether was 17, John Marks died unexpectedly. Meriwether was away at school. At the completion of the school term, he went back to Georgia and helped his mother and stepsiblings move to Locust Hill.

Most of William Lewis's estate of Locust Hill was left to Meriwether under the law of primogeniture. His mother retained one-third of the estate for the duration of her lifetime as dower rights. The estate included 24 slaves and 147 gallons of whisky. Having grown up and begun her married life in Virginia, Lucy was challenged by the changes that had occurred in and around Locust Hill while she was in Georgia.

There were stores and roads where there had been fields and the river had been dredged. With the help of her son, Meriwether, they began to rebuild the soil which had depleted of its nutrients from years of tobacco production. Eventually, grains were grown, but they did not generate the income tobacco had provided. Lucy, Meriwether, and Lucy's recently married daughter Jane (Anderson) added pigs to their production and Lucy became famous for her sugar-cured hams. Thomas Jefferson was one of her satisfied customers serving Lucy's sugar-cured hams at many festive occasions enjoyed at his mountaintop estate, Monticello.

Meriwether Lewis had learned to be a crack shot hunting and a connoisseur of medicinal plants as he matured, far too young, at his mothers' side. There was alcoholism in the family and many of the men's lives had ended badly leaving a stifling stigma in young Meriwether's thoughts. It is said that he wanted to marry but was unable to find a wife. Perhaps, watching his mother and her struggle, he chose to protect the young ladies he courted from experiencing the same burdens his mother was given. He remained nonconfrontational, purely honest, yet laconic in his conversation making him a bit mysterious and terse. An unusual combination for someone so manifest.

After a few years helping his mother reestablish Locust Hill, Meriwether Lewis served in the U.S. military then continued his education at college. At William & Mary in Williamsburg, he was taught by Dr. Charles Everitt, a physician, Parson Matthew Maury, and the Reverend James Waddell, a Presbyterian minister who ran an Episcopal parish. William Clark was a friend and classmate of Meriwether's, both members of the Anglican Church. Nicholas Lewis, his uncle, and his cousin, William D. Meriwether shared guardianship for Meriwether. While he attended college, Meriwether Lewis lived in William Meriwether's home, Clover Fields estate.

William & Mary is a research University and Meriwether was able to learn practical application of the medicinal properties of plants, advance his theological study, and study natural history in a perfect setting nearer Washington D.C where the newly formed nation was taking shape. His ability to transfer his knowledge to paper in script

and drawings was noted. He was just the sort of subject Jefferson could use as his private secretary; honest, intelligent, educated, and a relative.

Lewis had served in the regular Army during the gap of schooling and move from Georgia to reclamation at Locust Hill. Lieutenant William Clark was involved in the Battle of Fallen Timbers in 1795. He commanded a company of riflemen to a decisive victory bringing the Northwest Indian war to an end. Lewis served under Clark during this battle. When Lewis was asked to lead up the Missouri expedition, he insisted the President convince Clark to lead the expedition as co-Captain. Clark had resigned his commission in 1796 retiring due to poor health at 26 years old. He had returned to his family's plantation near Louisville, Kentucky. The President would have to reinstate and commission him before the expedition commenced. Congress did not approve this action, but Lewis and Clark agreed they would serve the Corps with equal leadership as Captains. The difference in pay was made up with double-pay, or bonus, on their return.

William Clark was a slave owner accustomed to full servitude. He took a slave named York to serve as his valet on the journey. Clark wrote, *"York's appearance played a key role in diplomatic relations."* Clark managed supplies, drew maps, and led hunting expeditions while maintaining strict discipline from the men applying whippings when thought to be necessary. Clark's leadership qualities exceeded Lewis's, but his education in flora, fauna, and spelling were notably lesser in their written reports. Lewis was admittedly not a good administrator. He set the pace, navigated, and documented animals, plants, Indians, and assisted Clark with maps and chronology. With Sacajawea, Lewis identified many new species of herbs and medicinal fauna using what was available to cure maladies in route. The President had obtained some coarse maps from Hudson Bay Company showing trapping routes along the rivers. Jefferson gave copies of these to the two Captains who worked together to update and expand the map set on their expedition.

Neither Lewis nor Clark played a musical instrument, but President Jefferson played the violin. His wife, Jane, played the harpsichord and while she was alive, they entertained guests and each other with their musical talents at Monticello. Its possibly, at the Presidents' suggestion,

Lewis and Clark sought a few men with some musical talent when they interviewed for the expedition. They also took Jews harps and blacksmith tools doubling as percussion instruments to distribute as gifts in route. Private Pierre Cruzatte was officially a boatman, but also played the fiddle. George Gibson specialized as a hunter, sign-language interpreter, and played the fiddle. Others in the corps played tambourine and they had at least one horn in the group. The Indians always delighted when the Corps erupted with the joyful noise in celebratory tone. Their largest celebration along the journey was likely New Year's Eve December 31, 1804 and January 1, 1805 at the Mandan village along the banks of the Missouri. The Jews harps were distributed to young male Indians who quickly learned to work the instruments and dance to their tunes. The corps would reward the performance(s) with beads and other gifts to show their appreciation. A new vibration moved to the interior of North America with the Lewis and Clark expedition.

Sacajawea and her husband joined the expedition at the Mandan village as Lewis and Clark headed west up the Missouri. Toussaint Charbonneau was a fur trader from Canada working for NWC. He was living among the Hidatsa and Mandan native tribes when the expedition reached the village. He had knowledge and maps of the upriver area. When the expedition left the Charbonneau's at the Mandan village on their return voyage, Sacajawea and *Pomp stayed with the Mandan's while Toussaint and his bombastic ego left to return to Canada* to brag of his adventure and inflate his wages for service as a guide. The explorer, John MacDonell, reported; *"Charbonneau was stabbed at the Manitou-a-banc end of the Portage la Prairie, Manitoba in the act of committing a rape upon her daughter by an old Sauliter woman with a canoe awl. A fate he highly deserved for his brutality."*

With the purchase of Louisiana Territory and formation of the United States, an awareness of common disparities and abusive vice were rising to the conscience of the people's in North America. Manifest Destiny was entering the politics of slavery, women's rights, and property acquisition. The structure of a diverse society and the nature of its members was festering due to perpetual changing circumstance. The early 1800's saw a second and occasional third generation born

of European and other national origins in North America. Women had begun to take important roles stabilizing the home front while the men fought wars and legislated. Religion was experiencing growth and development partially due to advanced transportation and communication evolution. Education became an obvious necessity for all ages, gender, and culture. It had finally occurred to society at large that communication and evolution might benefit by synchronism. In order to dominate, the *'would be'* heads of state would need to communicate with the Indigenous, Emigrants, Infidels, and others if they were to lead, follow, or even get out of the way. Women were becoming important partners in the making of the nation. Given the task of raising the next generation and keeping the home fires burning, their worth was being recognized yet not acknowledged in doctrine and script.

Abigail Adams had brought attention and respect to the position of First Lady to the young Nation. Susan B. Anthony, Clara Barton, and others would campaign and establish women's rights, yet there was one woman, the daughter of Congressman William McManus, who used her pen and persona to persuade authorities through newspaper print and in person. Jane Cazneau [pseuds; *Montgomery, Cora Montgomery, Corrine Montgomery*] would begin her activism as a journalist working for John L. O'Sullivan's <u>Democratic Review</u>, Horace Greeley's <u>New-York Tribune</u>, and Moses Yale Beache's <u>New York Sun</u>. Jane attended Troy Female Seminary but did not graduate from this early college for women. Jane's family was Lutheran, and she began her life as a Lutheran and later converted to Catholicism. She married Allen B. Storm August 2, 1826. This is the same date given for the birth of her son, William Mont Strom, possibly the reason for her dropout from Troy Female Seminary and name change. Very little information can be found on Allen B. Storm and some reports say Jane and Allen separated in 1831, however other reports say Jane McManus Storm was widowed in 1838. Allen Storm is reported to have died in New York City.

Jane Cazneau's son, William Mont Storm, held more than 33 patents in his lifetime, many of them in firearms and cartridges. His three-cylinder steam engine was one of the first with two horizontal

opposed, single action cylinders and one double-acting horizontal cylinder (1865). This portable engine could be used to run a sawblade. Mont Storm held the patent on the .577 Sporting Rifle. The model was breech-loading and fired animal gut cartridges. The cartridge was too fragile for percussion cap system ignition and the breech loading system proved to take too much time and required precision to avoid misfiring. There were several of these rifles sold during the Civil War as they were accurate at 1000-1300 feet, but for the reasons mentioned they lost their popularity. 770 of the .577 band percussion rifles were issued to the 21ˢᵗ Indiana Volunteer Infantry between 1862-1865.

Jane Cazneau's father, William McManus, was a Representative in the 19ᵗʰ Congress from March of 1825 to March of 1827. He was an attorney in Troy, New York, serving as Surrogate (a probate court that deals with probate and the administration of estates). In 1832 Jane McManus Storm, her father William McManus, and brother, Robert W. McManus, founded the Galveston Bay and Texas Land Company. Jane's investment in this business may have led to the rumors that she had divorced Allen Storm. That same year, 1832, Jane and her brother Robert went to Texas to obtain *Empresarios'* or land grants known as *leagues*. Jane McManus Storm arrived at the Capitol of Mexican Texas, San Antonio de Béxar, on horseback presenting the General Land and Records Office with a letter from the Mexican Consulate in New York, Jacob W. Radcliff. The letter requested eleven *sitios (4428.4 acres per1 sitio)* be granted (at $200.00 per league) according to the Texas agreement for land settlement along the rivers and grazing in the Republic of Texas. Her brother, Robert, filed a claim for himself and they filed a separate claim for their father. Each claim was for 48,712 acres. The number of people required to be brought to these land grants or *Empresarios'* was directly connected to the size of land purchased by grant, credit, or cash. The Galveston Bay and Texas Land Company pledged 300 families and purchased land adjacent to Steven F. Austin's colony along the Brazos River and a portion at Matagorda Bay.

Jane McManus Storm was an educated *femme fa•tale* who began her editorial career in support of *Manifest Destiny*. Her father's work with estates and probate was an asset to the Austin family beginning

with Moses Austin in 1821. Mexico became independent from Spain September 16, 1810. When the economic panic of 1819 occurred, Moses Austin left his lead mining business to embark on a scheme of colonization in Texas. Moses obtained a land grant from the Mexican *government* but died before he could begin fulfilling the terms of the grant. His son inherited the grant in his estate. After Moses Austin's death, Stephen Austin won recognition of the *empresario* grant from the newly independent state of Mexico following the armed conflict of the *Army of Three Guarantees* and Treaty of Córdoba August 14,1821. He founded a colony of several hundred English speaking colonists along the Brazos River. Austin became active in the interests of Anglo-American slaveholders by defeating an effort to ban slavery in Texas. He advocated annexation of Texas promoting that American settlers might be better served if they had liberty and self-government. Mexico had inserted clauses in the *empresarios* requiring that settlers take an oath to Catholicism. When Austin's attempt of self-government *empresarios* failed, he recommended the organization of state without waiting for the consent of the Mexican Congress and was thrown in prison in 1833. He was released in 1835 partially due to Jane Cazneau's editorials, the Galveston Bay and Texas Land Company's activity at Matagorda Bay, and the 800 settlers Austin had already settled in Texas along the Brazos River.

Before he was imprisoned in 1833, Austin hired Gail Borden, Jr., a land surveyor, to survey the land grants Moses Austin had acquired in 1822. This included all land grants between the San Jacinto and Lavaca Rivers, an area covering approximately $15,400^2$ miles in country that is now Texas. Often called the "Father of Modern Texas" for his contributions to the establishment of the *empresario* system and the Anglo colonization of Texas, Stephen F. Austin also deserves credit as one of the first Texas mapmakers. Keeping close to his surveying roots, Austin had the rivers and bays of Texas charted to locate the land best suited for his colony. Once he had accomplished that, he produced maps of Texas that became the primary cartographic references for the territory for decades promoting further immigration and colonization of Texas.

The survey was taking place as William McManus, his daughter Jane and son Robert, were making their way from New York to Texas with 300 German families to settle a colony on the Brazos in 1833. The Germans got as far as Matagorda Bay and refused to go any further. They determined to form their colony at that location. Matagorda is a census-designated place in Matagorda County, Texas. Located near the mouth of the Colorado River on the Upper Texas coast in the United States, Matagorda is primarily a tourist town with a population of 503 from the 2010 census. Commercial and recreational fishing are the top industry. Matagorda is at the end of State Highway 60, which runs over the Intracoastal Waterway and south to the Gulf of Mexico. It is the oldest town in Texas, established in 1827 when Stephen F. Austin obtained permission from the Mexican government to build a town to protect incoming settlers. Today the area is listed as number one in the nation by the North American Audubon Society with 234 distinct species of birds listed.

With Stephen F. Austin in prison, the Texas-Mexican friction was increasing as the settlers continued to flow into Texas according to the 1825 colonization *Law of Coahuila and Texas*. Another *empresario* had been filed prior to Austin's imprisonment by John McMullen establishing the McMullen-McGloin Colony October 24, 1831. This colony began with 200 families of Irish colonists on the southern bank of the Rio Grande in Mexico, directly across the border from Brownsville, Texas. John McMullen was fluent in Spanish and had been a translator for the provisional government. He established himself as a merchant in Metamoros, a city in the northeastern state of Tamaulipas. Heroica Matamoros is the second largest city in the state of Tamaulipas and was established in the early 1820's. McMullen and McGloin personally accompanied this first group of Irish colonists from New York to Texas on the Albion and New Packet Steamships in October of 1829. The colonists stayed at Nuestra Señora del Refugio Mission in Mexico for about a year and then moved to San Patricio on the north side of the Rio Grande. This caused McMullen-McGloin to invest in additional *empresario* which required additional settlers. Unable to pay for his share

of the *empresario* grant for the San Patricio holdings, McMullen sold his share to McGloin and became a merchant in San Antonio.

Many of the *Empresarios* were incomplete or foreclosed on due to these independent colonists choosing to abandon or relocate lands before the four-year residence clause had been met. There were several caveats in the *Law of Coahuila and Texas* in addition to the four-year claim. To obtain a deed to a league of land (*4,428 acres or 20 km² of grazing land or 177.1 acres of labor or cropland*) the claimant had to pledge to follow Catholicism as their religion. There was also the matter of Indigenous Indians, Mexicans, and free Slaves who were inhabiting the Republic of Texas. When the emigrants began moving on to the lands in Texas, the response from the Indigenous groups was the same in the south as it was in the north of the United States. Neither the northern or southern borders had been established and Mexico retained domain of Texas. The Canadians may have been less concerned about mixed ancestry, especially given the many Catholic Métis in the Montreal area. There were enthusiastic opinions about slavery adding to the tension leading to the Civil War. When Andrew Jackson became president in 1829, he initiated an "*Indian Removal*" policy. In 1834 the first United States citizen (acknowledged) of African descent was born in Macon Georgia to an Irish American plantation owner, Michael Healy. Michael Morris Healy and Mary Eliza Smith (*mixed race mulatto*) were joined in common-law marriage in 1829. The marriage was not recognized by the church and the children's legal status was that of their mother, *partus sequiter ventrum*. The book: "**Incidents in the Life of a Slave Girl**" written by Harriet Jacobs using the pseudonym Linda Brent, tells a similar story as Mary Eliza Smith. Published in 1861 by L. Maria Child, this story documents the story of a woman who lived the life of a slave and gained freedom for herself and for her children.

Patrick Francis Healy, the son of Michael Morris Healy and Mary Eliza Smith, became the 29th President of Georgetown University in 1874. This is a testament to the changes that occurred in the United States in a forty-year span. There would be 14 Presidents from the beginning of the 19th Century to Abraham Lincoln's assassination April 15, 1865. Patrick Francis Healy became the first mixed race Jesuit Priest.

The National Historic Landmark and flagship building on the main campus of Georgetown University in Washington D.C., Healy Hall, is named for Patrick Francis Healy. Within Healy Hall, Gaston Hall resides. Named for William Gaston, Chief Justice who served with Thomas Ruffian in the law office of David Robinson. Gaston and Ruffian were best known for North Caroline v. Mann 1835. *"Slave owners have absolute authority over their slaves and could not be found guilty of committing violence against them."* 13 N.C. 263 (N.C.1830). Another indication of the ambiguity of the era.

Montana had just become part of the Louisiana Purchase in 1803 and Lewis and Clark were about to make their epic journey up the Mississippi and Missouri in search of a route across the Rocky Mountains to the Pacific Ocean. Following their return there was little time for the country to explore their findings because the War of 1812 was brewing in addition to the Tejanos (Mexican American) conflicts with settlers and land disputes throughout the United States and its Territories. What was widely pronounced from the Lewis and Clark Expedition was the vast amount of productive land that was available for settlement barring the Indigenous Peoples resistance. Much of the land was productive grassland with only wild game, including buffalo, inhabiting the northern plains. Buffalo herds were declining, and Indians were existing on wild flora and fauna with a small number of grains, predominantly corn, produced for consumption. Agronomy and Agrarian techniques would be necessarily taught to both emigrants and Indigenous Peoples due to the diversity of landscape in the vast territory. Livestock would have to be introduced since there was no evidence of utilizing the open prairies for livestock production.

In Texas, the land contrasted with the northern plains. Mostly desert with some productive fertile land along the river valleys. There was livestock production happening on the vast open sands, although thousands of acres were necessary to support the animals and they were feral. The Spanish had brought horses to enable the vaquero wranglers to better manage the animals, but with the boundaries unsettled and the competition of Comanche and Cherokee Indians, the cattle were more like wild game in Mexico and Texas. Branding had not become a part of

marking in the early 1800's as there was no organized recording entity. The population of the United States and its Territories in 1800 was 5,308,483 with 893,602 of those counted being slaves. The questions on the census form 1800; *Number of free white males; Number of free white females; All other free persons; and Number of slaves.* This was the second census taken in the United States.

By 1860 the population had risen to 31,443,322 from 33 States and 10 organized Territories. This was the 8th census and much of the south still considered slaves as *'personal property'.* Most of the Southern States wealth was slaves. States were ranked by population and the questionnaire read; *Free Population; Slave Population; Dwellings; Families; persons; Description [Age, Sex (m or f)], color (W, B, or M), Value of Estate owned; Value of Real Estate; Value of Personal Property; Place of birth, naming State, Territory or County; Married within the year; Persons over 20 years who cannot read or write; Whether deaf and dumb, blind, insane, idiotic, pauper, or convict.* The 1860 data also revealed 10% of the population were farmers (owners and tenants) utilized occupations. 3.2% of those were (wage workers) and 3.0% were general laborers, 0.4% could read and write. The data from this census told the leaders of the country that slaves were the largest contributors to the nation's wealth and the number of persons educated to the minimal level of reading and writing was minuscule compared to the 35.4% increase in population. Another awareness became evident following the Civil War. Planters or Plantation owners did not know how to work fields or tend livestock. Most were void of personnel management ignoring the premise of *'free slaves'.* Wives were often left without inheritance for the number of husbands and sons who were killed in the wars. Two of the main figures who settled Texas were at odds with each other. Sam Houston and Steven Austin, two of the most colorful men influencing the governance of Texas, worked in tandem, yet followed opposite theories of how to manage the issues of slavery and Indians.

CHAPTER 7

PRESUMPTUOUS PIONEERS

Indian history was largely gathered from folklore or storytelling through the ages or by written accounts of politicians in the early settlement of the United States. The same is true of African American slaves and somewhat resonant of women in the early phases of settlement of the North American continent – with exceptions. Sacajawea was not able to communicate in writing, but Lewis and Clark chronicled their time spent with this young Shoshone Indian woman crediting her with teaching the expedition much about Indian culture(s) and native fauna of the plains. The unique task of harboring a cavity where humans are created and developed to maturity is the task women are built to do, yet women have labored alongside men in many industries. Where the feminine touch has pronouncedly lacked is in written documentation and opinion. Interestingly, during the 19th century in the United States, schools accepting women were forms of secular higher education. Seminaries educated women and the only socially acceptable occupation for women was teaching. Caveat: only unmarried women could be teachers. Most females were homeschooled, providing their mothers had access to books and time to instruct their children. Boys, regardless of their interest or ability, were sent to school. If unable to afford to send all sons to school, the oldest boy, regardless of ambition or interest, was educated pretty much at all costs to the mother and siblings. This leaves the women and girls at home to learn the management of households and staff, albeit without direction or finance. Advanced engagement of

peasant skills like cooking, cleaning, gardening, and animal husbandry were ongoing daily without wages. In 2020 wives of ranchers and farmers who do not claim wages on their annual income tax statements will end up with ½ of their spouses' social security – if they have been married to their spouse for seven or more years and are 62 or older.

Thru the ages it seems male gender has maintained a prodigious advantage when it comes to inheritance and oversight. Without going back to biblical times, let us examine the instance of Sacajawea and her son, Jean-Baptiste Charbonneau. When her husband, Toussaint Charbonneau, left her at the Mandan Village and subsequently was killed leaving her abandoned and widowed around twenty years old, she was left without means of support for herself or her child. For undisclosed reasons, William Clark was known to have been given guardianship of "Pomp" some years after the expedition. December 20, 1812, William Clark received Pomp in Saint Louis. This is the last written account of Sacajawea. There are however stories of her possible return to her Shoshone tribe where she remained in obscurity. Other legends of her tell of her growing old at the Mandan Village living her life out and buried there. For the significant role she played in the Corps of Engineers exploration of the Missouri River area she has received recognition and is memorialized in celebrations, statues, and even coin. Unfortunately, her story will never be written or told in her own words. May it simply be said she was extraordinary as a mother, a woman, and a founder of the United States. Women such as Abigail Adams, Lucy Lewis Marks, Mary Meriwether, and Dolley Madison all had husbands, sons, uncles, and cousins who gave them credence and a venue to explore and identify as contributors to a higher standard of responsibility to community. Their influence was forwarded by their male counterparts.

The last quarter of the 18th Century and beginning of the 19th two ladies of quite divergent backgrounds wove their way into the history of the settling of the United States. Sacajawea would have been between these ladies in age adding to the evasive chronicling of provocative lady pioneers. Eliza Bowen Jumel Burr; April 2, 1775 – July 16, 1865, and Jane McManus Storm Cazneau; April 6, 1807 – December 12, 1878.

Jane and Eliza were both engaged in real estate on a large scale, and somewhere in their lives each had an involvement with Aaron Burr. At least that is what Eliza believed as she named Jane Cazneau as co-conspirator when she filed for divorce four months after marrying Aaron Burr.

Keep in mind the Louisiana Purchase and the Lewis and Clark Expedition took place in 1803-1805 and that Aaron Burr was Vice President for Thomas Jefferson, Jefferson's first term. **Aaron Burr; born February 6, 1756**. His father was a Presbyterian Minister and the President of a College making him a PK (preacher's kid). His Vice Presidency fueled his animosity to Alexander Hamilton who he shot and killed in a dual in 1804. Perhaps life would have been different if Aaron Burr's wife, Theodosia Bartow Prevost, had lived beyond their 11 years together. Nine years Burr's senior, the pair was married in 1782. This was Theodosia's second marriage bringing five children, four daughters and one son, to the union. Theodosia Prevost Burr died in 1794 due to a longstanding illness thought to be cancer. Together Aaron and Theodosia had four children with one, daughter named after her mother, surviving to maturity. She would die in a shipwreck in 1812. Daughter Theodosia Burr Alston is mentioned in the Broadway musical "*Hamilton*" by Lin-Manuel Miranda. The song, "Dear Theodosia", (music and lyrics by Miranda) was performed by Leslie Odom Jr. in the original performance. Aaron Burr said his wife, Theodosia, was [*"the best woman and finest lady" he had ever known*]. Both historical figures were notably intelligent appearing to enjoy every aspect of the challenges of raising a '*girl*' child. Theodosia had a "*passionate commitment to education*" and taught her daughter "*as any wealthy male child*". Aaron continued his daughter's education after her mother died, although she was reading and writing by the age of three and could speak Latin, French and German and read Greek. By age 12 she had read all six volumes of "*Decline and Fall of the Roman Empire*". Theodosia Alston said of her father, Aaron Burr, "*I had rather not live than not be the daughter of such a man.*"

Jane Cazneau was the youngest of these women, and very oddly implicated in a romantic interlude with the controversial and

charismatic Aaron Burr. Jane was six years old when Theodosia Alston died in a shipwreck and twenty-six years old when Burr married Eliza Jumel. Burr may have enervated Eliza by fraternizing with Jane Storm and her father, William McManus, who had just finished his term as U.S. Representative and had entered land speculation founding the Galveston Bay and Texas Land Company. Eliza was born in poverty and through her own good sense had saved her husband, Stephen Jumel, from frittering away his fortune both in France and the United States by managing their property and business's in New York. Their business in France had declined because of the economic depressions including Napoleon's endless quest of domination. Eliza and Stephen were linked to Bonapartist sympathizers. Stephen died in France in an accident or pneumonia in 1832. Eliza was in the United States living in the Morris-Jumel Mansion in northern Manhattan. Stephen had purchased the home for Eliza from John Jacob Astor in 1810. Astor had converted the estate and mansion into a boarding house-tavern combination in this upscale area in New York.

"*Heav'n has no Rage, like Love to Hatred turn'd, Nor Hell a Fury, like a Woman scorn'd*", words from "**_The Mourning Bride_**" written by playwright and poet William Congreve (1697). This may have been the sentiments of Eliza Jumel Burr when she discovered her husband of four months was attempting to drain her bank account and turn her real estate into liquid assets. After all, Eliza had been an actress and was well acquainted with the value of her properties. Aaron Burr, quite contrary, had spent his life attempting to convince others of his value to them so that he might obtain financing for his lavish lifestyle. Eliza Jumel Burr chose Alexander Hamilton Jr. as her divorce attorney. The divorce was final September 14, 1836. Aaron Burr died on that day.

Jane Cazneau had a son, William Mont Storm, born August 2, 1826. Some reports say Jane divorced Allen Storm in 1831. Whichever account of Jane McManus is true, her son would be five or seven years old when Eliza named her in her divorce suit. A prolific journalist beginning in 1835, there are no published documentations found of her writing before this time. Given these facts about Jane Cazneau lead to the implication that Eliza needed a reason to divorce Burr and

the interest the McManus family had in land grants in Mexico fueled enough of a threat for Alexander Hamilton Jr. to succeed in securing a divorce for Jumel. Jane and her brother Robert traveled to Mexico in 1833 returning to New York in 1834 to travel with their father, William McManus, and 300 German settlers, to the property at Matagorda Bay in what is now Texas.

An important part of the developing capitalistic United States was the establishment of banking systems to finance the young economy, or at the very least establish it. One man had a significant role in both land acquisition and finance of the nation. Albert Gallatin reduced the national debt from $83 million to $45.2 million by 1812. Prior to becoming involved in politics, Gallatin was a pioneer of American settlement forming a business partnership with French land speculator Jean Savary. He traveled throughout various parts of the United States purchasing undeveloped Western lands. Gallatin strongly supported and arranged the financing for the Louisiana Purchase. He also championed and helped plan the Lewis and Clark Expedition to explore lands west of the Mississippi.

Lewis and Clark both were appointed governorships and given land for their work with the Corps of Engineers in discovery and mapping of the interior of North America. Clark married and had children. Lewis did not. Meriwether Lewis was appointed governor of Louisiana Territory and at once began proving new roads in the young state. He was caught up in land grant politics and Indian depredations, both of which he detested. Once again, his administrative malodorous discharge frustrated himself as well as his co-politicians. There was much controversy over his approval of trading licenses and land grant politics as he favored the lower class in negotiations. Unexpectedly, Lewis hired a free African slave as his valet on his return from the expedition. John Pernia served Lewis until his death.

As in life, the death of Meriwether Lewis was a conundrum. September 3, 1809 Governor Meriwether Lewis was found dead from two gunshot wounds. One to the head and one to the gut. Reports vary as to whether he was in his room or outside the lodge he was staying at on the Natchez trail on his way to Washington D.C. to resolve

personal money issues. It has also been debated whether it was murder or suicide. Author, Stephen Ambrose, dismissed the murder story as *"not convincing"*. This story postulated that robbers attacked Lewis as he walked outside in the dark of night before retiring. Lewis was fired at and ran to his room where he was shot once again and robbed. His body was not found until morning in his room. The woman who managed the lodge heard a scuffle and shots, but her story changed details as time passed.

Dr. Samuel B. Moore exhumed and examined Lewis's body 40 years later and reported; *"It seems more probable that he died by the hands of an assassin."* The doctor guessed that Meriwether Lewis had *PTSD* from the expedition and quite probably from his life before the expedition. Dr. Moore had examined others who trapped or traveled the northwest region of the continent and found they showed symptoms of *PTSD*. Lewis had tried suicide early on the fateful journey and it seemed, by the witnesses at the lodge, that he was distraught or uneasy during the evening meal. He was said to have been mumbling as in a discussion with himself or unseen umbra. Due to the fact of his destination and the reason for the journey he would no doubt have had reason to rehearse his arrival and personages he was expected to address. At any rate, the suicide theory did not lead to any evidence to that resolve. Investigating Lewis's habits he was not known to consume exorbitant amounts of alcohol nor use opioids.

Lewis had joined the Freemasons and was the first Master of Lodge No. 111 as he was the person encouraging its beginning in St. Louis September 16, 1808. September 18, 1809 William Clark was issued a traveling certificate to Freemasons Lodge No. 111 Saint Louis Chapter. When Lewis died, his valet, Perina, was owed back wages. Perina proceeded to Monticello to ask Jefferson to pay the $240.00 Lewis had left in arrears. Jefferson refused. Perina later committed suicide. This begs the question as to why Perina was not with Lewis on his final journey. Is it possible that it was this person, who was owed money and knew Lewis's personal habits, who may have '*killed his boss*'? Unfortunately, *dead men tell no tales.*

Captain William Clark, born August 1, 1770 in Virginia. His

parents were Scottish and English Ancestry. William was the 9ᵗʰ child of 10 born to John and Ann Rogers Clark. His siblings and father had strong military interests. At age fifteen, Clark moved with his parents and siblings to Louisville, Kentucky. Upon return from the Lewis and Clark expedition Clark married Julia Hancock in 1808. Clark had received double pay and 1600 acres of land from President Jefferson upon his return. He was appointed brigadier general of the militia for Louisiana, (later Missouri), Territory and Federal Indian Agent for western Indian tribes. During the war of 1812 President Monroe commissioned Clark Territorial governor of Missouri. He held this commission from 1813 to 1820. William and Julia had five children prior to her death in 1820. He married Harriet Kennerly Radford, a widow with three children. Together he and Harriet had two sons. In 1812 William Clark became guardian of Sacajawea's son Pompy. It is thought that Sacajawea died in this year by some historians, however, there is no actual documentation of this fact. There are also varied speculative reports that she had other children at that time who also became Clark's wards. Also, no proof of fact.

Clark had formed a friendship with the Nez Percé Indians and may have fathered a son, Daytime Smoker, with the daughter of Chief Red Grizzly Bear. Speculation of Sacajawea having more children may have begun with this unexplained boy being included with some of Clark's affairs. In 1809 William Clark joined Manuel Lisa in the formation of Saint Louis Missouri Fur Company. Clark aided in Treaty of Portage des Sioux in 1815. President Monroe appointed him superintendent of Indian Affairs at Saint Louis in 1822. William Clark served the Indian nations with duplicity. He reorganized the entire Indian Bureau in 1834, agreed with and implemented the policy of Indian removal from territorial lands. Over the course of his career, millions of acres passed from Indian to U.S. ownership by Clark's hand.

He was a patron of the Arts and he supported the establishment of schools, the growth of banks, and the incorporation of cities. He invested in real estate and railroads, supported one of the first museums in the west, and promoted other economic and cultural endeavors in the Saint Louis area. His reported treatment of his slave, York, on the

expedition and later, was cruel at times and he kept this air of superiority throughout his life. He died September 1, 1838 in Saint Louis, Missouri.

Jefferson's second term was not as successful as his first term. Both England and France were interfering with the neutral rights of American merchantmen and Jefferson remained preoccupied with keeping the United States from involvement in the Napoleonic wars in Europe. His attempted solution for England and France interference was an embargo on American shipping. The Embargo did not work. Following his term end, Jefferson retired to Monticello where he resumed designing roads and pondering other projects like the design for the University of Virginia. From his perch at Monticello, he had placed his house where his mind could contemplate his surroundings from an elevated point of view. He remained in contact with William Clark and Meriwether Lewis's mother following Lewis's death, but was content to tend to his own affairs unconnected with politics in Washington D.C. James Madison followed Jefferson as president in 1809.

Perhaps the most notable contribution of James Madison and his presidency was his beautiful and charming wife, Dolley Madison. James did ratify the Constitution and helped form the Bill of Rights. He also enacted the first revenue legislation and wanted to declare war once again with Britain, even though the country could not afford another battle stateside. The British went to Washington D.C. and burned the White House. Dolley's quick thinking saved a portrait of George Washington from being lost in the fire and her calm and tasteful demeanor brought the building back to order. Dolley organized the first Inaugural Ball in D.C. James was 18 years Dolley's senior and very dull company. Dolley was beautiful, the queen of fashion, and one of the most charming ladies ever to grace the White House. James Madison was Episcopalian and she a Quaker. Dolly was a widow who brought a son with her in her marriage to James. They did not have any children together.

Albert Gallatin had been appointed ambassador to Britain in 1826 and negotiated an extension of the Anglo-American control of Oregon Country in 1827. Following the negotiations, he returned to New York City becoming president of the National Bank of New York the

following year. Gallatin became highly influential and helped found New York University in 1831. In 1843 he was elected president of the New York Historical Society. In the mid-1840's he opposed President James K. Polk's expansionist policies and wrote a widely read pamphlet, *"Peace with Mexico"*, calling for an end to the Mexican-American war.

Jane Storm Cazneau was advocating the annexation of all of Mexico during the Mexican American War partially due to the knowledge she had of United States land grants. President Polk sent her on a *"secret peace mission"* to speak with the President of the Republic of Texas, Marabau B. Lamar, who resided in Saltillo. Jane Cazneau rode to the front of the Mexican American War where she witnessed the capture of Winifield Scotts' fortress of Veracruz in March of 1847. In 1845 Polk also sent John Slidell to Mexico to secure territorial concessions and at the same time to avert the approaching war with Mexico (which was in progress). Using the name *"Cora Montgomery"* Jane Cazneau helped negotiate the *Treaty of Guadalupe-Hidalgo* (1848) which included guarantees of property rights of both female and male nonresident landowners. While in Mexico, she worked on canal-building expeditions and banking projects.

Jane continued to work on obtaining title for the *empresarios* she and her brother had claimed in 1835 and had not completed. There was the four years occupation period to prove up the land claim. Cropland was elongated quadrangles or *porciones* located along waterways to ensure croplands. *Leagues* were considerably more property than could be obtained by homestead claims in other territories. The *leagues* were acres of Texas dessert and required the occupation of four years and Catholicism. Texas *league grant*s land were cheaper per acre than Montana Territory lands and could be bought on credit. Cropland (*porciones*) located along the rivers giving access to water for irrigation. Galveston Bay and Texas Land Company had three of their *empresarios* and *porciones* along the San Antonio River Valley. During her time working with Mexican and Texas governments, Jane became friends of Sam Houston. Houston had purchased an *empresario land grant* and was negotiating full title to the property along with the many other land

speculators who were caught in the struggles between Spain, France, Mexico, and Texas.

Sam Houston ran away from home and lived with the Cherokee Indians until age 18 when he returned home, he taught school for a while. When the War of 1812 broke out Houston enlisted and was promoted from private to third lieutenant by General Andrew Jackson who became his mentor and surrogate father. Sam Huston was injured in the battle of Horseshoe Bend ending his military career. He was appointed sub-agent to the Cherokee Nation and from there his political career progressed swiftly. By the time he was 34 years old he was serving as governor of Tennessee. In January of 1829, his projection in politics changed. January 22, he married Eliza Allen. Eliza was 19 years old, the daughter of a wealthy planter and a popular socialite. Sam Houston had known her since she was 13. He had served with her uncle, Robert Allen, when he was a U.S. Representative in 1823. Without a home to move into, Sam Houston and his young wife, Eliza moved into a small apartment on the second floor of the Nashville Inn. The Inn was the local gathering place for politicians and ruffians. Sam was legendary for his drinking, his melodrama, and his renegade spirit.

Four months after their wedding performed by a Scottish minister in the local Presbyterian Church, Eliza left Sam and moved back to her parents' home. She did not file for a divorce. This was a case of he said, she said, that has never unveiled its mystery as neither first party would speak of it, even though secondhand reports were circulated, and are still the fodder of discussion. After resignation from his governorship and perceived embarrassment at his fall from grace, Sam Houston made the decision that he would have to file for a divorce as Eliza would not speak of the subject and vowed to never approach the subject. She stayed true to that vow. Sam filed for a divorce in the territory where he resided to 'restore his reputation' and resume political standing and engagement. The divorce was granted in the Territory of Texas four years after the couple had separated. They had married in the Territory of Arkansas. The first two years after Eliza left Sam Houston he went back to living with the Cherokee and married a Cherokee woman named Diana Rogers Gentry, under Cherokee law. Diana and Sam opened a trading

post on the Neosho River. Houston drank so heavily during this period of his life the Cherokee began to say this '*new Indian's name*' is "*Big Drunk*".

Sam left his second wife, Diana, and went to D.C. to represent the Cherokee Indians. While he was there, he was asked to help with the conflicts between the Indians, Mexicans, and Texas settlers. When Sam Houston arrived in Texas, he was still drinking heavily but continued to have good relationships with the Indians. On October 2, 1835 he successfully led the militia in the Battle of Gonzales, the first battle of the Texas Revolution. In February of 1836 he negotiated a Treaty with the Cherokee Indians. David G. Burnet was serving as interim President of the Republic of Texas. Burnet was replaced and Sam Houston became the first President of the Republic of Texas in 1836.

David G. Burnet had moved to Stephen F. Austin's Colony in Mexican Texas after spending two years at a Comanche village on his way to Texas in 1817. He had fallen off his horse and the Comanche had rescued him. While he was recuperating at the Comanche village, he met Benjamin Milan, a writer for the Literary Gazette, who was engaged in trade with the Indians. Following their meeting and his recovery, Burnet returned to Cincinnati where he wrote a series of articles detailing his time spent with the Comanche for the Literary Gazette. The comradery Burnet formed with the Comanche made him an asset to the U.S. Military in their quest to acquire Texas territory. After hearing of Stephen Austin's successful colony for Anglos, Burnet returned to Texas and settled in Austin's colony in 1826. He provided legal advice to the 200 settlers in San Felipe and organized the first Presbyterian Sunday School in Texas. Burnet neither drank nor swore. He carried a Bible in his pocket and was considered deeply religious.

In 1827 Burnet traveled to the Republic of Texas state capitol of Saltillo and applied for grants as empresario under the General Colonization Law of 1824. The Law required that the grantee attract settlers to the '*colony*' to obtain title to the properties. David Burnet was unable to bring enough settlers to his empresario and was forced to sell the land. He later lost his right to operate a sawmill in Republic of Mexico because he *refused to convert to Roman Catholicism*. It may be

said he was too good of a man. Hugely different from Sam Houston, the man who would become President. Burnet sold his land grant to Galveston Bay and Texas Land Company for $12,000.00. Mirabeau Beaumont Lamar was Burnet's Secretary of War and succeeded Sam Houston as President of Republic of Texas. Lamar had distinguished himself in the Battle of San Jacinto. Lamar's vice president was David G. Burnet.

Mirabeau B. Lamar was of French Huguenot decent. His grandfather was Thomas Lamar one of the founding fathers of Maryland in 1660. Lamar declined the opportunity to attend Princeton and became a merchant editing a newspaper early in life. In 1828 he was living with his wife and family in Columbus, Georgia where he established the *Columbus Enquirer*. His mentorship with Lamar and Houston led him to wage war against bands of Cherokee and Comanche peoples to push them out of Texas during his tenure in politics. In 1839 Lamar founded the Texas State Library (presently known as the Texas State Library and Archives Commission). He established a fund to support public education in Texas, known as the *"Father of Texas Education"* because of his provisions of land support. Lamar supported legislation using the Morrill Act to acquire land for Texas A & M University and the University of Texas. He is known for saying; *"The cultivated mind is the guardian genius of democracy and, while guided and controlled by virtue, the noblest attribute of man. It is the only dictator that freemen acknowledge and the only security that freemen desire."*

Gazaway Bugg Lamar was a cousin of Mirabeau Lamar. Gazaway was a banker in New York City. When money was short in Texas during the Mexican American War, Mirabeau borrowed from Gazaway as he wanted to move from Laredo where he was post commander. He *"wanted more action"*. In 1845 the Texas Legislature elected Mirabeau as Eagle Pass Representative. He served from 1845 to 1857. President James Buchanan appointed Lamar as the Minister to Nicaragua, and a few months later to Costa Rica. He published an anthology of poems in 1857; *"Verse Memorials"* published by New York, W.P. Fetridge & Co., 224 pages.

Followers of President Abraham Lincoln's life and assassination may

be familiar with the name Gazaway Bugg Lamar. He was held for three months in Washington D.C. as a suspect in Lincoln's assassination. Gazaway owned the Bank of the Republic on Wall Street, but his major business was in Savanah, Georgia. He was a merchant in cotton, shipping, and a steamboat pioneer. Gazaway and his nephew Mirabeau had an extensive well-connected family throughout the south and east coast of U.S. Another investment of Gazaway Lamar's was a hotel in Knoxville, Tennessee which was renamed the Lamar House Hotel, associated with the Bijou Theater. With his extensive connections with businessmen in the south, Gazaway arranged loans, printed bonds, and as the Civil War neared, bought semi-obsolete rifles from the federal arsenal for the states of Georgia and South Carolina.

The United States did acquire Mexico in part due to Jane Cazneau's help in negotiating the *Treaty of Guadalupe-Hidalgo* (1848). President Polk sent her on a secret peace mission to Mexico in 1845 where she rode horseback to the front of the Mexican American war and witnessed the capture of Winifield Scott's fortress of Veracruz in March of 1847. The agreement United States made with Mexico assumed $3.25 million (equivalent to $96 million in 2020) in debts Mexico owed U.S. citizens and designated the border "*from east to west*". It also included *guarantees of property rights of both female and male nonresident landowners*. Jane Maria Eliza Cazneau (née McManus, widowed Storm) did not live long enough to gain title to the 11 leagues land she had claimed as her life was taken prematurely in 1878 when the steamer, Emily B. Souder, was caught and capsized in a huge storm. Jane was aboard the steamer and drowned on her way to Santo Domingo.

While Jane Storm Cazneau was in Mexico she wrote using her pen name "*Cora Montgomery*". While there she worked on canal-building expeditions and banking projects. At the end of the Mexican American War, she turned her attention to Cuba and the potential in represented advocating its annexation and denouncing the Spanish colonial overlords. She later settled in Maverick County Texas at *Camp Eagle Pass*. General William Leslie Cazneau founded Eagle Pass townsite in the 1840's. *Camp Eagle Pass* was an outpost for the Texas militia to stop illegal trade with Mexico during the Mexican American War. Jane and

William were married in 1849 and moved to the Dominican Republic in 1855. Sometime during this period of transition for both Mexico and Jane, she abandoned her advocation for Manifest Destiny and began to support annexation. She was hired by William H. Seward, Lincoln's Secretary of State, to write denunciations of the Confederacy, which she did from a dugout in *Eagle Pass*. *The Treaty of Guadalupe-Hidalgo* that she had a part in shaping came into force July 4, 1848.

Jane McManus Storm Cazneau and brother Robert W. McManus, had left New York for Texas with a group of German settlers. The German settlers refused to go beyond Matagorda Bay because of the warring Indians and Mexicans. Representing the Galveston Bay and Texas Land Company, William McManus and his investment group encouraged settlement in the annexation of Texas. One associate of William McManus, John McMullen, was attracted to land speculation by the same advantages offered in the *empresario land grant*.

John McMullen was married to Esther Espadas Cummings, the adopted mother of Eliza Jumel Jones niece of *Eliza Jumel Burr*. *Eliza Jumel Burr* had named Jane Cazneau as co-respondent in her divorce suit with *Aaron Burr*. James McGloin, James McMullen's partner, married McMullen's stepdaughter Eliza. Although appearance would say, *'politics makes strange bedfellows'*, history often omits the lady's side of the story. *Aunt Eliza Jumel* most likely influenced the involvement of her sister and niece in real estate. *Eliza* was a wealthy American socialite when she married Aaron Burr. She was born in poverty in Providence Rhode Island on April 2, 1775. Her mother, Phebe Kelley Bowen, was an indentured servant and her father, John Bowen, was a sailor. Her parents were both deceased by the time *Eliza* was 23. In 1799 she moved to New York, changed her name to *Eliza Brown*, and became an extra in a theater. *Aunt Eliza Jumel* was baptized Episcopalian in 1807. She had met and married a wealthy French-Haitian merchant, Stephen Jumel April 9, 1804. Stephen had changed his name; from Étienne Jumel, (1754-1832) born in France, and was rechristened Stephen Jumel when he emigrated to the American Colonies on the eve of the French Revolution. *Eliza* chose Episcopalian as her religion and was baptized

at Trinity Church in Manhattan in 1807. Stephen was Catholic his entire life.

The choice of Episcopalian religion by *Eliza Jumel* was unusual for two reasons. One because it was not the religion of Stephen and two because it was the religion of America's political class at the time of her baptism. Stephen Jumel's family were from the French Bordeaux area in the wine business. Stephen was managing family interest in a coffee plantation in Haiti where he was driven from due to slave insurrection in 1790. He amassed a fortune in the wine business and purchased the Roger Morris house for Eliza from John Jacob Astor in 1804. Astor had turned the beautiful home into a tavern and Eliza restored the home to its original grandeur. Eliza Jumel lived in her home in New York until her death July 16, 1865. She was the wealthiest woman in New York at the time of her passing.

CHAPTER 8

RED COATS AND COWBOYS

William Clark died September 1, 1838 in Saint Louis, Missouri. As one prodigious soul departs the country he contributed so much to shaping, another was about to arrive by way of Ontario, Canada. James J. Hill was born September 16, 1838 in the suburbs of Toronto. The son of James Hill and Ann Dunbar Hill, James was given the same first name as his father without a middle name. His parents were both born in Ireland and emigrated to Canada where James had relatives farming land grants they had obtained from the Canadian government. James and Ann were married in 1833 when she was 28 and James 22.

James Hill was hunting when his handmade bow snapped propelling him backwards lodging the arrow in his right eye. He was nine years old. His vision in the damaged eye was blurred and never returned completely but had insignificant effect on his nervous drive and voracious appetite for doing and learning. With the confines of school this young lad might have been stifled with the label of 'attention deficit disorder' but the fickle finger of fate took his father on Christmas day 1852 after a short illness leaving James Hill, the oldest son, the breadwinner of the family.

James's father had given up farming when James was ten and opened a tavern in Rockwood, Canada, not far from today's city of Guelph, Ontario, exposing Jim to rough men and women and the shady side of characters of the day. James's father was a Baptist and his mother a Catholic. After his fathers' passing, James and his younger brother

were raised with Quakers. While his father was alive the young Hill brothers attended regular school, which required tuition. James's mother was unable to afford the tuition. The neighboring family of William Wethereld insured Jim and his brother home schooling. The Wethereld's were Quaker's and William was a teacher by profession. Jim had shown advanced skill in algebra and geometry and the administrators offered to cover his tuition to continue in regular school, but Jim preferred to learn practical skills of geometry and surveying from Wethereld. While he was enrolled in school, he often played hooky losing track of time engrossed in the family volumes of Shakespeare and Sir Walter Scott's ***Ivanhoe***.

In 1854 Ann Hill gave up the tavern and moved her family to Guelph. James took a job clerking at a general store earning a dollar a week. He kept the books as Wethereld had taught him double-entry bookkeeping. Working at the store gave James a flavor for trade, merchandising, and customer service. At thirteen he added a *'middle'* to his name. A follower of Napoleon and his exploits, James chose *"Jerome"* after Napoleon's brothers first name. By 1855 his sister had married, and his younger brother was taking care of his mother. Jim was seventeen and determined he could manage on his own and did not want to stay in a small-town rural setting the rest of his life. He had a small savings, commencing his frugal lifestyle early in his life, and headed for the United States to explore the validity of the stories he had heard of this vast new country. His first stop was New York City where he was promptly robbed by a pick pocket. The clever lad had not put *"all his eggs in one basket"* and managed to have some of his moneys stashed elsewhere in his luggage. This first journey away from home may have begun James Jerome Hill's interest in the railroad industry.

George Stephenson constructed the first locomotive in 1814. By 1855 privately owned rail lines had begun to serve populated areas on the east coastal areas of North America. John Quincy Adams was president when the first railroad was constructed in the United States. The Baltimore & Ohio railroad opened in 1830 just as John Q. Adams was leaving the White House. In 1830 the rail network consisted of 30 miles of track. By 1840 there were 60 different rail lines operating over 2800 miles of track. The steam locomotive transitioned as did the design

of the locomotive throughout the 1800's on through the mid 1900's. Rail travel, compared to steamboat travel, cut travel time by 90% and became the main means of transportation as rapidly as rails were laid. During the few short years from the time James Jerome Hill left Canada and found his way to St. Paul, Minnesota he may have experienced several styles of locomotives and railcars adding to his design collection for future years. His thoughts may have also considered the truck design and curiosity of change of force needed on hills as opposed to flat land.

From New York, James J. Hill rode the train south through Pennsylvania, Washington D.C., Virginia, to Charlotte North Carolina then to Kentucky where he found a job at a fur trading post. Since he did not journal his journey during that period of his life it is suspect that he either found odd jobs or stowed away on trains or wagons as he contemplated the changing scenery, culture, and growth that was taking place. The Civil War was about to begin, and change was coming. At the trading post in Kentucky, he learned about trapping and fur trade from the stories told as traders brought their fur bundles to market. He advanced his record keeping skills learning a new industry from the business side. Jim learned to communicate with the varied personalities that traversed through from the banks of the rivers inland. From this vantage point it was a perfect time for a young man to realize the effect of the frontier movement in the conditioning of the nation.

From Kentucky James Hill took a steamer to St. Paul, Minnesota. He was 18 years old when he began working at a trading post in St. Paul called the *"Pig's Eye"*. With Hill's rugged constitution and tremendous physical endurance, he had already experienced more than some men do in a lifetime. Traveling from Ontario to New York then Kentucky ending up in St. Paul, James learned several means of transport improving his already articulate business savvy. St. Paul was a bustling city of ten thousand in Minnesota Territory. Minnesota would become a state two years after James arrived with St. Paul as the capitol. St. Paul quadrupled in size between 1856 and 1873 and was the head of navigation on the Mississippi between Lake Itasca in northern Minnesota to the Gulf of Mexico. A variety of businessmen did business through the *Pig's Eye* and Hill had learned to interrogate each as he pried out information on

making money through the transportation industry which was mainly shipping at that time. All the data was easily transported through James Hill's remarkable mathematical mind. He was also aware that freight boats were doing business into Canada via the Red River. He began envisioning a system that would become one of the largest interwoven transportation corridors in the world.

James Jerome Hill wanted to be fully engaged in his adopted country and tried to enlist in the army when the Civil War broke out. He was rejected because of the vision loss in his right eye. Wanting to do his part, Hill helped start the volunteer service corps of Minnesota. While serving in this compacity he was able to sharpen his entrepreneurial skills by working for several employers. One such employer was the St. Paul & Pacific Railroad which began his acquaintance with railroad shipping and transportation. When fuel was in short supply, he began offering coal instead of wood. When the Mississippi River froze over, Hill was able to offer grocers to ship by rail instead of steamboat. Although wars are devastating to economies, they do require innovation and aggression in the business of supply and demand. James Hill became an expert at recognizing the value of procuring supplies for immediate demand. With the skill and authority, Hill became well known as an industrious broker for goods and transportation. At the same time, he learned bookkeeping and reporting finance "on paper". A skill that would serve him well when he envisioned a railroad transportation corridor across the northernmost portions of the United States. His timing was perfect for his interests and ambition. At the end of the Civil war in 1865, James Hill had saved up a respectable amount of money and began looking at how the network of railroads converging from south and east in St. Paul were being financed and the cost of steel for rails. In 1867 Hill married Mary Theresa Mehegan, the daughter of Irish immigrants.

Like everything he did, James Hill jumped into marriage full throttle. James and Mary began their family of 10 children August 3, 1868 and continued through February 21, 1885. Mary was pregnant 90 months minimum the first 17 years of her 49 years of marriage. Mary must have had a strong constitution and tremendous physical endurance for her 21-year-old self. Jim was 30 and a workaholic. It is said she kept

stride with him taking care of her household and children sharing in a frugal lifestyle for several years. She was a Catholic and raised the children in that faith. They had three boys and seven girls. The oldest child, Mary Frances Hill, didn't have to change her name when she married. Her husband, Samuel Hill, was made head of the Montana Central Railroad. Samuel and Mary Frances would have difficulties in their later years, and she ended up on the east coast while Samuel remained on the west coast in the Puget Sound - Seattle area.

Another entrepreneur philanthropist started a flour and woolen mill across the river from St. Paul, Minnesota. Paris Gibson was born July 1, 1830 in Brownfield, Maine. Gibson was lightly involved in politics in Maine being a member of the legislature in that state before moving to Minneapolis, Minnesota. Paris married Valeria Goodnough Sweat in 1854. She was just sixteen. Unlike Mary Theresa Mehegan Hill, Valeria was frail and struggled through life bearing four children in her marriage, losing two when they were one and two. Sons Philip and Theodore would live to be adults. Paris was interested in industry and agriculture. He was on the Board of Regents of the University of Minnesota from 1871 to 1879 and with fellow investors had a startup flourmill called the Cataract Mill. It was the first flourmill in Minnesota.

With investment partners, Paris Gibson also started North Star Woolen Mill in St Anthony Falls which is now Minneapolis. He was a member of the Masonic lodge in Minneapolis and set up the first public library there. With his interest in the flour and wool mills, Paris kept his eye on the activities of agriculture and railroads contribution to its expanse as both Gibson and Hill became businesspeople in Minneapolis-St. Paul.

Paris Gibson's investment interests in Minnesota were like the fireworks on the fourth of July. They soared and were boisterous, but short lived. Lucky for the City of Great Falls, Montana, Paris Gibson would divest his interests in the flour and woolen mills in Minnesota and become a sheep rancher in Montana bringing his interest in electric power generation with him.

North Star Woolen Mill was set up in 1864 by Eastman, Gibson, and Company. Early owners included W.W. Eastman, Paris Gibson,

and John DeLaittre. This mill became the first water powered mill in the West Side Milling District of Minneapolis along the Mississippi River. It would replace Hudson Bay Company as national leader in the production of woolen blankets. The industrial revolution was taking place across the young nation and abroad. Cataract Flour Mill was another investment of Paris Gibson's. Both mills were in St. Anthony, a village founded in 1849 along the banks of the Mississippi where a naturally occurring cataract exists. A dam had been constructed above the falls in 1856-58 in a "V" shape to allow water flow to the east side and the west side of mill pond. This divergence needed a cooperative agreement between two waterpower companies. Minneapolis Mill Company kept ownership of the land and this fact would cause the financial disruption of North Star Woolen Mill.

The flour mill would lose its market share when the railroad through southern Canada and northern United States reached the Dakotas and Manitoba to the west and east to New York. In an abbreviated period, New York cornered the flour mill market with wheat from Canada and the Dakotas. The grain traveled by rail reaching mills that were more efficient than those built ten years earlier. The Industrial Revolution came like a Tsunami changing productions seemingly overnight.

Paris Gibson would seek a slower paced lifestyle out in the prairies of Montana. With his knowledge of wool, he was aware that the reason North Star Woolen Mills had topped the market with quality blankets was because of the quality of wool coming by steamboat from Fort Benton, Montana. He decided to head west to see about buying some land and sheep to startup his own ranch. Gibson had read a lot about the Missouri in the Journals of Lewis and Clark, but his short management of his family farm when his father Abel Gibson died didn't prepare him for anything like raising sheep on the wide-open prairies in an unsettled territory. He moved his family to Fort Benton in 1879 where he purchased a lumber company that failed. He then purchased a large parcel of land on Otter Creek and stocked it with sheep. By 1881 Paris and his two sons had become major sheep ranchers in Montana. The Gibson's were instrumental in the formation of Northern Montana Sheep Company.

About three years after moving to Fort Benton, Paris Gibson finally took a trip to see the great falls he had heard and read about south of Fort Benton. Having experienced the development of the Cataract on the Mississippi, Gibson knew exactly what could be achieved by harnessing the waters of the Missouri and development of the surrounding property. His one hesitation was finance.

Gibson knew a person of wealth who was making his way to Montana by way of the railroad. Gibson wrote to James J. Hill communicating his thoughts about the development of waterpower as well as coal and other minerals in the tributaries around the immediate area of Great Falls. In November of 1882 Paris Gibson returned to Minnesota to forge an agreement with Hill to become jointly involved with the development of a city, transportation corridor, and waterpower facility at the location of Great Falls. Great Falls was not incorporated until 1888 with Paris Gibson becoming the first Mayor in 1890. The townsite was platted by Herbert Percy Rolfe, a Fort Benton surveyor, Sun River rancher Robert Vaughn, and Theodore Gibson in 1883. Paris was the first postmaster in 1884 and suggested naming the community *Hill*ton, in honor of his friend and partner. James Hill rejected the suggestion and since Hill held the purse strings, the name Great Falls was chosen.

There is little information of a sawmill in Fort Benton at the time Paris Gibson moved to Montana, but this notice is found in The Benton Record March 01, 1875.

Sun River, MT January 23, 1875

"The co-partnership heretofore existing between the undersigned, under the name and sty of Furnell & Co. engaged in saw-mill business, is this day dissolved by mutual consent. John Largent is authorized to settle all outstanding business. John Largent, Matthew Furnell, Joseph S. Hill. … we will continue the business at the old stand under the name and firm of Largent & Adams, …"

Most likely this is the sawmill Paris Gibson invested in as he lived in Sun River while Great Falls was being constructed. Several accounts have reported that it was the *Panic of 1873* that brought Gibson to Montana. The sawmill at Sun River was put in sometime in the 1850's when Mullen Road and Camp Reynolds (Fort Shaw) were constructed.

Mullen Road construction was authorized in 1855 and Fort Shaw was founded June 30, 1867. It served Fort Benton and the surrounding area until the Railroad arrived in Great Falls 1889. The sty mentioned in the notice would be the lumber yard or enclosure in Fort Benton and Great Falls. John Largent and Joseph S. Hill had other investment interests with Paris Gibson when Great Falls was being established.

The greatest contributor to the *Panic of 1873* was the railroads and steamships bankruptcies. Henry Villard was born in Bavaria, Germany and immigrated to the United States in 1853. He wrote for newspapers in New York, Colorado, and Chicago and became a staunch supporter of abolition after covering the Civil War. He married William Lloyd Garrison's daughter, Helen Frances Garrison, after the war ended in 1866.

Unlike James Hill, Villard had a frail constitution and traveled to Europe in 1873 seeking treatment for a respiratory ailment. While in Heidelberg he was approached by Ben Holladay, owner of the Oregon Central Railroad. Because of James Hill's success with the Minneapolis-St. Paul line, Villard was very interested in the prospects of building an intercontinental Railroad up the Pacific Coast then taking the line east meeting up with the Great Northern Railroad. In early 1874 he proceeded to Oregon and obtained funding for the construction of Northern Pacific Railroad. With outside financial backing Henry Villard began seizing the principal mineral deposits, forest lands, mountain passes and valley roads up the Pacific coastline. An attempt at a transcontinental rail line had begun in Sacramento, California in 1863 when the 49er's gold rush was experiencing all the financial struggles between greed and despair. Mullen Road had become the closest transportation corridor in the United States running from Walla Walla, Washington to Fort Benton, Montana. It became a heavily traveled military and civilian route, but the railroad was gaining popularity decreasing travel time compared to steamboat and investors in the steamboat industry were no longer experiencing profits.

James Hill had saved his money and watched as the St. Paul & Pacific railroad took federal and state charters and five million acres of land grants to finance the rail lines. Rail lines enormous cost were scarcely being negotiated as finance for costs was difficult to obtain.

An acquaintance of James Hill's, Jesse P. Farley, worked as a receiver for St. Paul & Pacific Railroad. Mr. Farley kept communication with Hill about the Bondholders, who were mainly entrepreneurs of Dutch descent, letting him know the railroad was in despair. Hill decided to take his $100,000.00 of savings to his Scotch-Canadian trading partners and see if he could convince them to make an offer to purchase the Dutch bondholders claims in the SP & P RR. With his bookkeeping experience, Jim Hill approached Donald A. Smith and George Stephen, two Canadians, and Norman W. Kittson, a partner in the shipping business along the Red River. He presented them his business plan for the purchase of SP & P RR.

The accounts of the receiver were jiggled to improve earnings and the estimated value of the land and town sites, $12,216,718.00, had value added, $6,500,000.00. Hill offered $5,000,000.00 to the depressed bonded obligations with a promissory note for $1,000,000.00 and a friendly foreclosure suit on March 13, 1878. They accepted. Basically, James J. Hill had purchased the failing railroad for $5,000,000.00 by getting his partners to put up $9,000,000.00 with a plan to extend the rail line into Canada. Canada had wanted a rail line connection between Winnipeg and St. Paul on the Mississippi River. George Stephen found credit resources in the Bank of Montreal, of which he was an agent. In 1879 a boom year came. In October of 1879, the railroad was reorganized under the name of St. Paul, Minneapolis & Manitoba. Capitalizing in at $16,000,000.00 in bonds and $16,000,000.00 in stocks, each partner was distributed $5,000,000.00 outright. James J. Hill had paid his investors and had his railroad without any restraints from government or financial lenders.

Henry Villard was not doing as well in Sacramento, California. Villard had found other investors in Germany, but in investigating the bookkeeping for the Oregon & California Railroad he had found fraudulent practices in Cyrus K. Holladay's profit sheet on the Santa Fe Railway. He recommended that the German investors purchase controlling interests of all Holladay's transportation businesses, which they did, then removed Holladay from management replacing him with Villard. Politics falling behind progress, both Hill and Villard

soon realized a slowdown in their aggressive advancement of railways because Oregon and Montana were still territories. California became a free slavery State September 9, 1850 partially to gain some law and order to the chaotic land disputes and commerce flow that engulfed the area when gold was discovered. With federal and outside funds invested in the O & C RR laws regulating the transportation corridor moved swiftly. When the line reached Oregon Territory and needed to head east over mountains, and west for Hill's Great Northern, monies for finance were high risk which the young State of California and Nation of United States could not afford. These two men and their railroad enterprises were great contributors to the Panic of 1873.

James Hill had the advantage as he was his own financier. Hill was also personally involved in the layout of the tracks, building of locomotives, and traction of rail cars. When he came to the railroad business, locomotives had names. Hill gave them numbers, doubled tractive power making his road the most powerful with the ability to pull the longest trains. He traveled on many exploratory expeditions studying soil, water, climate, and resources along the "straight" path he later laid track. In 1873 Hill went to Washington D.C. and lobbied for a measure preventing cruelty to train travelers and later introduced statutes for protection of horses and other animals. He raised money holding land sales for the immigrants at $2.50 to $5.00 an acre from the land grant acres he had received with the purchase of the St. Paul & Minneapolis line. He promoted agriculture and communities by offering lower rates to immigrants with livestock and machinery in special cars to carry their families and goods west and built churches and schools in startup towns to encourage communities.

The first Federal Land Grant was the Pacific Railroad Act of 1882. This legislation granted 400-foot rights-of-way plus 10 square miles of land for every mile of track built to the railroad. The square mile acreage was not contiguous, but checkerboarded with surveys dividing it into sections of 1 section = 1 square mile. One township = 36 sq. miles. Ranges and Townships were numbered in a specific manner like a checkerboard with even numbers: i.e. 2,4,6 in black and odd numbers: i.e. 1, 3, 5 in red. This checkerboard property still exists along

the railroad tracks that run from Great Falls to Helena known as the *"Devils Kitchen"*. Railroads were given the odd numbered sections on each side and the Federal Government kept the rest. Two square miles of land from each Township was granted back to the States forming the basis of financing for State Colleges. This was the legislation that caused pause in the east / west railroads. The "land", to comply, required being a State. James Hill, as sole owner of the Great Northern line, continued with his efforts moving west which had halted at Minot, North Dakota in 1866. By purchasing the right-of-way and having a pass located and surveyed for the construction through the Rocky Mountains he was able to continue his line west to Spokane. John Frank Stevens found and surveyed Marias Pass, the illusive passage west, in 1895. Following his work for the Great Northern, James J. Hill recommended John Frank Stevens to President Theodore Roosevelt as Chief Engineer for the construction of the Panama Canal between 1905-1907.

James J. Hill was a Parvenu, yet for all the good he did for settling the west he was put in the class known as the *"Robber Barons"*. This group of businesspeople included Rockefeller's, Carnegie's, Henry Ford, and possibly the first to be labeled a *"Robber Baron"* was John Jacob Astor and son, William B. Astor. This *"Yankee Trader"* was a German butcher's son who came to New York in 1783 and found a job as apprentice to a furrier. This was the year the Revolutionary War ended and the Indians and fur trader's competition for a depleting income source was reaching its apex and derangement. In a brief time, John Astor could see the value in fur trade, and he moved to the Mohawk Valley in western New York State. Once among the Mohawk Indians he learned about the culture and their vulnerability to liquor. He moved back to New York and found a trading post at Broadway and Vesey Street where he formed the American Fur Company (AFC), trading furs from Missouri to Oregon and Canada. AFC functioned on Astor's *'style'* of trade vending liquor for furs and demoralizing Indians of all Nations across North America. His son, William B. Astor became known as *"the Landlord of New York"* by 1848. The British captured Astor's' Post in Astoria Oregon during the war of 1812. Beaver had been diminished as the century turned and the Industrial Revolution began

to take shape. The Industrial Revolution began using buffalo hides for making belt drives in the machines that were being developed. Astor began recruiting any low life he could muster to collect buffalo hides as other furs became scarce.

Silk became a market competitor for fur in 1831. Shipping paths had been forged to Europe, North and South America, and Africa on all coastlines offering a new fabric of choice around the world. Astor did reverence to no one and encouraged the harvest of buffalo for the hides without regard of the carnage the harvest was causing Native Americans and emigrants who came to the United States in hopes of settling and raising families. There was no law to rein him in and the resonance of the damage remains. Astor had perfect timing for the formation of AFC capturing many of the young men who wanted to get away from the politics engulfing the east coast and like HBC, Astor did keep records of trade and established posts. Next to Hudson Bay Company, AFC kept records of personnel who were licensed and records of trade that transpired at his posts. Regrettably, fire destroyed all records in 1835.

Kenneth McKenzie started the Upper Missouri Outfit with a trading post named Fort Union in 1829. The post was founded near where the settlement of Frazer Montana located and is often confused in historical reporting with Fort Union in North Dakota. The post was financed by John Astor's American Fur Company and run by Kenneth McKenzie who obtained ownership by conversion when he partnered with a group of businessmen in St. Louis. During the winter of 1833-1834 McKenzie traveled to Washington D.C. reporting to Government officials that the British traders were trafficking in liquor. He asked that his company be exempt from the laws that prevented the sale of whiskey to the Indians to compete fairly with the British trappers. His effort did not change the law, so he did what he figured was the next best solution to the problem. He shipped a still from St. Louis to Fort Union and started his own brand of whiskey made from corn raised by Mandan Indians. With all documentation of McKenzie's licensure and affiliation with AFC being destroyed in the fire, McKenzie became the King of the Missouri by both enemy and friend. Fort Union Trading Post Historic Structures Report (Part II) Historical Data Section.

In 1837 a smallpox epidemic hit McKenzie's Fort Union. Inoculations were attempted, but they proved unsuccessful. The Indians were told to stay away, but not trusting the white man's word, they came anyway thus spreading smallpox throughout the region. In the last years of the Civil War General Alfred Sully, with the Sioux Company I, 30th Wisconsin Infantry, garrisoned Fort Union. Sully chose not to use Fort Union as a Post due to the dilapidated condition and small size. United States Government bought and dismantled Fort Union using the material to expand Fort Buford (1829-1866).

The Métis Nation was growing, expanding their hunting and trapping area to the west of Red River Valley and south to the Dakota's and Montana. Because of the diminishing beaver, they had started growing crops. Many of the men were use to traveling, hunting, trapping and exploring and they had developed a food product called pemmican which sustained them on extended explorations and had become popular with all travelers. To carry their pemmican for commercial trade they developed a two-wheeled cart known as the Red River cart. The cart is distinctive in its oak construction, most often pulled by a single ox and driven by a woman. This simple two-wheeled cart could carry a half-ton of pemmican, buffalo hides, and necessary supplies moving approximately 20 miles a day. A group of students at Salish Kootenai College in Pablo, Montana learned the technique of building these carts from George White, (92 in 2004), of Ronan. An article about this endeavor can be found in "*State of the Arts*" September / October 2004 issue.

Métis were selling pemmican to the North West Company trappers even after Miles MacDonnel, the governor of Quebec, had prohibited it in 1814. MacDonnel seized pemmican supplies creating the pemmican war. The Métis Nation was outraged and began burning buildings and fences and attacking farms and homes of non-Métis settlers. These hostilities took place on the north side of the 49th parallel and served to intimidate trappers and traders in the Red River and Hudson Bay areas. Métis had also began hunting buffalo with horses and firearms on the Great Plains in Montana Territory. For centuries, the Great Plains Indians had coaxed herds of buffalo over cliffs and killed injured

survivors harvesting the carcass leaving nothing to waste. The Métis utilized the entire animals they killed, With their wagons and families procuring the meat into pemmican, they began harvesting herds of 150 head in one harvest for their hides where before 25 head had been a large harvest.

There are a small group of Mountains that rest on the border of north central Montana like sentinels on the prairie known as the Sweet Grass Hills. The Indians, Métis, trappers, and traders could view the plains in a 175-mile radius from these mountains searching for buffalo herds. As the encroachment of people continued from east and west the buffalo drifted from the southern plains north in and around the area of the Sweet Grass Hills, east of the Rocky Mountain Front in Montana and north to the southern plains of Alberta, Canada.

Sometime around 1831 Hudson Bay Company sent Henry Fisher on an expedition to negotiate with the Piegan tribe for trade along the 49th Parallel. The negotiations resulted in Old Bow Fort built as a Piegan Trading Post in 1832 near Browning. John E. Harriott was the head of this post which was abandoned in 1834. Harriott was an employee of HBC on an expedition lead by James Jock Bird in 1822-23. Kenneth McKenzie had sent Bird to negotiate with all Blackfoot tribes along the 49th. The Blood's had been trading at a post named Rocky Mountain House. Trappers and traders controlling the commerce at Rocky Mountain House and Piegan Trading post were ex-employees of the Hudson Bay Company or North West Company. Other names associated with these posts were Colin Fraser, Hugh Munroe, and Donald McDonald. When McKenzie began his whiskey trade at Fort Union it affected the Indian trade at these two northern posts bringing disease and drunken Indians who were becoming fearful and warlike. The aggression and disease spread further west to the Flathead Valley and north to Lethbridge and Calgary.

In 1853 A.W. Tinkham, a member of the Stevens Railway Survey Expedition working on Mullan Road, was sent to the Sweet Grass Hills in search of a railroad route from the Mississippi River to the Pacific Ocean. Hugh Monroe functioned as the party's guide. Tinkham wrote this event in his report; "*The old man, Monroe, whom I took with me as*

interpreter in case we fell in with any bands of Blackfeet, was very uneasy during our stay on the Buttes, and hardly seemed to act or breath freely until we were again on the prairies, and with an unobstructed sight. Passing so much of his life among the Indians, he had all their superstitious fears; and recalling every Indian story of combat and murder connected with these mountains, his mind seemed really confused under the superstitious dread which weighed upon him, and he acted with more than ordinary forgetfulness. Riding side by side, his rifle must have been cocked, and the motion discharged the gun, the ball passing into my horse just back of my leg. I was obliged to abandon her on the spot, one of the party after that generally walking by turns."

The uneasy behavior of Hugh Monroe and Tinkhams reference to superstition and murder connected with the Sweet Grass Hills had significant reason. The Buttes or Sweet Grass Hills were considered sacred sites for the Indians because of their abundance of edible flora and fauna and because of the view for siting buffalo herds and other game on the move. There was not a permanent encampment of Indians until the nineteenth century, only spring, summer, and fall tepee encampments for hunting parties evidenced by the many tepee rings throughout the area. When the Tinkham party traveled through, incidents of Indian's and trappers were increasing, many of them ending in deaths. Deciding who was at fault was difficult, but so was figuring out who was killed. Sometimes unidentified graves were found, and no witnesses came forth to relay an account of what had happened.

When the British captured Astoria, Oregon Territory, during the war of 1812 it put the boundary question back in to play as "the British" were also considered members of Hudson Bay Company according to the Peace of Utrecht. Treaties of 1814 and 1818 were made after the Lewis and Clark expedition and traced the International Boundary line to the "Lake of the Woods", it having been discovered that the headwaters of the Mississippi named as the western limit in the Treaty of Peace in 1783, lay south and west of the lake. For continuance of the boundary westward the earlier suggestion of the 49th parallel of latitude was adopted. The exact geography of the lake being unknown, the Treaty makers specified that from *"the most northwestern point of*

the lake" the line should be drawn *"due north or south as the case may be"* to the intersection of the 49^{th} *parallel, and then west "along with it to the Snowy Mountains."* These points were finally settled in the Webster-Ash Burton Treaty of 1842. Beyond the Mountains the land was left in joint occupation until the treaty of 1846 which settled the Oregon question and fixed the boundary again at *"49° north as far as the Strait of Georgia."* There remained the matter of having the designated line surveyed.

Until the International Boundary was surveyed and marked, the Sweet Grass Hills and the Cypress Hills were part of the Métis and Blackfoot Nations. The following story is found on an informational flyer, *"Hills Happenings"* Edition 5:

"The Métis nation took in the Sweet Grass Hills in the U.S., and the Cypress Hills in Alberta, Canada. Henry Dumont was an early settler in Elk River, Canada. He was a Métis buffalo hunter who came to Montana to work as a contractor moving dirt for the Great Northern Railroad when game depleted in the Cypress Hills. The railroad was under construction from Havre to Chester. Mr. Dumont reported that he stayed at a Metis settlement in the Sweet Grass Hills during the winter and cut railroad ties by hand. The Metis from the Elk River area are a mixture of Native and French Catholics who migrated from the Métis settlement along the Red River in Manitoba."

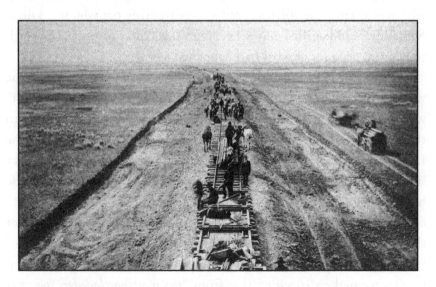

Photograph by Chas E. Morris taken August 11, 1887 on the stretch of track between Havre to Shelby. On this day a world record was set of eight and two-thirds miles laid in a single day. James J. Hill worked with his men through the clouds of mosquitoes in the heat of summer and the snow and sleet of winter sometimes sending one of his gandy dancers to coffee as he took the "stiff's" shovel and began "working on the railroad" himself. Construction crews were as many as 8,000 men and 3,300 teams for grading. Laying the track and building bridges employed another 225 teams and 650 men. Jim Turner, a rancher along the Marias and later from the Sweet Grass Hills, provided the meat for this crew while the men laid the track between Chester to Shelby. This influx of working men and the need for water stations for the steam locomotives every 10 miles was the main impetus for a small town every ten miles along Highway #2 known as the Hi-Line.

James Monroe was president from March 4, 1817 to March 4, 1825. Monroe had helped Robert R. Livingston negotiate the Louisiana purchase and was said to be: *"so honest that if you turned his soul inside out there would not be a spot on it."* The beginning of his term found Missouri Territory in economic depression following the Revolution. The people applied for admission to the Union as a slave state likely to have realized that the large plantation owners had no idea of how to work the land. Their application failed in 1819 so an amended bill for gradually ending slavery in Missouri precipitated two years of bitter debate in Congress. The Missouri Compromise bill resolved the struggle, pairing Missouri as a slave state with Maine a free state. Slavery was barred north and west of Missouri forever.

Spain had not yet ceded the Florida's to the United States. Monroe, with the help of his Secretary of State, John Quincy Adams, carried out Spanish secession in 1824. There was still the problem of property along the Pacific coast and James Monroe warned Russia that they must not encroach southward " ...*the American continents.*" He said, *"by the free and independent condition which they have assumed and maintain are henceforth not to be considered as subjects for future colonization's by **any** European Power.*" This became known as the **Monroe Doctrine** twenty

years later. Monroe died in 1831, one year after his wife and First Lady, Elizabeth Kortright Monroe died September 23, 1830.

Elizabeth married James in February of 1786 when she was 17. She was born in New York City. Her father, Lawrence Kortright, was the commander of an armed private ship commissioned to cruise against the commerce or warships of an enemy. He served the Crown but took no active part in the War of Independence. Elizabeth was beautiful and charming, n 1794 she went with her husband to France during the midst of the French Revolution. With only her servants accompanying, Elizabeth Monroe went to the prison where Marie Lafayette was imprisoned waiting her execution by guillotine and asked to visit Marie. Following Elizabeth Monroe's prison visit, the French released Marie Lafayette with no explanation. It was assumed that the interest of the American called for the prisoner's release. The French called Elizabeth "*la belle Americaine*". Marie's husband, Gilbert du Motier, Marquis de Lafayette, was also imprisoned at the time in the Austrian Netherlands. Lafayette had tried to steer a middle course in the French Revolution, but a radical faction ordered his arrest and he fled and was captured by Austrian troops. That was in August of 1792. In 1797 Napoleon secured his release.

Elizabeth and James Monroe had three children, two daughters and one son who died as an infant. One of their daughters, Maria, was married in the White House. Elizabeth Monroe's hostess style was far less elaborate than her predecessor, Dolly Madison. Dolly was said to have a rather expansive Virginia social style while Elizabeth followed her roots with New York style.

Records from Hudson Bay Company have given sketchy reports that around 1815-1820 Hugh Monroe was the first white man reported to have entered the Sweet Grass Hills. Known as **Rising Wolf** by the Piegan Indians, Hugh Monroe married a Piegan Indian Princess. This began sketchy reports, written and verbal, of the Piegan Indians in the Sweet Grass Hills. The marriage angered some and befriended others, but whatever the sentiment, it gave Hugh Monroe the opportunity to gain experience with the Native language and become a powerful trapper and guide for this little traveled area.

1831, the year Monroe died, is the year Hudson Bay Company sent Henry Fisher on an expedition to negotiate with the Piegan tribe for trade along the 49th Parallel. Old Bow Fort was built near Browning in 1832 as a Piegan Trading Post. John E. Harriott had been with James Jock Bird in 1822-1823; sent by HBC Kenneth McKenzie to negotiate with all Blackfoot tribes along the 49th parallel. The Blood Indians had been trading at a post named Rocky Mountain House, the same post near Calgary, Alberta, Canada that David Thompson had traveled to in 1806 on his expedition west in search of a passage to the Pacific for NWC. By the time Bird arrived at Rocky Mountain House both NWC and HBC ex-employees oversaw the post. Other names associated with these three early posts were Colin Fraser, Hugh Munroe, and Donald McDonald.

Fort Piegan, Fort McKenzie, and Ophir Post were located near Loma. Fort Lewis located near Fort Benton in 1843 and was moved in 1845 then renamed Fort Benton in 1846. Fort Campbell and Fort La Barge were also found near Fort Benton and owned by the American Fur Company. While these trading posts and forts were springing up, a transportation corridor known as *"The Oregon Trail"* became active from 1841 until 1846. The Oregon Trail started near Kansas City Missouri and ended in Seaside Oregon following the Platt and Snake rivers west to the mouth of the Columbia river.

In 1848 an outpost was established at Willow Rounds on the Marias River with Hammel in charge. Willow Rounds was north of Fort Conrad. A trail marked *"To Abbott's"* on an 1888 reconnaissance map sketched of the Sweet Grass Hills references a calvary route that follows the water drainage of Willow Creek. The mouth of this small creek enters the north shoreline of the Marias River with the head on the southeast side of West Butte flowing south. It was this creek that Captain Lewis journaled July 19, 1806; *"at 15 miles we passed a large creek on N side a little above its entrance; there is but little running water in this creek at present, its bed is about 30 yards wide and appears to come from the broken Mountains, so called from their ragged and irregular shape there are three of them extending from east to west almost unconnected, the center mountain terminates in a conic spire and is that which I have called*

the tower mountain. They are destitute of timber. From the entrance of this creek they bore N 10° W."

From his vantage point July 19, 1806, Captain Lewis was not able to see the jagged tops of the evergreens on West Butte. The Indians called the Butte "Hairy Cap" due to the appearance of the mountain top from the Rocky Mountains looking northeast. In the book, "<u>Floating on the Missouri 1859-1947</u>", James Willard Schultz has a map of the Missouri from Loma to Coal Banks landing. It shows a mountain on the south east side of the Little Rocky Mountains called "Hairy Cap". Creeks, mountains, and other geographic landmarks often carry non-exclusive names. Haystack Butte in the Sweet Grass Hills is an example. Although identified as Haystack Butte in most writings, photographs, and maps, this Butte is called "Sharks Tooth Butte" on an 1888 calvary reconnaissance map.

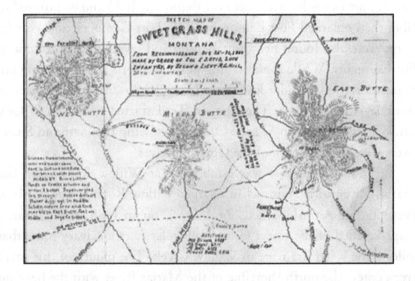

This point of entry of Willow Creek is on the north bank of the Marias. Willow Rounds was up-river on the south bank of the Marias between Sullivan bridge and Valier. Sol Abbott settled near Willow Rounds where he built a large log house. Henry Powell ran the trading post on the south bank across from the mouth of Willow Creek on the Marias. Powell and Abbott were the first white men known to run cattle along the Marias. Abbott collaborated with the Indians and I.G.

Baker keeping goods to trade for furs along "Healy Trail" later known as Whoop-up Trail. This was known as the Marias Post.

These two men partnered in cattle ranching filing adjacent desert land claims with Homestead Certificates issued through the Act of Congress of April 24, 1820. This Act was later replaced, but for a period of time it was not required that the claimant live on the land, only that they prove it up by showing an attempt to irrigate a portion of the filing. Filing along a river made this caveat easy to comply to. Many of the single men who filed such claims had their sisters or aunts file claims next to theirs expanding their ownership then they would prove it up. Once inspected and approved the land would be transferred to full ownership. Once transferred the owners would merge or sell.

Sol Abbott was of scotch ancestry, originally from Missouri. He had an Indian wife named Nancy. Indians knew Sol as *Osema* which means *Son-of-the-Sun* because of his bright red hair. Others knew him as Sorrel Horse (Sol) because he only kept sorrel horses for working his cattle carrying his LA brand. He was respected by the Indians, military, and traders in the Marias River valley as he maintained a peaceful relationship with the Blackfeet giving them permission to butcher his beef when needed. Young braves had attempted to kill Abbott and failed. They had seen him shot and knew that he had at least two musket balls in his body. Their superstition led them to believe he could not be killed. As a private man who tended to his business along the Whoop-up Trail, he was well known and respected by all.

Solomon Abbott died from two one-ounce musket balls that had entered his chest and worked their way to his spinal column killing him in 1895. He was buried on his ranch. Solomon and Nancy Abbott had two children: Nellie Maggie and one son. Henry Powell took over the trade post along the Trail. Powell's ranch was about a mile down River from Abbott's. Other early names of settlers adjacent to Abbott and Powell were James Martin, Dan Sullivan, and William Upham.

Rivet's Post and Fort Peck were both built in 1867, the same year of the Montana Sioux Wars. Fort Galpin was a trading post on the Missouri, 10 miles from the Milk River, built in 1862. Fort Sherman, Reed's Fort, Camp Lewis, and Juneau's Post were all located near Lewistown in the

1770's. Forts Claggett, Chadron, and Camp Cooke were found near the mouth of the Judith river. In 1871 the Northwest Fur Company established Fort Belknap and Fort Belknap Indian Agency located 30 miles east. Chinook is where the original Fort Belknap was. Towns people reused the materials to build their homes when the posts and forts were dismantled.

Forts were being built along the Missouri river to accommodate the shipment of furs east and for supply depots and protection of the steamboats coming upriver. In 1860 the first steamboat, Chippewa, arrived in Fort Benton. When the steamboat arrived the first Homestead Act had not been enacted. The Donation Land Claim Act allowed settlers to claim land in Oregon Territory which was a portion of the western part of Montana. This Act allowed settlers to claim 320 or 640 acres of free land between 1850 and 1854. Additional acres could then be purchased at a cost of $1.25 per acre until the law expired in 1855. This was one of the reasons early stock ranches, mainly sheep, were in Beaverhead, Ravalli, Deer Lodge, Mineral and Lincoln Counties. The Homestead Act was passed in 1862 opening all of Montana Territory to 360-acre free land claims. This increased steamboat commerce as the Indians became increasingly warlike. The boundary between Montana and Canada still lay in question of ownership and governance.

President Grant addressed the boundary problems in his annual message to Congress dated December 5, 1870:

"In April last, while engaged in locating a military reservation near Pembina, a corps of engineers discovered that the commonly-received boundary-line between the United States and the British possessions at that place is about forty-seven hundred feet south of the true position of the forty-ninth parallel, and that the line when run on what is now supposed to be the true position of the forty-ninth parallel, would leave the fort of the Hudson Bay Company, at Pembina, within the territory of the United States. This information being communicated to the British Government, I was requested to consent, and did consent, that the British occupation of the fort of the Hudson Bay Company should continue for the present. I deem it important, however, that this part of the boundary-line should be definitely fixed by a joint commission of the two governments, and I

submit herewith estimates of the expense of such a commission on the part of the United States, and recommend that an appropriation be made for that purpose. The land- boundary has already been fixed and marked from the summit of the Rocky Mountains to the Georgian Bay. It should now be in like manner marked from the Lake of the Woods to the summit of the Rocky Mountains."

The act of appropriation authorizing the survey was approved March 19, 1872. None of Montana Territory was surveyed before 1874. Creation of the United States Geological Commission happened in 1879. The United States commission attached the following as engineer officers; Major F.U. Farquhar, chief astronomer, Captain W.J. Twining, Captain J.F. Gregory, Lieutenant F.V. Greene, and Archibald Campbell. Major Twining and Archibald Campbell represented Canada and Great Britain. It was agreed that the parties would make topographical maps in a series on a scale of one inch to two miles. It was also an agreement to plant iron monuments along the southern border of Manitoba at intervals of one mile. West of Manitoba, what is now Alberta, there would be stone pyramids at intervals of approximate three miles to the Summit of the Rocky Mountains.

In October of 1871, Abe Farwell, proprietor of a trading post in the Cypress Hills, found that a Canadian from Red River had located a competitive post on the south side of the 49th parallel near the Sweet Grass Hills not far from his Canadian post. Mr. Farwell reported this mistaken merchant to the U.S. Army which prompted the Army to close the post and arrest John Kerler the proprietor. The Army had been ordered to stop whisky trade across the border, both north and south, with traders and Indians. John Kerler was reported to have been trading in intoxicants along with furs and other goods.

Tom Hardwick (also known as the Green River Renegade) had migrated to the Sweet Grass Hills in the winter of 1871 – 1872. Hardwick had served in the Confederate army and came to Montana in 1864 prospecting for gold. He did not have any luck mining and became a fur trapper and trader collaborating with half-breed(s) from various Indian tribes. Better known as a *'wolfer'*, Hardwick sold whisky to the Indians and trapped wolves by poisoning buffalo carcasses. Isaac

Dawson was one of the wolfers with Hardwick in the Sweet Grass Hills during the winter of 71-72. Mr. Dawson kept a diary and recounted this event. The diary was made available to the Helena Weekly Herald who published the account of the Sweet Grass Hills Massacre in the April 25, 1872 edition. This is part of the Dawson diary account of the Sweet Grass Hills Massacre reprinted in the _Montana_ magazine Volume Seven, Number Two, April 1957, page 16: "*Some of the half-breeds then started to ascertain what Indians they were, and what they wanted. After a very short exchange of words they made themselves known as Northern Piegans or Bloods. Soon after, the half-breeds started back, at the same time warning the Indians to leave Just as they started, a man named Thomas Hardwick opened fire on them, which resulted in a precipitate retreat in all directions.*" The Indians returned about two hours later with an entourage of forty to fifty warriors. "*They approached in a solid body two in the lead bearing defiantly their standard. The half-breeds again passed themselves in the lead as Mediators, and when the Indians approached within 200 yards of our forces they were told to go back, or the men would shoot. Regardless of the warning, they pressed forward, which at once called forth the war-notes of many a Winchester and needle gun. The tally of the fight was called, four departed braves were numbered on the field, and at least ten were known to have been wounded but escaped to the mountains.*"

This became known as the Battle of 1872 or the Sweet Grass Hills Massacre. A.J. Simmons was the U.S. Government Indian Agent for the upper Milk River country. As Indian Agent Mr. Simmons had to sort out these confrontations to find which tribes or traders were instigators and what damage occurred. The Dawson diary identified the Indians as Piegans or Bloods, however, it was learned that the Indians were Assiniboine's and had offered no outward hostility when Tom Hardwick fired the first shot.

This incident and the Cypress Hills Massacre July 11, 1873, prompted the Canadian Government to organize the North-West Mounted Police by an Order in Council August 30, 1873. This same year a giant fire burned across southern Alberta and into the Sweet Grass Hills. This fire drove the Canadian herd of buffalo across the

invisible boundary and they never returned to Canada. The fire resulted in the starvation of thousands of Blackfeet the following winter.

The International Boundary Survey directly north of the Sweet Grass Hills was conducted during the summer of 1874 under Captain W.J. Twining and Commissioner Archibald Campbell. Major Twining worked along the 49th parallel from Montana and Dakota while Commissioner Campbell moved supplies from Fort Buford to the Sweet Grass Hills. Following the Missouri River, he traveled 17 days accompanied by an escort of five companies' infantry escort, and two companies of Cavalry since they were traveling through Blackfoot Indian country. They reached the Cavalry camp near the SGH's just above Hill Post Office on August 2, 1874. It was reported that the party appreciated *"the delicious, cold, spring water"* found there. Leaving the calvary Camp, they traveled to Major Twinning's camp just north of West Butte; a distance of 30 miles. The survey had reached this point and was completed to the summit of the Rockies by the end of August 1874. Stone pyramids were placed at intervals of three miles for markers in 1874. Iron posts were set in 1908.

A creek flowing from East Butte to the Milk River is named Half-Breed Creek because of the number of tenants of French-Canadian and Blackfoot decent who homesteaded along the banks of the creek. These were the first residents to begin farming and ranching in and around the Sweet Grass Hills. The trappers who married Indian women were called Squaw Men and the children of these marriages became known as half-breeds.

In 1887 North West Mounted Police set up Writing on Stone camp on the Milk River directly north of the West Butte calvary camp. There had been a *'police'* camp at the location for several years, but a barracks, stable, and corrals were built when the Mounties were formed. Until the U.S. Custom Patrol was organized in July of 1926 there was no supervision of commerce like liquor, livestock, and wool being transported either direction of the invisible boundary. The small U.S. Calvary camp noted as *"Camp Otis"* was the only military support for hundreds of miles on the U.S. side. This tent encampment was needed by the military as a point of surveillance and supply for the United States

as was Writing on Stone camp in Canada collectively. The situation was bleak for settlers until the Sweet Grass Hills transferred ownership from the Indians to the U.S. Government in 1888.

Milk River sachets in and out of Montana on its way to Nashua where it meets with the Mighty Mo at Fort Peck. There are small lakes, creeks, and artesian springs that begin their journey to the Milk River from the Sweet Grass Hills. Some early settlers thought the Milk River would be the boundary for Canada and United States and settled in the area south of the Milk River, but north of the 49th Parallel. They were sadly disappointed that they were not U.S. citizens, nor were they able to engage in commerce freely between the two countries. There is still a forty-foot-wide strip known as *'no man's land'* between the two countries that remains making the stone and metal markers along the boundary freely penetrated by wildlife, livestock, and an occasional stray dog.

Montana Magazine published a story written by Hal G. Stearns, published in 1982. It's an account of Trevanian Hale, his tombstone, and the beginning of his end at the Cypress Hills Massacre. The graveyard in the center of Harlowtown Country Club is where Trevanian Hale rests. He died April 11, 1907.

"His obituary in the Musselshell News referred to him as a respected citizen. He was born in Oskaloosa, Iowa March 1, 1838 and at the age of 15 went to Salt Lake City, Utah, Colorado, Alder Gulch (now Helena) and Fort Benton. Here he engaged in trading with the Indians.

In 1874 he became sheriff of Choteau County for three terms, was deputy sheriff in Yellowstone Park, then lived at Castle, an early silver mining camp and came to Harlowtown in 1900 when the railroad arrived.

He also was credited with having engaged in many skirmishes with the Indians and was a volunteer opposing the Nez Perce at Cow Island on the Missouri in 1877."

Trevanian Hale married Clemas Doney at Fort Benton June 25, 1873. Together they had eight children. The obituary went on to say he was *"a kind loving father, a true friend, devoted husband and known for his many good deeds"*. Clemas Doney and Trevanian Hale had 34 years of marriage before he died. Rather striking is the fact that one year

following the Cypress Hills Massacre, Hale served Choteau County as sheriff – for three terms. He was married later the same month this event occurred. He would have been sheriff when the hearing was held in Helena two years later. Following his service as sheriff he was appointed deputy sheriff of Yellowstone National Park. After his term as deputy sheriff he lived at Castle, an early silver mining camp. He moved to Harlowton in 1900 when the railroad arrived.

Cypress Hills Massacre took place June 1, 1873. Hal G. Stearns accounting of this event involved a dozen, (perhaps 16) men, three were Americans: Trevanian Hale, John H. Evans, and a former Montana sheriff, Tom Hardwick. It was charged that these 'wolfers' *"were headed for Fort Benton from the Bear Paw Mountains. Indians from the north stole their horses and the whites set out afoot for Fort Benton. Here they obtained horses and pursued the Indians."*

In his telling of the Cypress Hills Massacre, *"on reaching the Canadian line they found a camp of Cree near Farwell's trading post in the Cypress Hills. The Cree were led by Chief Little Mountain."*

Abe Farwell was married to Crow Mary, a full blood Indian woman. There were some famed half-breeds at the post that night. *"J.M. Arnoux, Club Foot Tony, and a Cree named Alexis de la Bompard."* The wolfers concealed themselves around the Indian Camp surrounding Farwell's Post. When the Cree began stirring in the early morning and left their tents to get water the wolfers began firing on the encampment. By mid-morning 200 Cree, men, women, and children, had been slaughtered.

There were excessive hostilities directed at the Indians and Half-breeds from 1850 to 1900. Exacerbating the economic changes was the absence of defined boundaries and authority. Adding fuel to the fury, the railroad was progressing west at a remarkable rate despite the industries difficulties. The three Americans known to have taken part in the Cypress Hills Massacre were given a hearing in Helena two years after the event. *"The hearing was conducted by Colonel Wilbur F. Sanders, Lt. Col. J.F. MacLeod of the Mounted Police, and Major A.G. Irvine, Assistant Commissioner."* The Clerk at the hearing was Col. James Stanford, *"a former Mounted Policeman. Many Montanans believed there*

was no doubt concerning the guilt of the accused, but so bitter was the feeling against the Indians at that time, that any act would have been excused."

Trevanian Hale, John H. Evans, and Tom Hardwick were released, and the citizens of Helena celebrated in the streets getting totally drunk and setting bonfires in celebration. *"Three others arrested in Canada and tried in Winnipeg were subsequently freed because of the Helena trial's outcome."*

Fort Walsh was established in 1875. Its location is in the West Block of the Cypress Hills where Farwell's *"Whiskey Trading Post"* was found. The National Historic Site brochure of Fort Walsh says the Lakota tribe of Indians were murdered by wolf hunters and whiskey traders in 1873 at Farwell's Post. Whoever and whatever is the true story of the Cypress Hills Massacre, it is agreed that this incident directly resulted in the formation of the North West Mounted Police.

In 1876, Lt. Colonel (formerly Brigadier General) George Custer and his 255 soldiers were killed, by Sioux and Cheyenne Indians led by Crazy Horse and Sitting Bull, at the battle of the Little Bighorn. The Sioux and Cheyenne were defeated in 1877. The same year the Sioux and Cheyenne were defeated the Nez Perce, led by Chief Joseph, surrendered at the Bear Paw battlefield near Chinook and Fort Assiniboine was built near Havre. The Indians watched from the Bears Paw Mountains as the fort was constructed. They said it was built so fast it literally grew out of the ground in a few days. Because of all the Indian confrontations at the time the Fort was completed, the groundbreaking ceremony didn't take place until May 9, 1879. Little Poplar, a Cree Indian chief, had led some of his weakened and angry tribe across the border of North Dakota into Montana. Colonel Otis was sent a telegraph recommending that he *"keep a sharp lookout for Chief Little Poplar"*. This was the first telegraph to reach the northwest and held the attention of the United States politicians and public because of the relatively new means of communication. Chief Little Poplar was killed by a half-breed named James Ward and the telegraph delivered the message to the Nation's Capital the same day.

Colonel Otis was promoted to major-General Otis while at Fort Assiniboine and to General, and later he was appointed Military

governor of the Philippines. John J. Pershing served the regular army as lieutenant at Fort Assiniboine and was often met by locals riding between the two military camps in the Sweet Grass Hills. General Nelson Miles was in command when the Nez Perce were captured in the Bears Paw Mountains. Colonel E.S. Otis and Colonel Miles were the commanders who led the defeat of Sitting Bull and Crazy Horse. Major Marcus A. Reno commanded two troops of the 7th Cavalry and five companies of the 6th Infantry to the Sweet Grass Hills camps following the Battle of the Little Big Horn.

Pershing's most important assignment during his several years' sojourn in Montana was the removal of fugitive Cree Indians who had participated in the second Riel rebellion and had fled across the boundary when the rebellion was put down. It was the job of a diplomat rather than that of a soldier. Louis Riel, rebel against British authority and leader of the Métis, had been stood against a dead wall at Winnipeg and shot. These Cree thought a similar fate awaited them when they were turned over to the Royal Northwest Mounted police. Pershing spoke to them assuring them on behalf of the Great Father at Washington and the Great Mother of Canada that full and free pardon awaited them. He finally persuaded the Cree to leave and escorted them to the border where he turned them over to the Canadian authorities.

California Gold Rush (1848-1855) and the Civil War (1861-1865) would seemingly be two events that would have nothing in common, but that is not the case. Both brought devastation and progress to the United States at once leaving hundreds of people displaced and disparaged. It begs the question; *Is it freedom or riches that humans seek, and can we have both collectively?* California saw more than 300,000 people flood into the Territory from all directions. Most came without money and the obvious, they came to an undeveloped and unmapped landscape. The men with picks and shovels. The women with wares to set up a kitchen and hopes of finding a place where they could 'nest'. History has shown that men weren't always the hunter gathers. Originally that was 'women's' work. That women's work became the skill making the difference between survive or perish in the perilous atmosphere of gold fever.

California became a State September 9, 1850. In hopes of gaining some sort of taxable income from this enormous influx of people, the government formed so they could subject the marauders to a tax. This unsettled country needed money, or gold, to proceed. Like ANB monies for public education, this process of collection never seems to occur until two years after the need arises. By that time, the people have moved, and the numbers have changed. Like flies on a cow pie, once the nutrients are harvested it is on to the next pie. The 37th Congress, at President Abraham Lincolns urging, passed the Pacific Railroad Acts in 1862 hoping to have enough money to issue government bonds and land grants to railroad companies for construction of a transcontinental transportation corridor. Still not having recovered or organized following the Revolutionary War, the enthusiasm to proceed developing the interior of North America was undeterred. Ahh, if the money could be raised, who would do the work? Before those questions were answered, another economic blow occurred, the Civil War.

The Civil War realized the deaths of 620,000 humans with millions more injured and southern United States was left in ruins. Many of the young men who had headed to California in search of gold headed back east to help their families preserve what was of their farms and businesses. Once again women were left tending to children and figuring out how to survive as the country around them was raped and pillaged into wreck and ruin. In the middle of the devolution the leader of the free world was shot and killed. Abraham Lincoln was assassinated April 15, 1865. As the rest of the nation wreaked havoc over the riches and properties that were new to the immigrants, the Native Americans, primarily the Indians, watched and struggled to find a niche where they could survive as a culture. This group of Americans were experiencing their fourth or more generation of encounters with peoples from outside North America. They were realizing a surge of these migrants into their once sparsely populated lands. It had to be at first curious, then inquisitive, then intrusive, then offensively foreboding. Even more so when the new arrivals became offended of the Native Americans culture. Once permeating the continent, they began bringing new species of homo sapiens to the continent to serve them and have them adapt

surroundings to suite '*their*' needs. Quite a novel approach to the Native Americans who were territorial and survived on what was available for sustenance. Obviously the lower witted and shellfish of these intruders needed an equalizer to hold their own in this battle of wits, so they introduced liquor to the natives and '*voila*', eminent domain.

Through the gold fields and battlefields, the railroads were forthcoming. With picks, shovels, and sledgehammers putting every man who wanted work, board, and a paycheck to task bringing in foreigners' when needed to fill the gap. The tools and equipment were rudimentary, but so were the materials. It was formidable! Leaving a trail of tent cities and tacked together shacks in its 40-foot right-of-way wake, the iron horse trail moving east to west and west to east collided at Promontory, Utah territory. Thirty-two miles west of Brigham in Box Elder County, Utah, May 10, 1869, the Central Pacific and Union Pacific Railroads connected seaming their iron tracks together at this desert summit. It was the beginning of a faster, accessible, convenient, commerce route transcontinental. James Tufts was the acting Governor of Montana Territory on that eventful day. He sent a telegraph message to President Leland Stanford of Central Pacific and Vice President Thomas C. Durant of Union Pacific Railroads from his office at Virginia City:

"*Montana rejoices at the completion of the great Continental thoroughfare and bides her time for an early connection with it.*"

Prior to the Utah & Northern Railway connecting Utah to Dillon, Montana, the route of choice to get to here from there was the Stansbury trail. This well-established trail led through Utah north to Idaho Falls, up the Snake River by Camas Creek to Beaver Canyon, over Monida Pass into Montana, down Red Rock Creek to Deer Lodge or Virginia City, then to Helena. There are winding two lane highways that can take you thru most of this scenic, mountainous teraine with creeks and rivers flowing soothingly along the roadway. A pleasant drive if you are not in a hurry. A hazardous hike, float, or horseback ride. This would not be the trail that Kid Russell traveled with Pike Miller. There was a stage route going straight north as the crow flies from Dillon, when the pair departed the Utah & Northern train and headed to Helena. It was

also winding and weary, but beautiful and void of intrusive traffic or metropolitan areas along the way. There is not a lot written about or by Charles Marion Russell of his journey with Pike Miller from St Louis to Montana until they arrive in Helena. At sixteen he was probably wide eyed and full of wonderment. In his mind's eye he was on his way; to where was yet to be discovered.

CHAPTER 9

MORE POWER

The jury is still out whether powerful men are stubborn or are they powerful because they have the facts. Facts are stubborn things and for James J. Hill to get his rail line across Montana and on to Seattle he had a few facts to overcome. Since he had bought a failing Railroad in St Paul, he was entitled to the benefits that were written into the agreement. You might say he reached the end of the line in Minot, North Dakota and had to reconnoiter. By 1887 Paris Gibson had introduced Jim Hill to the Great Falls on the Missouri and all the potential they held for the River and beyond. After receiving 'script' to assist with preliminary land purchase and platting of a city, Paris Gibson invited James Hill to view the actual falls and the surrounding land so that he might outline his plan on a broader vision.

Gibson had his son, Theodore, greet Hill in Fort Benton where Jim Hill would be departing a Steamboat. From Fort Benton to Great Falls, Gibson had arranged numerous stage changes to hustle Hill to the Falls while there was still daylight to see some of the area in the valley where the falls stand on the Missouri and then turn southwest with a view across the green valley. After a view of the falls, they would travel to the Sun River confluence meeting the Missouri at the base of Prospect Hill. From the point just below the mouth of Sun River they would turn west. The glorious Montana sunset would light their way to Paris Gibson's tent home in Sun River where John Wood had prepared an exquisite meal for the particularly important party.

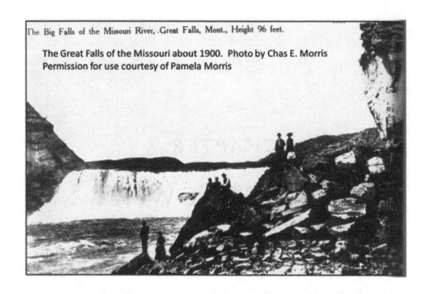

The Big Falls of the Missouri River, Great Falls, Mont., Height 96 feet.

The Great Falls of the Missouri about 1900. Photo by Chas E. Morris
Permission for use courtesy of Pamela Morris

It worked! Paris Gibson wrote; "*It was evident that what Mr. Hill had seen during the day had made a deep impression on his mind for, while standing on a spot about 50 feet away from my tent this man of wonderful perception and of broad vision outlined to me a plan for the extension of the Great Northern Railway,* (then called the St. Paul, Minneapolis and Manitoba Railway), *westward from the Red River valley to Great Falls and assured me that this great work would at once be undertaken and would be pushed forward to completion in a shorter time than any trunk road on the continent had ever been built.*" James Jerome Hill could deliver as promised as the SPM&MRR had already made its way to Winnipeg, Manitoba, Canada and would continue west to Lethbridge, Alberta, Canada while waiting for the U.S. paperwork to be finished. As soon as possible the railroad would head south to the border at Sweetgrass then on to Shelby and Great Falls.

This wayside trip south to see Paris Gibson was but a hiccup in James Hill's itinerary at that time. He had to deal with Montana being a territory, a pass across the Rockies that had not been surveyed, and he needed an act of congress to obtain the right-of-way through the Indian reservation in Northern Montana. The rail line straight south of Lethbridge to Great Falls skirted the Indian reservations that, with a little creative planning, made it possible. Paris Gibson had a craft that

allowed him to get things done, most often, his way. He did not micro-manage people and he put a good team together. Like the management style of Jack Welch, the CEO of General Electric Transportation System (GETS), from1981 to 2001. Jack Welch died March 1, 2020.

Paris Gibson thought the world of Jim Hill. Paris wrote, *"This great plan for railway extension seemed to proceed, fully matured, from the brain of this remarkable man as we stood near the head of the rapids that mark the beginning of the falls of the Missouri. I need not state that these prophetic words were fulfilled, almost to the letter. It has ever been my belief since this eventful day when Mr. Hill saw, for the first time, the falls of the Missouri and their rich surroundings, that no other capitalist and railway builder in the world could have so comprehended at a glance, as he did, the resources and the possibilities of this great Rocky Mountain region and that, had he been able to do so, would have dared, at this early date in the history of the Far West, to build a railway line through a trackless wilderness, composed largely of Indian Reservations. Let it also be understood that, in extending his railway line into this unsettled country, he was paralleling the Northern Pacific Railway that had been heavily endowed by the National Government while his projected line was to be built without the aid of a dollar from the Federal Government. Among the great achievements of our country in railway building, this extension of the Great Northern road to the falls of the Missouri, in North Central Montana, easily stands as the first. Additional interest attaches to this achievement, when we consider that this road was so managed that it did not fall, at that time, nor has it ever since fallen, into the hands of a receiver."* (Conrad papers, Paris Gibson.)

Paris Gibson's centerpiece, Paris Gibson Square Museum of Art at 1400 1ˢᵗ Ave. N, and Paris Gibson Education Center at 2400 Central Ave. in Great Falls was completed in October of 1896. The building originally had a clock tower that was removed before 1906 because the structure of the building was not strong enough to support the weight of the tower. Sunday February 15, 1976 the Great Falls Tribune ran an article by John Barber showing a picture of the building with the tower before it was removed. This building was a Junior High School when it was first constructed. As with all thing's city and other government,

it wasn't a simple matter of owning the property and constructing a building on the property, controversy pursued. An investigation as to *"whether the school was built to specifications was laid out by the school Board"*. There were also reports of collusion between the architect and contractor defrauding the school district of thousands of dollars. The building had a swimming pool that was deemed unsafe and the space was refurbished to use for storage. Cleverly placed, Paris Gibson and his contribution to Cascade County and the City of Great Falls will long assure his presence will not be forgotten however financed.

James Hill had the Fort Assiniboine military reservation south of Havre right-of-way surveyed and certified by the Congress by December 10, 1886. Hill wasted no time in turning south at Havre with his rail line heading for the head navigation system on the Missouri. The bustling shipping center for steamboats coming up from St. Louis and freight wagons loaded for mining camps, Fort Benton saw a rail line completed September 29, 1887. James J. Hill drove the silver spike for the Empire Builder, Great Northern rail line. Mrs. Mary Theresa Mehegan Hill was at the ceremony with her husband and presented the silver spike to Mayor Jere Sullivan saying, *"Mr. Mayor, here is a memento of this occasion for the City of Fort Benton."* In the April 3, 1955 edition of the Great Falls Tribune, Mrs. L. K. Devlin of Havre reported that she had *"witnessed the driving of the silver spike by Jim Hill in 1887"*. Mrs. Devlin (Laura Lepper Devlin) said the family drove from Havre in a spring wagon. *"I'll never forget the day because where the crowd had gathered, a man was selling watermelons from a wagonload he had driven to town from some point in the Missouri Valley. My father bought a melon and we children feasted. That was the highlight of the big celebration for us."* **Laura Lepper Devlin** in an interview for the River Press.

Whether James Hill saw the Grand Union Hotel in 1883 on his visit to see Paris Gibson or Mary Hill toured the Grand Union on this historical visit to Fort Benton in 1887, the Hill's had a home constructed in St. Paul on a hill overlooking the Mississippi with many features of the interior of that home resembling the interior of the Grand Union. It is a great credit to the owners and community of this historic relic that the integrity and story of this beautiful piece of old west architecture

has been preserved, restored, and well-kept since its opening November 1, 1882. John David Ellingsen's 1971 masters-degree thesis at Montana State University centered on the Grand Union. He documented the existence of the hotel's main-floor room known as the "*saddle room*". This room was for cowboys who needed a place to stay over the winter and did not have money to pay room-rent. They could turn their saddles in and have a room until spring. Their rancher-employers could redeem the saddles and put the cowboys back to work if they were still around. This allowed cowboys their cash on hand to spend in Fort Benton as they were assured, they would have a place to sleep for the winter. Good marketing plan.

Paris Gibson said that Jim Hill had given him '*script*' when he went to Minneapolis in 1881. This currency was first introduced by President Andrew Johnson in hopes of improving the economy. Ulysses S. Grant supported the theory that money should be backed by physical gold. The *script* issued was given a greater value than the greenback dollar and eventually led to the collapse of the U.S. gold market September 24, 1869. The event was known as Black Friday and was found to have been a stock fraud and bribery scandal initiated by Jay Gould and Jim Fisk. Because the currency had been issued by the government, when the scandal was exposed the railroads that were financed with Government backing ceased to progress. This slowed the progress of the transcontinental rail line. The script had a value, and because of Hills involvement in transportation of goods during the Civil War, he was holding a bundle. This is the currency Paris Gibson used to begin building the City of Great Falls.

For his part in the Black Friday debacle, Jay Gould was scarcely affected. Within five years he controlled the UP Railroad and soon after Western Union Telegraph Company and the Manhattan Elevated Railroad. Gould's partner in the fraud scandal led him to a shortened life. After an argument over money and a Broadway showgirl named Josie Mansfield, Edward Stokes shot Jim Fisk dead in 1872.

Pursuing acquisition of the parcel of property Paris Gibson wanted to begin his city on required a settlement for property domain. Sale of 160-acre parcels, sold according to land legislation, required property

owners to reside upon and improve the land. The improvement was not difficult to achieve, but neither Paris Gibson nor James J. Hill intended to 'reside' on the property in their first conception. Hill and Gibson avoided the restriction by utilizing a land law, revised in 1872, that allowed those serving in the military over ninety days the right to any federal public lands. The land could be bought by using "soldier-homestead script". This loophole enabled the pair to acquire thousands of acres and water rights with the acreage.

A few buildings, previously constructed as a stage stop at Sun River, in an area south of the river, constituted the beginnings of a town that preceded Gibson's planned townsite. Residents living in these coarse buildings expected the 1881 Johnstown plat, named after John Largent, an original settler of the Sun River Valley, would grow and develop rather than Gibson's plat. Gibson bought Johnstown in 1882 and the site was slowly consumed by the expanding city of Great Falls.

The lumberyard built in 1881 near the mouth of Sun River initially served the building industry in Fort Benton and may have been the Furnell & Co. Sawmill owned by John Largent, Matthew Furnell and Joseph S. Hill then sold to Paris Gibson with a name change to Largent & Adams. Furnell and Largent had worked together and been partners since 1871 when the pair worked for American Fur Company at Fort Benton. John J. Healy was another young man chasing a dream who met Matt Furnell mining in Idaho before ending up in Alder Gulch near Virginia City in 1865. This pair had a brief partnership in a hardware business in Alder Gulch before heading north to Sun River and on to Fort Benton. This was the year the Civil War ended and on January 2, 1865 the legendary bare-knuckle boxing match between welterweight Con Orem and heavyweight Hugh O'Neill fought 185 rounds before darkness ended the match in Virginia City, Montana.

"**A Pictorial History of the Sun River Valley**" by the Sun River Historical Society printed by Promoter Publishing, Shelby, Montana February 1989, has the original platted map of the town of Sun River filed by John Largent December 1874 on page 78. The following page has a photo of the first building built in Sun River with John Largent Sr. and John H. Largent Jr. in front of the cabin Largent bought from

Goff, a trapper. The plat is patented and was surveyed by Benjamin F. Marsh in the County of Lewis and Clark Montana Territory. Page 81 of this book has a photograph of John and his wife Sara Ellen Largent with their son in front of their house. Page 80 has a picture of the Largent Hotel with several people on the second story balcony as well as on the ground floor porch. The Hotel, built in 1876, is made of brick from George Wiegand's kiln. Brick became a popular building material due to the scarcity of lumber in the immediate vicinity. As transportation corridors opened, the brick yards closed. Many city centers throughout Montana still have brick buildings that boast of their beginnings. Each of the kiln sites used a special clay and mix giving the bricks unique finishes that distinguish the maker. Havre had one brick yard that placed the name of the town on the bricks making them collectors' items over time.

"**Sun River Valley History II**" has pictures of Matt and Della Furnell and their residence sketch along with Joseph L. Largent and John Largent sketches and the Largent House on page 77. A brief history of Matt Furnell is on page 131 with the same sketches of Matt and Della and their house. Matt was born in Woodstock, Nuevo Leon, Canada June 20, 1842. Woodstock sits along the northside of Highway 401 northeast of Windsor, Canada (east of Detroit, Michigan). Matt and Della Furnell were friends of Charlie Russell and Della became a good friend of Nancy Cooper Russell when Matt died May 7, 1896. That was four months before Charlie and Nancy married September 7, 1896. Nancy was not confirmed when she and Charlie married, but she attended confirmation classes with Matt and Della Furnell's children and was confirmed at the Church of Incarnation, Great Falls Montana in December of 1898. Being confirmed in the class with Nancy Cooper Russell were Florence Montana Furnell, George Ray Furnell, and Carlos Eugene Kumpe. Carlos would later marry Florence Furnell.

Although many of Charlie Russell's close friends, including Con Price, have written that they never knew Charlie to follow a specific religion; they say they knew he was a Christian. Both Nancy and Charlie attended services in the Episcopal Church where Charlie's funeral service was held. The Russell's had a special alcove and when

they attended it was most often the 8:30 A.M. service. Religion was a big part of settling the west. Della and Matt Furnell actively pursued the construction of a small Episcopalian church in Sun River with the help of the Ford Brothers, John Largent, Matt Dunn, and others around 1883. The building was used as the Methodist Church during 1957 to 1964. It stood at the corner of Second and Largent Street, Sun River.

Many young men chasing gold and escaping the Civil war came west for adventure or work. They had given up the religion their family had followed or were infidels as Teddy Blue (Edward C.) Abbott claimed he was. In her book "**We Pointed Them North,** Recollections of a Cowpuncher" by Helena Huntington Smith, Abbott says; "*The settlers would all get in their churches Sundays, and that exhorter would be hollering hell-fire and brimstone so you could hear him a mile. We'd all go to hell, the way they looked at it.*" Perhaps it was all they had to hang on to when they started west with only the clothes on their backs that made religion so precious to the settlers. There was one religion that had its beginnings in North America and its founders determined they would conquer the wild west in their own image. Joseph Smith started Mormonism or Church of Jesus Christ of Latter-day Saints religion in western New York in 1830. The practice of polygamy by Smith was one of the doctrines that barred Smith and his followers from voting in Idaho during the 1880's. Joseph Smith was killed in May of 1845 while being jailed on polygamy charges waiting for trial. He was shot while incarcerated. Brigham Young took over as leader or second President of the Quorum of Twelve that had assumed leadership when Smith was killed. Brigham Young would eventually lead the Church of Later Day Saints pioneers' in an exodus through the desert to Salt Lake City Utah. A polygamist with 55 wives, Young led the Utah war against the United States eventually announcing the discontinuation of polygamy in 1890 to follow U.S. voting rules. Brigham Young supported slavery in his expansion into Utah which was another point of friction at that time. Since the Civil War settled the slavery issue, the government compromised the voting rules by wording the church response to say; "*a voter could not belong to any group which believed in the practice of polygamy.*" Certain men in the Church continued to live with more than

one wife despite continued opposition. Mormons in Idaho were pleased they finally could vote in United States elections.

Brigham Young's journey is full of accomplishments and sinuous tributaries which might be expected from a man with 55 wives. Consider the effects of this singular fact in 1863 when the sparse population on the Utah desert largely consisted of men.

Native American Indians were experiencing incoming settlers throughout the United States in the 1800's, especially the areas unexplored where gold was found. First the discovery, then the onslaught of gold diggers and near-do-wells with or without their families. Brigham Young was a lot of things, but a gold digger was not one of them. He started life in Vermont June 1, 1801. His parents, John Young and Abigail 'Nabby' Howe Young were farmers near Whittingham, Vermont. When Brigham was 14 years old his mother died of tuberculosis. Two years later when he turned 16 his father "*made*" him leave home. He learned the trade of carpentry and painting under apprenticeship of Herber C. Kimball. Kimball served as one of the original twelve apostles when the Mormon church organized under Joseph Smith in 1830. Once Brigham gained enough skill to work on his own, he started his own construction business drifting away from Mormonism. He had not been exposed to a Bible before leaving the oversight of Herber Kimball and once introduced, he did some deep reading which led him to the Methodist faith by conversion. In 1841 he was baptized into the Methodist church insisting on immersion instead of their normal practice of sprinkling.

During the time he was working on his own he married and had two daughters. His wife died. Herber C. Kimball, with wife Vilate, took the daughters to live with them while Brigham sorted things out. His brother came to see him during this time and introduced Brigham to The Book of Mormon Joseph Smith had given him. His brother told Brigham about Alpheus Gifford speaking in tongues and how it had influenced Smith as Smith began to understand this unknown language ("Adamic language"). As Brigham studied the Book and language, he traveled with a group of Mormon missionaries to Kingston, Ontario, Canada to a Zion's Camp where he learned of Joseph Smith's attempt to regain land which Mormons had been expelled from in Clay County,

Missouri in 1834. He believed he was able to understand this language and thought of continuing the movement Smith had begun in Utah. He went on a mission to New York State and to New England then to Nauvoo, Illinois to visit an aunt, Rhoda Howe Richards. In May of 1835 he was Ordained as one of the First Twelve Apostles of the Church of Jesus Christ of Latter-day Saints.

Two years following the death of Joseph Smith, the Quorum of Twelve, as leadership that had sustained the Church Membership during the two years void, voted Brigham Young the second President of the Church. He at once began a movement where Smith had left off, in Utah at the Great Salt Lake. He arrived in the Valley of Salt Lake July 24, 1847 and by August 22 he had organized the Mormon Tabernacle Choir. By the time of his death, August 29,1877, it is estimated that Brigham Young encouraged 250,000 Mormon pioneers to exodus through the desert to settle in Utah. To entice them he founded the University of Utah, Brigham Young University, founded Salt Lake City, built a Tabernacle, built numerous roads, bridges, forts, irrigation projects, established a public welfare system, organized a militia, became the 1st Governor of the State, and was the first to subscribe to Union Pacific stock encouraging the railroad advancement of the transcontinental railroad. He also issued an extermination order against the Timpanogo Indians.

One of the settlements Joseph Smith had left in the desert thought their location was in Utah, but in fact was still a part of Washington Territory. Consequently, some of Young's followers continued west to join family and friends already settled in the Bear River valley in Idaho. Shoshone Indians were at first cautiously friendly to the white settlers encroaching on their lands. There was enough wildlife and native fauna to enable the storing of food supplies to carry everyone through the winters. Mormons were craftsmen and agronomists, so they began working the soil and building trade posts and communities. The change was insinuating, but sustainable, until the onslaught of greedy gold diggers began arriving in hordes. The Shoshone began experiencing food shortages. As hunger increased amongst the Indians so did tension rise between whites and Indians. Along the Oregon

Trail the Mormons coming from Utah heading west were experiencing greater and more frequent confrontations with the Shoshone. There began cries for help to the U.S. Government from the Mormon settlers. Most of the plundering was occurring in the Bear River area. This came to a devastating apex during the winter of 1882-1883. The snow was '*crotch high to a tall Indian*' as the saying goes.

Chief Bear Hunter had escalated the fears of whites by conducting Shoshone raids stealing cattle from domestic cattle herds and attacking bands of gold miners looting their camps. As a Chief, he felt he should act rather than watch as his people starved. A storekeeper at a trading post turned Chief Sagwitch away warning the young Shoshone of oncoming military action if the Indians continued to loot and intimidate whites in the valley. Youth and naivety let Chief Sagwitch to believe it would be possible to reason with the military when they saw the pathetic condition of the Shoshone, so he did not deliver the message to the rest of the tribe. The Indian village sheltered in a ravine along the edge of Bear River valley hunkered down and waited as the snow continued to fall and temperatures held below zero.

As the silence of snow falling continued the Indians reserved what little energy, they had by staying close to their tents trying to keep from starving or freezing. Their best days came when the wind was silent, and the sun shown on the white crystals of ice that had settled on the trees and ground along the banks of "**Boa Ogoi**" (Bear River). In a moment everything would change when Chief Sagwitch emerged from his teepee January 29, 1863. He put his hand to his forehead to view the bluff above the encampment at what appeared to be a strange bank of fog blocking out the suns magnificent rise. The fog was oddly moving in the sub-zero temperature causing the Chief to stare. Trying to wake his senses to what this wall of haze encroaching down the ravine might be: a very odd event. Too late to save anyone, Sagwitch realized the perceived fog was caused by the breath of the approaching charge of American soldiers and their horses as they descended upon the Shoshone murdering every living thing in the settlement. It was so cold that icicles formed on the soldiers' mustaches as their commander, Colonel Patrick Conner, ordered; "*Make clean work of the savages.*" This

was Bear River Massacre leaving more than 500 people slaughtered near Preston Idaho. The United States Army records describe the soldiers slaughter of everything in the encampment without mercy or hesitation. Among the dead were 24 soldiers.

This was the west when Charles Marion Russell made his debut March 19, 1864 in St. Louis, Missouri. It would not be long before this boy would begin drawing and modeling sketches and figures that shaped his idea of what this place called *"the west"* looked like. Time would only cement his curiosity to know, not to wonder, what it was really like and how it really looked from his own vantage point. As Charlie grew so did the nation. Ready or not, change came. For better or for worse, time waits for no one.

PART II

COWBOYS, INDIANS, BOUNDARIES

The West at its Best

CHAPTER 10

ROAMING THE RANGE

Before Fort Benton was built, Indian tribes east of the Rocky Mountains traded annually at the great meeting center where the Missouri meets the Knife and Heart Rivers. The encampment was built by the Mandan tribe. The Mandan Indians hosted tribes from as far south as Mexico and north from Canada at an annual gathering in the fall of each year. It was at this gathering that herbs were traded for medicine bags that would help thwart maladies for the Indians of North America. This practice worked well until 1725 when the Ravens Nest band, living in Crowsnest Pass near Waterton, Canada, were virtually wiped out by smallpox. This band of Blackfeet were introduced to horses and rifles by trappers from Oregon Territory.

Curley Bear Waggoner, elder of the Blackfoot Nation, said in an interview in 1997; *"Assiniboine brought smallpox to the Blackfoot. The white free fur traders had infested the Assiniboine Nation. A Blackfoot hunting party was observing the Assiniboine camp and saw no movement. They became curious after three days of observation. It was concluded that it was a trick. No movement for days was not acceptable.*

The party raided the Assiniboine camp and took war trophies of robes and any other plunder that was mobile. A few short days later the Blackfoot became ill and began dying. The smallpox had invaded a Nation and reduced its numbers drastically."

The introduction of horses changed the Culture's relationship to the land and each other. Indians began to actively hunt bison from the

backs of horses and expanded their territories. This led to conflicts with neighboring tribes such as the Kootenai, Salish, Piegan, and Blackfoot. The Kootenai were the first to get horses and the Blackfoot were the first to get rifles. By 1810 the Blackfeet had closed all mountain passes, keeping them under surveillance until the 1850's. By 1850 the rigor of encroaching governments was initiating fear and fury in the native cultures. This temper led to the "Trail of Tears" (1831-1877), "Marias Massacre" (1870), "Custer's Last Stand" (1876), "Nez Perce War" (also known as "Trail of Courage") (1877), and the capture and death of "Louis Riel" (1887).

In 1847 sheep were brought to the Bitterroot Valley by Father DeSmet. This band was brought from St Louis overland, traveling through Miles City and Beaverhead county on their way to serve at the Salish St Mary Mission. Father DeSmet thought he could use the sheep as a tool for teaching the Indians about animal husbandry and supplement mutton in the Indians' diet. They were primarily breeding animals for meat production replacing the declining numbers of wild game. It was a start to the Jesuit order attempting to teach renewable food sourcing to the Indians. The Blackfoot trusted Father DeSmet and it appeared that he might make some progress in educating the Tribes in religion and agriculture. Unfortunately, Father DeSmets' efforts were unsuccessful. The bridge in communication and cultures was too vast and one man, regardless of his education and will, could do little to change the path of resistance to becoming civilized. The Indians had no opportunity of choice. They knew nothing of the language or the culture of the white men.

The Jesuit recognized disappearing buffalo herds were going to cause great disturbance to the Indigenous Peoples. Sheep, although not equivalent to the buffalo, could provide a wool crop that could be sold or traded for goods and used for its fiber and hide to replace buffalo hides and furs. The Indians showed no interest in learning to spin and weave. They did not like the flavor of the meat, probably because if the slightest amount of wool touches the meat the lanolin oil flavors the entire carcass with a rancid flavor. In any supply orders found for goods transported to Montana between 1860 and 1890

there are no looms, spinning wheels, carding combs, or other wool cloth making tools. In short, the Jesuits failed to provide even the basic skills of processing the wool into fabric. They did not teach the Indians how to prepare sheep carcass for the table or show them how to shear or prepare the hide.

Sheep adapted to Montana winters well and did not require hay be put up in winter as they forage on buckbrush and other shrubs and grasses that reach a height above snowfall. Their herding instincts would trample large areas of meadows exposing enough grass for these smaller animals to forage. It seemed a reasonable start to Father DeSmet. Unfortunately, the Indians were not impressed with the addition of mutton to their diet provided by an animal they did not wish to care for. Sheep are known for their attraction of ticks and lice as well and require a skilled shearer to remove their wool quickly or they will die if held on their back too long. Rather than trying to teach the Indians a religion they could not comprehend, the Jesuit's and others might have gained more respect if they had taught the Indians a few peasant skills. How to dress out a sheep and spin wool into yarn might have been good places to start.

The Bureau of Indian Affairs was originally created as an agency within the U.S. War Department, March 11, 1824, without authorization from Congress, by John C. Calhoun. The U.S. War Department was the forerunner of the Department of Defense. Congress created a post for a commissioner to head the Bureau of Indian Affairs in 1832 and in 1834 the Indian Reorganization Act was passed. This Act expanded the BIA to include education adding the BIE and Indian Health Services to the department. BIA, BIE, and Indian Health Services were all placed under the Department of Interior when it formed. Originally, territorial governors served as direct superintendents to the BIA. This created a conflict of interest as the Government interests were in settlement and statehood. There was little interest in advocation for the Indians.

March 3 of 1849 the Department of Interior was established. This put natural resources, Native Americans (Indians), and all territorial matters under the governance of this Department. The

first Indian Reservation started in California in 1850. This began an internal department fight about whether military or civilian officials oversee the BIA. In 1855 California State Legislature passed the Wagon Road Act authorizing the construction of a wagon road from Sacramento to the Nevada border. Mullin Road was built by the U.S. Army in 1859 -60. This was the first road to cross the Rocky Mountains. It connected Fort Benton to Ellensburg Washington opening a route from the west coast to Montana territory. This new overland route enabled import of lumber from the Pacific Northwest for building construction replacing many of the tent cities and trading centers that had been set up to house the growing population in Montana territory.

Directly west of the elbow in the eastern California border, along the Pacific coast, Fort Bragg located in 1857. Fort Bragg was named after army officer Braxton Bragg. Bragg served the U.S. in the Mexican American War and later the Confederate Army during the Civil War. The City of Fort Bragg was incorporated in 1889 and serves as a tourist destination today because of its picturesque views of the Pacific Ocean. In 2020 the forested area was host to the Glass fire so named for the point of interest, Glass Beach. The California Western Railroad known as the "Skunk Train" was built to run timber to the small lumber mills that were being built at the mouth of every creek that ran along the coastline to San Francisco. By 1867, the reservation and military outpost at Fort Bragg California was abandoned and the garrison was dismantled and loaded onto the steamer Panama evacuating and abandoning Mendocino County's first military post. Glass Beach occurred from the deposits of garbage dumped into the ocean by the Native American Mendocino Indians, military, and settlers when trade establishments were built in the location to serve the needs of this area. Over time the sand and sea waves worked the glass making the discarded pieces smooth. These glass chip pieces are called sea glass. This is the colorful remains that stretch along the Pacific Coastline as a tourist attraction today.

Mullen Road increased commerce from Fort Benton west to Walla Walla, Washington and allowed lumber and other goods coming from

Washington, Oregon, and California a shortened route to Montana. Before this transportation corridor was available, hordes of settlers were arriving with their household goods and families by steamboat. The boats were usually full, and lumber was a lesser paying fare. When Mullen Road opened, Fort Benton was the farthest inland port in the world and the navigational head of the Missouri River. Travel to and from Fort Benton on the Missouri became increasingly dangerous, but the danger did not slow the traffic. Shipment of live cattle down the Missouri began in 1878 with one hundred head of live beef carried by steamboat to Bismarck for local consumption. Bismarck was the outfitting point for the Black Hills where there were Calvary camps requiring supplies.

There may have been a direct connection to the explosive livestock population in Montana Territory and the Morrill Act of 1862. July 2 this act was passed granting every State 30,000 acre for every Senator and Representative. The numbers were based on the 1860 census. Montana Territory had an at-large Congressional representation. Republicans dominated Capitol Hill and former confederate officers were most often Democrats. Many of the early politicians who shaped Montana were Democrats. Most of the livestock owners in Montana from 1860 to 1889 were politically connected. During this period, process of law and order replaced responsibility. Information technology was non-existent, and justice was archaic and chaotic. The descriptive term is usually *Vigilante*. Everyone who could afford one carried at least one rifle and one handgun, including the ladies.

Prior to the import of lumber via the Mullin Road there were 'portable' sawmills set up in areas where there was timber. Most of the lumber worked was used in the immediate vicinity where it was produced. Where larger settlements had started up, brick foundations were built using local clay forming the bricks making each of the early towns forever unique in their composition. The vast regions of plains in Montana remained tent cities and dugouts. Once materials were available, many of the dugout claims constructed a small wooden house. May 20 of 1862 President Lincoln passed the Homestead Act granting

160 acres to any individual who filed and proved up the claim. Many relatives filed adjacent claims eventually combining the filings to single ranches or farms. Often the female relatives would come to the territory and file the claim then return to their homes 'back east', then return in five years to have the government inspect the improvements and receive deed to the property.

Department of Agriculture (DOA) was created in 1862 but was not raised to cabinet status. The Hatch Act followed in 1887 providing for the federal funding of Agricultural experimental stations in each state. DOA did not reach cabinet status until 1889 when President Grover Cleveland signed the bill and Land Grant Colleges were added to the department in 1890. The land grant colleges and extension service were included to teach agronomy throughout the United States but were organized primarily with consideration of colleges and universities inclusion of blacks. Indians were not mentioned and were left to governance by Treaties which they neither understood nor followed, particularly in Montana Territory, due to boundary disparities. Texas was having the same boundary disparities with the additional challenge of the neighboring country at war with Texas and the governing powers of Texas in dispute with each other over the rights of different Indian tribes and freed slaves.

November 8, 1889 Montana became a State. The Smith-Lever Act of 1914 allowed Federal money to be split equally between the white land-grant colleges, which had been included in the first Morrill Act, and the African American land-grant colleges. **None** of the land-grant college discussion of federal money for Home Demonstration and Extension service included Indians.

A letter written by Agent Henry W. Reed was sent to the Secretary of Interior in January of 1863.

"From Fort Randall to Fort Benton, a distance of some eighteen hundred miles … there was … not a single military post, nor civil officer of any kind, not an officer or soldier of the army, indeed no authority or government of any kind, except singly and alone, one or two Indian agents."

Agent Reed's letter prompted Acting Secretary of the Interior, W.G. Otto, and commissioner of Indian Affairs, William P. Dole, to ask

that one company of calvary be stationed at Fort Benton. The letter also asks, by "*necessity, at least two troops accompany the boat which will be conveying the Indian annuity goods up the Missouri River*." After delivery of the goods "*it is recommended that the troops be stationed at the Arickaree village not only for the protection of the friendly Indians, but also to protect the agent and his employs and the government property in that neighborhood*". Agent Reed requests that a copy of his letter be sent to the Secretary of War, Edwin M. Stanton.

Following the receipt of agent Reed's letter in 1863 military posts replaced trading posts along the Missouri, Marias, and Milk Rivers. Willow Rounds was established on the Marias with Hammel in charge. Thirty miles north along the Marias, Flatwood was established with Malcom Clarke in charge. Along the Milk River to the north of Malcom Clarke, Michael Champagne was placed in charge of a military post on the east side of West Butte in the Sweet Grass Hills south of Milk River. The forts and outposts provided some supplies and protection for the settlers who were increasing almost as rapidly as the buffalo and wild game was decreasing, but corruption, declining food supplies, and disease were overtaking the Indians.

In 1869 President Grant advanced the "Peace Policy" with the Indian tribes to remove corrupt Indian agents. The agents were intended to supervise distribution of supplies to the Indians. Agents were compromised by threats to their own safety and had become corrupt using the government goods for trade for their own benefit. The Policy was supposed to eliminate the corrupt agents and replace them with Christian missionaries. The military's task was to move the Indians to the lands around the Missions so they could be taught how to read, write, and embrace Christianity. The military was ordered to force the Indians from their lands if they did not embrace the Christian teachings. In 1871 the Indian Appropriation Act ended the practice of dealing with the Plains Indians by treaty. Plains Indians became wards of the Federal Government and were no longer independent in sovereignty. In 1874 the boundaries of the Blackfeet Indian Reservation were reassigned by this treaty assigning the Blackfeet Reservation to the care of the Methodist Church. In 1885 the Jesuits received permission

to establish a mission on the Blackfeet Reservation which extended to the Missouri River about six miles above the mouth of the Sun River. Father's Giorda and Imoda along with Brothers Francis and DeKnock were assigned.

Granville Stuart and his brother James had come to Montana around 1858 chasing gold. This pair of entrepreneurs recognized that the gold veins found in Montana territory were shallow and a better investment might be served in providing local markets supplying the mining camps and military posts with food and mercantile. Granville Stuart and Con Kohrs operated one of Montana's first butcher shops in Bannek. Later Granville became one of the largest stockmen in Montana as owner of the DHS brand. A large section of north central Montana was open range to Granville Stuart's DHS brand. Charlie Russell and Con Price were but two of the line riders for this brand. E. C. Abbott, also known as "Teddy Blue," was another friend of the pair who was a representative for Granville Stuart and hired both Con and Charlie as wranglers for open range riders from Malta west to the Rocky Mountain Front north of the Marias River and south of Milk River. Well, sort of south of the Milk. Since the range was open, if the cattle found places to cross and head north then the cowboy's jobs were to find them and bring them back to Montana for branding and shipping. Everything centered around those two events and a lot happened in between, including winters.

Teddy Blue (Edward Charles Abbott) was born in England and his father and mother came to the United States when he was eleven. His grandfather, Edward Abbott, had worked for Lord Ashburton as secretary when Ashburton was sent to Canada to survey the boundary between Canada and the United States from the Lake of the Woods east to the Atlantic in 1848. Edward Abbott stayed in North America once the boundary survey was done and invested in the Grand Trunk Railway which was building a rail line in eastern Canada. After making a lot of money with his investment, Edward moved to Nebraska buying a small farm outside of Lincoln.

In 1871 Teddy Blue's father came to Nebraska with his family at the encouragement of his father, Edward Abbott. E.C. Abbott

will be referenced as Ted or Teddy Blue to keep this family linage from some confusion. Ted was eleven years old when he arrived in Nebraska. He had been an unhealthy baby, in fact so weak the doctors did not think he would live, but live he did, every day in every way. In his own words he says of his life when the family arrived in Nebraska; *"we were so poor I was barefoot and eating corn bread with syrup every day."* Born December 17, 1860, Ted was four years older than Charlie Russell. If the miles made in a lifetime counted for age, Ted was miles ahead of Charlie when it comes to travel and exposure by the time he turned 16. His life in Nebraska found him at odds with his father. He admired his father's mastery of language and must have picked up much of the discipline of learning from books as he is one of the Montana cowboys who left a written record along the trail. He grew into one of the most reliable historians and loyal friend. Most of the cowboys of open range knew, respected, and worked with or for Ted until his marriage and the arrival of barbed wire. It's interesting to see how his attitude changed about just *"eating corn bread with syrup every day"* to sounding like that bill of fare was a pretty good meal.

Edward Charles (Teddy Blue) and Mary Abbott were friends of Charlie and Nancy Russell and there are numerous photographs of them together at Bullhead Lodge on Lake McDonald and at least two of Charlie and Mary, in Great Falls by Charlies' Studio cabin, in full Indian attire. Charlie with a buffalo headdress and buckskins and Mary in her native ceremonial dress. The Russell's' were married in 1886 and Mary Stuart and Teddy Blue Abbott were married in 1889. "Blue" was more than a line rider for Granville Stuart, he became Stuart's representative and a son-in-law after many years of pursuit. Teddy Blue's wife, Mary, was a half-breed. Her mother was a Shoshone Indian, the daughter of a chief making her a princess.

Granville Stuart had a half-breed son named Charley. Charley Stuart rode with the round-up camps and often herded the horses for the crew. Working with the crews put him in contact with Charlie Russell, Charles E. Morris, his brother-in-law, Teddy Blue, and Matt Morgan. The following is a photograph by Chas E. Morris of Charlie

139

Russell and Charley Stuart as Indians of the plains passing a peace pipe. A reverse role Charlie enjoyed playing. With Charlie is his horse, Monty. Both Charlie and Monty retired from working for the brand around 1891. The photo was taken around 1891.

In the book, "True, Free Spirit. Charles E. Morris Cowboy Photographer of the Old West" by Bill Morris the following photo shows Charley Stuart, Granville Stuart's son standing watch over a la manada, the Spanish word for horse herd. The Spanish word for horse is caballo; the root of caballero which is a gentleman horseman. A vaquero is a cowboy. La manada was turned into 'remuda' by the western cowboys in reference to a herd of horses broke to ride. There is a single rope string holding this herd of cowponies. Saddle horses were wrangled daily at the roundups and the cowboys would step inside the rope surround and lariat the one they were going to use that day. The remainder were turned out to graze and rest until the next morning.

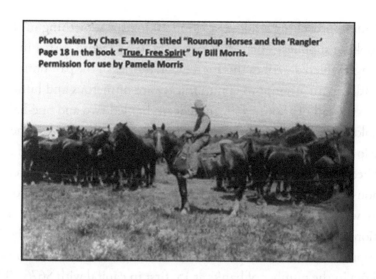
Photo taken by Chas E. Morris titled "Roundup Horses and the 'Rangler' Page 18 in the book "True, Free Spirit" by Bill Morris. Permission for use by Pamela Morris

Charley Stuart had lost his vision in one eye. He was frequently given the job of night wrangler, the same job Charles M. Russell, Chas E. Morris, and Con Price often held at round-up time. It's possible, and even probable, this vision deficit, color blindness, or other vision challenges gave these men an extra sensitive sense for night watch over the herd making them better than some at this important work. Charles (Chas) Edward Morris was recognized/honored by the Smithsonian as the outstanding western photographer 1900-1910.

In 1856 small quantities of gold had been discovered in Deer Lodge county by John Saunders and Robert Herford followed by some "fair diggings" found by James and Granville Stuart, Thomas Adams, and Reese Anderson in 1858. In July of 1862 considerable quantities of gold were found on Grasshopper Creek near Bannack. Mining camps, military posts, and section crews kept local markets in business after the gold ran out. Granville Stuart recognized the opportunity and operated a butcher shop in Bannack where beef sold for 25¢ a pound when gold was scarce and difficult to mine. Some settlers had dairy cows and would sell their butter for $1.25 a pound. Butter production was labor intense and keeping cows for milking was a niche before fences and refrigeration became common. Military camps were the merchant's best customers. Indians began going to the camps asking for food and more often, baking powder. There are many stories of lone

Indians approaching a home or camp asking for something in the way of cooking supplies. There does not seem to be a word, either in sign or verbiage, which describes this ingredient. Stories of the pantomimes and charades in an attempt to communicate are numerous and humorous.

In the fall of 1866, a four-mule team hauled two and one-half tons of gold from Butte to Fort Benton for transportation down the river. The lode was worth one and one-half million dollars. Silver and quartz had been discovered in the Butte area in 1862 making Montana territory famous for bullion production. To the credit of Montana Territory, the solid wealth per capita rated Montana businessmen as high as any section of the Union, and higher than those in most sections. The 1880 Comptroller of currency presented; Montana ranked second to North Dakota in the number of banks at 15, first in capital with $676,708.00, first in deposits with $2,009,894 and first in average deposit to each inhabitant of $51.33.

The volume and diversity of people moving west in the 1800's appears exciting and romantic in books and on screen, but more often it was tedious or terrifying and consistently challenging work. The greatest task in settling the west, besides setting boundaries, was working with an establish culture. Before the Indians could be dealt with the United States needed to identify its northern border. The southern border between Mexico and United States was settled in 1819 and reaffirmed in the *Treaty of Limits* 1828. That is what the politics said, but there was a lot of fighting going on along the southern border with Indians, freed slaves, Mexican landowners, and Texas *empresarios*. The boundary commission Edward Abbott, Teddy Blue Abbott's grandfather, had worked on in 1848 dealt with the border east of Lake of the Woods to the Atlantic Ocean. England and the United States finally approved the North West Boundary Commission March 19, 1872. This survey would bring many military and government employees to the Sweet Grass Hills in North Central Montana Territory. The little band of Mountains resting peacefully as *Islands on the Prairie* are where Charles Marion Russell found his *home on the range*.

When the Boundary Commission formed, the U.S. appointed Major Marcus A. Reno to select the survey party. Major Reno had been

put in command of the 7th Cavalry during Custer's absence in the winter of 1875 thru to Custer's' return in the Spring of 1876. In June of 1876, Reno was second in command of the 7th Cavalry as part of the Dakota Column headed by General Alfred Terry. The troops were stationed at Fort Raymond at the confluence of Yellowstone and Big Horn Rivers. The Fort was originally a fur trading post established by Manuel Lisa in 1807 for trade with the Crow Indians. Lisa was appointed U.S. Indian agent by the governor of Missouri Territory. Although he had a wife and family living in St. Louis, he married Mitane, the daughter of Big Elk, principal chief of the Omaha in 1814, to secure alliance with that tribe.

On June 25, 1876, Reno was directed to take companies A, G, & M across the Little Bighorn River to attack a Lakota and Cheyanne Indian encampment of around 8,000 Indians. As Major Reno approached the Indian encampment from the south, after crossing the river, his front was met by Indians on the warpath. Reno ordered his men to retreat to the bluffs beyond the woods across the river. Company G dismounted in the north woods along the riverbank where they hid in the trees. Some of the men attempted to return across the river before the Indians left and were killed. When the warriors retreated from the woods the remainder of company G returned to Major Reno whose men had been reduced to half in number.

Captain Benteen met Major Reno and was ordered to halt and help the remaining men in Reno's command. Captain Weir requested, and was given permission, to take company D towards the sounds of rifle fire. Reno stayed with his men who remained pinned down by the warriors for an entire day. On the 26th, Weir returned with dead and wounded. General Terry approached and the warriors retreated. The companies learned of Custer's fate the following day.

Marcus A. Reno was born November 15, 1834 in Carrolton, Illinois. Graduating ranking 20th in his class of 38, Reno departed West Point Military Academy in September of 1851. Taking almost six years to complete his course was due to demerits for being tardy. Perhaps it was this early habit that saved his fate in the battle of the Little Bighorn.

December 18, 1876 Lieutenant F.D. Baldwin, in command of companies G, H, and I of the 5th U.S. Infantry, defeated Sitting Bull

at Redwater River in Eastern Montana. This was a general military campaign inaugurated by Lieutenant Col Nelson A. Miles to return the Indians to their respective reservations after Custer's' battle.

Two military supply camps had been set up in the Sweet Grass Hills in 1870 for surveillance of the Indian and homesteaders in the area. Archibald Campbell, a commissioner for the Canadian Royal Engineers from British Columbia, represented Canada for the Boundary Commission approved March 19, 1872. This Commission was to complete the survey of the Boundary from the Lake of the Woods west to the Pacific coast. In 1873 the United States had 250 civilians, two troops of 7^{th} Calvary with a company of 20^{th} infantry at the two camps in the Sweet Grass Hills that were extensions of Fort Assiniboine command south of Havre. In 1774 the 6^{th} infantry was added to the U.S. commission and the Canadians assigned 300 Old Countrymen, a corps of mounted scouts' (mostly half-breeds) under William Hallett (a famous Scotch Metis). Another 217 officers and 244 horses of Northwest Mounted Police under French command led by Colonel George Aurther were sent from Toronto June 6^{th}, 1874. Canada expanded a small camp at Writing-on-Stone just north of West Butte on the Milk River to accommodate the Mounties and horses. Barracks, corrals, and pasture were added to the post.

The Mounted Police from Canada had formally formed to the Northwest Mounted Police appointing their red coat uniforms as formal wear in 1874 to distinguish themselves from the U.S. military. The uniform is known as the **Red Surge**. Fredrick Remington's; "Dismounted: The Fourth Troopers Moving" was painted during this period as was O.C. Seltzers "Outpost" and Charlie Russell's "When Law Dulls the Edge of Chance".

Captain Twining had a road built to East Butte in the Sweet Grass Hills in 1874. There had been reports of gold, silver, and copper on East Butte, but Twining's party only found quartz. James Hill sent a party to explore the route for a rail line to Gold Butte and a stage drop was set up at Hill, a location to the south west of Sharks Tooth (also known as Haystack Butte), near the Calvary Camp on East Butte in the Sweet Grass Hills. To add a bit more interest, gold was reported in Middle

Butte and reports of the findings started to trickle to Fort Benton in the fall of 1884. The Sweet Grass Hills and the surrounding area south to the Marias River belonged to the Indians and a claim could only be made by an Indian, a licensed trapper, or Metis, or someone who was married to any of the afore mentioned. The Piegan Indians had begun a permanent settlement in the ravine or gulch on the northwest side of Gold Butte (also known as Middle Butte), because of the strategic shape and location enabling them to watch as the military maneuvered, and wild game migrated in and around the Hills.

By 1880, the year Charlie Russell arrived in Montana Territory, most of the gold mines were depleted of their mother lodes leaving struggling miners and settlers to harvest tailings sustaining on a bare living at the abandoned townsites left in the wake. The rise and fall of mining sites in the mountains of Montana Territory was breathtaking. As the word stampede best defines the rush of people clamoring to the area where a claim had been staked and the wake of wreckage and ruin as the people departed. The ghost towns and deserted cabins still stand as witness to places called home for thousands of people.

Crusade of rival powers between the Indians, trappers, slaves, and emigrants were launched among these cultures in the Revolutionary, French and Indian, and Civil wars leaving contentious diversionists throughout northwest territory. Complicating that fact was the earnest politicians who had no experience in shaping the United States parliament. Never had so vast a land with such a diverse population required establishment. They were indeed **The Blind Men And The Elephant** John G. Saxe described in his poem.

The Senate documents laid out following Grant's "Peace Policy" were specific in how the Blackfeet were to adapt to their new life in their old lands. They all were to be schooled to ensure civilization. It was stated in the treaty that; *"the necessity of education is admitted"*, especially the Indians who are or may be settled on agricultural reservations. By settling on *"agricultural reservations"*, as agreed to by treaty, the Indians pledged themselves to compel their children, male and female, between the ages of six and sixteen years old, to attend school. Agents for the Indians were to *"see that this stipulation"* was *"strictly complied with"*.

The federal government further ordered that; "*for every thirty children between said ages who can be induced or compelled to attend school a house shall be provided, and a teacher competent to teach the elementary branches of an English education*" would reside among the Indians, be furnished with all necessities', and faithfully discharge his or her duties as a teacher. These provisions were to continue for not less than twenty years.

Father DeSmet of the Jesuit Order, or Black Robe, had sent requests to Washington D.C. for supplies at his Salish St Mary Mission to which he received this reply.

"*Referring to your letter ... that the balance to be delivered will not be enough to prevent suffering and the destruction of the stock herd, you are advised of the fact that the total appropriations made by Congress for the Indians belonging to your agency has already been exhausted ... and as it is not in the power of this Department to make any further provisions for their support ... Nothing further can be done*".

Here was the Native American culture being "civilized" according to someone else's standards requiring fundamentals like combing hair, wearing shoes and clothing. It required sitting in a chair and sleeping in a bed, using utensils for eating, reading, speaking English, and telling time thought to be the basics. The Agent in charge between 1873 and 1876 wrote:

"*They appear to have no purpose in life except to hunt and to procure robes and peltries for the traders; no thought of settlement; no knowledge of the value of agriculture; no comprehension of social or family relations or morality; the animal instinct of self-preservation; and the cunning that provides for it*".

Treaties made with the Indians may have been destined to be permanent and allay forever the feuds of rival powers, but they are, in fact, the source from which national hostilities sprang. Contingencies happened for which there were no special provisions. Advantages occurred, unforeseen or anticipated, which offered powerful temptations which were not resisted. The Interest and ambitions of the Indians were disregarded or considered as obsolete because they were not agreeable or convenient for the plenipotentiaries.

Because the buffalo were becoming scarce, Indian settlements began to crop up along rivers in Montana territory and Canada, and at vantage points like the Sweet Grass Hills and the Knees around Fort Benton and Conrad. When buffalo and wild berries were plentiful these areas were only traversed during the seasons of harvest to prepare stores of food for winter months. When the white man emerged, these areas were used for hunting year around because the Indians were unable to secure enough food to support the tribes through the winters at their former encampments in the Rocky Mountains.

There is a rocky outcrop on the north ridge above Two-bit Gulch on Middle Butte where the road turns west and there is a natural formation that makes the perfect look-out. The Indians and the gold diggers used it to watch for patrols so they could warn the encampment when the military was approaching and cease their diggings. The Indians saw no value in the gold as it didn't fill their bellies.

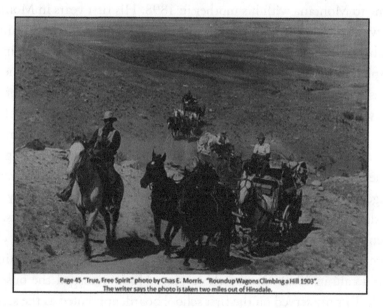

Page 45 "True, Free Spirit" photo by Chas E. Morris. "Roundup Wagons Climbing a Hill 1903". The writer says the photo is taken two miles out of Hinsdale.

This roundup wagons photo is identified as taken "*two miles out of Hinsdale*". This writer challenges that fact. This looks like the view to the north from the rock lookout described leading into Gold Butte. In the upper left there is a small lake. In the upper right there is a dark

patch indicating an irrigated field, either a garden or hayfield. Across the top there are homesteads or yards with painted buildings in a line with the road that runs east and west. The road running east to west in the Sweet Grass Hills parallels the border about two miles south. It runs approximately from the Sutton ranch to the Tony Fey ranch. Fred Parsell, Tony Fey, Harry Gardner Sr. and Suttons settled in that area as did others who had moved out before 1930. The little lake may possibly be "Grandma's lake", the location where Fredrick Theodore Parsell set up homestead for his mother.

The men identified in the photo are; Pilot Bob Ater, cook, Ralph Waite, John Glenhouse is driving the bed-wagon and Tommy Smith is on the end with the water wagon. Tommy Smith worked with Bert Furnell at Spencer Cattle Company in Canada. Smith later moved to Chester where he served on the first City Council in 1910. Joel Thomas (Tommy) Smith was born in Grenola, Kansas September 7, 1885. He came to Montana with his mother in 1898. His first years in Montana he worked as a round-up cook and night wrangler in the summers. He broke his leg working for a cattle outfit and spent 9 months in the hospital in Lethbridge the winter of 1906-1907. In 1908 he returned to Chester and took over his mother's homestead north of Joplin for five years. May 2, 1910, he married Hilda C. Reick in Minot, North Dakota. The couple lived with neighboring ranches until Tommy's claim was proved up because while he was in North Dakota for his wedding and honeymoon mice had moved into his homestead cabin and it was no longer habitable. Once the homestead was proved up, Tommy and Hilda sold out and moved to Chester where Tommy engaged in business opening a meat market. The couple later purchased the Mint, a cigar store and pool hall. They later added lunches and ice cream turning it into a café in 1929. During those years Hilda managed the business while Tommy served on the first school board, appointed as the second Marshall, he became Sheriff of Northwest Territory. He was the first deputy Sheriff in Hill then Liberty Counties as the county boundaries changed and then worked as postmaster for four years.

Photo of the inside of the Mint with Hilda (seated) and Tommy Smith behind the counter. Chas E. Morris photographer. Approximate year 1919. Heating stove and pipe on rear wall. Grill, counter, and stools with two unknown customers seated in center photo. The floor shows the wear pattern. Signage in banners and plaques display the popular items marketed in that era. Coke, an early soda favorite.

C.J. McNamara was in the Sweet Grass Hills working for the T hanging L brand and later formed a partnership with Marlow out of Big Sandy with the IX brand. He often rode with his roundup crews along the Marias River and during the winter months he would bar tend for Tony Fey in Gold Butte. C.J. McNamara was hired by the government to set up the last big horse roundup from the Rocky Mountain front east to the Little Rockies and Phillips County. Chas E. Morris would have been aware of this roundup. There is mention in Bill Morris's book about his grandfather's work rounding up horses with McNamara out of Big Sandy. There is also a photo of a roundup crew on page 20 of "True, Free Spirit" of the Marias Roundup camp on Willow Creek in Canada with Charles M. Russell, Matt Morgan, and Tommy Smith. C.J. McNamara is pictured to the far left seated on the ground. A copy of this photo has appeared in several CMR articles and books. Matt Morgan submitted the photo to the "Montana Stockgrowers Magazine" August 1, 1955 edition with brands on the canvas roof over the chuck wagon of the outfits the roundup was working for. The T hanging

L is just below the quarter circle C outfit brand. This article has T. Warrington Shaw in the byline. The same photo appears on page 45 of "Our Heritage, Historical Events in Liberty County" in the Bingham family story. Roundups for the Bingham Ranch would include Canada and Willow Creek area as the Bingham Ranch sits near the Canadian border at the northeast side of East Butte. This ranch is still in the Bingham family in 2020.

A party of four men, Marion Carey, Fred Derwent, George Walters, and John DesChamp found gold in Two-bit Gulch and wanted to file a claim in 1873. They were not sure how to be politically correct in the matter. No sooner had the first group of claimants arrived in Fort Benton when Joe Kipp, Chas Thomas, Hi Upham and seven others arrived filing claims with 5oz. of placer gold. The claims had escalated by 1888 when the Indians and Half-breeds began selling out squatter's claims and the caveat of *'marriage'* to an Indian or being a *'licensed HBC trapper'* came to light after the first filings. The federal government purchased the Hills and surrounding Indian territory defining new boundaries in both the U.S. and Canada.

Many men headed north at the end of the Civil War. Montana territory was experiencing increased battles between whites and Indians and was yet an unsettled frontier open to homesteading. Gold had been discovered at Last Chance Gulch in 1852 but was not mined until later after Bannack, Montana began a mine in 1862 followed by Virginia City in 1863 and Helena then Butte in 1864. By 1881 north central Montana to the Rockies and all points west was the last territory to be defined in the United States. Railroads had begun encroaching from all directions stopping just short of Montana. The wagon trail between Bismarck, North Dakota and Lewistown was flowing like the Missouri had in the past with trading posts all along the south-central plains.

Among the throng of folks arriving in Fort Benton were ladies setting the cultural bar a bit higher and requiring a higher standard for hygiene, manners, and housing. A few of the military commander's wives were at Forts around Montana Territory, but it was challenging and often a dangerous lifestyle for both men and women. The majority female population was Indian, Métis, or Military spouse. Many of the

150

men who were property and livestock owners headed east returning to Fort Benton by steamer with a wife. Matthew Furnell was one such pioneer who left for Chicago for a load of freight and returned with a wife, a sister-in-law, and a sister-in-law of Thomas Dunn's.

This was Matt Furnells' second marriage. Matt married Della M. Peek April 26, 1882 in White Pigeon Michigan. Della was 24 and Matt was 40. Mr. and Mrs. Furnell arrived in Fort Benton by steamboat June3, 1882. The entry in the steamboat ledger has Matthew Furnell and wife returning on the same page as passengers Kate Peeke, departing from Michigan, and Miss Fannie Iliff, departing from Chicago. Matthew signed for passage with a T.C. Powers & Bro. waiver. The Furnell's, Peeke, and Iliff party paid for passage with a "coupon". A unique entry of payment for passage on the river boats. Captain Andy M. Johnson brought the steamboat Butte and it's 23 passengers safely from Bismarck departing May 17, 1882.

Matt Furnell's first marriage to Miss Kate Dunn, December 14, 1877, had left Matt a widower. The bride was the sister of Mr. Thomas Dunn and the ceremony took place at Thomas Dunn's home in Sun River with the vows performed by Father Imoda. Major Edward Dunn and Matt Dunn, both active businessmen in Sun River and Fort Benton, were not related to Major Edward Dunn. Reports of the ceremony was covered in the Benton Record. The wedding was attended by a few friends and relatives who served as witnesses.

Matt and Edward Dunn were neighboring rancher to Matt Furnell. Both were charter members of the Sun River Stock Growers. Thomas Dunn was co-owner of the trading post at Sun River crossing with Joseph Healy, John J. Healy's brother. Major Edward Dunn was head of the department freight for T.C. Powers & Bro. in Fort Benton. Furnell had worked with T.C. Powers & Bro. when he was freighting and again when he was working for the Northwest Fur Company. The Furnell Ranch in Sun River was adjacent to T.C. Powers & Bro. ranch. March 1878 the Benton Record reported that the bride, Miss Kate Dunn, "*is a very amiable lady, and the groom has long been considered one of the most eligible bachelors on Sun River*".

After little more than one year of marriage, Kate Furnell died in

childbirth with her son. The Benton Weekly Record reported April 11, 1879; "*February 21, 1879, infant son of Mr. & Mrs. Matt Furnell buried in same grave with mother*". Matt Furnell is also resting in the Sun River Cemetery as is his first son from his second marriage, George Raymond Furnell. Matt was devastated over the loss of his wife and firstborn in 1879. He buried his young family in the cemetery at Sun River and himself in his work on his ranch. Sun River Valley History II has the Sun River Cemetery roster and Kate A., Matthew, and "Ray" (George) Furnell are listed with no mention of Kate and Matt's son being buried with her. There are most likely other graves of infants who are left unaccounted for that are a generation of fatalities that statistically would attest to the conditions surrounding this moment in time.

The saga of Matt Furnell is that he was born in a small village outside of Toronto, Ontario, Canada June 20, 1842. Those who knew Matt said his story was that he had been separated from his family when he was 12 years old. He had one sister who he lost track of when the household broke up. He regained contact with her in 1866 when he made a trip back to Ontario. He found his sister was living in Michigan. When he separated from his family Matt went to work as a farm hand. He worked at various farms and gradually made his way to New York where there are records of him in 1860. He would have been 18 years old. From New York Matt somehow found his way to the Gold Coast of California and worked the placer mines of the Sierra Company for three years.

In 1863 he moved to the placer mines of Boise Idaho where he met J.J. Healy. 1863 is the same year A.B. Hamilton was in Virginia City, Idaho Territory. Montana would become a Territory by an Act of Congress May 26, 1864. Abraham Lincoln was President and Charles Marion Russell was born in St Louis March 19, just in time to see Montana become a territory. Matt Furnell worked through the summer in the Idaho mines and in the fall, he headed north to Canada by way of Walla Walla, Washington arriving in Canada in early winter of 1864. Matt worked mines in Caribou and Kootenai districts of British Columbia returning to the United States that same winter ending up

working mines at Alder Gulch near Virginia City. The fall of 1865 he was working at Last Chance Gulch in Helena, Montana.

In 1866 Matt Furnell traveled to Norwich Ontario Canada for what was said to be a visit to his old home. 1866 is the year A.B. Hamilton was Sheriff of Choteau County and Justice of the Peace for Benton City. Matt returned to Helena via New York with enough freight to begin a hardware business with J.J. Healy. During this same period, Matt Furnell, J.J. Healy and John Largent built a toll bridge on the Sun River and Furnell and Largent started a lumberyard at Sun River with a sty in Fort Benton while Healy established a trading post. The trade post at Sun River was turned over to Thomas Dunn, Matt Furnell's first wife's brother, and Joseph Healy, John J. Healy's brother. Furnell and John Largent both went to work for Northwest Fur Company while J.J. Healy teamed up with A.B. Hamilton, T.C. Powers & Bros., and I.G. Baker in a business venture that led to the transportation corridor known as Whoop-up Trail and Fort Whoop-up in Lethbridge, Alberta, Canada.

In 1871 at 29 yrs. old, Matt Furnell bought 100 head of Texas heifers from Fred Krammer and S.M. Hall. Records of Krammer and Hall are found in the Conrad papers. Moving his cattle to Sun River, Matt Furnell purchased a large parcel of land in the valley. The Benton Record of March 1, 1875 has a business dissolution notice for Furnell & Co. engaged in saw-mill business. The notice shows Matthew Furnell as a resident of Sun River.

Matt Furnell built a house in Great Falls that was reported by the newspaper, Benton Record, October 16, 1875, to be a *"stylish residence in Great Falls"*. The occasion for the report was a surprise housewarming party attended by *"several young ladies and gentlemen from Great Falls"*. Matt is said to have been a little upset when he arrived at the house full of people late one evening, but he later warmed up to the occasion and participated in the dancing and celebration. He built a second house on the property in Sun River that the Benton Record reported as *"adding value to the Sun River community"* in 1878. He left the house in Great Falls vacant until he married Miss Della M. Peek of White Pigeon Michigan.

J.J. Healy and A.B. Hamilton had determined their trade in Canada

at Fort Whoop-Up would not be sustainable. The railroad had reached Lethbridge from the east and was heading south to Montana Territory. Fort Whoop-Up was sold to Dave Akers in 1876.

November 8, 1882 the Benton Record has the filing of Matt Furnell's final notice of proof for his land claim on homestead entry #1071 section 28, township 21 north, range 1 east, Choteau County. The property is owned by Ervin Blaine Carlson in 2019. Signing as witness to Matt's proof of continuous residence were William Mulcahy, Bernard W. Murray of Sun River, MT, Joseph S. Hill, and Thomas F. Healy of Fort Benton, MT.

Miss Kate Peek married W.H. Ford in 1883. Miss Mattie Iliff married Thomas Dunn May 18, 1880. Miss Fannie Iliff was a passenger from Chicago on the steamboat that arrived in Fort Benton in 1882 with Kate Peek and Mr. and Mrs. Matt Furnell and is most likely a relative of Tom Dunn's wife, Mattie. Thomas Dunn is the brother of Matt Furnell's first wife, Kate Dunn.

Della Peek Furnell may have known Matt through mutual acquaintances as the Peek Cemetery in White Pigeon, Missouri has the Iliff name on gravestones. Another familiar name in the Peek cemetery is Nelson K. Healy and other Healy's. There was also some evidence that Matt had found where his sister relocated after Matt left home when he visited Norwich Canada in 1866. She had relocated in northern Michigan as reported in "Progressive Men of the State of Montana" by A.W. Bowen & Company published about 1902. No date in the book. Kate A. Peek, Della's sister, and C.A. Howard were Della and Matt's witnesses at their wedding. C.A. Howard may have been Matt's brother-in-law. Della's sister, Kate A. Peek Ford, lived on the ranch adjacent to Furnell's in Sun River. Robert Simpson (R.S.) Ford was co-executor with Della for Matt's estate when he passed away May 7, 1896, the year Nancy and Charlie Russell married. R. S. Ford's son, Lee M. Ford, was a pallbearer for Charlie Russell in 1926. Lee M. Ford was the husband of Della Furnell's sister, Kate.

When Matt married Della, he had two houses, one in Great Falls and a second large house on the ranch near Sun River. Della was not fond of living in the country but with her sister next door she stayed

at the ranch the first few years of her marriage. When she had her first child, George Ray Furnell, born April 26, 1882, she limited her stays at the ranch to fair weather days. When George was old enough to start school, Della moved to the house in Great Falls where she stayed with occasional overnights at the ranch during summer months.

Besides George, Della and Matt had two more children: Albert Matthew Furnell born March 26, 1885 at the ranch in Sun River, and Florence Montana Furnell born December 10, 1887 in Florence County, Michigan.

Charlie and Nancy Russell introduced Matt and Della Furnell's second son, Albert, to his future wife, Edna Ellis, at a dinner in their home. Albert (Bert) and Edna (Babe) Furnell owned the Elephant Livery Stables, a subsidiary of Bailey & Dupee Baggage Transfer located at 300 2nd Ave. S in Great Falls, listed in "Polk's Great Falls & Cascade County Directory for 1914" the year Bert and Edna were married. Bert completed high school in Great Falls then went to work for the Deer Creek and Spencer Cattle Company's in Canada before he married.

The following letter was sent to Matthew Murray Furnell, grandson of Matt and Della Furnell. Matthew Murray Furnell was born December 29, 1916. He was the son of Albert Matthew (Bert) and Edna Ellis (Babe) Furnell. Permission for content of this letter was granted by the Montana State Brand and Livestock Department, formerly the Montana Stockgrowers Association. Addressed to Mr. Matt Furnell, Whitlash, Montana:

Vaughn, Montana
June 11, 1955
Dear Sir;
As we have talked about this at the Montana Stockgrowers Assoc. meeting at Helena, I thought you might be interested in additional information about your grandfather's activity with the early day Association here at Sun River.
Matt Furnell was one of the charter members of the Sun River (or more formally District 2 of the Lewis & Clark, Choteau and Meagher Counties Stock Protective Association). Which formed at Sun River in Feb. of 1880.

The Charter for the District group was granted by the State organization on Feb. 18, 1880.

Matt Furnell was on the arbitration committee of the Association in 1880, 1881, and 1882. He was elected V. Pres. On May 3, 1884. Along with other cattle owners he voted, in the 1883 meeting to prohibit gambling on the range during roundup times … in other words no more poker for the cowboys.

[Mr. Gill then writes Matt Furnell's brand as recorded in 1880 then states; "you may still have the same brand", which the Furnell ranch did in 1955. The brand Matthew Murray Furnell used was the quarter circle F.]

He continues; "You may even be interested in knowing he was in charge of the Stock growers' annual ball, held at Sun River in Feb. of 1881 … and that he had $7 left in the kitty when it was over.

Should you ever be interested in selling that Buffalo head, I would certainly be interested.

Yours truly,
Larry Gill

*Above material from the files of R.S. Ford, Sun River, now the property of his son, Lee Ford."

Matt Furnell's brands

The buffalo head referenced was given to Matt Furnell, the grandfather of this letter recipient, by Charles Marion Russell as a gift. Matt always had his latch string out and watched out for young cowboys like Charlie so gamblers' like "Pretty Charlie" didn't take advantage. Matt Furnell had been the foremost promoter of having gambling prohibited "on the range during roundup times …" in 1883. Furnell was sort of running herd over the free ranging younger men who loved horses and cattle and those double-rigged saddles.

Matt Furnell was a big intimidating guy and whatever brought him

to cattle ranching in Montana was stoic and imbedded in this cowboy. Matt was active in the development of the territory and state at every stage. He was consistent in striving to upbuild, and always with noble and true purposes, but refused personal honors.

In Charles M. Russell's' book, *"Trails Plowed Under"*, in "A REFORMED COWPUNCHER AT MILES CITY" Charlie writes a bit about this friend.

"Another gent from the upper Sun River country, also born on the range an' raised in the saddle, ain't no baby in build. He's had a hoss under him so long that his legs is kind of warped, an' when he sits in one of the chairs they have these days in front of the root beer bars, he straddles it instead of sittin' like a human. This feller, like Teddy, ain't usin' nothin' stronger than the law allows now, but in old days he was no stranger to corn juice or any of the other beverages that brought cheer and pleasure to the life of a cow-puncher. At the stock meetin's he used to attend, all the speakin' he listened to was done in front of a bar." Those first Stock meetings and Sun River Ranger meetings were held at the Largent bar.

The paragraph that follows names an *"old cow owner"* named Bill. This sounds like W.H. Ford, father-in-law of Kate Peek Ford, Della Furnell's sister.

Matt and Della Furnell's residence in Great Falls is walking distance from the Russell Museum and Cabin. The home still stands at 1517 Third Ave. North. Della was very social and when the oldest of their three children reached school age she and the children moved to town where Della continued to participate with friends, family, and community. Matt would come to town for all notable events as often as the ranch work allowed. Although reluctant to be involved with community, Matt did serve on the School Board for one term at Sun River and was a Sun River Ranger as well as holding several offices on the Sun River Livestock Board district. This marriage was successful because of this willing team. Della loved socializing and Matt supported and provided well for Della to have the time and finance to be a wife, Mother, and socialite in the Cascade County and Great Falls communities.

Photo by Roberta A. Beute 2018. 1517 Third Ave. North, Great Falls, MT.

Della continued to stay at the ranch during the summer months when the children were out of school. George and Florence tolerated ranch life but did not show the passion for it that Bert had. Bert learned to handle bronc's and teams by the age of six. He couldn't find a comfort level in town and had difficulty making friends in Great Falls, but the neighboring ranches, Ford's and Dunn's, had children with interests in common, so he spent much of what time he could with his dad at the ranch.

Bert was 27 years old in 1912 when he received an invitation from Nancy and Charlie Russell to attend the Calgary Stampede as their guest. Bert was working for Henry Pike Webster at the Deer Creek Ranch in Alberta Canada near the Sweet Grass Hills. Webster was born in Benton Harbor, Michigan, a short distance northwest of White Pigeon, Michigan where Della, Bert's mother, was from. Mr. Webster had also received an invitation to the Stampede from Charlie and

Nancy. He met the party in Raymond, Alberta where he boarded the train. Bert had been introduced to Edna Ellis, at a dinner Nancy and Charlie hosted at their home in Great Falls. The Russell's were friends of Edna's parents, John and Effie Ellis, and had sent them an invitation letting them know they had arranged for them to be transported by Bert Furnell to meet the train in Sweetgrass so the group could travel to Calgary together.

Bert's father, Matt Furnell, had died May 7, 1896, four months prior to Nancy and Charlie's marriage September 7, 1896. Matt had been doctoring at home in Great Falls for three months. The day after his passing Matt and Della's oldest son, George Raymond, fell ill and passed out. Doctors were unable to diagnose the problem. George completed his freshman year of high school that spring and was 13 years old. After weeks of medical tests George was diagnosed with juvenile diabetes. School was out for the summer so Della, at the urging of her mother, sent Ray to a sanitarium at Battle Creek, Michigan, in hopes that he would be cured of this little-known ailment. It is ironic that Matt Furnell's two sons would lose their father at about the same age as his father had abandoned his family.

Della spent the summer dealing with Matt's estate and traveling to Michigan where she and her mother visited Ray. Bert was 11, and Florence was 9. These two children stayed at the ranch in Sun River until Della returned to Great Falls in the fall when school started. The two children spent the summer managing the ranch. Bert had the help of his father's friends and their sons. Florence had her aunts and a few other girls in the Sun River community to visit, but she enjoyed being a 'tomboy' for the summer months and found herself interested in the outdoors and animals. Not so much that she wasn't anxious for school to begin again so she could get back to Great Falls, but enough so the summer didn't become an endless stretch of boredom.

Della Peek Furnell had three sisters' living in Montana when Matt passed away in 1896. Kate lived in Sun River. Lee Ford's ranch bordered the Furnell ranch. Lou Peek (also spelled Peeke) lived with Kate for a few years before marrying Henry W. Stringfellow of Havre October 5, 1893 at the Episcopalian Church in Great Falls. Lou was born in

Michigan,1871, and died August 3, 1961 in Silver Springs, Maryland. Matt and Della Furnell were witness for Lou and Henry at the wedding ceremony.

Za Peek, Kate and Della's younger sister, was married to Wallace N. Porter. Wallace N. Porter is listed as an election judge in the August 23, 1906 edition of the Havre Herald and again as a winter term teacher at Gold Butte May 6 of 1908. Za and Wallace Porter had a daughter, Genevieve, who was often referenced in the Liberty County Times as having various maladies having many visits to the doctor in Chester and Havre. March 3, 1907 edition of the Liberty County Times reported that *"Bert Furnell came from Canada to visit his aunt, Mrs. W.N. Porter, and niece Genevieve this week"*. There was a Porter ranch located near Corral Creek on East Butte, and another Porter field east of Harold Brown's ranch. This author was unable to identify if either were the W.N. Porter ranch.

Mr. Porter died, and Za married Mr. Scott. That is the only information found at this time about Za Peek and Mr. Scott. Za C. Peek was born in 1877 in Pigeon Falls, Michigan referencing the Michigan census records. According to the Havre Herald and the Great Falls Tribune, after Matt Furnell died Della would travel to visit Lou Stringfellow in Havre, and Za Porter in the Sweet Grass Hills then later Za Scott in Dillon. Lou Stringfellow saw her sister and niece, Florence, often as Della took the train out of Havre either traveling to California or Michigan. At the time, Della could also take the train from Great Falls to Dillon to visit her sister Za. Della was caught up in a legal battle in the first Inheritance law passed in Montana March 4, 1896. The law had not been enacted at the time of Matthew Furnell's passing and Matt's probated will was challenged by the appellant court.

County Treasure v. Gelsthorpe Furnell et al. in the Appellant Court of Montana, November 1, 1897 the case of **Inheritance Tax – Validity – Estates Previously Probated,** the following transpired:

" *…the legislature is limited in its right or privilege of succession … as defined by section 17 of article 12 of the state constitution …"*

Article XII section 17; *"The word property as used in this article is hereby declared to include moneys, credits, bonds, stocks, franchises and all*

matters and things (real, personal, and mixed) capable of private ownership but this shall not be construed so as to authorize taxation of the stocks of any company or corporation when the property of such company or corporation represented by stocks is within the State and has been taxed."

This tricky legal verbiage was passed July 19, 1897, nearly one year **after** the inheritance tax law was in force. The representative for Furnell et al., Wm. T. Pigot, argued:

"...the tax or assessment could not be collected, for as to such case the law was invalid ..."

Invalid? Perhaps if it had been Mrs. Furnell who had died a year before the law was enacted. But in Montana in 1896 women were part of the property and although probated in the lower court, Della Mary Peek Furnell had to pay the Choteau county treasurer inheritance tax on her husband's estate with no consideration that their three children were each to receive half divided into three equal shares.

What could be expected of the law makers in this newly formed State governed by men? The Morrill Act of July 2, 1862 had granted every state 30,000 acres for every Senator and Representative. The numbers were based on the 1860 census. These were the cattle barons and the incentive for raising cattle on the open range. 30,000 acres of unmarked property to run however many head of livestock your brand reported when the calves went to market. Of course, these noble lawmakers would not fudge on their reports. Compare the 30,000 free acres to the 160 the homestead act provided. It was realized by the authorities that 160 acres in Montana couldn't support enough agricultural revenue for a family to maintain a sustainable income, so they graciously expanded with the 1909 Enlarged Homestead Act raising the number of acres to 320 and lowering the time to prove up the claim to 3 years as opposed to 5 years previously required for proving up a land claim. When the land in the Sweet Grass Hills was bought by the government from the Indians, the government interestingly gave Indians 600 acres for each Indian who wanted to stay. Most of the Indians thought that they had to work the land and didn't make claims. The few who did make claims didn't stay to prove them up, instead selling the claim. This was another misunderstood finite clause in the settlement of the west.

In the Toole County History book "Echo's from the Prairies" there are numerous references to early settlers who tell of prosperous times until fence lines marked territory. Fences forced the numbers of livestock down and created an additional expense of building fence and keeping it up. Property disputes erupted. The face of rural America devolved. Large farmers and ranchers began buying up adjacent homestead claims forcing the small farmers out.

WHO YOU KNOW
WHERE YOU GO

When the Russell's first married in 1896 Charlie was selling much of his work to Charles Schatzelein, an art dealer from Butte, who according to Nancy was keeping the Russell's rent paid for their home in Choteau. Schatzelein expressed his opinion that Charlie wasn't charging enough for his paintings. He suggested to the couple that Nancy take over the business end of Charlie's work and Charlie happily took his advice. In her book, "Good Medicine" Nancy relates her surprise and determination to become the person who would show the world the genius she saw in the man she had married. Charlie had been unassuming for thirty-two years of his life. From this pairing a legacy was forged and there was no holding Nancy back. She knew little about cowboys, Indians, finance, and fanfare, but she successfully promoted the man she loved etching their story into Montana history.

Their first big step into their future together was to move from Cascade to Great Falls giving them access to the Railroad transportation corridor north to Canada and south to Helena. At Shelby they could take the Great Northern to New York, and from Helena they could travel further south and west all the way to California. Nancy was 18 years old when she married and 21 when she moved into their home. Charlie was 35. He had spent 16 years with his parents, 16 years on his own with people he met on his quest for independence, and three years

as a husband. Having a 'house' was not as important to Charlie as it was to Nancy but having the means to provide a house was important to both. Nancy's love for Charlie was not delusional and as they made their adjustment to life together, she made sure her husband could fully enjoy all his passions within the income her husband provided.

Charlie had another silent partner that was a huge part of his life before Nancy. Everyone who knew Charlie knew his horse, Monty. When word got out that Charlie had taken Monty to Cascade and left him there for Nancy's use, it was a sad day at the Mint. All those wannabee's and friends who enjoyed the company of this cowboy artist knew it wouldn't be long before Charlie would be packing a wedding ring on his leftie. The gloom hung heavy in the Falls as time moved on and Charlie was seen less and less in the water holes and increasingly in newsprint. A fella's horse was a part of himself and unknown to Nancy, entrusting Monty's care to her was a definitive gesture of his feelings.

The Industrial Revolution was happening in the United States. International railroads and boundaries would be established. Charlie and Monty would see the open range get fenced in. There was not much time to think about any of that, but Charlie could feel it and sketch it. Sometimes just leaving a drawing on a napkin or edge of a flyer or newspaper. Sometimes on the letters he sent back home or to friends or walls in the buildings he visited. Charlie got down what he could and kept true to his nature of hunting the Indians looking for adventures' others were missing. Without disappointment, Charles M. Russell found that the Indians were quite in contrast of what he had heard. They, in fact, were more open and informative than the politicians and businesspeople he encountered. They were eager to spend time with him and celebrated his ability to draw scenes with accuracy, especially capturing the details of their personal features and colorful dress. They made no demands and felt no competition or threat in their mutual relationship.

Charlie Russell left his family, home, and school in Missouri to live the life of a cowboy in the unsettled regions of north central United States just before he turned sixteen (1880). Son of Charles Silas Russell and Mary Elizabeth Mead, Charlie's passion for art was demonstrated

early in his life. He sketched and molded clay often in the image of horses, dogs, and cattle. Schoolroom settings became dull and he would often skip out of school and go to the trading posts along the river to listen to the trader's stories about their trapping and hunting excursions. The stories made it sound so colorful and raw, especially talk of the Indians (Savages). His young adventurous mind began planning to run away and turn Indian fighter. School became problematic in the plan and there were things he needed to learn, like how to ride a horse, before he could head west. The opportunity to learn to ride came by way of his aunt on his father's side, Cornellia Tilden Russell, and her husband William Fulkerson.

Fulkerson served as Colonel in the Confederate army during the Civil War and was married to Cornellia Russell, the youngest daughter of Joseph and Jane G. Richards Russell. Cornellia Tilden Russell and William Fulkerson were married October 17, 1861 in Tennessee. The Fulkerson's moved their family to Illinois in 1866 where they obtained the Hazel Dell farm north of Jerseyville, Illinois with *script*. The property did not have a house, so the Fulkerson family had one built that was completed in 1872. There were, however, barns, corrals, and outbuildings on the property enabling the Colonel and his wife to bring some livestock with them from Tennessee when they moved.

Charles Marion Russell learned to ride on a famous Civil War horse named Great Britain. William H. Fulkerson was Charlie's riding instructor. Great Britain was said to have saved Fulkerson's life during the Civil War and was given to Fulkerson at the end of the war. This combination of experience of horse and instructor would most likely peak any young boy's interest in beauty of beast and landscape. His uncle had his estate taken from him following the Civil War. This was common of soldiers who had fought for the confederacy. The compensation was enough *script* to buy Hazel Dell and the gift of the horse that had saved Colonel Fulkerson's life.

Charles M. Russell followed his passion and along the way found a partner who was the love of his life. Nancy Cooper Russell saw more than a cowboy in her life and through love and perseverance proved

165

to her husband, and the world, that her vision of the man she married was spot on.

Charles Marion Russell (March 19, 1864 – October 24, 1926)

Charlie would have been two years old when his half-aunt and her husband came to Illinois and eight by the time the Fulkerson house was complete. Even with some basic horsemanship skills, Charles M. Russell faced many challenges in his choice to run away from what he knew to head for the "wild west".

Frustrated with Charlies' truancy at school, Charles S. and Mary Russell sent their son to Burlington, New Jersey to a military school when he was fourteen. At the end of the Civil War in 1865 the military became active in settling the yet undefined regions of the plains. Charlie found an interest in learning about Pioneer life at the school. His much-loved artistic ability was challenged along with his self-preservation skills in the strict scholastic regiment. He could maintain an interest in some, but not all, of the academics. He found himself doodling sketches of what he thought the '*west*' looked like. His black and white subjects were great in sketches, but he struggled with hue's. He would later find Montana's ever-changing landscape challenging to capture because of his color vision deficiency. Charlie would not know he had this deficiency until years after he struggled with adding color to his paintings, and even then, it took arduous work and study. Color blindness was only first recognized in 1798. That was before the Louisiana Purchase, the Spanish American Wars, and the Civil war. Charlie wasn't yet a twinkle in his father's eye and this minor deviant in vision was not widely known. Later in life associates and customers wanting artwork from Charlie would be frustrated with the time it took Charlie to finish an order. The work of the artist may have contributed to Nancy Russell's bouts with depression. She loved her husband and respected his artistic talent, but she became the agent for her husband and the customers were often not patient or kind.

When he returned to St Louis from military school, Charlie's parents introduced him to Pike Miller. Miller owned a sheep ranch in Montana Territory and was returning to his ranch in Montana. Charlie's mother, Mary Elizabeth Mead Russell, had a relative, John W. Bascom, on a

ranch near Vernal, Utah, which was near Promontory where the Union Pacific Railroad reached in 1869. From that point west it wasn't far to the Utah & Northern Railway that ran North to Montana. The Bascom ranch bordered the largest sheep ranch in Utah owned by Jesse Knight. Pike Miller most probably knew Knight as most large sheep vs. cattle ranchers often met at roundups and shipping points. It was not 'out of the way' to stop by the Bascom Ranch in Vernal before heading to Price Utah where Charlie and Pike Miller boarded the train heading north to Montana Territory.

Charlie's cousin, John W. Bascom, had worked for Jesse Knight in Montana Territory and southern Alberta, Canada, then returned to Utah where he had served as deputy sheriff of Uintah County. Bascom had purchased a ranch adjacent to Knight who had hit one of the biggest gold mines ever in Utah. Taking some of his earnings becoming an industrialist, Knight bought a large property in Werner County, southern Alberta, Canada, and had hired Ike Lybbert to manage his livestock on his Canadian sheep ranch. Ike Lybbert was John W. Bascom's brother-in-law by way of John's wife Rachel Lybbert Bascom. Jesse Knights' son, Raymond, would later take over the ranch. Raymond Knight built the Church of Jesus Christ of Latter-Day Saints in Raymond, Alberta, Canada. Raymond was more interested in horses and cattle than his father, so he expanded the ranchland in Canada increasing his sheep to include cattle and horses in one of the largest livestock enterprises in Southern Alberta.

Frederic Remington (October 4, 1861 – December 26, 1909)

Frederic Remington was also a cousin of John W. Bascom. Bascom was related to Remington and Russell through their mothers, Clarissa Bascom Sacrider Remington, and Mary Elizabeth Mead Russell. Frederic was a poor student often daydreaming and doodling in class frustrating his father with complaints from his teachers. At age 11 Fredrick was sent to Vermont to an Episcopal church run Military school. He took his first drawing classes at this school and later transferred to another military school. His father hoped the schools would give him the necessary discipline training for a military career.

After attending one year of art study at Yale, Remington went home

to attend his ailing father. That was 1879 and his father died one year later of tuberculosis. Frederic lived off his inheritance for a while and at age 19 he traveled to Montana; first investing in a cattle operation then trying his hand at gold mining. He realized he had capital for neither but was experiencing a west that was undergoing monumental change. In addition to the shrinking buffalo herds, the U.S. Cavalry, Métis, and Indians were heading into major confrontations. In 1881 Remington took photos of the vast unfenced prairies and colorful Native Americans in Montana Territory making note of the true colors such as: *shadows of horses should be a cool carmine & Blue*", to supplement his black-and-white photos. Art critics later criticized Remington's palette as *"primitive and unnatural"*.

The first known photograph of a tornado was made August 28, 1884 near Howard, South Dakota. October 14 of the same year George Eastman patented paper-strip photographic film which brought photography to the artist tool chest. July 29, 1894 the Society of Independent Artists was founded in Paris and this simplified method of photography was shared with artists around the world as an advanced means of capturing movement in still shots aiding in the recreation of moments in time. US Military and Politicians began to use photographs for documentation and promotion giving authentic visual accounting of events and individuals. Once paper-strip film was unleashed it was followed by moving pictures. France inventors had worked on moving pictures with Louis Le Prince releasing the first documented moving picture in 1878. Cinematographic first short film was released in Paris December 28, 1889 by Lumière Brothers. These new ways of replicating photographs opened a new dimension in art.

In 1887 Remington made a trip to Canada where he produced illustrations of the Blackfoot, the Crow Nation, and the Canadian Mounties. He became a favorite of Western Army officers fighting the last Native American battles and was commissioned to do eighty-three illustrations for a book by Theodore Roosevelt. Roosevelt and Remington had similar early adventures in the Midwest both trying ranching and both losing money in their quest to be "cowboys". As Charlie Russell would attest to, it's not as easy as it appears on canvas.

Charlie Russell and Fredrick Remington had some similar vision of the fury that was the winding down of the wild west. Somewhere between a territory and statehood at an International no-man's-land, two young artists were capturing what was left of the wild west and those savage Indians. The significant difference is that Charlie lived the life of a cowboy and understood all the minute details that made a significant difference in a painting and a picture.

Both Russell and Remington were living with the Blood and Piegan Indians in 1888. The Blood and Piegan's summer hunting camps were in the Sweet Grass Hills where gold had recently been discovered and the Indians and Half-breeds had begun to sell their squatter's rights and land claims. "Our Heritage" has a statement from Con Price on page 12; "I have seen steers so fat we could hardly drive them into the roundups after grazing for a summer on the grass in the Sweet Grass Hills." It was no wonder that the buffalo herds migrated to this sanctuary when their numbers began to dwindle.

Before the excitement became a flurry in the Sweet Grass Hills, Charlie Russell and Pike Miller had made their journey to Helena from St Louis via Utah through Idaho (via the Utah & Northern Railroad), and on to Helena where Pike Miller purchased supplies for his sheep ranch in Judith Basin along with a wagon and team to haul the supplies to the ranch. Charlie was not quite 16 when he and Pike had left St Louis in the early spring of 1880. There has not been mention of the pair celebrating anywhere along the trail, so Charlie probably missed that 16th birthday. Charlie did mention to friends later that he found Pike Miller to be a less than pleasant traveling partner and nicknamed him "*ornery*" Miller. When the pair arrived at Helena, they found the streets lined with freight outfits. Miller ignored Charlie while he was getting his supplies. Some reports say it was Miller who called Charlie "*ornery*". Charlie figured he better get himself a couple of horses with the money he had so he could follow ornery to his Montana ranch. He had not bought his own horse before and soon found out he was not good at picking a mount, yet. By the time they reached the ranch Charlie was feeling like the two horses he had bought were a mistake, but they got him to the sheep ranch.

Charlie could not find a comfort level working with Miller, his draft horses, and those stinky sheep. Making clay figures of those little woolies was one thing; but dealing with the smelly seemingly stupid live critters and their rank odor was not a job Charlie was willing to learn with ornery Miller giving orders without instruction. He took his two draft horses and tack and left the sheep business without bidding farewell, after a noticeably abbreviated time, at Pike Miller's ranch. His first night on his own, without food or a bedroll, he met a hunter-trapper named Jake Hoover. Charles M. Russell had escaped the confinement of school and the oppressive abuse of a sheep herder, but his education was just beginning and his enthusiasm for learning to get it right stayed with him throughout his lifetime. The winter season of trapping was over, but the settlers, miners, and military personnel gave hunters a market for fresh meat. Charlie was about to learn where the fun ends and the work begins hunting and dressing out wild game. He would also learn how to skin and procure hides as there was a market for those too, and anything that had value was used by the frontiersmen. Charlie would learn that everything involved with survival out west required attention to surroundings and detail, something he had already practiced.

Jake Hoover could see Charlie was woefully equipped for the frontier simply by the horses and gear Charlie had. Despite his naiveté, Jake took an immediate liking to Charlie as many more men of the west would. Charlie had a way of talking with his hands that communicated his point of view in a media everyone could relate to. The beautiful skies, breath-taking landscapes, colorful Indigenous Peoples, and animals that appear in his works today contain such accuracy as to transport the viewer to the place and time in Montana. His challenges and assets would not have sustained any other person, but Charlie was not just anybody. Kid Russell, with the help of his chosen life's companions, adapted to a culture and country that was strange and sometimes savage requiring quick wit and definitive action for survival. He had the best of communication skills. A good listener.

Jake and the Kid worked together for most of two years. Hoover never told Charlie how or what to do but he offered suggestions. The first suggestion he gave to Charlie was about picking a horse. He said

he wouldn't recommend a mare and suggested a lighter horse than the work horses Charlie had. He mentioned that they would probably meet some Indians along the way who would have such animals to trade and the Indians would find Charlie's draft horses attractive for pulling travois and other tasks. He told Charlie the Indians would be friendly and open to trade. Charlie took in all the details.

As Jake Hoover had said, the two of them met a group of young Piegan Indians who indeed had horses to trade and were anxious to have Charlie's big draft horses. He traded for two smaller geldings. One was a pinto he named Monty. Monty was Charlie's first silent partner. Charlie and Monty would be a pair until 1904 when Monty died of old age in Great Falls. Monty had a stable and pen alongside Charlie's cabin in Great Falls his last few years of life so as the century turned, together horse and rider watched the west they knew disappear.

Kid Russell worked alongside Jake Hoover trapping and hunting, learning the work that comes with dressing out wild game and preserving pelts. The two men would travel as far north as Fort Benton where the Steamboat still brought passengers, both civilian and military, and supplies up the Missouri. That was networking at that time. It gave Charlie a broad canvas at a gracious pace which he deeply enjoyed savoring every detail and person he encountered. In 2019 Jake Hoover's cabin still stands where it was moved: on the Trask Ranch in Judith Basin. Approximately forty miles from Lewistown near the town of Utica. Charles M. Russell, Jake Hoover, and Monty were three frontier companions who shared their passions in life each adapting to the changing times adding to their knowledge with each learning from the other. As a trapper, Charlie was learning the habits of wildlife in their native habitat. Harvesting game meat and preserving hides gave Charlie the feel of the animals and their coats. He learned how the hides change with the seasons and what the animals ate to survive. This was the west Charlie was looking for. Jake Hoover and Kid Russell found a niche market that kept them comfortable in the lifestyle they chose to maintain.

There were several contentious factors surrounding Charlie in the Judith Basin. One was the "savage" Indians. His first encounter had

been when a friendly group of young Piegans traded horses with him and he had gotten Monty. Jake Hoover had been there to initiate the introductions and the horse trading, but what would happen if Charlie met up with some Indians when he was alone? Later in life Charlie shared this story with friends:

"Charlie admitted to moments of uneasiness when he first met Indians on his initial trip into Judith Basin. He made a story about two Indian's at Jake Hoover's camp and the boy was alone; the Indians demanded food. Charlie cooks pancakes faster than he's ever done anything in his life."

This story has been told in several forms of media and books. This version was in "C M Russell's West" photography by Sam Abell and Introduction by Ginger Renneron.

That lesson of cooking pancakes never left Charlie. He loved to entertain serving up pancakes and coffee and dried apples for dessert. The fall hunting camps that pop up around the Mountains in Montana still come to life at early dawn to the smell of coffee and pancakes on the grill. There was good reason for unease in Montana territory when Charlie left St Louis heading out on his own. Disappearance of beaver and other fur bearing animals had happened by the late 1700's. The first steamboat had arrived at Fort Lewis in 1832. In 1850 the name of Fort Lewis was changed to Fort Benton. The Chippewa was the first mountain steamboat to reach Fort Benton in 1859. It was a two-month round trip from St Louis, Missouri to Fort Benton, Montana Territory. Prior to 1891 all business from southern Alberta, Canada throughout Montana Territory was done in Fort Benton. When the railroad arrived the speed of the shift in commerce was breath-taking. Seemingly overnight, banking, shipping of furs, wool, and hides, gold, coal, household goods and livestock were transported all directions instead of by steamboat on the Missouri from Red Rock Creek in Montana over 2700 miles to the Mississippi.

From Charlie Russell's return to the U.S. from his first cattle drive to Canada to 1886 there are few records of where he was and what he was doing. One thing that is known is that he spent some of that time with the Piegan Indians both in Canada and the U.S., and at calvary and Royal Canadian Mounted Police camps. It was during this time

the Indians began to regard Charlie as a powerful Medicine Man. His gentle manner and ability to raise sculpted images from clay and sketch likenesses with intimate detail was an unexpected gift from a white man who sought to learn to communicate with the Indians in a medium that was comprehensive.

Other men who would become homesteaders and ranchers were starting to arrive by steamboat and with military regiments from Canada and United States. One such arrival was Herman Brinkman. He came to Montana via Miles City with Colonel Fetterman's Yellowstone expedition. The entourage arrived in Fort Benton on the steamship Key West around 1866. Herman's wife and oldest daughter, Edith, joined him later and he began his life in Montana mining, freighting, cutting wood for steamboats (wood runner), and working for the Benton-St Louis Cattle Company. He turned his crafts to building water wheels along the rivers of Montana bringing irrigation systems for gardens throughout the valleys. The last of his water wheels was destroyed in the flood of 1964 on the Marias River a few miles above Loma. As his family grew, he homesteaded on the Marias River Valley where he lived out his life. His three sons, John, Charles, and Henry grew up working on their home ranch: all of them excellent horsemen. They were sought after ranch hands earning $50 a month instead of the going wage of $40. John went to work for the Circle outfit while Kelly went to work on the Teton and Charles went to work for Spencer's. John and Charles Brinkman filed adjacent homestead claims to their parent's ranch forming a cattle ranch that extended into Toole and Liberty Counties. Eventually they worked for McNamara & Marlow out of Big Sandy during the spring, summer, and fall. The two Brinkman girls married cowboys. Edith married Tom Morgan Sr. and May married Al Branson, both top hands in northern Montana in the late 1800's and early 1900's. Morgan and Branson also worked for McNamara & Marlow.

John Brinkman tried a short adventuresome job on the riverboat as part of the crew, but after peeling potatoes from Fort Benton to St Louis and back again he thought that being "a cowboy" sounded pretty good. John stayed on the home ranch marrying December 24, 1910. His wife was the widow Fey Lawrenson Mansfield, a schoolteacher who was the

first teacher in Chester. Fey had taught at Landusky before coming to Chester. One of her students at Landusky was Danny Landusky, son of the town's namesake.

John and Fey Brinkman were very social, although Fey experienced frail health most of her adult life. Handicapped by ill health and the isolation of ranch life, Fey continued to educate herself in literature, languages, and sciences keeping correspondents with national and international authorities. One class of itinerants Fey was not fond of was the hired men who had no wish to improve their situation in life. John was an excellent roper and was often sought out to judge rodeo competitions when they began having roping events. He judged the Calgary Stampede and became friends with Guy Weadick. Charles M. Russell and Con Price were also friends of the Brinkman's. John loaned Con a suit to get married in, however, after receiving a wedding photo of Con and Claudia Toole Price, John never saw the garment again.

The Russell's and Brinkman's visited Weadick's Stampede Ranch in Alberta Canada on occasion. When Guy Weadick came to Calgary from Texas he was enamored with the surrounding country. He purchased the ranch north of Calgary as a retreat for himself and his wife and all the friends they made in their effort to organize the 1912 Calgary Stampede with the North American Indian exhibition.

EWES AREN'T FOR EVERYONE

Sheep became a commercial industry in Montana in 1869 with the arrival of 1,500 head in Beaverhead county brought in by J.F. Bishop and R.A. Reynolds. The band was purchased in California for $2.50 average per head and were trailed from California thru Oregon and Idaho before reaching Miles City November 17, 1869. Another firm arrived the same year with 30,000 head of sheep from California. They became dissatisfied with the country and headed south with 32,000 head of breeding sheep two years later and located in Apache County, Arizona having driven their band along the Mormon Trail through Utah.

Poindexter and Orr established a livestock operation in 1870 when they drove a 2,700 band of sheep and 375 head of horses to Montana from California. They located in Beaverhead County and have / had the first brand recorded in Montana State – the square and compass brand. In 1882 Poindexter and Orr sold 4,000 head of cattle to the Cochrane ranch of Canada and had them trailed to the ranch just south of Calgary. Young C.M. Russell participated in this, his first cattle drive. Sometime in the early 1900's, William Townshend, foreman for Poindexter and Orr Cattle Company, came to the Sweet Grass Hills and purchased a ranch in Bear Gulch Creek. He was in partnership with Tom Maynaise. Townshend married Mable Bingham in 1910 and the partnership dissolved.

From around 1865 to 1886 it was common for stockmen establishing

ranches in Montana to start with sheep then convert to cattle in one or two years. During that period of open range, the grass was plentiful, and sheep were considerably more affordable at $2.50 average per head netting $3.00 to $4.00 per head as three years old or older. It was considered that 5 head of sheep could survive on the same amount of land that one cow needed for range. In addition, there was the wool crop. Sheep frequently birth twins and triplets are not uncommon, so herd size often doubles in less than a year. The gestation period for ewes is 142 to 154 days which means it is possible to raise two lamb crops a year. The annual increase of flocks was placed at 48 per cent in 1881. Two-year old sheep averaged an upward range from 80 to 115 per cent. A live lamb was worth $2.00 and at three months valued at $2.50 to $3.00.

Wool was being exported replacing the declining buffalo hide trade and becoming one of Montana's largest agricultural export crops. The 1880 Department of Interior census reported 1,300,000 pounds of wool was exported from the Territory. Montana's first commercial sheep ranch was in Beaverhead Valley. John Bishop and R.A Reynolds sold the first crop of wool shipped out of Montana. Charles Broadwater bought and freighted the first "*wool clip*" marketing it in Utah. Railroad transportation of wool was established in the southwest of Montana significantly lower shipping costs to textile facilities.

Before 1873 the estimates are less than a thousand head of sheep in Montana. By 1881 there was 300,000 head. Most of the wool crops were either high grade Merino or Cotswold. Sheep that were brought to Montana from California often had inferior wool, but after the first clipping the regrowth produced a notably resilient finish. Fleece averaged six pounds and wool sold at .25 to .30 cents per pound. One pound of beef was selling for .25 cents at the butcher shops. Profits in wool-growing were placed higher than in cattle growing. Conservative figures reflected from 25 to 35 per cent per annum on all capital invested. Wool clip would pay every item of expense leaving clear gain. A single herder averaged 2,000 head of sheep, however, shearing required numerous skilled shearers for clipping and packing. Crews of

20 or more men would travel throughout the territory in late winter to early spring to complete this work.

Although cattle were the preferred livestock by the early 1900's, many first-generation ranchers wanting to start out on their own began with sheep. Sheep were more affordable and because of the shorter gestation period and odds of producing twins thereby doubling the herd size, starting with sheep then upgrading to cattle was a trend until around 1930. By this time, the grazing range was becoming depleted of native forage that cattle preferred on pastures where sheep were grazed. This caused an interruption in gain when the shift from sheep to cattle took place. The problem was recognized immediately and because pastures were fenced, ranchers began rotating fields for grazing and developing water reservoirs with dams to resolve the problem. Some ranchers maintained both sheep and cattle crops but found it increasingly difficult to find herders for the sheep in Montana.

The population of miners, businessmen, and emigrants did not favor mutton to beef in the 1870's. Cowboys and Indians also preferred beef to sheep for both handling and harvest. Butchering a sheep requires keeping the lanolin rich wool from touching the meat or the flavor of the meat is soured. Sheep have a distinct odor which may be offensive to horses and cattle as well as humans. If a water source had sheep drinking from it, several days would have to pass before cattle or horses would drink from the same pool. River crossings for cattle herds were often stalled when cattle refused to cross for unknown reasons (to the wranglers). In the same way, pasture that is grazed by sheep is left without desirable forage for horses or cattle. These were some of the reasons for the sheep vs. cattle wars. These disputes over property were not as prevalent in Montana territory as in Wyoming and Utah, but Granville Stuart reported there was one settler on Birch Creek in 1872 who sent a letter to a neighboring rancher that if "*the sheep weren't moved*" he "*would kill the herder and scatter the sheep*". Disposing of the herder may have been a task not difficult to achieve at that time, but scattering sheep remains an arduous task even for two dogs and a good horse.

Repping was the term used for the person with full authority of a

roundup crew. The rep kept tally of all the brand owners for the open range cattle gathered by their crew, particularly in the fall roundups. Later the term was changed to foreman, but when the range was open someone had to know, identify, and tally the number of cattle carrying each brand within the herds gathered. Once fences defined range, cattle were kept in pastures with single owners. Being the rep was a promotion from cowhand that came with a lot of responsibility along with benefits like having a string of good cow horses for your personal use and being your own boss. The stock owners rarely worked their own livestock and instead relied on representatives to manage the cowboys and livestock. It was not for everyone because it required that you know all the brands and what ranch they belonged to which meant reading, writing, and math or ciphering. Rather than sorting and shipping by brand, mixed brands were shipped filling out the 2,000 head drive and later filling train cars. There was no separating, and payment was sent to the brand owners from the buyers at the endpoint.

This method of handling stock was starkly different between cattle and sheep ranchers. Sheep tend to stay in a bunch and are marked with earmarks or dye on their wool and occasionally a small brand on the jaw. Their range was a tighter circle keeping a herder close to home. Cattle travel miles and cowboys saw a lot of country during roundups. Cowboys met a lot more people, traveled a lot more country, and got to town to socialize more than sheep herders did giving the cowboy an opportunity to learn about local cultures.

"The Immortal Irishman" by Timothy Egan has a quote from Thomas Meagher; *"Nothing delights me as much being on horseback."* This same edition quotes Meagher in a letter he wrote to Father DeSmet: *"Every collection of log huts is called a city in this ambitious country."* These two sentiments written in the mid 1800's pretty well state the pros and cons of this unique area. For young C.M. Russell, his best friend was carrying him through this journey. Anyone who has ever felt as Thomas Meagher about being on horseback can imagine how Charlie Russell felt covering Montana on Monty.

1865 is the year Secretary of State, William H. Seward and William West floated the idea that perhaps Montana Territory could become

the "*New Ireland of which no doubt General Meagher would in due time be elected Governor*". Indeed, Thomas Francis Meagher was contacted by telegram from President Andrew Johnson informing him he had been appointed Secretary of Montana, the second highest office in the Territory. Meagher did not find Montana as beautiful and charming as Charlie Russell did. In his defense, he had more on his plate to manage. Meagher spent most of his time in Montana without his wife and often without pay. Twenty years before Kid Russell entered the State, during Meagher's tenure, the Indians were savage and the west truly untamed. Being on horseback, Meagher could daydream his way back to the Emerald Isle and view the vast landscape with a lush green covering of foliage.

In his book, "The Blackfeet; *Raiders of the Northwestern Plains*", John C Ewers gives explanation and accounting of the Indians and references to David Thompson and others who worked with, and made record of transitions happening in Montana during the late 1700's through the mid 1900's. In addition to his personal experience, Ewers spent endless hours researching documented accounts of the Indians and their culture. Included are many accounts from female Indians, of their treatment and role, as this devolution transpired.

It was estimated that there were 484,134 head of livestock occupying 38,000,000 acres of land in Montana's estimated at 58.0 million acres in 1880. The estimated acreage is a flatland estimate not considering the added acreage of slopes on hills and Mountains, the type of topography covering most of the territory. Momentous changes had occurred in fifteen years to Montana territory. With communication systems what they were at that time, some of the history will never be told. Some can be found in threads of evidence left by the scars on the landscape and traces found in reports and ledgers now available online and in the library in books that haven't had their covers opened in years. Bill Morris's pictorial accounting of his father Chas E. Morris photography journey through the west tells more about how it was than most historical accounts can relay in words.

The number of cattle, horses, and sheep in Montana Territory on the 1880 tax list:

Cattle – 274,316; Horses – 51,356; Sheep – 249,978. Wool export in pounds: 1875 – 90,000; 1880 – 1,300,000. Cattle export 1775: Head – 5,000; Value -- $110.000.00. Cattle export 1880: Head – 30,000; Value -- $750,000.00.

Statistics and information in this chapter can be found in "Montana and Yellowstone National Park" by Robert E. Strahorn and "Ranching in Beaverhead County 1863 – 1960, Transition Through Three Generations" by Lisa Nicholas scholar works from the University of Montana.

In 1880, 1,150 head of live beef cattle were transported from Fort Benton to Bismarck for shipment by rail to Chicago. Indians had attempted to halt the advance of the railroad, but track arrived in the summer of 1873. James J. Hill received a portion of his land grants for the completion of his rail line to Dakota Territory. Once the line was operating people traveling east from Montana would take a Steamboat as far as Bismarck and then continue their passage by train. Emigrants and merchants began using these same transportation routes traveling east and west with their belongings and goods.

Indians encountered in the west were not as savage as they were hungry, confused, and afraid. A truly disastrous physical condition mixed with cumulative emotions. Witnesses found in the late 1800's that the Indians were being run off their own lands and starving due to the decline in forage and wildlife, both of which had been the sole sustenance of the Indian. The greatest threat to non-Indian's were the thieves, robbers, desperados, criminals, vigilantes, and the worst class of refugees from justice who had swarmed Montana Territory in search of gold and other ores. The Indian was considered to be *too lazy to utilize any form of natural wealth and too despicably jealous and mean to allow others to utilize it.* Vigilante Committees were forming throughout the territory wherever trade centers established. Charlie carried a handgun and a rifle which he had become proficient with while hunting with Jake Hoover, but he had given up the thought of hunting savages. He was empathetic to the Indians and becoming ever more suspect of the educated 'white's' he met and did business with. He also knew he was more interested in horses and cattle than sheep and wild game. Many

men Charlie's age and older were traveling through Judith Basin with cattle herds. Jake and Charlie sold wild game to the camp cooks which afforded them an income and usually an invite to a meal. It gave Kid Russell a chance to study the cross-culture of the west and some men his age traveling to Montana for the first time with the herds of cattle. Charlie's father, thinking Charlie couldn't possibly make it on his own in Montana, sent Charlie money to come home in 1881. Charlie sent the money back to his father in St Louis. He let his parents know he would return in his own time on his own dime.

The diversity of people in this northwest region had begun in the 1700's with trappers and traders who had depleted the beaver population in the territory by the late 1700's. Many of the French trappers had married Indians and remained in the country with their families. Other groups, Irish, Spanish, Scots, Dutch and Chinese had immigrated to the "new land" for the Revolutionary War, the French and Indian Wars, the Civil War, and the building of the railroads across the continent. Immigrants did not come to Montana from one direction. They came from all directions finding land that was vast and reasonably virgin.

In 1883 Charlie knew his parents really wanted to see with their own eyes how he was so in early spring after prime hunting and trapping season was over, he dutifully made a trip to St Louis. He stayed for about all he could stand of four weeks. His cousin, James Fulkerson, who was nine months younger than Charlie, wanted to come west with Charlie and the pair made it back as far as Billings. James contracted mountain fever, now known as Lyme Disease, and died in Billings May 27, 1883. Charlie was not sure what to do because he didn't have a horse or saddle and had run out of money. He bumped into a cowboy he knew on the street one day and borrowed a horse and saddle and headed for Judith Basin.

Charlie Russell almost missed seeing the "savage Indians", instead arriving when they were at their most desperate state. The trappers were becoming equally desperate with the decline of buffalo and furs. Compounding the danger were the thieves who would murder and steal from anyone without restraint as boundaries were not established for jurisdiction. It seems utterly amazing that after a brief trip to St Louis

in 1883 this eighteen-year-old boy insisted on returning to Montana where he lived most of his life.

It was spring calving time on the open ranges. The big cattle outfits were getting their wranglers to brand the new calves before they began to scatter. Wranglers earned $40 a month and all the grub they could eat. The work would last through the winter if the man could hold his own with the elements. Charlie had not had a lot of practice at the craft but was eager to give it a try. John Cabler of the Z and V outfit gave him a job as horse-wrangler. The horse-wrangler position was a night shift watch which may have suited Charlie Russell better than he might have supposed. Charlie Russell may have had the advantage of seeing more accurately at night as color blindness (deficiency) is often exacerbated in bright light. Some hue's jump out in color and fade or intensify causing a pulsating motion. At night, the hues are not as definitive making night vision sharper for a person with this deficiency.

In the fall the ranches were getting ready for the big roundups. The Z and V met up with Judith roundup foreman, Horace Brewster. As round-up foreman (Rep), Brewster worked for several brand owners. All brands of cattle were roaming on open range after calving and branding in the spring. Fall was the big gathering when all cows and calves were rounded up. Once gathered, calves were separated out for shipping. This practice is still a fall activity in Montana, but rangeland is fenced, and the only sorting of brands comes when the calves cross the scales, and an odd brand shows up and is returned to its owner. Before barbed wire, fall roundup crews consisted of wranglers who had worked for a brand ranch all year plus any cowboys who could sit a horse and needed the money. There were hundreds of cowboys covering thousands of square miles requiring twice as many horses as men. "True", Horace Brewster's boss name, had just lost his night herder for the horse herd and John Cabler recommended Charlie Russell for the job.

Charlie confided in friends later that he was unsure of his abilities with his short stint for Z and V and their small herd, but he felt fortunate to have a job. True was a little unsure as well as he had been foreman of the fall round-up for several years and had not heard anything about Kid Russell. One of the hands, Ed Older, was a wrangler with the Judith

roundup and recognized Charlie as the "*kid who drew S.S. Hobson's ranch so real*". True called Charlie the "*Buckskin Kid*" and bet Ed they would be afoot in the morning. Charlie had to turn up the volume for the larger audience. He had found out that singing to the livestock at night was a good habit for keeping cattle from stampeding as well as calming to the horses. True and the boys were all happy to see their mounts rested and ready for the days' work the next morning. About the same time, it was beginning to occur to Charlie that he was good at more than one thing. His drawings had a value. For one thing they made an introduction. He was good at something and people were starting to notice. The west was becoming to Charlie and that was becoming clear in the work that sprang from the man.

Charlie worked for True intermittently on the Judith roundups for the better part of eleven years and was promoted to herding cattle by the fall of 1883. Before turning the cattle out to open range, Poindexter and Orr had their square and compass brand cattle sorted from the big roundup herd to send 4,000 head from Lewistown to the Cochran ranch outside of Calgary, Alberta, Canada. Poindexter and Orr were still in the sheep business but were among the livestock owners who had transitioned to running both cattle and sheep. Most of the trail hands had headed east with the calves after fall roundup. Some would stay in Chicago until they spent the money they had earned. Others would return to the ranches and cabins to winter the cows. Charlie was offered a job wrangling for the square and compass herd heading north to Calgary.

The pay was $40 a month, all the beans you could eat and all the Arbuckle you could drink. Charlie had Monty, his pack horse, saddle, tack, and bedroll, (another skill Jake Hoover had shown him), and a job offer to herd cows into the start of winter expanding his range with a paying job. Forty dollars a month wasn't going to make Charlie a rich man, but the work suited him, and he was being introduced to the wild west with a bunch of cowboys who knew more about where they were going than he did. At least that was his hope.

The average trail drive at that time was around 500 miles and sixty days was how much time it would take averaging 20 miles a day with

intermittent watering stops. Lewistown to Calgary is a distance around 420 miles. Counting the time it would take to trail the cattle to Calgary and return to Judith Basin, the crew probably were paid for two months plus food and extra horses if needed. There were few men available who could ride and had their own horse who were not already working for a brand. Charlie was in the right place at the right time and got his first job as a cowpuncher heading further into uncharted territory. The route would take him north along the Whoop Up Trail passing near the Sweet Grass Hills, Raymond, Alberta, Canada, Fort Macleod, and Head-Smashed-In Buffalo Jump.

Water is readily available along the route. Most herds of cattle were limited in size to 2,000 head due to limited watering resources along routes. With water availability and a crew of 30 cowboys the 4000 head of cattle probably averaged 15 miles a day. The camp and road outfit provided an ax, shovel, pick, tools, cooking and mess articles, and firearms along with a cook and wagon. Many of the men who swarmed Montana after the Civil War came looking for easy money and were idle and shiftless never wanting to stretch their abilities beyond the boundaries of 'easy come easy go'. Poker and out and out thievery were their prime pastimes and tracking a cow on horseback did not fit their repertoire. Most of the men Charlie had rode with during the roundup were on the trail drives to Chicago or sitting at a bar or poker table, or both. Winter was about to settle in, but Charlie trusted that he and Monty could manage the job.

The act of appropriation authorizing a survey of the 49th Parallel was approved March 19, 1872 but none of Montana Territory was surveyed by the US before 1874. Creation of the United States Geological commission happened in 1879. The International border between Canada and United States had yet to be defined. A joint Commission was necessary to set up governance of the commerce and property divisions between the two Nations. There was no "port-of-entry" denoting the 49th parallel but a small town had assembled near where Coutts and Sweetgrass now reside and it was generally presumed that directly east and west of those two little towns was the border line

between countries. Kid Russell would get his first look at the Marias and Milk Rivers and parts of Canada.

Whoop-Up Trail became a transportation corridor in 1862 when John J. Healy made his first trip from Fort Benton, Montana to Milk River, Alberta, Canada. Healy subscribed to the John Jacob Astor style of trading with the Indians. Astor started the American Fur Company with his style of vending liquor for furs and demoralizing the Indians, all nations. By extracting himself from situations and by religion and training, his rational maintained control of his greed and passion for dominance. The give and take of nature's role in the frontier made Astor naturally at home gaining dominance financially in society at large. J.J. Healy was a quick study of this trading style and aware of the effect. The frontier movement was a 'constant' in the conditioning of the nation in the mid to late 1800's. It marked the national character along with low-church religion and democracy. This conflictive duplexity continues today.

Fort Conrad was built as a trading post along the Whoop-Up trail in 1875. This was an important stop-over point for wagons traveling between Fort Benton and Lethbridge. This small post became a major trade center for the Blackfeet Indians. Located about ten miles upstream from where the Baker Massacre occurred on the Marias River, Fort Conrad never had a stockade. It was built after the Baker Massacre at the dry fork of the Marias south of Lothair where the Denson Ranch was originally; later becoming the Pugsley Ranch. There were a few log buildings, a storeroom, warehouse, barns, and corrals. Sol Abbott and Henry Powell were the first to operate it. John Healy and A.B. Hamilton purchased the trading post and then sold it to I.G. Baker. In 1878 Joe Kipp bought Fort Conrad where his family lived until they moved to the Blackfoot Indian Reservation in 1885. James McDevitt purchased the Fort from Kipp and in 1888 Mike Connelly moved with his family from Fort Benton to Fort Conrad. Until the flood of 1908, bones and skulls from the Baker Massacre were frequently found on the field. Timber D. Hull found a skull on the bank of Lake Elwell in September of 2020. It is thought to be one of the last remaining artifacts from this sad event along the banks of the Marias River.

In 1878 the Canadian Temperance Act was passed to thwart the illicit sale of liquor to the Indians. The Indians were placed on the defensive by the unrelenting onslaught of whites who brought not only gunfire but the more destructive forces of vice and disease. The Canadian government realized lawlessness on the rise from the Indians under the influence of the intoxicant that was not pure liquor, but was a mixture of toxic elements along with traces of fermented corn-based liquor. Canadian militia was under increasing threat from inebriated Indians and outlaw fur trappers who were experiencing a loss of income due to the vanishing sources of their trade. Both Britain and the United States were blaming the Indians for the delay in getting the boundary between countries surveyed.

Charles M. Russell's first cattle drive was going to take him through much of the country he would revisit and record throughout his life. The history of Montana from territory to Statehood is greatly influenced by Indians and Métis. These two cultures were the first people's inhabiting the regions of the interior of North America. Predominant in north central Montana and south-central Canada were the Blackfoot Indians. Blackfoot is disambiguation of the Blackfeet Nation. The Blackfeet Nation consists of several tribes including Piegan, Gros Ventre, Blood, and Blackfoot Sioux. Blackfoot and Piegan were largely located north of the 49th Parallel once the boundary was surveyed. By the late 1800's all Native American Tribes had been adversely affected by the disappearance of wildlife and the encroachment of European settlers. Poindexter and Orr no doubt had some Indian and Métis riding with their cowboys for three good reasons: 1.) *To ensure safety and function as guides.* 2.) *They were readily available and willing to work.* 3.) *Métis and Indians both had the right to cross the border without restrictions according to the Jay Treaty.*

Working with the Métis may have influenced Charlie as the unique and colorful sash worn as an intricate part of Métis attire became a part of Charles M. Russell's wardrobe. Most of the Métis were proficient in English as well as numerous Indian dialects and sign language. Métis evolved from Hudson Bay Company licensed employees who had married Native North American Indians. The marriages and children

from these communal matches became a unique culture evolving into a nation of their own governance. The Latin words *miscene* and *misticicius* mean "to mix" and "mixed race" respectively. Métis is a French word with the literal translation of "half-breed". Another word the Métis used to commit their origin was "michif" meaning "country born". A nationhood of people derived in North America with known ancestry.

Indian tribes, Métis, trappers, Chinese, and other cultures each dressed in a specific manner and specialized in specific food processing, beadwork, paint gathering, and other facets of skilled trades that enabled each to have niche marketing products. Since pharmaceuticals were unavailable, food and fauna were their medicines. The chemistry of plants carried important constituents according to the plant and environment from where it originated. These were most valuable trade items. Knowledge of carpentry, laundering clothes, cooking, hunting, and navigation were some specialized talents this diversity brought to the west.

Métis are generally very industrious, most often intelligent, stoic, and dress with a practical flare. Their foodstuff, pemmican, and the sac-à-feu (bag) were two identifying items these voyagers carried in their distinctive two wheeled carts. The sash and sac-à-feu became an identifying part of Charlie's wardrobe. The bag was used for carrying his clay and art tools and the sash for a belt wrapped around a coat or scarf and muffler to keep warm in winter. The sash could also be used as a strap or sling passing across the forehead and over the shoulders to support a load on the back or a rope for pulling, a washcloth, towel, a first-aid or emergency sewing kit, and blanket under saddle or an emergency bridle were common conversions for this clothing article. The most common use was to hold up the pants rather than suspenders. Charlie may have learned from the Métis the meanings of the colors the sash displayed in emotions giving a better understanding of tactile connection to color.

Spending a month or two with 4,000 head of cattle, 30 or more cowboys with as many or more horses plus all you could eat, with pay to boot, probably looked like a pretty good start to Kid Russell. There was the opportunity for Charlie to add to his resume, meet some real

cowboys, and see new country. There was one more thought that may have been on Charles M. Russell's mind. The Knight Ranch was located right along the Whoop-up Trail and Charlie had learned about it when he and Pike Miller had stopped at his second cousin, John Bascom's, when they left St Louis and traveled through Utah before catching the train to Montana. John's brother-in-law, Ike Lybbert, was working as a blacksmith on the Knight ranch shoeing horses for the Mounted Police and US Calvary. The ranch consisted of approximately 400,000 acres of land stocked with over 15,000 head of cattle and 40,000 head of sheep. It was an opportune time for a young artist to have a look at some plains Indians in their native habitat and meet the Mounties. The Piegan tribe appeared to be the friendliest of the Blackfeet and had a permanent camp in the Sweet Grass Hills. Charlie didn't have anything waiting for him back in Judith Basin and there was a lot of country he had not seen.

CHAPTER 13

BOYS TO MEN

After leaving the cattle herd near Calgary sometime in December of 1883, Charlie headed south stopping at the Knight Ranch on his way back to Judith Basin. While he was there, he drew a sketch on the bunkhouse wall that remained when John Bascom's son, Earl, came to the Knight Ranch in 1914.

The ranch hands working for Jesse Knight knew the country for miles around in all directions and possibly suggested that Charlie take a shortcut on his return trip to Judith Basin. The Sweet Grass Hills lie north of Fort Benton and there was a small settlement called Gold Butte on the northwest side of Middle Butte, a Canadian army camp north of Middle Butte, and two army camps in the Sweet Grass Hills about a day's ride apart. One south of the Writing On Stone Canadian camp on Milk River near Big Lake on West Butte and the other on the south side of East Butte. The trail would be open, and the army camps welcomed guests in the barracks. Gold Butte had a saloon and trade post both offering lodging and food. Charlie most likely followed that route back as far as Fort Benton giving him safe lodgings at night and trails to follow in daylight cutting a hundred miles off his return journey.

The two Calvary camps in the Sweet Grass Hills were in need of recruits as the boundary had not been surveyed and lawlessness was burgeoning in dispute for the declining buffalo hide and fur trade plus emergence of gold fever, land claims, and general employment. Gold Butte had a frenzy of activity prior to the construction of any permanent

buildings once gold was discovered. Marion Carey, Fred Derwent, Rodney Barnes, John Der Champs and George Walters filed a gold claim at the Choteau County Courthouse. Federal writers' Project, Montana: Published in 1939 by Viking Press, N.Y. page 281 states; *"Placer gold was found there [Gold Butte] by a Blackfoot in 1884. It was not a fabulous strike, as stampeders soon learned, but until the vein was worked out nearly every shovel of pay dirt yielded $.25 in color (gold left after waste has been washed away). Hence, the discovery canyon was named Two Bit Gulch"*.

An extensive article titled *"Gold Butte … Once a thriving Mining Town"* in The Shelby Promoter and Tribune dated Thursday, July 9, 1964 by Jonni Flanagan states that *"White gold was discovered in 1884 by Rodney A. Barnes and George Walters near Middle Butte."* The discovery of gold in the Sweet Grass Hills most often is credited to Rodney A. Barnes although there are variations of the discovery. One fact is consistent, the Indians owned the Sweet Grass Hills until 1889 and if you were not an Indian you were not legally making claims, homestead or otherwise, in the Sweet Grass Hills prior to that time.

James Hill tapped into Montana mining starts of Daly & Clark, copper kings, in 1882 and in 1883 he spent a night in the Sweet Grass Hills near where the town of Hill located just south of the East Butte Calvary camp. Over an open fire looking toward the Rocky Mountain front growing golden at sunset, James Hill said in a prophetic matter; *"The Manitoba will even cross those great piles of rock and earth and press on to the Pacific Ocean, until Seattle, Tacoma, and Portland are connected with the East by the best constructed transcontinental road in America"*. A large entourage of military, International government, map makers and others traveled with Hill on this excursion exploring the possibility of building a rail spur to the Sweet Grass Hills.

The reporting of gold found in 1884 and James Hill's visit to the Hills in 1883 had both been preceded by scouting parties, politicians, and settlers beginning in 1881. Gold was discovered but was left unclaimed because the Hills were Indian lands. Gold Butte was originally a Piegan encampment used in the summer for procuring buffalo meat, wild berries and sweetgrass to be taken back to winter encampments for

survival and trade. When settlers began encroaching, the Blackfoot and Piegan had begun staying at the Gold Butte encampment making it a permanent settlement. The men sent to the Hills with government work and private enterprise knew they could not file a claim unless they were half-breeds, trappers for Hudson Bay Company, Indian, or married to an Indian. When the first signs of gold and other ores were discovered it took several months before a group of men found one legitimate claimant to file on the canyon in Gold Butte. Even then, the party was inclined to remain elusive about the exact location and specific names until they found out if their claim would be legal.

John George "Kootnai" Brown, once a scout for the military camps in the Buttes (also known as the Sweet Grass Hills), was among the first settlers of Waterton Lakes National Park. In a 1955 Great Falls Tribune article, a Lethbridge Correspondent wrote an article about John George Brown: *"Kootnai married an Indian woman and the two are buried in Waterton ... He said he took his wife to the Sweet Grass Hills one winter and lived in a little cabin built while they were with the half-breeds hunting buffalo."* The cabin built on West Butte was the only permanent cabin in the area before the gold claim was filed. Kootnai Brown and Joe Kipp most probably shared time at the cabin on Kicking Horse Creek around 1883. This cabin would later become part of the Lazy KY Ranch owned by Con and Claudia Price and Charles M. and Nancy Cooper Russell, although by 1905 Con and Claudia had built a larger cabin at a new location. It's possible that Charlie met Kootnai Brown and Joe Kipp in Gold Butte the winter of 1883 and shared a story or two over some drinks. It is even plausible that Charlie was invited to stay in that cabin or any of the military camps. There was no hurry for Charlie to get back to Judith Basin. There were numerous 'squatters' claims and retired military men with a few homesteaders and miners who had dugouts for camps and welcomed visitors for the company. Gold Butte was a Piegan encampment turned mining town in 1884 so there is no doubt Charlie would have found the people and area interesting and surprisingly isolated and still a bit of the "wild west".

Another story told of the *'Gold in them thar Hills'*: "The History of Montana 1739-1885" carries the topic of the "Sweet Grass Hills Mines"

on page 493. It reports that the mines were discovered in the fall of 1884 near the boundary, *"probably eighty miles from Fort Benton, in a northwesterly direction. Captain Twining made a road there in 1874 to a point near these diggings ..."* This piece further states that *"It appears that in the fall of 1884, Marion Carey, Fred Derwent, George Walters, and John Des Champ, ... and in the spring prospected on the east side of Middle Butte. In April 1885, Joe Kipp, Charley Thomas, Hi Upham, and about ten others"* It says: *"the Cary party took out eleven and one-half ounces of gold from the main gulch'*. Mrs. Frank Shaw and Thelma Warrington, through the Montana Historical Society, provided this information pointing out that the book has no author, and the information was gathered by paid researchers. The book was published by Warner, Beers & Company, Chicago, 1885 and can be found in the genealogy department of the Great Falls Public Library. John Deschamps would be John Grochon or Grandchamp as the spelling changes with the writer. John Grochon married a Blackfoot woman named Dosite. When John perished in a blizzard in 1885 Bruce Toole bought the Grochon place, cabin, and squatters claim, from John's widow, Dosite, a fullblood Blackfoot woman.

The Department of Interior had established March 3, 1849 and was supposed to have administrative authority over the Indians and natural resources; however, it had no administrative authority over either the Indians or resources in Montana until 1864 when the Montana Organic Act was created. This Act preceded the Constitution and established Montana as a territory governed by the laws of this Act giving the Department of Interior jurisdiction. This was important because until the Department of Interior had jurisdiction of the Indians and natural resources there was no governance over the uncharted territories that were legally only governed by the Jay Treaty. Once the Department of Interior had jurisdiction, they could establish Agencies for the Indians to disperse foodstuffs, establish churches and schools, and began teaching the Indians farming and conservation. That was the plan. Joe Kipp and Kootani Brown were two of the main players in establishing Indian agencies as both had worked with and for the government and military as liaisons. Kipp had helped establish the First Piegan Indian Agency

at Heart Butte near Badger Creek where Claudius Bruce Toole worked as the first Chief Clerk.

James Brown owned one of the largest freighting businesses based in Fort Benton, Diamond R Freighting, which he bought from John J. Roe & Company and sold to Matthew Carroll, George Steele, and C.A. Broadwater in 1868. Brown continued to work for Diamond R until 1870 moving government stores from Fort Shaw to Fort Benton, and in the fall to Fort Ellis, for $150 a month. Brown had a ranch near 8-mile spring on the Marias River. In the spring of 1871 Brown and Kipp built a trading post on the Belly River in Canada. Brown continued working for the US Government as border agent after the boundary survey party of 1872-1876 roughly identified the border. C.B. Toole took over Brown's position in Sweetgrass in1888 when the boundary was established, and a customs building was placed on the Sweetgrass Coutts location.

After the survey party had departed from the Hills there remained the matters of the Indians and jurisdiction. To mine and homestead the northern region of Choteau county Montana needed to become a state and be surveyed. James Hill had launched an aggressive campaign in Europe and the United States to get his railroad built and populate the country it served with customers. The promise of free and/or cheap land or possibility of striking gold had begun bringing emigrants from all countries of the world to North America. The difficulty was that with all the people crowding into Montana, few were educated or interested in politics. Their interests were purely personal. They wanted to reap the rewards of earning a living, raising a family, and live as free men. These were all noble passions, but the family raising part was going to be difficult without women. Most of the females throughout the Territory were Indians, Métis, or military wives. Officers in the U.S. Calvary could offer their wife a reasonable safe home at the fort where they were stationed but that was the only amenity. Contrarily, there were men of all ages and character coming to Montana, many of them with cattle drives from Texas. Others came looking for a paying job.

Con Price was one of the young men who had decided at an early

age he was going to strike out on his own and ended up in Montana. This is his story.

Cornelius (Con) Price; April 4,1869 – March 9, 1958.

In Con's book, "Memories of Old Montana", H.E. Britzman said of Charlie Russell and Con Price:

"These two men were more than cowpuncher friends and associates in a ranch partnership. Charlie regarded Con as one of the greatest bronc riders of his time, and Con considers Charlie the finest kind of friend a man could have had."

Cornelius Price was born in Manchester Iowa in 1869. His father served in the Civil War and had contracted consumption, was discharged, and sent home to his family of four children and wife in poor condition. His father died shortly after his return home leaving Con's mother without an income to care for Con and his three siblings. Unable to afford her children, she contacted a Catholic Priest who found "*wealthy*" families to adopt the children. Con was placed with the Calligan family near Manson Iowa. The contract for the adoptive parents said they were to give him an education and when he turned twenty-one, he would be allowed to leave with a horse, saddle and $500.00.

Con's mother remarried a few years later and her husband wanted the children back. The adoptive parents of Con's three siblings readily gave them up, but the Calligans' contested. A lawsuit ensued and Con's mother won custody. Con reluctantly returned to his mother and his seemingly lazy stepfather.

Con says his stepfather; "was a comical looking Irishman" who "*didn't have intelligence enough to raise a pig*". He also thought his stepdad, "*the old man*", liked to be "*swelled about what he could do*" and Con "*sure poured it on him*". Con got his stepdads' confidence and was put to herding the cattle on a "*pretty good horse*". He got the idea to steal the horse and go back to his adopted parents, which was about 100 miles away. He made the trip in about three days making up stories to the ranchers where he sheltered overnight along the trail. About three miles before reaching his adoptive parents he turned his horse loose knowing it would go home and he would not be arrested for stealing. Con knew

some of the questions the ranchers had along the way were because he had a *"pretty good horse"*, but no tack, as he was riding bareback.

His foster parents *"catched"* him around until they thought he would be safe and started him back in school. Con would gather the milk cows for the Calligan's in the evenings when he got home from school. They gave him a little mare that could run like a racehorse. He was still riding bareback always looking around to see if anyone was coming to get him. One evening he saw a team and wagon coming towards him and recognized his stepfather and mother. He was about two miles from the house. He had to pass by them to get to the house and there was a creek on one side and fence on the other. His stepfather stopped his wagon and unhitched the team mounting a mare that Con recognized as a "pretty fast ride". He headed for some timber and his stepdad lost his trail.

Managing to get to the house before his stepdad, his foster mom told him to run into the corn field and hide. He could hear his stepfather making all kinds of threats, but the foster parents held tight to his whereabouts. His mother and stepfather finally gave it up and left. Con remained a little edgy keeping an eye out each time he was out. A couple of weeks later two men in a buggy came looking for him. He had just dismounted near some brush and took off running. One of the men weighed about 250 pounds as near as Con could estimate. He was intimidating in size alone, besides announcing he was a sheriff. He handcuffed Con and took him to the train station putting him on a ride back to his mother and stepdad.

His stepdad did not trust him at all after the runaway and had him herding the cattle on foot. Con says he made fun of his stepdad behind his back whenever he had a chance and got caught one time because the other kids were laughing so hard. He said he most probably made *"life about as miserable for him as he did"* for Con.

In 1879 Cons mother, siblings, and stepfather headed west across the plains to the Black Hills stopping at a village not far from Deadwood named *"Scoop Town"*. Now called Sturgis, Con was able to go into the theaters and bars because there was no law prohibiting minors from going to the dives or gambling halls. Con says he *"got an eyeful!"*. He

also got his first peek at gambling and he remembers a woman dealing poker named Big Gussie. Con took a liking to all aspects of poker, the names, the bets, the money were all fascinating. He said; *"men were all faro dealers – and wore long whiskers … and the barbers sure got well paid to keep those whiskers in perfect style - and fine clothes and jewelry they wore must have cost a small fortune"*.

Faro is not a direct relative of poker. It was widely popular in the 1800's as it has easy to learn rules and has better odds than most games of chance using only one deck of cards and allows numerous players each game. Its fast action turnover derives from the French game of Basset. The rules are simple, and the betting is usually a lower ante than other 'poker' card games. What was attractive about the game was the simplicity which became problematic as card sharks would soon start card counting, palming, or other scams. These tactics often led to fatal disputes when money was short and loaded guns were readily available.

Scoop Town was only about three miles from Fort Meade. Fort Meade was occupied by colored soldiers as many forts were after the Civil War. Con had not been around a diverse culture before but thought it was interesting that these soldiers were about the only folks in Scoop Town with money to spend. Part of the regiment stationed at Fort Meade were sent to Wyoming to stop a war that broke out between the stock men and cattle rustlers. Con signed with the regiment as a civilian taking care of the Calvary mounts and found his way to Wyoming with a paying job.

The name Scoop Town was given to the camp located one mile west of Grasshopper Jim Fredrick's store, so named by the soldiers who were likely to be "scooped" when they woke up in the lodge cleaned out after a night of ruckus behavior. The soldiers of Scoop Town were moved to Camp Ruhlen, later called Sturgis, after being one day late to prevent the Wagnus massacre a few miles north. The Wagnus family, consisting of two brothers and one wife, were found shot and the woman mutilated, on sacred Indian grounds near the Black Hills along the Bismarck Trail July 17, 1877. Sturgis was named for Lieutenant J.G. Sturgis, killed June 25, 1876 at Little Big Horn. The 1st Infantry were initially at Camp Ruhlen joined by 11th U.S. Infantry and later

the 7th U.S. Calvary when it became Sturgis. Along Highway 79 N at mile 116 is a marker erected in 1954 locating the original site of this military encampment.

Con went to Wyoming. When the Calvary returned to South Dakota, Con stayed working on ranches eventually trailing a herd of cattle to Montana ending up in Miles City. He stayed in Miles City until he ran out of money, then hopped a freight train heading for the Big Horn. From there he worked his way to Judith Basin working horses and cattle for anyone who was looking for a cowhand or bronc rider.

Along the trail to Montana, several years before Con and Charlie met, Con picked up the moniker "*No Bed*". Con had never learned the knack of making a good bedroll as he wasn't fortunate enough to have met a Jake Hoover. He sorts of put some cloth and "hen skins" together and rolled it out creating more discomfort than their baggage deserved. He called down comforters "hen skins" and said the frost would creep up through them during the night and they were colder than having "no bed". He survived with stories of tragic demise of the bedroll down tumulus river crossings, high winds, and co-workers with lice to gain sympathy. He was often a night herder, making bedrolls in the camp available if Con could talk his fellow cowboys into sharing, so he would have a bed for his daytime rest(s).

The stories of lice being problematic during the time after the civil war, until running water and electricity became a part of most households, is a story told throughout homesteader and military accounts. Bedbugs were another scourge difficult to exterminate. In Donna Gray's book, "Nothing to Tell", Marie Walker Converse tells *"they had to be boiled"*, speaking about *all* the clothes. A perplexing task for a cowhand. Page 63 of "True, Free Spirit" has a photo by Chas E. Morris of Tommy Smith, Chester, Montana, washing his clothes in a small basin titled "Wife Wanted". Thankfully, bedbugs and lice have been part of the disappearing west along with consumption, cholera, smallpox, and other maladies now almost extinct or at the very least controlled, until the coronavirus 2019. Con was such a charmer that he managed to be welcome everywhere, bedroll or not.

"That Pestiferous Bedbug" by G.H. Ellis June 1929, The U.S.

Reclamation Service found on page 247 of *"Sun River Valley History II"*, is a true story about the pesky bedbug and how difficult it was to exterminate them. Even yet, in 2019, the pesky bugs *"come all marching in column formation with a General in Chief at their head"*, as this author learned on return from a trip to China. They steal away in luggage and reorganize at their port wherever it may be.

When Charlie and Con met, neither was attached to any property except their own horses and gear. Con had never known a time in his adult life when someone took care of him and he delighted in every detail of being a cowboy, including horses that were a little spirited and cowboys that were a little daft. He was not born to money so there was no expectation of entitlement in him. In Delia Owens book, "Where the Crawdad Sings", she says; *"Con Price married the daughter of a wealthy rancher."* Wealthy or not, Claudia L. Toole Price was well connected to the political powers that laid the foundation for the state of Montana. At 22 years old, she had patience and a sense of humor which was an asset without compare and essential if the antics Con tells of in his books were her daily delights. A few years after Charlie and Nancy Russell married, Con Price took the plunge eloping with Claudia in December of 1899.

Claudia was the daughter of Claudius (Cornelius) Bruce Toole, born in Missouri, Savannah, Andrew County October 16, 1844, and Belle Hazlett Mullen born in Ohio,1859. C.B. Toole had fought for the confederacy and in 1862 he enlisted in the Missouri State Guards at St. Joseph. He was in the command of General Sterling Price. From 1881 to 1885 he served as chief clerk at the Blackfeet Indian Agency under Majors Allen and Baldwin. Con thought Mr. Toole a *"very fine aristocratic gentleman who didn't think Con desirable company for his daughter"*. C.B. Toole may have had a tender spot for this authentic and enthusiastic cowboy because of his last name.

Serving as first Chief Clerk at the Piegan Indian Agency at Heart Butte near Badger Creek southwest of Browning around 1881, Claudia Price's parents lived at the Agency until they moved to the Diamond Willow Ranch. Marcus D. Baldwin was in command of the agency appointed by President Cleveland as Superintendent to the Blackfoot,

Blood, and Piegan Indian Nations. Major Baldwin came from Ohio to Montana in 1885 with his wife, Sarah, and two sons. Toole and Baldwin worked together at this Agency until 1888 when Toole moved to the Port at Sweetgrass to become deputy collector of customs under Diamond G. Brown. In 1888 the Baldwin's had the first white baby born on an Indian Reservation in Montana. The Chief's called the baby girl Kokoa meaning "little girl" in native tongue. The Baldwin's liked the name and kept it. In 1891 Marcus, Sarah, and family moved to Kalispell where the first home designed by Marcus D. Baldwin was constructed. The home is a Historical Preservation site in Kalispell.

As Clerk for the Blackfeet Agency Toole attempted to teach the Indians how to grow crops and develop their skill at raising produce since the buffalo were rapidly disappearing and the vast prairies were being homesteaded. Jobs for hunter gatherers were non-existent. A once proud culture was being told their traditional methods of survival were no longer acceptable. The way of life of the Indian would change requiring the Indians to learn how to farm and become educated in academics and religious belief presented to them by foreigners of North America.

Claudia L. Toole Price was born in 1877. Her brother, Edwin Bruce Toole was born in 1881. Edwin (Cap) Toole was the tag along younger brother that buffered his sister's rendezvous with Con Price as he courted this enchanting Miss in the Sweet Grass Hills. Claudia had another brother, Claudius Lucien Toole, but he was too young to keep a secret, so he wasn't included in the courtship. Cap took over the Diamond Willow and raised his family there while Lucien became his father's private secretary and moved with his parents following college.

Edwin Bruce (Cap) Toole married Dora Maude McDowell in 1904. Their two sons, Clifford B. Toole born 1906 and Claude Jack Toole born 1911, were born and raised on the Diamond Willow. C.J. (Jack) Toole took over management of the ranch after his father's passing. Jack's wife, Jean Midboe, was the granddaughter of Col. W.F. Sanders, Montana's first Senator, and the grandniece of Sidney Edgerton, chief justice in 1873, becoming first governor of Montana Territory in 1864-1865. Edgerton was from Ohio. Jack was the first president of the

199

Montana Cattlemen's' Association which he helped organize in 1957. He was the first accessor of Toole County, and served as Toole County representative in the State legislature from 1946-1948. He was the Democratic candidate for Lieutenant Governor in 1952.

Joseph Kemp Toole was the younger brother of Claudius Bruce Toole. Joseph was born in 1851 and came to Montana Territory in 1869 when he was 19 traveling by steamboat up the Missouri from St. Louis to Fort Benton. In 1870 he was admitted to the Montana bar and in 1871 he was elected district attorney. He was the first Governor of Montana when it became a state in 1889. Joseph was again elected as the fourth Governor of the State. Before he became Governor, J. Kemp Toole had been a delegate to the States Constitutional Convention and Territorial representative to Congress.

May 5, 1890, Governor Toole married Lily Rosecrans in Washington D.C. in a small private ceremony at a church in the Nation's capital. Lily was Roman Catholic but there was not time to obtain the dispensation required for a wedding in the Catholic Church. Her father, Brigadier General William Stark Rosecrans, and two friends were the only guests. The couple moved into their home at 102 S. Rodney Street, Helena, Montana. Governor and First Lady Toole had three sons. The oldest, Rosecrans, died in 1898 when he was seven. He was visiting his aunt and grandfather in Ohio when he died of diphtheria. Story by Ellen Baumler, Great Falls Tribune Section L, June 26, 2016.

Edwin Toole, Claudia's Grandfather, was born in 1808 and was a schoolteacher before entering law school. He married Lucinda Shepherd Porter in 1833. Lucy was born in 1811. Edwin was born in Kentucky. He and his family moved around for his school and teaching before settling in Kentucky. His wife died in April of 1878. In August of 1879 he visited his two sons who were practicing law in Helena Montana. Of Edwin's ten children, five sons and two daughters came to Montana and settled.

The oldest son of Edwin Toole, Edwin Warren Toole, born in 1839, is reputed to have been one of Montana's foremost attorneys. Before he came to Montana Edwin W. Toole had settled on "The Platt Purchase" Indian lands in the northwest corner of Missouri. Claudia Price's Great

Grandfather, Daniel, came to America from Ireland. He settled briefly in Pennsylvania and moved to Virginia then Kentucky in 1775.

Claudia Toole Prices' sister-in-law, Maude McDowell Toole, was Judge Jack McDowell's youngest of two daughters. Mr. McDowell was United States Land Commissioner, Notary Public, Justice of the Peace, store merchant and ranch owner in the Sweet Grass Hills. He was the first district clerk in Choteau County before it was divided into Choteau, Toole, Liberty, and Hill Counties. District 22, McDowell's district, was twenty miles north and south and thirty miles east and west, in the northwest corner of Choteau County. It included all three Buttes known as the Sweet Grass Hills. Judge McDowell sold the Diamond Willow Ranch to Claudius Bruce Toole. The ranch corrals, outbuildings, and hay corrals were located on Simmons Creek, a branch of Willow Creek. The location is not far from Three-Mile-Coulee where there had been a large Indian encampment according to archeological exploration.

John McDowell (Judge McDowell) joined the army when he was 16 years old. A neighbor had been drafted during the Civil War and offered McDowell $400 to go in his place. John turned the money over to his parents in return for their consent. He served in Infantry Co. A, 182 Ohio Regiment from October 20, 1864 to July 11, 1865. With the war's end he went to Kansas hunting buffalo and filing a homestead claim. February 7, 1882, he married Anna Vowers. The couple had two daughters in Miltonvale, Kansas. Myrtle born May 3, 1884 and Dora Maud (Maude), born July 22, 1886.

The McDowell family came to Montana in 1890 and lived for a time at Butte City. They moved to Neihart, where the silver mines were booming, and operated a store in 1892. The railroad from Great Falls to Neihart was being built to haul silver ore to the old Boston Smelter. When the first locomotive pulled into Neihart the school children ran along ahead of the engine, but Maud McDowell was not one of them. She had a seat in the cab, riding with the engineer.

Judge McDowell's daughter, Maude, remembers "in 1894 John McDowell and a friend, William Morley, made a trip to the Sweet Grass Hills". Business was slowing down in Neihart at the store and

the Mercantile in Gold Butte was for sale. McDowell filed a land claim on Simmons Creek where he had Bill Morley built a barn and corrals. He found a small vacant cabin in Gold Butte and had Morley repair the building. He moved his family and furniture into the rustic cabin picking them up in Shelby with a six-horse team in July of 1894. The family rode the narrow-gauge railway called "The Turkey Track" from Great Falls to Shelby where Mr. McDowell picked them at the depot with a team and wagon taking them to their new home forty miles northeast of Shelby.

When gold ran out around Gold Butte the buildings were abandoned and furniture, filings, and fabric were left hanging to blow in the wind. Among some of the records and photos salvaged from the decadent remains were pages of Judge McDowell's ledger(s) listing marriage licenses' and land filings including a somewhat weathered yet still legible page with Charles M. Russell's entry for a land claim on May 14, 1904. Most of the artifacts recovered from what was the town of Gold Butte have found their way to the History Museum in Helena. Nancy Russell filed a desert claim next to the Lazy KY in 1908. Both Russell filings became part of the Lazy KY ranch, a separate ranch located on West Butte connected to the Diamond Willow where Con and Claudia started their life together in the Sweet Grass Hills. The Russell's and the Prices' were partners in the moderate spread. Con managed the livestock and worked the ranch. Charlie and Nancy would send him money when they had some to spare. Con said Charlie was *"the best partner anyone could have had"*, and Charlie replied with; *"Con does all the work"*. The cabin that Con and Claudia lived in when they first married was where the original Lazy KY began. It remains on the site where it was moved near the Diamond Willow, but Con and Claudia had their own cabin built that was completed in 1905. This is the cabin referenced as the 'Lazy KY' in photographs and sketches. Mae Griesbach was hired as schoolteacher and lived in the cabin her first year in the Sweet Grass Hills. She was the first occupant. The cabin remains in the yard of her grandson, Chuck Clark, on the southwest slope of West Butte.

There was no school for the children in Gold Butte when Judge McDowell moved his family to Two-Bit Gulch where a few cabins and

a trading post were providing the appearance of a start-up town. Anna McDowell and her girls returned to Neihart for the 1894-95 school year. At the end of the school year the ladies McDowell returned to Gold Butte. In August of 1895 Gold Butte formed a school.

The following minutes were taken from the Gold Butte School Board Organizational meeting; *"August 16th, 1895, an excerpt from the Clerks record of Gold Butte School about that transaction; Trustees met in a special meeting present J.M. Wilcox and W.R. Bass. It was decided to purchase a log cabin of C.A. Whittemeyer for $25.00 and pay for it when the district gets funds. The clerk was instructed to look up a teacher so as to commence school immediately. Mr. Bass was instructed to purchase lumber from Mr. Whittemeyer to seat schoolhouse. No other business, Board adjourned subject to call of trustees. Meeting was held at Jack McDowell's house. Jack McDowell clerk"*

Gold Butte became a part of Toole County in 1914.

In addition to having the second school in District 22, Gold Butte had the first Post Office in what became Toole County. The earliest Post Office reported in the Sweet Grass Hills was Whitlash in 1892. Whitlash is located about a quarter of a mile east of Breed Creek. The Post Office in Gold Butte, Montana Territory, had its startup February 9, 1895. As United States Land Commissioner, Jack McDowell filed the application for a Post Office taking the liberty to name the small camp Gold Butte. Peter Hughes was appointed the first Postmaster. 'Judge McDowell' wore several hats in the late 1800's and early 1900's serving as Justice of the Peace, Notary Public, store merchant, and cattle rancher. Jack and Anna moved away from the Hills once their daughters were married. Both daughters, Maude and Myrtle, married ranchers in the Hills and were active in the community throughout their lives.

Claudia Price's uncle, Edwin Warren Toole, referred to the Sweet Grass Hills as a *"benighted region"*. He referred to his niece and nephew as being *"stupid in ignorance and obscurity"* referencing their education.

July 23, 1888 E. Toole wrote to Claudius:

"Cattlemen here tell Charley that you can't hold cattle at the "Hills" as the winds and storms of winter drive them off from 100 to 150 miles, and that you will have to participate in a number of round-ups at heavy

expense to recover your cattle thus scattered and driven away. Have you contemplated this matter?"

The "Charley" mentioned in this letter is most likely not Charles M. Russell. It's possibly Thomas Charles Power (T.C. Power), Senator, who served as president of the American National Bank in Helena or Charles D. Eliot who was a sheep rancher turned banker. The Toole family was continually active in getting Montana Territory to statehood. Knowing tax laws would change on land and livestock, they were skeptical of how the stockmen would be affected. Most of the big outfits were owned by investors who never spent a day working cattle. Before tax laws could be enacted the property would be surveyed and fenced marking property lines. This would end open range grazing of livestock limiting the numbers of animals an individual ranch could manage. Fence lines created taxable boundaries. Running a ranch would require hands-on management techniques. The Toole family had been involved in law and politics with no experience in raising livestock.

C.B. Toole was born in Savannah, Michigan October 16, 1844. He attended public schools in Savannah and then went to Private school in St. Joseph Missouri. In 1862 he enlisted in the Missouri State Guards at St. Joseph. He came to Montana in 1881. There's more than a handful of folks who came to the Fort Benton and Sun River areas from Michigan. At least four of the young women who married businessmen in Great Falls, the Peek sisters, Della, Kate, Za, and Lou were from White Pigeon Michigan. Della Peek Furnell and Kate Peek Ford both ended up with homes and husbands in Sun River.

When C.B. Toole bought the Diamond Willow Ranch there was no house on the property. There was, however, a cabin not far from the ranch buildings at the head of Kicking Horse Creek. The cabin was built by John Grochon, a pioneer rancher frozen to death in a blizzard in 1886. John's widow, a full blood Blackfoot, sold the cabin and squatters claim to Claudius Bruce Toole in 1887 when he learned he would be leaving the Piegan Indian Agency to take the position of clerk at the port of entry in Sweetgrass. When school was out in the spring of '87', Claudia's father moved the Grochon cabin to the Diamond Willow ranch for the family to live in while a large home was constructed in

the ranch yard. This one room cabin would become the home Con and Claudia Price for a brief time as the start of the Lazy KY.

Mrs. Grochon (Dosite) was a full blood Blackfoot Indian woman making her husband a legitimate Half-Breed or Squaw-man. John Grochon came to the Sweet Grass Hills as a prospector and married Dosite according to Indian custom. Many of the white settlers obtained property in the Hills this way. Some reports say that John Grochon was part of the group, along with Rodney Barnes, to have found Gold in Middle Butte. Since John Grochon was part of the group making the first gold claim on Middle Butte along with Rodney Barnes (a white man), Grochon's wife's Blackfoot lineage legitimized the early prospecting activity in Indian Territory.

In 1888 C.B. Toole purchased a small house in Sweetgrass for he and his wife to live in when the weather was bad in the winter and during the week while he was working at the Customs office. Claudia, Edwin, and Cliff Toole stayed at the ranch as there was no school in the area for them to attend. When the big house was finished Claudius hired a foreman, Jeff Pruitt, who lived in the cabin with his wife, Jesse. Jesse would watch the children and home schooled the children in the cabin.

John Grochon had gone out on foot for a drink at Gold Butte during the winter of 1886 and spent some time at one of the bars. Even though there was a blinding snowstorm outside, Grochon was infused with alcohol making himself feel overly confident. He boldly left the bar late and headed home afoot into the blizzard. Dosite received news that his body was found in the spring of 1887 just five miles from the cabin. The terrain from Gold Butte to the cabin on West Butte crossed a couple of creeks, several coulee's, some shrubbery, a flat, and some steep rock faced hillsides. The blizzard that consumed John Grochon was just another storm in one of the worst winters in Montana history. His disappearance didn't cause alarm because it was not uncommon for many an early miner, trapper, or settler to become unsettled and just move on in the late 1800's, perhaps especially on the northern border of Montana territory. The wind and sifting snow had erased all tracks of John's trail as he walked toward his home and his wife had to '*wait for a chinook*' to uncover the mystery of her husband's disappearance.

Claudius Toole knew little about the Grochon's, other than his widow was a full-blood Indian, requirement for Squatter's claim. Métis spelling could be Grochon, Grosjean, Groshen, or Grandchamp. Toole found a story in the 1887 Fort Benton Press of "*Grandchamp*" found frozen in the Sweet Grass Hills. Because of the '*squatters*' claim status, Claudius wanted to be sure to get all the land transfer paperwork correct.

Since the Pruitt's had taken care of the Toole Children when Claudius and Belle were staying in Sweetgrass, Claudius let Jesse and Jeff Pruitt stay in the cabin even after Jeff was no longer foreman for Toole. The Toole children could always count on Jesse to feed them or help them out if they needed it. After Jeff died, Jesse remained at the Cabin. After Edwin (Cap) and Maude were married, Jack Toole and his brother Cliff, along with two of the neighbor children, attended school in the Lazy KY Cabin Jack's second year of school. This was the newly constructed cabin that Mae Griesbach Clark taught her first year in the Sweet Grass Hills.

The Grochon Cabin had been used as the "West Butte School" in 1898. This was the original 'Grochon' cabin located at the head of Kicking Horse Creek hence the K, then moved closer to the Diamond Willow where the creek branched, the Y. Con and Claudia Prices' cabin, known as the Lazy KY, was completed in 1905. The Gold Butte School Board had agreed that "*if there were sufficient funds*" they would hire a teacher for West Butte because of the growing population farther west. Sarah Barker was the first teacher and she was paid $45 a month for three months. After that, the location for the West Butte School was built about one and a half miles west of the Robert Christian ranch.

Jeff Pruitt was quite a drinker and frequented the Gold Butte bars. The story is told that when he was home in the Grochon cabin he would lie on the bed in the corner of the cabin and shoot holes in the ridgepoles while drinking bourbon. The lead was still lodged in the ridgepoles when the cabin was restored by 4-H and Boy Scout groups in 1959. Jeff Pruitt died in 1905. He had been drinking in Gold Butte and was riding back to the cabin when …

Cap Toole: "*He must have been in a hilarious mood after a few drinks*

and reached down from his horse and grabbed a broad axe handle that was sticking up out of the snow in a woodpile alongside the road. He slung it over his shoulder and his hand froze to the handle while the sharp blade dug a hole into his back. Pruitt showed up at the old Grand champ's cabin that night and the men on the ranch had to pry his frozen hand off the handle in order to get to the broad axe. He got blood poisoning from the hole in his back and he died." Story by Jack Toole, Great Falls Tribune.

It was this rustic relic of a log structure that gave Charlie and Con hours of tranquility and inspiration as they shared their wits, wisdom, and survival antics in the area of the United States not yet defined. It was important if you owned livestock that you brand the calves as soon as possible when they were born because when the livestock reached the market the money went to the brand owner. It was important to have a different brand for cattle, horses, and sheep with possibly an ear mark or waddle to boot. Charlie and Cons' horse brand was 'T' and cattle brand Lazy 'KY'. Governor Toole owned the 'T' brand when Montana was a Territory, but he had not used it for many years. C. Bruce Toole asked his brother for the 'T' for Con and Charlie's horse brand. The recorder of brands, in courtesy of the Governor, transferred the brand at no cost to Con and Charlie.

A story F.W. Mack told when he was Postmaster in Gold Butte gives a little flavor to Con and Russell and their Lazy KY days at the cabin on the ranch in the Sweet Grass Hills. The newspaper scrap was found among Gold Butte's artifacts.

Story by Tana Mac; the date and name of the paper were illegible. Tana Mac is the pseudonym for Helen Clarke, author of "*O.C. Seltzer: Montana's Second Genius*". She was a column writer for the Great Falls Tribune and several other Montana newspapers as well as a Montana artist. Helen's maiden sir name was McDonald.

"The cowboys in the Hills wanted to play a joke on Russell and his ranching partner, Con Price. They came into my post office and said to me, "Mack, will you wrap and mail a package for us?"

"Sure, what have you got boys?"

"We got some feathers and bones. We want t' pay fer the cost o' mailing 'em and wrapping 'em too. It's t' be a joke on Charlie and Con, cuz we

lifted one of their geese, and ate it, and this is all that's left. Will ya send the package t' West Butte?"

They put their money on the counter, and I wrapped and mailed the package. We all knew Charlie and Con would enjoy the joke on themselves. It would be a reminder of the times they had been hard up and had lifted a chicken or two, or even maybe a goose."

From this short antidote it's easy to see how the locals in the Sweet Grass Hills regarded these two men. They were one with the community and got the same treatment. Times were never so bad that the opportunity to pull a prank on a fellow near do well, no matter the standing in other realms of society, would pass by without a little horseplay.

The history behind the *"lifted chicken"* may be revealed in a story Con tells in his book, **"Trails I Rode"**; Charlie Russell had decided to give up his $40 a month cowboy position in the fall of 1891 as wire fences, railroads and Civilization was beginning to choke the life out of the west that Charlie had learned to love. He received a letter from a friend and gambler in Great Falls, Charlie Green (also known as "Pretty Charlie") offering $75 a month plus food. C.M.R. left the open range around Milk River country with Monty and his Grey pack horse to start work as an "artist" by contract. It wasn't long before Charlie found that meeting someone else's expectations of what and when he should produce in a piece of art didn't quite fit his schedule. He paid his $10 advance back to the contract holder and looked for a place to bunk with no funds.

Con was living *"in a shack on the south side of Great Falls with a bunch of cowboys, a round-up cook, and a broken-down prize fighter"*. Charlie was the only one of the cowboys who was bringing in any money and it was short. They called the place the *"Red Onion. Charlie was the coffee and hot cake man. One time we had a Christmas dinner and in some way got a chicken (I don't want to remember how we got it) and we held council as to how it would be cooked ...".* Con relates; *"We had some queer characters as guests. Broken gamblers, cowboys, horse thieves, cattle rustlers, in fact, everybody that hit town broke seemed to find the Red Onion to get something to eat."*

Chicken dinner didn't always mean 'domestic chickens' in the old cow camps. A photograph by Chas E. Morris in his son's book, "_True, Free Spirit. Charles E. Morris Cowboy Photographer of the Old West_", has a photo on page 61 of Chas titled "Chicken for Dinner". The cowboy is pictured holding a pistol in his right hand and two prairie chickens with their heads cut off handing them to the camp cook, Curley Robinson, to prepare for dinner. The pistol is a Colt 32/20. The cowboys around the camp do not looked thrilled at the two feathered offerings.

CHAPTER 14

BUSINESS AS UNUSUAL

Until the Great Northern reached Havre on the Hi Line, the main hub for commerce in Montana Territory was Fort Benton. In 1859-61 the 624-mile Mullen road was built from Walla Walla, Washington to Fort Benton. Lieutenant John Mullen had spent the winter of 1853-1854 in the pass that bears his name observing the depth of snow and other problems that might be relative to building a railroad over the terrain. Mullen had been left at the pass by a survey party sent to the Sweet Grass Hills to survey the 49th parallel and scout routes for roads and possibly a rail line into the Hills. Northern Pacific Railroad built through the Mullen route thirty years later.

Charlie's trip back to Judith Basin following his return to Montana after visiting his parents in 1882, and the cattle drive to Calgary, Alberta, Canada, was probably the best of times and worst of times for Charlie. What was happening to Charlie is a realization of self and self-worth. He was meeting many of the men who had persevered the country and cultures for years and Indians who were natives' that were being suppressed in so many obvious ways. Yet the people were but a small picture of the wild west. The winter of 1882-1883 was an epic disaster for the Piegan and Blackfoot. They are estimated to have lost 1,600 peoples due to disease, starvation, and weather. To see the Indians starving when thousands of head of cattle were being brought to Montana territory the spring, summer and fall of 1882 was a grotesque

materialization of what fighting wild savages and hunting buffalo had produced.

A young James Turner (Jim) had remained in Tennessee in 1881 to tend to his parent's property. His mother had died in 1879 and his father, William P. Turner Sr. and older brother, William P. Jr. left their ranch near Nashville by train heading for Montana. They brought their 300 head of registered shorthorn cattle by rail as far as Bismarck, North Dakota. William Sr. had arranged to ship the cattle by steamboat from Bismarck to Fort Benton that fall, but live cattle are difficult to manage, and the steamboats were loaded with settlers and *"profitable dead freight"*. Masters Turner were obliged to spend an expensive winter in Bismarck with their stock in hopes of getting passage for their cattle on the steamboat in the spring.

By spring of 1882, the Turners continued to be refused passage for the livestock on the Steamboats to Fort Benton, so they purchased an ox team and wagon and drove the cattle to Sun River. James caught up with them along the trail which may have saved further hardships as the two William's Turner had been forced to sell some of the cattle for $100 before Jim's arrival.

Jim Turner was said to be a true *"Knight of the Saddle"*. He remained in Montana his entire life starting out working for Clary & Ford and the Spencer Ranch in Sun River while his brother and father set up camp at the big bend of the Marias River. "Nosey" Baker, a squaw man, sold them his buildings and land rights for $400. Squaw man was another name for a white man married to an Indian woman.

This was the first herd of registered shorthorn cattle to come to Montana. They became exceedingly popular in a brief time because of their ability to throw calves with short, or sometimes no, horns and their tight hides and hair. They survived the winters better and were not as prone to travel long distances from their home ground. Texas cattle were popular because of the distance they could travel on little feed and water. The bulls of longhorn breeding use their horns to keep the cows in a bunch and herd them helping the cowboys along the trail drives keep the herd together. The trait was appreciated when driving a herd from Texas to Montana, but once arrived at their destination the cattle

turned and headed south grazing along the way never looking back. This made the wranglers cover extensive territory looking for brands to tally herds. Shorthorns don't stray far from where they are dropped making for shorter roundups with higher return counts at shipping time back in the days before fences.

James Turner was born September 13, 1862 near Nashville, Tennessee. He was 19 when he arrived in Montana the late summer of 1882. Samuel Spencer, a rancher in Sun River, hired Jim and another cowboy to gather 100 head of beef cattle in northeast Montana and trail them to the Great Falls Meat Company where they were contracted to Frye. Frye Great Falls Meat Company was affiliated with T.C. Powers in 1882. T.C. Powers was supplying goods for most of the trading posts and meat for the Blackfeet Agency through USDA and the United States Indian Service Blackfeet Agency. Frye Company is in the leather business and continue in 2020 as a shoe and leather supplier. The location of the Great Falls Meat Company is part of Great Falls Historic District, National Register of Historic Places designated in 1986.

James Turner married Susie Price March 27, 1894. Susie Price was the first teacher at the Blackfeet First Agency near Heart Butte in 1880. She was the daughter of Perry and Julia Yetter Price from Monroe county Pennsylvania and came to Montana to teach. She had an uncle, Martin Wasacha, living on the south side of the Marias River where he ran sheep along the river valley as far southeast as Fort Benton. When school was not in session Susie would stay with her uncle on his ranch and help with cooking and housework. Martin was a bachelor all his life but was known for his hospitality. As the saying went in the late 1800's, "his latch string was always out". Clary and Ford's cattle grazed the open range along the south side of the Marias as did the DHS, F, and 7 Block. With Susie cooking, Martin's cabin was a beehive of cowboys during the summer months. As one of the few white women in the country, she had a band of suitors, but James Turner was the charmer who swept her off her feet.

James and Susie Turner took up government homestead claims in the Marias River District and were the 1st white settlers in this section where they raised sheep. They had two children: a son, Clark, and a

daughter, Beatrice. At one time Susie ran a post office out of their home officially naming the Post Office Beatrice. When the Sweet Grass Hills were opened for homesteading, James and Susie sold their sheep and filed claims next to John and Beatrice Wasacha on the south side of East Butte where they started a cattle ranch.

Martin Wasacha was born in Switzerland and came to California at 11 years old in 1868. In 1870 he moved to Washington with his brother Perry. Perry purchased a sheep ranch in Washington and Martin worked for his brother until 1878 when he trailed a band of sheep across the Rocky Mountains to Fort Benton to ship down the Missouri by steamboat to Bismarck, North Dakota and beyond to eastern markets. Martin's other brother, John, and his wife, Beatrice, had ventured to Montana Territory earlier and were working for established ranches as cook and wrangler between Dupuyer and Pondera. Pondera was later named Naismith and finally Conrad. John and Beatrice lived in Pondera coulee 15 miles south of the Turner ranch until 1888 when they filed a homestead claim on the southeast side of East Butte in the Sweet Grass Hills. Their ranch was south of Camp Otis, the calvary outpost in the Sweet Grass Hills, near Sharkstooth (aka Haystack) Butte. Martin Wasacha died in 1953 at ninety-six years old. Martin and his brother John are buried in Fort Benton.

Charlie Russell was said to have visited Martin at his cabin on the Marias where this bachelor accumulated artifacts, many from the Baker Massacre. Martin Wasacha moved to Lothair when his eyesight began to fail. He was fond of guns and would sit on his porch with a rifle nearby and carve diamond willows with a display of arrow heads, spears, and Indian skulls at his feet. He had two paintings of Russell's that he left in his cabin when he moved. When he returned to retrieve some of the things he had left behind, he found the cabin and contents destroyed and the paintings gone. Before Martin left his cabin, it was not uncommon for grizzles to hunt the Marias river valley. Martin Wasacha is credited for killing the last grizzly seen on the Marias River in Choteau County.

W.R. Crockford, a cowboy from Springhill, Texas, arrived in Montana with a trail herd headed North in 1883. He worked in the

Augusta area then Choteau and Shelby. He was a seasoned cowhand when C.M. Russell and Con Price were starting out and became a friend to both. He worked with Russell on roundups and every time Dick got bucked off, Russell would have a sketch of it by the time Dick hit the ground – so Dick claimed. Mr. Crockford was only 5'8" but he sat tall in the saddle. He possessed presence and looked *"very much a cowboy"*. This is probably one of the reasons C.M. Russell liked to use him as a model for his work.

Around 1899 Mr. Crockford served as deputy sheriff in Shelby. While he was deputy sheriff, he was called to the Sweet Grass Hills to pick up a horse thief that had been captured by some ranchers. Before he could start back to Shelby with his prisoner, a messenger from Lethbridge, Alberta, Canada got word to him that the Mounties were holding a badly wanted desperado for Montana authorities. Dick was in a fix. What to do with the horse thief? It was nearly forty miles to Shelby and seventy to Lethbridge. The horse thief suggested that Dick go on to Lethbridge and gave his word that he would herd himself to Shelby and wait at the hotel for Dick. Dick took the man up on his promise but never expected to see him again. To Dick's everlasting surprise, the prisoner was waiting at Shelby when Dick returned.

William Richard Crockford, son of George A. and Margaret (Butter) Crockford married Ella Maud Davies, on August 9, 1897 in Great Falls, Montana. She was 16 years old. Born in Idaho, the daughter of M. Davies and Belle (Foster) Davies. Dick was born in Texas and was 34 years old. Maud was working for her mother at a boarding house at Willow Rounds on the Marias River. The boarding house charged $14 a month to out-of-work and homeless cowboys and was known to have clean quarters with the rent including some meals.

The Montanian, Choteau, Montana, reported in the August 5, 1898 issue that; *"Mr. and Mrs. W.R. Crockford, of Shelby, lost their infant son. There were 27 cowboys, riders, and old-time friends of Mr. Crockford accompanying the remains of the child who was born July 25th. The child was buried in the Marias River cemetery by the side of Mrs. Crockford's brother"*.

Cowboys in Montana in 1880 thru 1900's were a close-knit group of

unique characters even though they didn't see each other often. Times were changing. Barbed wire had been patented in 1867 by Lucien B. Smith of Kent, Ohio and Montana became the 41st State of the Union on November 8, 1889. It had taken sixty years of traversing through seven different territories for the area that is now Montana to become a state. Grover Cleveland was President and had signed the bill February 22, 1889. Being the first Democrat to be elected following the Civil War, Cleveland's passive approach to governance in passing the Daws General Allotment Act of 1887 was causing much decern with the Republicans. The Daws Act redistributed Native American reservations land to the individual tribe members. March 3, 1890, as soon as he could, Republican President Benjamin Harrison announced he would open the 1.9-million-acre tract of Indian territory for settlement precisely at noon on April 22.

Grover Cleveland is the only President to serve two nonconsecutive terms to date in 2020. His first term saw another first and only event of its kind hosted in the White House. He was married with the ceremony taking place in the White House. His wife, Frances Folsom, was 27 years his junior and even his closest co-workers did not know of the romance. Frances had just graduated from college.

February 4, 1887, during his first term 1885-1889, Cleveland signed the Interstate Commerce Act to regulate the railroad industry. It required railroad rates to be *"reasonable and just"* and prohibited *"fare discrimination"*. This was the first federal law to regulate private industry in the United States and it created the Interstate Commerce Commission. He second term, Grover Cleveland brought the country through the Panic of 1893 and enacted the Endicott Era of Defense which strengthened and modernized U.S. military with additions to the militia that remained in use until they were replaced in WWII, 1945. Two bills that were vetoed by Cleveland are: 1. *A bill granting phony pensions that congressmen were awarding to placate the Grand Army of the Republic.* This was the most powerful political pressure group of the 19th Century. 2. *A bill excluding immigrants who could not read and write some language.*

When Montana became a territory in May of 1864, the Legislative

Assembly gathered in Bannack City in December in a dirt-roofed cabin. The assembly passed seven hundred pages of laws and chose Virginia City as Capital of Montana Territory. Twenty years later a constitutional convention convened in Helena January 1884. This document was ratified by the people in November, but congress failed to take any action about Montana's admission to the Union because of political tension between the Democrats and Republicans and the railroads competition for commerce routes to mining areas. The federal government passed the Enabling Act of 1889 and the voters of Montana Territory ratified a new constitution admitting Montana to the Union. Into the next century, 1972, the elected delegates of the State called a constitutional convention and created a new constitution to replace the document that had been amended, revised, and partially repealed over time. Montana lawmakers do not seem to want to hurry change, but they keep working at it.

Through all the ruckus and rigor that comes with people and change, one man stayed steady to his course. James J. Hill, as told by politicians and scholars, *was not an ordinary "Man of Vision". He was one who was willing to create, by his own labor if necessary, a vision into reality."* His vision of the Montana plains was that the Hi-Line and beyond become dry land farms. That this *"unproductive barren wasteland that not even sheep could live upon,"* could and would produce enough grain and beef to feed the entire populace of the United States.

February 23, 1956 the Chester, Montana, Liberty County Times ran an article about Jim Hill. *"Hill may have induced more European peasants to settle in the American west than any other man."* This would be a boisterous judgmental statement made by the outspoken editor of this paper, which was B.B. Weldy, resplendent and proud Republican style. Those *"peasants"* were intelligent, courageous, hardworking displaced people of all ethnic backgrounds who boldly left everything they knew and owned behind to begin a journey into the unknown. Jim Hill's vision was to provide transportation to get them to Montana. The evolution of the land is credited to those who stayed and endured. As some reported, *"In clouds of June mosquitoes and flies which set oxen bellowing in pain and horses leaping from their harnesses. Under the*

blistering prairie sun of August, rattlesnakes, water with green scum (and worse), causing dysentery. This turning to chilly nights, to snow, to sleet and hail and wind from the north. In a world as white as it is bitter making cottonwoods along creeks snap and explode like rifle fire." These wondrous people stayed to break new ground and meet new neighbors. Their heirs continue the challenges of Big Sky Country. A fickle mistress.

In rented Great Northern freight cars, homesteaders were permitted all secondhand articles such as household goods, machinery, agricultural implements, vehicles, wagons, tools, etc., plus the following: *"fifty bushels of grain, sufficient feed for animals in transit, 2500 feet of lumber, 500 fence posts, a small portable house, trees and shrubbery, small stock including hogs and sheep not to exceed 20 head, or horses, mules and cattle not to exceed 10 head."*

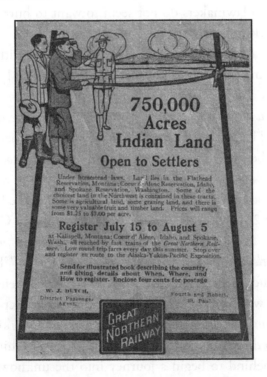

Jim Hill worked side by side at any task to fill his vision. His goal while extending his rail line was one mile a day. He used imported steel on his rails as he felt it was superior to any produced in the United

States. He did soil analysis and surveys ensuring the straightest roadbeds reducing friction of his traction systems. He numbered his locomotives and increased power while maintaining the most affordable and rapid transport system of its era. This was the Jim Hill Charlie Russell writes about in his book, "**Trails Plowed Under**" in the section titled *"Bill's Shelby Hotel"*:

*"Shelby's changed a lot since them days. In the old times the residents there include a lot of humorists who have a habit of stopping trains an'entertainin' passengers. Most of these last is from the East, an' they seemed to be serious-minded, with little fun in their make-up. The Shelby folks get so jokey with one theatrical troupe that stops there that many of these actors will turn pale to-day at the mention of the place. At last **Jim Hill** gets on the fight an' threatens to build around by way of **Gold Butte** an' cut Shelby, preferrin' to climb the **Sweetgrass Hills** to runnin' his train through this jolly bunch. This hotel of Bill's was one of the few places I've seen that's got flies both winter an' summer. During the cold months they come from all over the Northwest to winter with Bill, an' hive in the kitchen an' dinin'room. ...*

Before the railroad could cross the continent on this great northern route, the unmapped pass through the Rocky Mountains needed to be identified. James Hill hired Santiago Jameson to search out a pass, which he successfully did, discovering Marias Pass in 1889 shortening the Saint Paul, Minnesota to Seattle, Washington rail line by 100 miles. John Frank Stevens, an American engineer, was charged with overseeing the construction of the Great Northern Railroad through the Rocky Mountains.

The Great Falls and Canada Railroad Company was the first rail line in Montana running north and south across the International boundary from Lethbridge reaching Great Falls in 1890. This north-south narrow-gauge line's major commerce was coal and the existence of the train route provided passenger service between the two countries. Shelby, Montana became a junction in 1891 providing freight and passenger travel north and south from Lethbridge, Alberta, Canada to Salt Lake City. East-west travel extended between Shelby, Montana and New York.

Known mainly for hosting the Jack Dempsey-Tommy Gibbons heavyweight boxing championship July 4, 1923, Shelby was chosen in part because people could travel from all directions to get to Shelby by train. The border town of Sweetgrass developed as a U S. Customs and Immigration Office before the train arrived and grew substantially as a passenger and coal shipping center with the rail line. Sunburst sprouted between Shelby and Sweetgrass and was named for the glorious sunrises seen as the Sun bursts over the Sweet Grass Hills in the morning.

Charles Marion Russell had his eyes wide open even before he left St. Louis when he was sixteen. Reading his stories and looking at his art will tell you this man was non-confrontational and highly observant. He saw what others missed and called it luck, but it was more than luck, it was good judgement. What to keep and what to give up, often making the right decision because it was right, not because it was easy. Even his best friend, Monty, was a challenge for this *wanna be a cowboy*. He tells about Monty being an Indian pony use to being mounted from the far side (right side), and of taking the time to get Monty use to this white man's ways with a saddle and bridle and a step-up mount from the near side (left). Charlie felt for the horses he rode, the white men and Indians he rode with, and the wild animals he encountered in their habitat. He learned best by observation and wore his heart on his sleeve. He seemed to pick up on the uniqueness of each thing he encountered, including whiskey. "*There's a difference in whiskey, some's worse than others.*" ["Trails I Rode" CMR friend Murphy]

As a man who rode with them, Charlie said cowpunchers were careless, homeless, hard-drinking men. From the time he arrived in the wild west Charlie could see that whiskey was a "*brave-maker*" and there were plenty of times that called for some of this good medicine. He also noticed the effect seemed different for the Indians. They seemed to turn bad and become dangerous when they got their fill. This behavior worsened during Prohibition. It may have been on his first trip to Gold Butte in the Sweet Grass Hills that Charlie Russell found out that the case might have been the brew and not the consumer when it came to whiskey. The whiskey traded to the Indians (Indian Whiskey) was a mixture of "*two gallons of alcohol in a barrel of Missouri River water*

with two ounces of strychnine to make them crazy-because strychnine is the greatest stimulant in the world. Then three plugs of tobacco to make them sick because Indians wouldn't figure it was whiskey if it didn't make them sick. Five bars of soap to give it a bead and a half-a-pound of red pepper, and then you put in some sagebrush and you boil it until its brown. Strain this into your barrel and you got your Indian Whiskey." This is a recipe from Teddy Blue Abbott from the book "**We Pointed Them North**". If they were pointed in any direction after drinking this concoction, they probably lost their way.

Charlie notices that the bunch drinking at the Bucket of Blood Saloon in Gold Butte were all talking low like they were at a funeral. Charlie asks if the gents had been pallbearers and were spreading sorrow. The bar tender lets Charlie in on the secret of the difference in brands of booze. The barkeep says, *"This bunch, if they stay to the finish, will whisper themselves to sleep."*

It is difficult to guess where and when Charles Marion Russell learned what he did, but through it all he stayed true to who he was. He enjoyed watching the cowboys with their quirks that gave away some secrets of their past. How they sat a horse. How they wore their hat. How they dressed and the style of tack they rode with. He found out he was *"a cowpuncher from the Rockies rangin' north, usin' centerfire or single-cinch saddle, with a high fork an' cantle; packed a sixty or sixty-five foot rawhide rope, an' swung a big loop."* Always to add a little color to his tales, Charlie tells about wintering in "Cheyenne" and tying on a rather enjoyable time until he was seeing double and passed out. When he woke up there was a feller sitting across from him on a bunk. After Charlie puts on his hat and dresses this feller gives Charlie an evaluation of what he has learned about Kid Russell just by watching him dress and stand up. Even though Charlie did not remember how he got there or where he was, he remembered everything this stranger told him about himself well enough to write it down years later. Facts are stubborn things.

That night out in Cheyenne was somewhere in the winter of 1883-1884. Tracking CMR before he married is sketchy, literally. He was good about putting dates on his drawings. The problem is knowing where

he put the drawings. Sometimes in the sand or on a wall or napkin. A few have been captured for display, but from the tales told there are far more sketches that remain etched in memories or lost to the wind than are captured and kept in collections. Charlie must have been the fastest draw in the west for years. The best example and largest collection are in the letters that have been put in books. The second-best collection might be some of the photographs Chas E. Morris took with his glass plate camera before he went to photography school. Just as Charlie, Con, and a host of their friends did not think they were "good" writers, Chas E. Morris didn't think he should charge for the photographs he was taking to learn his trade. He thought of it more as a hobby to record the life he was living in Montana. Morris was a great photographer just as Con and Charlie are fabulous tellers of tales and painters of mindful thought. Today, whoever would have known what "Bronc to Breakfast" was if it had not been for these cowboys? (See Charlie Russell 1908 oil painting) The camp cook was never happy when this event occurred so it's good it was not an every morning occurrence, but it happened more than once as the day shift saddled up to tend the herd.

Pictures, whether paintings or photographs, reflect real life. Charlie saw that bronc for breakfast in the fall of 1892 at a cow camp on the Missouri River. As related by Joe Roke in "Our Heritage", "*Charlie Russell happened into the camp and one morning a lively bronc backed across the cook's campfire, scattering the cook's paraphernalia far and wide. The incident gave Russell the inspiration which took the form of*" his painting.

Joe Roke was a pioneer rancher in the Sweet Grass Hills filing a desert claim on land near the head of Little Sage Creek in 1898. He was riding for the N bar N outfit. He and his brother, Matt Roke, had joined a cattle drive in Texas heading to the badlands in South Dakota. From 1880 until 1892 the Roke brothers helped drive several herds of cattle from the eastern and southern states to Wyoming, Idaho, Montana, and the Dakotas. They worked for numerous outfits ending their careers following the herds to Montana. Joe settled on his own place in the Sweet Grass Hills.

CHAPTER 15

NO HOLDING BACK

The challenges of life in Montana in the 1880's required a full commitment from any person wishing to stay in the unsettled State. Government aid was spread thin. Cowboys were learning the hard way it is difficult to be capitalists when there is no capital to begin with. The military struggled attempting to build protective enclosures called 'Forts'. These were most often located where there were already established trading posts with trails that were the transportation corridors of the day. Fort Shaw was one such location and this adobe brick fortress still stands as a testament to the settlers who stood their ground and families who remain in Montana.

Fort Shaw was established June 30, 1867 with its principal mission to protect the stage and freight routes passing through the Sun River Valley from Fort Benton to Helena. It served as headquarters for the District of Montana Territory military with Colonel John Gibbon in charge. Infantry was moved from camp Cooke to Fort Shaw and in 1869 five companies of 7th Infantry, 12 officers, and 195 men were sent from Fort Shaw to fortify Fort Benton. Today this small community struggles to survive nestled along Sun River where the foothills meet the Rocky Mountains. It was a perfect location for the Mullen Road to start its climb to places west over the great divide. It was also the location for the numerous tribes of Indians to concentrate once the Jesuits began to struggle with conversion of the Native American savages. It was a necessity to have a close military presence offering some protection to

settlers and businessmen trying to locate cities, schools, and churches to accommodate families and form communities. The steamboat port at Fort Benton welcomed many newcomers to Montana. Fort Shaw appeared as a funnel for everyone traveling west or south across the territory. The lush meadows in Sun River valley beckoned respite for the stock and wagons traveling all directions.

Newspaper reports across the state had accounts of people traveling to small towns or posts "*by stage*". Many of the "*stage*" drops were known to never have had a scheduled stop or mapped *stage route*. In 1785 the Continental Congress authorized the Postmaster General to award mail transportation contracts to stagecoach operators. This subsidized public travel and commerce with postal funds. Stagecoach mail became the preferred delivery over horseback. March 3, 1845 Congress abandoned its preference for stagecoaches with contracts awarded to the lowest bidder for what "*may be necessary to provide for the due celerity, certainty and security of such transportations*". Postal clerks shortened the phrase to three asterisks or stars (***). These bids became known as star bids, and the routes became known as star routes.

By 1849, the Department had cut transportation costs on all routes – horseback, stage, steamboat, and railroad – by 17 percent, from $2,938,551.00 in 1844 to $2,428,515.00. The population growth was burgeoning. Route distances rose 20 percent for the same years, from 35.4 million miles to 42.5 million miles in 1849. Still, throughout the 1850's, the Department continued to favor stagecoaches over horses on certain routes. In 1852, Postmaster General Samuel D. Hubbard instructed contract bidders to state the type of conveyance. "*If higher mode than horseback be intended*", noting that stagecoaches were preferred on certain routes. Stagecoach required a greater entourage ensuring more security for transport of goods and services. From 1802 to 1859, postal laws required carriers to be "*free white persons*". Violators were fined. The typical four-year contract did not provide payment for missed trips, regardless of weather conditions. Unexcused service failures could result in fines up to three times the trip's price.

Postmaster General Joseph Holt's 1859 Annual Report criticized the "*enormous sums*" paid to stagecoach companies to transport mails, "*some*

of which [were] so light as scarcely to yield a revenue sufficient to defray the expense of carrying them on horseback". He declared, "*In advertising for the new lettings, 'Star Bids' ... will alone be invited ... without any designation of modes of conveyance*". The 1860 Annual Report is the last to discriminate between "*coach*" and "*inferior*" modes of service.

Contractors had to be at least 16 years old until 1902 when the age limit was raised to 21. Subcontractors or carriers could be 16. Contractors were bonded and took an oath of office. Subcontractors and carriers also took the oath but did not need to be bonded. The requirement for driving a stage or freight was the ability to manage horses, teams, people, and cargo including mail. Freighting was a highly skilled trade multitasking most vividly depicted today at the Calgary Stampede wagon races. References to freight hauling would include the job of stage and mail. The pay was good, but it was one of the most perilous jobs in the west from 1850 to 1900.

In Lieutenant Francis Vinton Greene's Journal of 1874 titled "***Down the Missouri by Mackinaw Boat***" he describes Sun River Valley; "*Helena and its surrounding mines lie 80 miles to the southwest through the Gateway of the Mountains. The mining interests there are said to be declining but it is not in mines that Northern Montana has her wealth, it is in her grazing land. It is destined to be the great stock raising region of the country; already it rivals Texas for beef raising – both in numbers and quality and the sheep that have been introduced have done splendidly and only a little more capital is required to introduce many herds of them.*"

Floating down a river or riding along the river valleys in northern Montana territory did give the impression that this was truly a garden of Eden or Paradise as some of the settlements east of Sand Coulee project with their names. Taking a swing north between Malta west to Cut Bank one gets a different impression. This basin between Milk River and the Missouri and Marias Rivers is somewhat less productive. The grasslands are replaced by alkali-strewn sagebrush prairie. Dryland farmers have attempted assorted crops on the barren acres with some success where the rivers provide irrigation, but many pioneers lost out to insects and drought by 1900. This large expanse of real estate with the Little Rockies, Bears Paw Mountains, and the Sweet Grass Hills

protruding like Islands on the prairie is the area that hosted many of the cattle baron's herds before barbed wire. It was largely this northern stretch of dusty plains where Charlie Russell, Con Price, and Teddy Blue Abbott closed out their days of wrangling and settled into their own family lives. While they were still riding single there were a couple of mining camps that flared up in Landusky, Zortman, Winifred, Sweet Grass Hills, and those little bergs of Paradise and Eden. None of the findings led to big strikes, but they managed to keep gold fever active and the bandits that couldn't and wouldn't climb aboard a cow horse or walk behind a plow in Montana stayed on looking for easy money. If there was not a dance in town you could always find a poker game because even in a camp someone was carrying a blanket and a deck of cards. Bill Morris's book has a photo named "The Cowboy's Call" on page 14 showing a blanket spread out on the prairie with cowboys having a game of poker. The game pictured must be a little shady as one man has his gun drawn and another is drawing his.

Once the railroad crews started leaving stragglers, there came to be a large group of professional gamblers throughout the territory on into Canada. Once the government had people sign up for social security numbers these fellers would list *"rodeo rider"* as their profession. That was an income hard to track.

Along about 1885, John D. C. Atkins, commissioner of Indian Affairs, caught wind that some of these gold diggers were working on Indian Reservation claims. He wrote to the Blackfeet agency in Browning: *"The law provides how trespassers shall be removed. … the law is mandatory … you are hereby directed to notify the miners and prospectors in the Sweet Grass Hills, within the reservation limits … and warn them to remove from the reservation. If they refuse to comply with such warning, you will at once report the fact to this office."*

The **River Press** of June 17, 1885, printed the Commissioner's letter under the headlines:

"This is too Bad! The Miners and Prospectors of the Sweet Grass Hills and Little Rockies Will Probably Have to Go."

Some things never change. It's apparent the agencies within the Federal and State Governments communicated as well in the 1800's

as they do today. Montana Territory and it's designated reservations were not defined and the military camps had been in the Sweet Grass Hills for several years by the time Commissioner Atkins instructed the Blackfeet Agent to "*go talk to those miners*". **_The River Press_** published a letter to the editor from Rex at the Camp of Sweet Grass Hills, October 23, 1885.

November 4, 1885: The company was "*performing good service for the government in endeavoring to put a stop to the incursions of marauding Indians. Camp life is not all that fancy as painted. It is review at sunrise, inspection at sunset, taps and lights out at 8 P.M., no one allowed to leave camp without permission. Our bill of fare is as follows: breakfast, bacon, dinner hog meat, supper bacon. It is very good for a few meals, but for a steady diet it gets monotonous ... There are two prisoners in one guard tent. We are not allowed to go out fishing in sight of the camp without permission. There are several more candidates for the guard house. We regard the restrictions of the camp insupportable, and it is important that the rations should be increased and improved.*"

It's reasonably safe to presume "Rex" was looking for an increase to the *bill of fare* and that the guards of the prisoners might well be the candidates for the guard house, but it was not his place to be the judge of that. Maybe a little fishing trip would bring a bit of joy to the whole bunch. What else could be done? These little gold flashes in the pan were just that and lasted about as long. The first strike made some money for the finder, but it was slim pickings after that. Food was becoming more important for the Indians and everyone else.

The **Shelby Promoter and Tribune of Shelby**
reported Thursday July 9, 1964-

"*When buffalo robes became scarce the bull trains (wagons pulled by oxen usually moving in a train or brigade of eight to ten teams) traveling the Old North Trail, also known as Whoop-Up Trail, from Fort Benton to Fort Hamilton near Lethbridge, Alberta, Canada, would return to Fort Benton with wagon loads of coal. The first train load of coal, 36 tons, arrived in*

Fort Benton November 1, 1880. The last [wagon] train passed over the Whoop-Up Trail from Fort Benton to Fort McLeod in 1892."

It wasn't long before the bull trains would not be hauling coal. The railroad was on its way and when it arrived those old bulls got retired and then, probably ate. Shipping by rail was 90% more efficient than other means of transportation in the 1800's.

Charlie Russell kept on working the fall roundups, but he was sort of scarce around the campsites in the winter and spring. He said he was spending time with the Piegans and other Blackfeet Indians. He would not have had to travel far from Great Falls with several of the Missions and Agency's moving closer to Fort Benton, Choteau, Vaughn, and Sun River. If he ventured to First Agency, he would have met Susie Price (later Mrs. James Turner) as she was the first teacher at the Agency. He would have also become acquainted with Claudius Bruce Toole as he was the Clerk from 1883 – 1887-8. Claudia Toole (Price) and her brother Edwin (Cap) Toole would have been attending school.

Sun River History and Pictorial books have threaded references to Charlie visiting in and around the area of the Ford's and Furnell's homes. Matt Furnell and W.H. Ford lived in proximity and both managed livestock for T.C. Powers, Dan Floweree, Healy Brothers, Dunn Brothers, and others. Matt Furnell drove stage and freight for T.C. Powers, I.G. Baker, and J.J. Healy. Furnell had two homes, one in Great Falls, 1517 Third Ave. N., and the other on Section 28, township 21 N, Range east, Cascade County, at that time Choteau County. Matt was married to Matt and Thomas Dunn's sister Kate for about 18 months from 1875 to 1876 when she died in childbirth.

Matt Furnell was sent to Chicago for an order of freight for T.C. Powers early in 1882. He returned with the load of freight, a wife, and sister-in-law, Kate Peeke. The Furnell-Peeke party met Miss Fannie Iliff in Bismarck. She had traveled by train from Chicago where she resided. The manifest for the Steamboat Matt and Della Furnell took from Bismarck to Fort Benton showed their trip was paid with a *"voucher"*. Kate Peeke and Fannie Iliff were the only passengers of the 23 aboard the steamship with their passage fee waived with a *"coupon"*.

When the history of Montana is told, the tales of men who

were settling fresh territory and establishing trade relations were the same small group. Healy, Powers, Baker, and Toole's names crop up throughout written history, but Matt Furnell evidently requested that he remain reclusive throughout his life in Sun River and Great Falls. There wasn't television back then and by reports, these men worked from sunup to sundown. The stage and freight drivers often worked through the night using the superstitions of the Indians in the dark to help insure their safe journey(s). Matt Furnell drove stage, was a charter member of the Choteau and Meagher Counties Stock Protective Association and was a Sun River Ranger. Matt and his early day sawmill partner, John Largent, were both big men. Over six feet tall and broad shouldered. This might be one of the reasons Furnell drove stage and freight maintaining a seated position on a wagon rather than riding a horse. According to Teddy Blue Abbott and Charlie Russell, big men the size of Furnell and Largent were "*hard on horses*". They were referring to the miles the wranglers rode and the terrain they covered. Most freighters could ride a horse, but most cowboys could not manage a team.

Furnell raised horses and cattle, and even some sheep at one time. The sheep might have been promoted under the influence of Paris Gibson because early accounts of Ranger activity reported their rules gave permission to shoot any sheep, and their owners, that were found on range determined to be "*cattle range*". Paris Gibson changed the outlook for sheep in Montana and is often credited for the fact that Montana did not have as much trouble with sheep and cattle disputes as Wyoming, Colorado, and Utah. Claudius Bruce Toole may also have had some influence in the acceptance of sheep in the livestock population of Montana Territory. In addition to being the Chief Clerk at the Blackfeet Indian Agency under Majors Allen and Baldwin, he was the Supervisor of Sheep Industry and a member of the State Board of Sheep commission.

Della wasn't fond of rural life and once her oldest child was school age she stayed in her home in Great Falls participating in the Ladies groups and social life the burgeoning city offered. Della did learn how to drive a team and buggy. In the summer she would take the children

to the ranch at Sun River for picnics and brandings. Her husband made the same concession the opposite direction, but he was not just a fair-weather commuter. Matt was the U.S. Mail person. Through rain and sleet, he would drive his horse driven stage and wagons in addition to managing his horse and cattle ranch in Sun River.

Matt would spend most weekends in Great Falls with his family during the winter if weather permitted. He served on the School Board in Sun River one term. Della was always entertaining, and Matt showed up for mixed socials, but his focus remained with his livestock and ranch. He had been on his own most of his life and was old enough to be Charlie Russell's dad. He was a good hand with horses and cattle, not afraid to share his knowledge. If Charlie needed a roost or some coin, Matt always had chores and room for extras. Matt fell ill in the spring of 1896 and died May 7 after three months of doctoring at home in Great Falls. It is not a surprise that Charlie married a few months later after losing this old friend.

Della Peek Furnell and her three sisters, Kate (Ford), Lou (Stringfellow), and Za (Porter) were welcomed in Montana communities. Kate Peeke (Ford) and Fannie Iliff had arrived by steamboat in Fort Benton June 9, 1882. Lou and Za Peek came to Montana by train around 1889. Lou and Za lived with Matt and Della until they married helping out in Sun River or in Great Falls. There were families living in the Sweet Grass Hills who had relatives working in Sun River. As Matt Furnell's sisters-in-law these two young ladies had a perfect opportunity to meet businessmen in the area. Lou married Henry Stringfellow October 5, 1893. Henry was a businessman from Havre. Za married one of the Porter brothers, Wallace. The Porters came to Montana from Nova Scotia sometime around 1886. They were bridge builders who were working for the Great Northern constructing bridges between Havre and Butte. Za married around 1890. This author was unable to locate the exact date. The Porter's were related to the Hiram Smith family. Hiram had a thoroughbred racehorse that won Hiram some money when the horse was young. Sam Sears was the name of the horse. When Za married, Sam Sears was retired from the track and Hiram thought he'd give him to the Porter's as a wedding gift. Wallace

Porter didn't have an interest in racing or raising horses. Much to Hiram Smiths' affright, Mr. Porter put Sam Sears to pulling a plow.

A story by Dillwyn R. Davies in Sun River II history mentions the R.S., W.H., and Kate Peeke Ford ranch joining the Mulcahy place on the west and the Matthew Furnell place joining to the east with T.C. Power holdings between Ed Reineke and Matt Furnell. R.S and W.H. Ford were the owners of Sun River Crossing and the Ford Bros store in Sun River. Dillwyn Davies mentions seeing Charlie Russell riding by his place on his way to Furnell's and Ford's for roundups and brandings that were walking distance from his home. He tells of a conversation with Charlie Russell about wolves and the devastating winters of 1883 and 1886. He said Charlie called the western prairie wolf the lobo. *"The lobo was generally considered somewhat smaller than the timber wolf of the east. It did not like carrion, but usually killed his own fresh meat."*

Another young man from Sun River who met Charlie when he was young and hadn't found a career yet was Clarence Bull. Clarence was working for the Ridgley Calendar Company in Great Falls. He had an interest in photography and the company was printing Charlie's paintings on their calendars. Russell would come in and visit with Clarence and encouraged him to do some sketching and painting. Sketching and painting did not work out for Clarence, but he won many awards for his photographs and became a cameraman for MGM after meeting Mrs. Frank Lloyd, the wife of a Hollywood producer, at one of his photograph exhibitions.

Matt and Della Furnell had three children. George Raymond born July 3, 1883, Albert Murray born March 26, 1885, and Florence Montana Furnell (Kumpe) born December 10, 1887. George (Ray) was born in Sun River. Albert was born in Great Falls. Florence was born in Florence County, Michigan. Della made her first trip home to be with her family for the birth of her daughter. She gave her the first name of the Township where she was born and her middle name for the State she would call home. The Furnell children were 13, 11, and 8 years old respectively, when their father died. Ray and Bert spent most of their summers at the ranch in Sun River with their aunt and the Ford children to play with. Della would spend most weekends at

the ranch in fair weather until Ray was old enough to start school. Ray was never fond of the ranch, although his best friends were also his cousins. Bert hated to go to town for any reason. He grew up at his father's side and spent more time with his dad and the horses than he did with his brother and cousins. Florence didn't spend a lot of time at the ranch. Once her grandmother, Almyra (Myra) Dimmick Peek, had her hands on a granddaughter, she began making frequent trips to Montana. Henry W. Stringfellow, a Havre pioneer merchant, married Lou Peek October 5, 1893 in the Great Falls Church of the Incarnation (Episcopal). This church is located at 600 3rd Ave. North and is the same church which hosted Charles Marion Russell's funeral service. Matt and Della Furnell were witnesses to the wedding ceremony.

"**The Advertiser**", Havre, Montana Tuesday November 29, 1983 edition has a lengthy article about Henry W. Stringfellow written by Gary A. Wilson giving many details about this early day merchant. The article has a sketch of Stringfellow and the Havre Commercial Co. and Department Store on the southeast corner of Third Avenue and First Street. The sketch is dated March 27, 1909 and the building is still a part of downtown Havre in 2020. What later turned into a drugstore at first carried groceries, paint, cigars, tobacco, fine linens, wagons, and other merchandise as advertised in 1896 newspapers. His first building burned in 1904 and he reconstructed which would be the building in the sketch mentioned in this writing.

Henry W. Stringfellow was born in Virginia and came to Montana in 1882 when he was 18. He spent his first few years at an uncle's ranch near Wolf Creek. He taught bookkeeping at a local school and worked at a store in Sun River before moving to Havre. In 1916 Stringfellow added an extension on his building to accommodate automobiles where Fords were the first offers and later Willy-Knight and Whippets were sold. The store continued to grow until it was reported to be one of the largest of its kind in Montana with 50 employees, 25,000 square feet of floor space, and an annual business of $500,000.00. Stringfellow was said to be a *"great boss"* as reported by a former employee, Bella Snortum, reported. *"He was on the quiet side and he really treated the employees with respect and kindness."* Bella had different words for *"the*

man across the street", F.A. Buttery, who started his original chain of stores in Havre Montana.

A severe storm damaged the store in June of 1906 and Stringfellow once again rebuilt. That same year his father, Martin, his brother, Rittenhouse, and Henry's son, Henry all moved to Havre. Martin was 70 years old. He took up a homestead located about 20 miles south of town in the Bears Paw Mountains on Clear Creek. Henry later used it as a summer retreat. In 1983 it was part of the Young family ranch. Martin died in 1909 on a return visit to Virginia. He had been a farmer in Virginia and served as a captain in the Virginia Militia under "**Stonewall Jackson**" in the War Between the States. Rittenhouse worked for his brother in the store and lived at a farm on the east side of town. The farm had a large barn that housed wagons and later cars. The farm was later a dairy run by the Fuglevand and Rimmer families. Ray Rimmer reported that he remembered Henry Stringfellow as a *"likeable person who was a fair and decent landlord"*. Rimmer thought the farm was originally a **Great Northern Railroad** experimental farm. Stringfellow had originally used it for raising horses and feed for livestock. Because of Hill's significant presence in Havre during that period, James Hill most likely had a business relationship with H.W. Stringfellow. Being a brother-in-law of Matt Furnell, he most likely had affiliation with Matt Furnell as well with the horses Matt raised and his freighting business.

Henry C. Stringfellow died in 1935 from a fall down the basement stairs of his store. He was 71 years old. Henry and Lou Stringfellow lived in a three-story green and white Victorian wood frame house with extensive elaborate woodwork on the interior at 332 Second Avenue in Havre. Mr. and Mrs. F.A. Buttrey lived on the corner of 6th Street and second Avenue in an English style three story wood frame. H. Earl Clack, the founder of the Husky Gas Station chain, and his family lived on the west side of Second Avenue between 5th and 6th Streets in stylish three-story brick homes. These homes are in the Historic District of Havre and are still standing in 2020. The author of this writing lived with Bob and Georgia Rice in the F.A. Buttrey house in the maid's

quarters, 205 6th Street, Havre. Bob and Sally Seabrasse owned the F.A. Buttrey home at that time.

After her husband's death, Lou Peek Stringfellow moved to San Pedro, California where her daughter, Virginia, and her husband Roy Bruner were living with their family. Virginia and Roy Bruner had a *"storybook wedding"* in Havre as reported by Mary Almas-Antunes and Edith LaGrow who remembered the event as; *"crowned with an elegant wedding at St. Mark's Episcopal Church, of which the Stringfellow's were members."* James J. Hill financed the construction of this beautiful stone church that stands at the northeast corner of 3rd Avenue and 6th Street in Havre. The Reverend Conrad Wellen said of H.W. Stringfellow; *"His business integrity was unquestioned. In friendship he was quietly fervent and steadfast. He was sober in life, tireless in industry, of a sturdy independence of spirit."* The Reverend referenced **II Samuel 18:27 (KJV)** – *He is a good man, and cometh with good things.*

CHAPTER 16

A FEMININE TOUCH

When the train arrived in Havre Montana it changed the gender disparity dramatically. It provided transportation that was safer, faster, and a more comfortable means to travel west for families. Getting to north central Montana may have been easier, but once arriving the task of setting up a home and raising a family required fortitude with a willingness to be innovative and independent. Many families arriving wanted to own their land and farm or ranch. Those two industries remain at the top of dangerous and difficult jobs in the world. Daily these people were at the mercy of nature and elements which they could not control. Most were miles away from any sort of supply depot or medical help plus the void of churches and schools. The four Peek(e) sisters who came from White Pigeon, Michigan were exceptions in many ways to the norm of women arriving in Montana in the 1880's.

Della and Kate came first and married men who were already established and had houses built. Their parents, George and Almyra (Myra) Peek, were farmers in Florence Township, Michigan, but the ladies lived in White Pigeon in a large home with a housekeeper and family nearby. Their life in White Pigeon must have been vastly different in culture and population as the country, soil, and population were and are drastically different in productivity. A 160-acre piece of property in Michigan would be adequate to produce crops that would support several head of horses, cows, or other livestock and raise a garden in a small plot to feed a family of 12. This juxtaposed style

of farming, by its nature, formed communities that were close knit resolute urbane villages.

Della is referenced as a '*socialite*' in the City of Great Falls. That was a difficult and lonely position to take in 1883. Many of the families in Sun River were Métis with mothers who were Indian. The military families at Fort Shaw centered their social life at the Fort, partially for safety and because of the vacancy of other offerings for socialization. Activities that drew communities together were dances, church, and community picnics or basket socials. There was always music at these events, and the instruments were varied but usually included a fiddle or violin, guitar, harmonica, accordion, and piano or organ. The Jews harp was replaced with a blade of grass pulled tightly between the thumbs and blown, or often just a whistle. Spoons and washboards were added by anyone who wanted to join the band with a little percussion.

Portable instruments were easier to obtain around campfires and impromptu gatherings, but a piano was special. There are many stories of the pianos, and how they arrived, in the Sweet Grass Hills. Moving a piano takes earnest effort. Since none were built in Montana territory, they arrived by steamboats or passage by rail car or wagon transfer to their destination. Reports of crushed pianos along wagon trails where freight wagons had been raided or unable to sustain the weight in the mud or snow were common. Piano's arriving in the Sweet Grass Hills of noted history were Edith DeYoung's, Hattie May Parsell's, and Effie Ellis's.

Edith Brinkman Morgan DeYoung's black walnut baby grand piano came to Fort Benton by steamboat as a wedding gift from her husband, Thomas Francis Morgan, on Mrs. Edith L. Brinkman Morgan's 16th birthday. T.P. Strode was a business associate of Thomas Morgan's and happened to be in Fort Benton when the baby grand piano was downloaded from the Steamboat. The piano made journeys to Herman Brinkman's ranch on the Marias northwest of Fort Benton, to the settlement that would become Stanford, Montana, and back to Fort Benton where it was stored until Edith moved back to her parents after Thomas died. Matt Morgan and his brother Tom hauled the piano to the Sweet Grass Hills to T.P. Strode's ranch on East Butte from the Brinkman Ranch on the Marias in 1908. Edith had died and Sam

DeYoung and the Morgan boys were divesting Thomas Francis Morgan and Edith's estates.

Thomas Francis Morgan was a cousin of Thomas Francis Meager. He was born in Willsburg, New York and came west to Fort Benton, Montana Territory via steamboat when he was a young lad. He was employed by T.C. Power & Bro Co. and for many years oversaw the warehouse in Fort Benton. Edith Brinkman was about six years old when she came west with her parents, the Herman Brinkman's. The Brinkman's came to Fort Benton via steamboat and purchased a piece of property that had been the site of the Old Fort (Union). The property then became known as the Brinkman Addition of Fort Benton. Thomas and Edith Morgan had moved to Minot, North Dakota for a short time in the late 1800's and Thomas was accidentally shot and died a year later from the wound. Edith moved back to her parents on the ranch on the Marias River where she met Sam DeYoung. They married and moved the family and piano, to the Sweet Grass Hills in 1901.

Thomas Morgan was a horseman who had brought several good stallions to Montana via steamboat. He raised Thoroughbreds, Standard Bred, Black Hawk Morgan, both Saddle and Harness horses, and some very fast racehorses. Thomas and Edith had taken their family to Minot, North Dakota to sell and race their horses. Minot, North Dakota was a big sports town at the turn of the century. Since the railroad had arrived, people were able to get to Minot from all directions to participate or watch events. The horse racetrack two miles south of town was a big draw for Canadians and U.S. citizens. Tom Morgan always said he *"would not own a horse that could not go a hundred miles in a day, then after a night's rest make a hundred miles the next day"*.

Thomas Francis Morgan died in Fort Benton. He was riding a Thoroughbred Bay Gelding named Chatto near Langdon, North Dakota on his way back to Montana when he was accidently shot in the left hand, arm, and chest with a ten-gauge shot gun. His son, Matt Morgan, took Chatto to the Sweet Grass Hills with the family when Edith and her second husband, Samuel DeYoung, moved the family. Chatto lived to be over thirty years old.

T.P. Strode first came to the Hills and filed a squatter claim near

a bachelor named Jackson Harrison Moore who was doing some gold digging on Sage Creek on the east side of East Butte. Moore had brought a small band of horses with him when he came from Oregon. He was raising and selling his horses to the Calvary camp as his dreams of striking it rich panning gold was not panning out. Sage Creek head waters are on East Butte and it flows east then turns south and flows to the Marias River.

T.P. Strode had left his home in Kentucky when his mother died. He was fifteen. He tried working on farms and found a job working on the Albert Lea Railroad as a brakeman. In 1880 he came to Montana and went to work for the Northern Pacific Railroad as a bridge builder. He wasn't afraid of heights and preferred working above the other workers to avoid getting hit by the tools that were frequently dropped. Tom was working on a bridge near Missoula, Montana one day. It happened to be the day before pay-day and a man held up the track crew. The robber was infuriated that the entire crew netted him only thirty-five cents. He threatened them with his gun. Tom had only his tools, but he took a wrench and threw it at the gunman striking him in the head. He began climbing down to get to the crew. By the time he reached them they had swarmed the gunman and hung him. It made Tom sick to think the man had died without a trial. He knew he was right to do what he did, but he could not shake the guilty feeling. Tom Strode quit the Railroad and bought a horse and saddle and headed out without a thought of where he was going. He ended up at Prickly Pear where he picketed his horse for the night. He had been warned that the Indians were becoming hostile, so he was not resting easy. He saw an Indian crawling toward him with a knife in his mouth. He took his shotgun and fired it at the Indian blowing his head off. The next day when he stopped in town to eat and rest, someone stole his horse. He walked to Fort Shaw where he met a family traveling in a camp wagon. They were searching the riverbank because none of them could swim and their young daughter had fallen in and drowned. Tom dove in and retrieved the body of the little girl.

After burying the body and performing a service, as best he could, Tom rode with the family to Augusta. At Augusta his luck changed. He found work at the Berthelote Ranch on Elk Creek and when he had

earned a little money, he bought his own homestead stocking it with thoroughbred horses he got from his father in Kentucky, Colonel Strode. The area around Augusta was a little wilder and woolier than T.P. had anticipated. Lynn Stark met T.P. Strode on a sheep shearing job in the Augusta area. He invited Strode to the Sweet Grass Hills for a look around as it was about to be opened up for settlement. In 1888 Strode traded his thoroughbreds for a band of sheep and went into partnership with a cousin, John N. Dorsey. They drove their sheep to the Sweet Grass Hills taking three days to swim their band across the Marias. Arthur Ross held a squatter claim on the northeast side of Middle Butte that wasn't proved up and Lynn Stark had a small band of sheep on the claim. Strode and Dorsey left their sheep at the Ross place and started filings on open claims on Bear Gulch and Sage Creek on East Butte.

Lynn Stark and Mr. Moore had squatter claims with cabins on them in Bear Gulch along Bear Creek. Harrison Jackson Moore let T.P. live at his place while Strode looked around East Butte for open claims. Strode bought both Stark and Moore's claims and some adjacent Indian claims. T.P. Strode was related to Harrison Jackson Moore through a Jefferson Davis lineage. Author and professor of creative writing at the University of Alabama, Hudson Strode, wrote a trilogy on Jefferson Davis. His almost familial love for Davis seeps through every page. (Hudson Moore– October 31, 1892 – Sept. 22, 1976).

T.P. Strode hired both Stark and Moore to work for him around 1888 allowing both to have their own livestock to run with the stirrup brands. The Strode ranch yard had a bunkhouse and other cabins for living quarters for families and hired men to be housed year-round. When T.P. Strode married he built a beautiful 15 room house with a fenced yard surrounded with a hedge of wild rose bushes and cottonwood trees. The landscaping did not stop there. He continued with numerous flower gardens throughout the yard adding voluptuous colors to the lavish greens already abounding in the meadow and hillsides of the natural enclave of Bear Gulch. Edith Brinkman Morgan DeYoung's piano added another dimension to the attraction. The gulch amphitheater opens to the north with a view into Canada where Bear Creek flows to the Milk River. Edith had died and her son Matt was looking for a place to keep the piano when

her children were divesting the estate. The piano was stored in the hayloft of the horse barn that sat on the bank of Bear Creek. This creek playfully dips underground in places hiding brook trout as it flows merrily year-round north to the Milk River in Canada from East Butte.

Years later as this scene has aged it continues to enchant in its grandeur and solitude. One of the few places in the world where there are no train whistles or transportation corridors to interrupt nature at its finest. Edith Brinkman Morgan DeYoung's son, Matt Morgan, visited the Strode ranch around 1919 and thought he saw the top of that black walnut baby grand piano patching up a hole in the Strode horse barn. No one is sure what happened to this piece of history and the only sign of anything resembling a keyboard or black walnut wood is that patch in the grand old barn. Mr. Moore was a practical man and most probably found, what he considered, an honorable use for that oddly shaped piece of 'good wood'.

To say that Tom Strode was *quite a guy* is an understatement. He was a gentleman and a scholar who loved his neighbors and the community that he helped build. He decided at one point that one Whitlash was not enough for this world, so he platted another. He encouraged his brother, A.C. Strode to come to Chester and start a mercantile business, which he did. Virginia Herron came to teach at the Strawberry School southwest of Whitlash in 1907. She married A.C. Strode and for a while they had a mercantile in Hill before moving to Chester and opening a mercantile known as the Green Store supplying Hill, Whitlash, and Gold Butte for several years.

For years there was rarely an edition of the Chester newspaper that did not have one of the Strode's mentioned in a column or an ad. T.P.'s livestock took awards throughout Montana and Alberta Canada. The property where T.P. and Ella Strode along with Alfred C. and Virginia Strode located the second Whitlash was purchased from Frank Stratton who had purchased it from Milford S. and Elizabeth R. Whorley. George F. Elstone made the survey January 1, 1910. One of the reasons T.P. Strode decided to build Whitlash in a new location was because the Hill Post Office was going to close. James Hamilton had established Hill August 6, 1898. In the time it took for the filing for the Hill Post Office and approval, it had been decided that there would not be

enough precious metals in the Sweet Grass Hills for James Hill to bring a spur line railroad to the Hills and the tracks had proceeded to Shelby.

Rosine Lauener was Postmistress at the Hill Post Office from December 15, 1908 to 1912, acting for Hamilton. Hamilton had moved back to Washington D.C. Whitlash P.O. was established February 9, 1892 where the Pete and Fanny Hofer ranch was off the road near Sharks Tooth Butte. Jim Whitlash had taken the position of Postmaster when the application was sent in but had left to prospect in Butte before approval was received. Maurice Price was located between Hill and Whitlash and agreed to run the mail and stage stop from his ranch until George B. Bourne moved the P.O. to the Hawley cabin near Whitlash. When Bourne was not available, he had Peter Hughes serve as postmaster for the Whitlash Post Office.

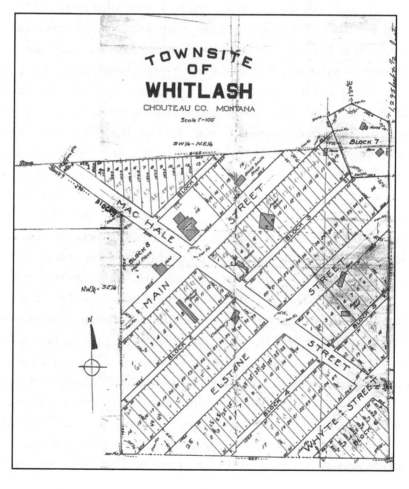

"Montana, the magazine of western history" spring 1955 issue had a story on page 63 headed "Early Gold Digger …". *"Colonel W.F. Sanders and his lady, during their visit to Helena, went over to Mr. J.W. Whitlash's ledges and descended into the deepest shaft on the union, 101 feet below the surface. The lady, with her own fair hands, selected some very fine specimens of quartz thickly studded with gold. There are few ladies in this Territory who would venture to make such a descent, in a small bucket sliding down an inclined plane on two poles."*

The J.W. Whitlash story would be feasibly the most accurate of how this city got its name as the post office moved for several years when the stage routes changed. Schools and stores cropped up and migrated until a large building was constructed by Lester Allen Stott and Lester (Ted) Edward Allen in 1914. Lester Allen would later become Lester Stott's son-in-law. The large building housed the post office, store, two apartments, a dining area, and the living quarters of both the Stott and Allen families. The pressed tin ceiling was salvaged from the Prairie Inn in Chester when it was torn down and the safe was salvaged from Bourne / Hamilton's store and post office at Hill when they moved back east. Bourne and Hamilton had located in Montana territory near Great Falls in 1888. When the Sweet Grass Hills area opened for homesteading, they filed several claims and started the stage / postal routes in the Hill's, the first being at Whitlash and then Hill. At the time of their filings and establishment of post offices, Bourne and Hamilton thought there was enough gold in Gold Butte and on East Butte for James Hill to run a spur rail link to Gold Butte through Hill.

George B. Bourne and James E. Hamilton were foster brothers. The Hamilton's invited George to join their family after his parents died. The pair were the best of friends and business partners. It helped that Mr. Hamilton was a bank director in Washington D.C., but it was not a determinant factor in the core values of these two young men. They came to Montana in 1888 and stopped at the west border of Choteau county, Conrad. Their timing was great if they were searching for the cowboy life, but neither of these men had experienced the deprivation and physical challenges of livestock and nature. They found property in

the Sweet Grass Hills and built a dirt floor cabin. It was not long before they realized if they wanted mail more than once a year, they would have to ride to Fort Benton. The same was true for any business or entertainment. They determined to build a community in this territory they determined to call home. For several years, they hired ranch hands while they set up business offices in Chester trying to keep their ranch and their business solvent. They worked at it for several years but found that finding reliable help for absentee ownership was not feasible in Montana. The isolation and harsh winters led most hired men to go to town on payday, spending most of the rest of the winter in town. Heavy livestock losses and a few dry springs were enough to drive many homesteaders to greener pastures.

T.P. Strode was experiencing difficulties with his second coming of Whitlash and human nature. The building had just begun when the townsite was set afire burning a large hole in Tom Strode's beloved Sweet Grass Hills. He was thankful the wind was not blowing and that no people and only one residence was destroyed in the town. The insurance would not afford a rebuild of the city, so Whitlash along with Strode's dream, went up in smoke. The fire *"started in the creamery, then moved to the machine shed, dance hall, the saloon, a dwelling, another saloon, the store and, at long last, the lonely hotel."(Eva Strode Melvin, Shelby Promotor Column).*

Fire jumped into the ripe grain fields and started several small prairie fires including the school section along the ridge to the southeast on into the back pastures. If the night had been windy the blaze would have jumped the ridge and burned east to T.P. Strode's Stirrup Ranch. A sheep shed with a band of sheep locked inside burned on the Prescott ranch before the flames were extinguished.

It was 1905 when the building had begun at the new Whitlash. Fitzpatrick had given his notice at the post office and Eva Strode (Melvin) had taken temporary position as postmistress. Fitzpatrick lived two miles west of the current Whitlash at the intersection of Strawberry and Gold Butte Road. Although it would not seem to be much further for Eva to travel to work, Eva was finding the daily trip to the post office burdensome. Thomas and Albert Strode agreed to purchase the land

just ½ mile west of Whitlash on Breed Creek for the site of the new town and post office. The fire happened in 1912 and construction was still in progress with the exception of the creamery, store, and machine shop / livery stable. The worst part was the upheaval of the loss of the buildings and businesses caused by some arsonist in the community. The Liberty County Times had a post in their local column in August of 1912 that *"A.C. Strode and wife are at Whitlash this week. Mr. Strode is supervising the work of preparing the creamery for removal to Chester."*

It was 1909 when a fire had burned the Fitzpatrick homestead near Whitlash. William Dohrs had offered a *"$500.00 reward for the arrest and conviction of the party or parties"* who set that fire, to no resolve. This 1912 "Whitlash" fire required an expert sleuth. Detective Jack Teel was hired by the local ranchers to hunt down the culprit. Teel stayed at the Thomas Strode ranch while he completed his investigation and arrest. He was an ambi-eyed and ambidextrous lawman who carried two holstered guns which he shot simultaneously left, and right, killing two gophers every time. He was a personable individual and knew the neighborhood as he had worked in Gold Butte on a few cases prior to the Whitlash fire. He suspected a newcomer to the country; a rather small nondescript character in his 50's named Lou Burson. Lou Burson confessed at his trial and was sent to the penitentiary.

Whitlash was without a Post Office for a brief time and Hill Post Office reopened with McDaniel followed by Jeppeson as Postmistresses until it closed in 1967. Benny Odeguard bought the 40 acres old town site from T.P. Strode in 1940 for $25.00 an acre, which he paid in monthly payments. $25.00 an acre was high priced property at that time. Some land was selling for around $3.00 an acre and $12.00 was considered top dollar.

The Liberty County Times February 23, 1956 Golden Anniversary Issue has an article without a byline titled *"Post Offices or how come it's called Whitlash?"* Communications being what they were in the late 1800's, folks from Whitlash who were asked: "How did Whitlash get its name?", were not about to say they did not know, so the two favorite tales that have been repeated most frequently are: *"A number of men congregated in a small shack for the purpose of selecting a name for their*

post office and sending it in to the Postal Department. The name Whiplash was selected, and the returned document had misspelled the word." The second favorite hints to the actual reference of T.P. Strode's miner friend named Whitlash. Unfamiliar with Jim W. Whitlash, yet knowing a Bob Whitlatch had mined in Gold Butte, the story of not knowing the correct spelling or a spelling error occurring somewhere between the application and assignment of the post office name, the name came back as Whitlash.

The beautiful home and yard T.P. Strode built in Bear Gulch is sub irrigated, and because of its placement, out of the wind, sheltered from glaring sun and cradled by the crest of East Butte. Having horse raising coursing through his veins, Tom Strode brought registered Percheron horses and registered Herford cattle for breeding and show. His horse barn was built into the side of the natural shale shelf along the west wall of the gulch. It sheltered 100 head of Percheron with a hayloft on top keeping fresh hay enough for year-round feeding. He wasn't afraid to share his good fortune and hired many men to work while they gathered enough money to start their own farms and ranches. Lynn Stark finally struck out on his own and Jackson Harrison Moore lived on the ranch in the bunkhouse until his death in 1927. Born in New York in May of 1834, he was 82 years old when he died.

Eva Strode Melvin, T.P. Strode's daughter, wrote for the Great Falls Tribune and Shelby Promoter in the 1960's and 1970's. Eva lived in Great Falls after leaving the Sweet Grass Hills and relates many of her girlhood experiences of the Hills in her articles. She wrote of Charlie Russell, Bert Furnell, and Con Price and many others who passed through the Sweet Grass Hills and had occasion to visit the Strode ranch. It was not uncommon for twenty or more guests to be seated at the supper table. It was more of a retreat than ranch for both visitors and staff at the Strode's. There was no drinking or dancing at the ranch though. Friends and family had to mount up or take a buckboard to Whitlash or Gold Butte and leave the quiet repose. Eva tells of times she and her siblings returned home the morning after dances to their anxious waiting parents.

From 1895 to 1900 the Sweet Grass Hills were flooded with

families. Squatters claims were being turned into homesteads. These mountains have numerous freshwater springs and lakes. The creeks and springs provide plenty of water and the rolling terrain with native bluegrass and timothy is perfect for livestock. There were several horse and cattle ranches with a few sheep ranchers folded in the flock at the turn of the century. Fredrick Theodore Parsell started out with a band of sheep and expanded into one of the largest ranches in the Hills raising sheep, cattle, and work horses. His son, Robert Parsell, said, "*raising both cattle and sheep are good for the land if you rotate them right. The sheep will keep the weeds out because they eat some of the stuff the cattle won't, and the cattle like some of the taller grasses so sheep can get down to some of the weeds growing closer to the ground. You just need to watch and rotate to keep the range in appropriate shape.*"

Fredrick (Fred) came to the Sweet Grass Hills to shear sheep in 1891. Born in Peoria, Illinois February 5, 1869, the oldest of four children, Fred's parents moved to Oregon when Fred was 15. His parents tried farming in Oregon Territory with little success. His father died after three years. Oregon was big sheep country and Fredrick learned how to shear sheep helping his mother with the farm and his siblings while earning wages outside of their family farm. Sheep shearers were starting to travel to Montana Territory during shearing season east of the Rockies as there were increasing numbers of sheep coming to Montana from California and Utah with fewer herders who knew how to tend the critters. Fred's first job in Montana was near Dillon for Poindexter and Orr. There was a China man named "Mitto O." who worked with Poindexter and Orr. Fred had sheared for Mitto O, Poindexter, Orr, and others in the Dillon area a few years with a group of young men who came to Idaho and Montana in the spring then returned to Oregon after shearing season ended in Judith Basin. Mitti O's story is that he was abandoned or ran away as a young boy and Mr. Orr found him and raised him. No one knew his name and he didn't speak English when he was first found. He began calling this man who was like a father to him Mitti O.

Fredrick helped his mother with the farm every fall and winter until she remarried in 1899. Once he was settled in the Sweet Grass Hills,

Fred convinced his mother and her husband to settle a homestead to the west of his holdings on a little lake he named "Grandma's Lake". Fred's mother, Amanda Coe, did move to the Hills and with her husband, lived at the edge of Grandma's Lake until moving to California when Fred's brother moved to Amanda's homestead.

In the spring of 1894, Fred and two companions comprising the shearing crew were traveling to Montana by freight train looking for work. It was shearing season in Montana and the Great Northern route took them east as far as Cut Bank. They had their "*bedrooms and sheep shearing equipment*" with them and decided to walk from Cut Bank to Shelby. About four miles west of Shelby a heavy rainstorm moved in on the group. There was a section foreman's station close by when the rain started, and they took shelter there. The Section foreman's wife, Mrs. Gurth, invited them to dinner. They remained with the Gurth's keeping warm and well fed until the storm blew over. They continued to Shelby. A man by the name of John Stark saw the sheep shearing crew and advised them to go to the Sweet Grass Hills directing them to the ranches there. He directed them to the post office where they could take the stage to a stop where his brother had a cabin. They went as far as the "*Cameron*" place with the stage and mail wagon. John Stark's brother, Lynn Stark was minding the stage stop there and kept the three young men for two days while a blustery snowstorm came through giving a hint that spring was on its way.

When the storm cleared, Lynn sent the men walking towards East Butte pointing out the landmarks of Grassy and Sharkstooth Buttes. John and Beatrice Wasacha's operated a sheep Ranch located at the southern base of East Butte. John was Martin Wasacha 's brother and Beatrice Wasacha was Susan Price Turner's aunt (Mrs. James Turner). Their ranches were on Cottonwood Creek near the town of Hill and Camp Otis Calvary camp. Hill post office and stage stop were in the area as were Bourne & Hamilton's holdings on the south side of East Butte. Fredrick Theodore Parsell would later purchase 800 head of sheep from Bourne & Hamilton to start his own ranch. Parsell also purchased John Stark's cabin and squatters claim known as the "*Cameron*" putting in a dam at the base of a coulee creating a lake for watering his livestock.

Today the lake is stocked with fish. The lake continues to provide great habitat for the birds and wildlife at the southeast base of Middle (Gold) Butte. "*Cameron*" is located just below the bottom center front of "*the slipper*" that appears from the shale rock forming a shadow silhouette of a lady's high heel slipper when you view the Hills from Interstate 15.

After walking across the foothills of Middle, Grassy, and East Buttes of the Sweet Grass Hills, Fred decided he wanted to settle in the area. He had a sweetheart back in Oregon and the country he had crossed looked like a beautiful place to settle down and raise a family. Fredrick Theodore Parsell and Hattie May Sayers were Mormons and there was a large community of Mormons north of Gold Butte in Canada in the settlement of Raymond. There were large sheep ranchers in Canada that had already established a market for wool and mutton. The harsh winter of 1886 and 1889 took a toll on the numbers of sheep in the territory leaving plenty of room for start-ups for the industry, particularly in the Hills because of the recent offering of land that had been opened up when the Indian's sold their lands to the government. Fredrick Theodore had to head back to Oregon and see if Miss Sayers thought enough of him to give up her teaching position and become a sheep ranchers wife in the Sweet Grass Hills of Montana.

Hattie May Sayers was born in Peru, Nebraska May 15, 1870. Her family had moved to Oregon when she was nine years old. She was teaching school in Freewater, Oregon when she met Fred Parsell and they became engaged in 1898. They made plans for a wedding in Spokane, Washington, but as the eighteenth-Century Scottish poet, Robert Burns said, "*The best laid schemes o'mice an'men / Gang aft a-gley.*" Fred returned to the Sweet Grass Hills to shear sheep and take up a homestead. He "was too busy" in the spring 1899 to take time to go to Spokane for the planned wedding. Plans were adjusted and Hattie May would take the train to Cut Bank in April and the couple would marry. Fred would meet the train and they would be married that day, then they would travel to the homestead he had purchased with its rustic little cabin sporting a refurbished roof.

Fred purchased the homestead from the Arch Carrol family. The Carrol's had lived in the little cabin with a tattered straw roof. Replacing

the roof was one of the jobs that kept Fred from his original wedding plan. He wanted to build another room on the cabin before Hattie May arrived, but time was running out and the new roof would have to suffice on the honeymoon cottage. Gold Butte was three miles over the hill from the cabin, so Fred waited until the afternoon before Hattie arrived to get the marriage license from Judge McDowell in Gold Butte. He paid the Judge for the license and excitedly revealed the couples plans to marry in Cut Bank the following day as soon as Hattie got off the train. Judge McDowell told Fred, "*hold on their young fellow. You're goanna have to change your plans. The law says the marriage ceremony has to be performed in the county where the license is issued, and this here is Choteau County. Cut Bank is in Teton County.*"

Miss Hattie May Sayers was already on her way to Cut Bank by train, with her organ and phonograph, and all her needful things for setting up her home in the Hills. Fredrick Theodore Parsell could only think of one thing to do; get the biggest wagon and best team of horses he could muster and load his bride up with all her trimmings and take her to Gold Butte for the wedding ceremony. Fred took a look at his big wagon and thought he might as well pick up a load of lumber when he made the trip to Cut Bank so he could finish his add on to the cabin and that part of his plan was solid. He would get to town early enough to get the lumber and load the wagon before the train came in. He'd have to break the news about the wedding to Hattie May when she got off the train.

After learning about the County line law, Fred asked Judge McDowell what could be done, maybe he could get his money back and get the license in Cut Bank the next morning. Well, that would not work either. He' d have to go to Conrad to get the license. Mrs. McDowell was listening to the dilemma and she suggested that Fred and Hattie get married in Gold Butte. Fred Parsell and Anna McDowell arranged for a ceremony in Gold Butte at the McDowell's home. Then there was the discussion of the train schedule and the time it took to get from Cut Bank to Gold Butte. The days were still short in April, so it would most likely be dark by the time Fred and Hattie would arrive. Anna McDowell offered for the couple to stay with the McDowell's in

separate rooms at their home. She would shuffle her two girls around and for their trouble they could be witnesses for the wedding ceremony the next morning.

The McDowell girls, Maude, and Myrtle were excited and did not mind a bit that they had to give up their rooms for the night. Judge McDowell preformed the marriage ceremony in the kitchen of the McDowell home, which the ladies had prepared for the special occasion. Kitchens were usually the largest rooms in the house in that day. The young couple got an early start to their cabin the next morning. It was only three miles as the crow flies, but it was a challenging distance. The road was muddy and Mr. and Mrs. Fred Parsell had to split the load to two wagons transferring some of the heavier items, including the organ, to another wagon to distribute weight so the horses could make it over the pitch of the Gold Butte road. Problems solved; all was well when they arrived at their rustic honeymoon home. Hattie May Parsell remarked, "*It was a beautiful little place, **with rather rough terrain***" at their 50th wedding anniversary celebration in 1950 in their Sears Roebuck home located alongside the original cabin site. The photograph titled "Roundup Wagons Climbing a Hill – 1903" in the previous pages of this book is the approximate hill Mr. and Mrs. Parsell climbed over with their heavy-laden wagon on their way home their first day as husband and wife.

Rather understated, by Hattie May's remark, it is fair to say this little lady had grit. She also had her music and art and a husband who, with her tireless assistance, built a small empire at the very top northcentral border of Montana. Fred and Hattie May replaced the cabin in 1918, and the placement of their two-story home held just as much adventure as did their trip from Cut Bank with the lumber and organ. They picked up the house at the train depot in Chester which brought them to Gold Butte from the east with the same climb to the location. By this time their oldest son, Robert was old enough to drive and they had a Model A truck. Even with these amenities the climb required more than one trip and a shuffling of loads with teams and wagons employed to get the "kit" in place. Young Robert helped construct the house where he would later raise his family. The photo

of Lance and Joan Parsell Stewart would be Fredrick and Hattie May Parsell's great granddaughter with her husband, Dr. Lance Stewart, and Fredrick and Hattie May's great-great-great grandchildren.

Lance and Joan Parsell Stewart with their grandchildren 2020

The band of 800 sheep Fredrick Theodore had bought from Bourne & Hamilton grew to 8000 at one time. Hattie May enjoyed riding horseback and helping with the sheep, especially lambing. She "*rode horse every day. When I couldn't get on a horse anymore, I had to admit I was getting old*". Hattie painted and the family has a collection of oils, all original scenes she painted of the view she had from her yard. She had four children. Robert, Harvey, Leonard, and Dorothy. In 1958 Fred and Hattie had seven grandchildren and six great-grand-children. Leonard died in 1940 and their daughter Dorothy (Mrs. Loren Pilling), was living in Calgary, Alberta, Canada on the Elbow River. She lived in the same home until the end of her life.

Hattie May Sayer Parsell kept regular school for her children when no other school was available. She followed the curriculum set out by the county. Fred said they "*never attended a dance or overindulged in liquor*". There was really no need to go to a dance as the family reported that "*when they were growing up, they often rolled up the carpets and danced to the music of the phonograph or player piano*". The phonograph and player

piano with its scrolls remain in working condition at the ranch where Hattie and Fred's grand and great grandchildren continue to farm and ranch. Her organ that had such a challenging arrival was displayed at the Toole County Museum in Shelby and Hattie's wedding gown was displayed on a form at the same facility. Fredrick Theodore Parsell had a Seth Thomas clock given to him by his parents in 1884 which was displayed in the kitchen when the Parsell's had their 50th anniversary celebration. They also had a handmade spool chair which Fred had purchased from Mr. Pritchard whose family had brought it over from England when they emigrated. Hattie had brought a 2nd edition of the Noah Webster dictionary with her on the train.

A remarkable industrious couple, Hattie cooked for the hired men often numbering as many as eight in addition to her family. Fred's hobby was training Sheep Dogs and raising work horses which he broke to drive and sold to farmers settling in the area. During World War I their wool crop brought $18,500.00. Lambs brought 36 cents a pound and ewes sold for $9.00 a head. That price per head dropped to $3.50 after the harsh winter in 1907-08 killed many of their sheep.

Along with other heavy hardware like stoves and beds, pianos became part of the landscape along the trails as journey's were often interrupted by Indian or thieves on a raid or the need to lighten the load due to weather conditions. Bless the efforts made by the pioneers for bringing their instruments with them because it changed the atmosphere and lifted the spirits of these stoic people. It was a time before radio and most music was *"church"* songs like *"Shall We Gather at the River"* and *"Amazing Grace"*. *"Home on the Range"* came out in 1872 and radio wasn't a household item until after electricity arrived. The cowboys all sang tunes that they had learned in school or church before they left home. If they spent enough time in saloons or at community gatherings, they may have learned a few new songs, but their music was limited and redundant if not lugubrious. Some Civil war tunes were popular, songs like *"Twinkle Twinkle Little Star"* and *"Jesus Loves Me"* passing for lullabies to the skittish livestock on a gloomy night. The Texas Rangers had formed in 1835 making *"Sam Bass"* somewhat of an outlaw legend. The tune *'Sam Bass'* was known far and wide, partially because of its

story, and partially because of its length. With a little imagination some of the night herders could make it last their entire shift. All the cowboys knew the first seven verses, and the night herders knew (or made up) thirty or more.

The year after Charlie and Nancy were married, 1896, Con Price wintered in Cascade just a few streets away from Charlie and Nancy Russell's honeymoon cottage. Con had been gone for a while and did not know Charlie had gotten married. One of the bunch of Oldtimers who had batched with Charlie and Con in Great Falls at the Red Onion around 1886 had found his way to Cascade. He told Con he could bunk with him. Con said, *"He could hang paper, paint, and do carpenter work. A queer character who didn't have much sense"*. This feller liked that song, *"Sam Bass"* and he sang it while he was working with wood, which was most of the time that winter. Since it was not the *"Red Onion"*, the name Charlie and Con had called their winter roost in Great Falls, Con figures he best tolerate the tune. Con said he'd heard it sung with a bunch of verses, but that winter he learned it could go on and on for more than 12 hours and never have the same verse repeated, (if you could stand to listen to it that long).

1896 was the last winter Con Price and Charlie Russell spent living in proximity. The time of the big Fall roundup was passed, and places were being fenced. The buffalo were gone from the plains and the train had made short trips for livestock being shipped any direction. Nancy and Charlie moved to Great Falls. Con went to work for Peter Wagner near the Canadian line at the southwest end of the Sweet Grass Hills. Wagner was close enough to Canada that livestock still wandered off to that foreign country and cowboys still had to make some wide circles rounding up stray horses and cattle and keeping the sheep out of the cattle men's herds. It was about that time Con Price took an interest in a pretty girl. The young daughter of Claudius Bruce Toole, Claudia Toole. A romance began.

Radios didn't become commercialized until the 1920's when Westinghouse applied for and received the first commercial radio license opening the door for the creation of radio stations. Prior to 1920, broadcasting wireless transmissions had remained in the control of

the U.S. Navy. Advancement of radio broadcasting following Nikola Tesla's 1893 wireless transmission in St. Louis, Missouri was curtailed until the end of World War I. KDKA in Pittsburg, Pennsylvania was the station broadcasting returns for the Harding – Cox Presidential election from their 100-watt tower atop Westinghouse Companies' East Pittsburg plant. The election returns were interspersed with music and a message; *"Will anyone hearing this broadcast please communicate with us, as we are anxious to know how far the broadcast is reaching and how it is being received?"* Once this wireless event became commercial it expanded exponentially and by 1925 the dawn of wireless image projection was making its way to commercialization. It wasn't long before radios were the rage and lonesome cowboy ballads were heard around the globe. Anything that had a good two-step beat or three-four time was appreciated, but the cowboys would dance to everything. The cowboy often taking flight so you could see the bottom of both boots as they flung their arms and gaily jigged to any spark of a note.

It was a joyful noise that spread across the lonesome prairie giving a serenity masquerading as romance. The Industrial Revolution, with motors and engines whirring and purring, came with pleasant overtones of entertainment at the flip of a switch. Water was becoming available as well. First with cisterns and pumps followed closely by electric pumps, pipes, and faucets. Indoor bathrooms were slower in coming as most of the houses did not include sewage drains. The outhouse remained a common accessory, and still does, in rural Montana. Oldtimers always remark; *"there's never any plumbing problems in the outhouse"*.

Con Price has humorous stories about music, songs, and outhouses in his books. The mood of Con's writings, which are often about Charles M. Russell, emit fondness and humor when the times of which he wrote were void of either of these sentiments. The tale in this reference is one of Charlie at home alone as Nancy was gone for a spell. One of Charlie's old-time friends was having a drink passing through Great Falls and Charlie sees him and offers a place for him to stay for the night. Since Nancy is gone, this old friend takes Charlie up on his offer. As the evening wears on Charlie notices this feller isn't calling it quits, but he seems wore out and uneasy. Finally, Charlie figures out,

254

after being asked about the barn several times in the conversation, that this feller needs to use the bathroom. Charlie proudly says, *"there's no need for going outside"* and walks the feller down the hallway where their bathroom is located and shows him the commode. Well, this old friend is having none of it and won't stoop to going to the bathroom in a friend's house. Indoor plumbing was not for everyone. It took a while for some things to *'catch on'*, but thankfully they did.

Another event recalled by Con Price is his elopement one December eve in 1899. Con was 30 and Claudia Toole was 22. They had decided that running away to get married would be safer than having a discussion with Claudia's parents, especially her father. The Wagner ranch, where Con was working, was about 7 miles from the Diamond Willow, where Claudia lived. It was late December with a snowstorm blowing in. There was already a couple of feet of snow piled up with more coming down when Con headed for the Diamond Willow. He had arranged to borrow a team and spring wagon from his boss, Peter Wagner. Claudia's room was on the second floor and it was dark by the time he arrived with snow belly deep to the horses. He parked as close as he dared and walked over to her window which was directly above the living room. He could see her father sitting in his chair in front of the fireplace reading a book. The Toole's had *"two bloodhounds that bellowed and howled"*. Con stepped aside so Claudius wouldn't see him outside the window, but Mr. Toole did not move. Claudia took the cue from the howling hounds and started throwing her needful things out the window to Con. Con thought maybe Claudia would be traveling light so the first two trips he scrambled, but the depth of the snow and the trips just kept piling up. When he thought she must have about everything she needed she sent down *"bales of sheet music"*. Claudia played the piano. It was the only vice she is known to have, probably taking lessons from Susie Price Turner when she was a student at First Agency. Con said, *"every time one of those bales of music hit the ground it sounded like someone shot a high-powered rifle"*. Each trip Con made from the wagon to the window, the pile waiting for him got bigger. He started to think *"the piano might be coming. She took ALL her sheet music"*, but she finally came out the window.

With the snow build up and running late anyway, by the time they reached Shelby "*they had to wait overnight before proceeding to Great Falls*". They were sure Claudius would be upset with the marriage and elopement, but when they returned to Shelby a few days later there was a letter to Con from Claudius saying all was forgiven and Mr. and Mrs. Con Price were welcome at the Diamond Willow.

A few days after their return, Con was in Shelby and stopped in at a bar where he saw a friend that "*had one cock eye*". Cock eye says, "*well, you're married, are you?*" Then he asks Con, "*Did you marry a white woman?*" Con gave a positive response, and the man says, "*You done damn well, but I feel sorry for the girl.*" The marriage took place "*Christmas week*" in 1899 just before the turn of the Century. This account and more can be found in Con Price's "**Memories of Old Montana**". This was the beginning of Con and Claudia's life together at the Lazy KY. Claudia's brother lived in the big house at the Diamond Willow and Con with Claudia moved into the Grochon cabin.

Con purchased the land that was the original "*Squatters claim*" Claudius Bruce Toole had bought from the widow Dosite Grochon. To prove up the claim Con fenced 3,000 acres which included a couple of school sections adjacent to the Diamond Willow. Con was able to run stock on open range for a few years before the government surveyed, but then he had to make a change and start paying taxes. Charlie Russell continued to visit the Sweet Grass Hills and he told Con he'd like to partner up and get a few more cows and horses on the little ranch. Con suggested they split the profits annually, but Charlie just told Con, "*Count the stock and send me the bill and I will send you a check.*" Charlie had a rather good handle on how profitable ranching had become with the arrival of barbed wire and passing of time. Since he had given up being a cowboy and turned into an artist, he knew the work Con would be doing. Charlie could be a fair-weather rancher keeping a hand in the cattle and horse business whenever time allowed.

Con tells a few stories about he and Claudia in that rugged cabin in the winters. She must have had an incredible sense of humor and strong constitution. Con does mention that when he first saw her, she was on the ranch with her two wild brothers and she was "*just as tough*

(or maybe tougher) than either of the boys". Claudia gave piano lessons to the neighbors in the Sweet Grass Hills for a while and there are pictures of her with Con and visitors outside the cabin. According to friends and neighbors, Claudia spent fair weather days with her parents or family in Shelby or Great Falls while Charlie and Con batched in the cabin at the Lazy KY.

One of Claudia's piano students was the daughter of Peter Wagner. Barbara Wagner was only 3 ½ years old when her parents moved to the Sweet Grass Hills. She tells her story in **Montana Backgrounds 315**. As little as she was, she remembers walking alongside the wagon on the journey to the Hills. The optical illusion of the Buttes on the prairie made it look like they were not far away. Her mother had all her household items and her five children's things piled on the wagon her father and uncle had brought to Shelby to fetch the family at the train depot. It was dark by the time they reached the ranch. She says her mother never reconciled to life in the Hills after leaving Yankton, South Dakota. To add to her mothers' dismay, she lost Barbara's baby brother two months after their move. In spite of her mother's mood, Barbara loved life in the Hills and married a rancher, Louis Berthelote, who bought a ranch about five miles from Gold Butte where they lived out their lives and raised their family. It probably helped that Barbara loved the outdoors and horseback riding.

Barbara's father had worked as a blacksmith in Yankton, South Dakota before coming to the Hills. This was a complimentary trade to have for running a ranch. They were one of the first ranches to raise registered Herefords on West Butte. Their home ranch was near the Lazy KY with no organized school or church in the community. The absence of these institutions increased the interest in learning how to play a musical instrument, and Barbara's was the piano. She adored her teacher, Claudia Toole Price, and her lessons. The Wagner family had their own band with the violin, guitar, accordion, organ, and piano. Their neighbors were the O'Laughlin boys and Barbara played for dances with one of the O'Laughlin boys. Annie O'Laughlin was a teacher and taught school for a couple of years, more as a tutor as there was no school building. She would go to the ranches and her boys

would attend with the other students, who were occasionally hired men or adult relatives. Girls were attending school more regularly when it was offered. These one-room schools were collectively socialization and education. Often at the end of the study session the musical instruments came out and there was a '*jam*' session with singing and dancing. Ranches with large rooms were popular gathering places.

In Barbara's neighborhood it was the Dave Thomas kitchen. Unfortunately, the Thomas house was lost to fire, but the memories remain. In the Whitlash community the go to place was the Stratton's. They could fit three quadrilles in their living room and were located directly south of the Port of Entry at Aden. When there was a dance at the community hall it ended with everyone from across the line and the Gold Butte communities heading over to Stratton's and having breakfast, then carrying on with dancing until the sun came up and they headed home. The custom officers would leave the gate at the border unlatched in case anyone wanted to get home after hours, but most families who made the trip to the dance stayed for breakfast and daylight before heading home.

Barbara Wagner Berthelote shares a couple of unique experiences of her life on the ranch. The families would have Sunday School in the schoolhouse in summer months because there was not a standalone church building. The ministers did travel around horseback. Brother Van would show up occasionally, and the neighbors would gather. Barbara recalled one such service when Brother Van used his saddle for the alter.

Another time she was horseback riding past the Lazy KY with her friends and they saw a man standing on his head bracing himself against a tree. The children were curious and rode into the yard for a closer look. The man "*maneuvered himself back to normal position – and lo! It was Charlie Russell!*" Barbara said, "*he explained he'd been suffering with appendicitis, and the doctor had told him if he'd stand on his head long enough and often enough, he would cure it.*" Barbara: "*It didn't work though, as he later had an operation.*"

Recalling the loss of another brother, Barbara tells of her father broadcasting seed in the field while her brother was disking. A bolt

of lightning struck her brother killing him and the team. It is easy to see her mother's resignation and melancholy nature and Barbara's understanding of the feelings while taking the initiative to overcome them herself as a child.

When Con and Claudia left the Sweet Grass Hills the cabin yard sat close to a road and would accumulate large snowdrifts in winter months. Often the traffic detoured through the KY yard to avoid getting stuck. Peter Wagner had purchased Con's land and cabin. Wagner had a contentious history with Al Pratt, a neighbor who lived just a few miles north on the same coulee where the lazy KY was located. Con had a few disagreements with Al Pratt that had never risen too much other than shouting and some idle threat, but Al was a hot head and would often take his buggy whip out and rail on whoever was obstructing his path. It was 1912 and Peter Wagner was older. When winter came, Al Pratt came to the gate of the KY yard to avoid the snowbank on the road. Peter happened to be at the KY at the time and told Pratt to stay off the KY and go around on the road. He mounted his horse and rode over to the fence to make sure Pratt would not come through the gate to the cabin yard. Pratt took his buggy whip and hit Wagner across the face with the frozen whip. Peter Wagner had reached out to grab Pratt's team and when he saw the whip lashing at him, he drew and fired his gun killing Pratt.

Pratt fell from the wagon and lay dead on the ground for more than a day. Wagner rode to Gold Butte and reported that he killed Pratt immediately and there was an investigation. The River Press reported June 12, 1912 that a jury trial had been arranged. Jury selection would take place in Judge Tattan's court beginning June 18 held in the McIntyre Opera house. The trial was set for the 20th – 22nd. The River press reported July 3, 1912 that the trial was in progress for more than a week. The case was stubbornly contested because Pratt died of bullet wounds to his back and Wagner claimed self-defense. The investigation did show that Pratt's gun was drawn and lay by his body.

Con Price testified at the trial and told the court that Pratt had pulled a Winchester on him once and threatened to kill him. Wagner said he was carrying an automatic revolver which he was not real familiar

with. He had not intended to shoot Pratt, but he was reaching for the harness on the team and the whip hit him and his horse and the gun discharged further startling the horse he was on causing it to bolt. In his panic to get his horse under control the gun continued to fire. The verdict was not guilty.

Con said Peter Wagner had told him several times prior to this incident that he was "deathly afraid of Al Pratt". Fear is a powerful and often dangerous emotion. This very unfortunate incident caused a lot of unease in the West Butte community. To add to Peter Wagner's burden Charlie and Nancy Russell's claims had never been proven up and they were tied in with the Price's property. They eventually sold at sheriff's sale and were bought by Walter Clark. Oil companies were leasing everything they could in the area in and around the Hills and the August 30, 1922 Montana Courier reported that "*one thousand one hundred twenty acres of the Peter Wagner leases of two thousand one hundred and twenty acres have been taken over by the Black Magic Oil Company*". The leases were checker-boarded over the entire acreage. November 19, 1922 the Great Falls Tribune reports a "*sealed verdict in closing up Wagner Action*". Less than $100 was at issue. Unfortunately for the people who bought properties in the Hills once oil had been discovered inherited the terms of the oil leases for their duration on the property.

Con Price said, "*I could never understand why as long as the people were very poor, they were peaceable and neighborly. When they got a little prosperous some to them were in court the year around.*" Another rancher from the East Butte area visited St. Paul, Minnesota on cattle buying trip. While he was in St. Paul, he spoke to Robert J. Johnson from the Pioneer Press of St. Paul. This was November of 1955. Bill Schafer: "*I just don't like the way things are now. I never dreamed I'd ever make as much money as I pay in taxes today and a man just doesn't make the money he used to. Why, when we were getting about 7 cents (a pound) for beef I netted more than I make now. We never heard of income tax and we didn't have so much money tied up.*

Besides, if a man had a few dollars left over he could invest it – in cattle or land – you just can't do that anymore. Everything costs so darn much."

Back in 1903 when Mr. Schafer began ranching in Northern Montana there were no fences. That changed as did the property tax laws. Open range ceased and everyone had to 'own' or lease the land where their cattle grazed. Schafer goes on to say that "a **man** carried his home with him. A bedroll, three or four good horses, his saddle and tack. Life was free and easy. One man was as good as another as long as he behaved himself. And when a man gave you his word you could take it. Today there's a lot of meanness and clannishness."

When Schaffer was riding with round up crews, he earned $35.00 a month which included "*grub. There wasn't all this thinking about wages and nothing else. Sometimes on roundups we worked all night long. We had to. At that time, too, cowboys and ranchers alike were mostly bachelors. It was later the women, then families, then school problems came up. Schools are still a problem. All in all, the cowboys of 50 years ago were a pretty good class of people. They didn't try to do much for themselves.*"

Bill Schafer raised two daughters on his rural ranch. They both completed high school and one completed college. Mark Engstrom and his family continue to ranch in the Sweet Grass Hills on the same land Bill Schafer homesteaded and expanded his ranch.

As the Indians were being forced to leave the Sweet Grass Hills more family's began moving in. The military camps were dismantled, and cabins or buildings were built and placed along wagon trails and called "*post offices*" or "*stage stops*", which were really the same. Sometimes the proprietor of these stops was retired military who had filed a claim and others were bachelors who didn't have any place to go or liked the area and found a niche that paid them enough to stay in the area for a while.

Zachariah (Tom) Murray Jr. came to Helena Montana in 1877. Tom was born in Pleasanton Kansas in 1859 and educated as a teacher. He taught one year in Kansas and decided to see what Montana Territory had to offer. Unable to find work as a teacher (as there were no schools), Tom found work at a round up camp in Sun River. He got his first glimpse of the Sweet Grass Hills riding for **XIT** brand. Cattle wearing this brand were Texas longhorns from the Texas ranch owned by Colonel B.H. Campbell who registered it in July of 1885. The brand was designed to be made with one straight iron and was thought to be

difficult to alter. It became known as the *"ten in Texas"* as Campbell's *empresario* covered ten counties in Texas and the number of cattle were from 125,000 to 150,000 head. The brand wasn't Montana owned but the businessmen who bought the cattle in Texas and had them brought to Montana carried the bill of sales for the branded cattle and the roundup crews would put Montana brands on them in the spring when the cows calved. Therefore, it was important to have a lot of cowboys working during the fair-weather months. If they could handle a rope and had a good horse, they were golden. When they saw an unbranded calf known as a slick or maverick, they threw a loop and branded it on the spot.

While Tom Murray Jr. was riding open range, he found the Sweet Grass Hills area along Trail Creek particularly attractive. The Piegan Indians were being moved from the Hills and were being encouraged to learn agronomics. The Sweet Grass Hills to the Rocky Mountain front was Blackfoot Indian Reservation which was rumored to be changing so homestead claims could be filed. Tom Murray decided to come back later to file a claim. In the meantime, he decided to go back to Kansas in the spring of 1880. He returned in the Spring of 1884 and for the remainder of his life he never ceased telling of his disappointment in the disappearance of the buffalo in those four brief years. The Hills were still reservation but many of the Indians and Half-Breeds were selling their squatters claims. Tom Murray was able to obtain a claim on Trial Creek where he and his brother Henry built a dugout to prove up the land. They trapped wolves and did some Gold prospecting until the land was open for settlement. They expanded their property by filing desert claims adjacent to their squatters' claim. Their desert claims had meadows that were sub-irrigated by Trail Creek and the Murray families raised large gardens in the meadow producing enough fresh produce to market to the settlers in the oil fields from the Sweet Grass Hills to Shelby.

First Agency was promoting agronomics along with the government's attempt to teach the Indians to raise crops to supplement their diets and improve their lifestyles on Reservations. Tom taught agronomics at First Agency in addition to his own commercial garden and livestock

at his ranch. He wrote his parents in Kansas persuading his parents and siblings to come to the Sweet Grass Hills and homestead. Zacahariah (Tom) Murray's father, William H. Murray's mother was a first cousin to Jefferson Davis from the tidelands of Old Virginia, so they were connected by the cousin's network known as the FFV's (First Families of Virginia). William H. and Diantha Murray had eight children in Kansas where William had met and married Diantha. The children of this couple were; William H. Murray Jr., Zacahariah (Tom) Murray, Henry Murray, Mary, Sarah, Minerva Jane, Myrtle, and Ida May. Mary married Johnson then Kimble. Sarah married Hiram Smith and they went to California then came to the Sweet Grass Hills in 1891. Minerva Jane married Arch Carrol. Myrtle married John Umphrey and Ida May Umphrey married George Murray. Mary Murray's first husband had died leaving her one son, Murray Johnson. Murray's father, John Johnson, died in 1892. He was born in Sweden and had been married before. His wife and two of their children had died of typhoid fever and John was left with one son, Charles, to raise as a single father. He met and married Mary Murray when she was 18. Together they had one son, Murray Johnson, who was 15 when his father died. Murray had completed grade and high school before his father died and had helped his parents in their store and bakery business before coming to Montana. His mother, Mary Murray Johnson, married William Kimble in 1893. George and Ida May Umphrey Murray and their two daughters, Lena and Loie, their son George Jr., and Mr. and Mrs. John Umphrey came to the Sweet Grass Hills in 1896. The William Kimble family came to the Sweet Grass Hills with Arch and Minerva Jane Murray Carroll family. The John Murray Ellis family, Effie, and her sister Stella Colvin and their two daughters Edna and Myrtle were with the entourage in 1897. The William Kimble, Arch Carroll, and John Ellis families arrived by train, the men in emigrant cars a few weeks before the women and children arrived in Chester the summer of 1897.

Mrs. Mary Johnson Kimble had visited Helena, Montana in 1885 representing the family at her brother, William H. Murray Jr.'s funeral. William had been killed by a rockslide while working in Last Chance Gulch in Virginia City. W.H. Murray Jr. and his brother Henry had

followed Zachariah (Tom) back to Montana in the spring of 1884 and W.H. Jr. died in Helena before Henry and Tom filed their claims in the Sweet Grass Hills. Mary Murray Johnson Kimble had some idea of what Montana was like before she came west with the other members of her family in 1897.

George and Ida May Umphrey Murray and Hiram and Sarah Murray Smith were established at their ranch on the west side of East Butte on Breed Creek, sometimes known as Half-Breed Creek, when their relatives arrived in 1897. This ranch is still operating with a family tie. Robert W. Thompson (Bobby) and his wife, Diana Isaacs Thompson, and their two sons, Jeff, and Nick, live in the original house that was constructed by Hiram and Sarah Smith. The setting of this ranch is as picturesque as T.P. Strode's ranch that is northeast on East Butte. The headwaters of Breed Creek are above the ranch yard and the topography gradually descends to a valley with rolling hills and small lakes exposing full view of Middle Butte and West Butte to the west. On a perfect day, the Rocky Mountain front can be seen. Half-Breed Creek drops underground intermittently at its uppermost beginnings and crosses the road leading to Whitlash. A 4-H Campground rests on the east side of the road, and ranch yard once owned by Troy Lakey is located on the west side. It was the south branch of this gulch, Ribbon Gulch, where a substantial showing of copper was found in the late 1800's, however, the diggings were shallow. Gold and other precious metals held the same outcome leaving this pristine ranch in a near natural state. Robert W. Thompson is the grandson of Juanita Johnson Thompson, daughter of Murray and Myrtle McDowell Johnson.

Ida May Umphrey was born October 19, 1871 in Lynn County Kansas. She was one of four children of Samuel Franklin and Deborah Umphrey. In 1886 she was married to George Murray. In 1897 George and Ida moved to the Sweet Grass Hills. Her daughter, Loie Murray Aiken, died of a high fever illness leaving two small children, Edith and Glenn. Ida May and George Murray raised Edith and Glenn. Ida May's sister, Rose Stark, preceded her in death. She died November 1, 1955. George Jr. died in 1921 and her husband died in 1926. Her daughter, Mrs. Lena Bauer, moved to Prosser, Washington. Ida had

five grandchildren, four great grandchildren, and three great-great grandchildren when she died.

John Murray Ellis and Effie G. Colvin married in Pleasanton Kansas October 11, 1888. John had a farm near Mound City Kansas where he and his bride began their lives together. They had two baby girls in the first years of their marriage. The little farmhouse just did not quite fit the growing family, so they built a larger home that was completed in 1895. Pleasanton was a progressive community at the time fully accepting women into the frays of politics. Annie Austin served as mayor of Pleasanton in 1894. Information from "**Pioneer Women**" by Joanna L. Stratton copyright 1981.

Shortly after their house was completed John and Effie sold their little farm in Kansas as did their cousins the Arch Carroll's and William Kimball's, making plans to head west to Montana. The train was offering low fares for emigrant cars. The men and young Murray Johnson left with furniture, dishes, farm equipment, cattle, pigs, and chickens to get settled before the women and children arrived. In the railroad car with Murray Johnson were two horses, two cows, a few chickens, a 30-30 Winchester carbine, a coffee grinder, a grain cradle, kerosene lamps, and an assortment of copper rivets. One piece of what might be called non-essential furniture John Ellis had to contend with was his wife Effie's piano.

Effie had her two girls, Edna and Myrtle, to prepare for the journey, and her younger sister, Stella Colvin. Their mother had died when Stella was four and Edna had been taking care of her and their father in Kansas. Moving to Montana, Effie and her father thought it best for Stella to go with the Ellis's. With Minerva Carroll and the Carroll children, Mrs. Mary Kimball, and the Ellis ladies boarded the Great Northern passenger train and headed west for a fresh start. Edna Ellis Furnell would spend her entire life in the Sweet Grass Hills once they left Kansas except for the last few years when she was placed in an assisted care facility in Great Falls. In 1904 Edna, her mother Effie, and sister, Myrtle, went back to Pleasanton, Kansas to visit her grandfather. She could not wait to get back to the Sweet Grass Hills in Montana and she never ventured far from "*them thar Hills*" again.

John Ellis met the passenger train in Chester Montana with a lumber wagon big enough to carry the luggage of the collective Ellis, Kimball, and Carroll families to their new homes in the Hills. He wasn't in a hurry and his mind churned with thoughts knowing Effie had left her nice new home in Kansas to come to a rustic cabin in a new community, which didn't have a school or a church. There was time, before the train arrived, to pick up a load of lumber. It would give a good solid floor for the passengers to set on during the long bumpy ride ahead. There was a steady incline to the Cabin nestled on the east side of Gold Butte. The location sat in the rolling foothills at the base of the shale rock coming off the trademark cone shape.

As the wagon lumbered north with the women and children in the back using their luggage as seats, the Carroll family was dropped off at the Hiram and Sarah Smith cabin, about seven miles south of Whitlash. The Carroll family were cousins of the Smiths. The remainder of the group proceeded on through town where they saw the post office and store and a few small tarpaper houses. Here they turned northwest and traveled another four miles and dropped off the Kimball / Johnson family. Robert H., Mamie, and Agnes Carroll were all toddlers and slept much of the journey. Their home (also a cabin) was only five miles from the Ellis cabin. Effie had an idea of what her new *home* might look like by the time she arrived. She was not disappointed. There on this elevated earth sat a sad little house welcoming her exhausted and excited family. Waiting inside was her piano and sheet music settled in one corner adding comfort and joy to this once lonesome home. John Ellis knew those familiar *friends* would lift Effie's heart. Their two daughters, Myrtle and Edna, and Effie's sister Stella were excited and loved everything about this new *home*.

The next morning, they rose to a glorious sunrise accentuated by the glow that silhouetted East Butte. Just outside the front door was the exquisite view of Montana opening like the panorama of a cinematic screen. To the east she could look out and see Hiram and Sarah Smith's ranch. It was more than beautiful and not difficult to fall in love with. With a song in her heart and a little tune on the piano, it was ♪*off to work*♪ for Effie and girls.

She seemed content with her rustic cabin as she made it her home until her daughter, Edna, and son-in-law, Bert Furnell, built a new home on the property in 1950. Effie liked to sew and made all her girls and herself dresses, and she liked to quilt. It wasn't hard to stay busy, but Effie particularly liked to see younger people enjoying music and would invite families to visit making perfect opportunities for her girls to sing and dance and get to know the neighbors. With this new group of settlers in the Hills, the community started a church and school for the number of children and ladies who were now a part local population. Effie taught school, without pay, for a while and played piano for church on Sundays which was held in their home until the school and other buildings were constructed that would house the congregation. When the large post office and store building were constructed in Whitlash, Sunday services were moved there.

One day Effie was home alone and there was a young man knocking at the door with an invitation to *"Susie's for a quilting bee"*. Effie accepted before she thought about what she had done. She went back to the door to see if she could catch the handsome cowboy and ask, *"Susie who, and where does she live?"* The young stranger was Jim Turner, but he had disappeared on the horizon by the time Effie went back to the door. He and his wife, Susan (Price) Turner, were living on the south side of east Butte just south of the Calvary camp. Effie asked around and found that there was only one Susie in the Hills at that time. She made it to the quilting bee and had a very pleasant afternoon meeting several other ladies from the community on East Butte. Susie Turner had been Claudia Toole Price's piano teacher at First Agency, so the Sweet Grass Hills community was amassing quite a group of musicians making it a gathering place for men and women on both sides of the border.

Mrs. Ellis had friends and relatives scattered throughout northeast Montana. Her brother-in-law, John J. Ellis, was postmaster at Sun River. Sun River was a community that was still getting churches and schools established and Effie, with her sister Stella, and two daughters would come to Sun River in the winter months and stay with relatives. Effie gave piano lessons and played for churches in Great Falls and Sun River. Della Furnell's sister, Kate Ford, recommended that Della have

Florence take lessons from Effie. Florence was active with her friends in Great Falls, but Della was depressed and preoccupied with caring for her oldest son. She thought it might be good for Florence to learn to play piano so she arranged for lessons and bought a beautiful **Rosewood** piano hoping that would encourage her daughters' interest in playing. As Ivan Doig tells it in his novel "<u>Work Song</u>", "*Rosewood, the diamond of woods*".

Arrangements were made for Florence to take lessons from Effie; however, Florence was not inspired. Her brother, Bert, enjoyed playing by ear when he was home, but he did not take lessons. The **Rosewood** piano did find an admirer though. Della's oldest son Ray died, and her son Bert worked in Sun River with his uncle for a while. When he graduated from High School, he went to Canada to work at a ranch leaving Della and Florence in their big house alone. When Della met Effie, Stella, Myrtle, and Edna she invited them to stay with Florence and Della during the winter months. Effie was able to give Florence and her friends all piano lessons on the **Rosewood** piano. Effie probably never imagined having that beautiful piano at her home in the Sweet Grass Hills, but it eventually found its way to the ranch. Florence Furnell Kumphe gave it to her niece, Francis Furnell, as a gift. Florence did not enjoy the piano and after she married and moved from Great Falls, she knew that even if Francis didn't play it, Effie and Edna would. Effie gave her piano to the Whitlash Church.

Effie and her 'girls' became popular visitors to the Sun River and Great Falls communities. Effie gave piano lessons to everyone who was interested, and she played for churches when she was invited to. Florence enjoyed having the visitors to share with her Great Falls socialites and the Ellis girls with their aunt Stella equally enjoyed getting to know the families in Sun River and Great Falls.

Nancy Russell remained close with Della Furnell and enjoyed the companionship of this robust cluster of ladies. Charlie Russell kept an eye on Albert Furnell. Charlie and Nancy had an idea that maybe they would play matchmakers to young Bert Furnell and Edna Ellis just as the Roberts had introduced Nancy and Charlie. Nothing fancy, just a dinner. Bert didn't come home often, but it was easy enough to get

his schedule. Edna was available and unsuspecting. The Russell's had already began having Effie and her girls and Florence over for visits. Even though Bert had ridden with Charlie in the horse and cattle roundups in the Hills, he had not met any of the girls around Whitlash or Gold Butte. It was not unusual for him to have dinner with Charlie and Nancy when he did get to the Falls as he had been friends with Charlie all his life.

As outgoing as Florence Furnell was, her brother, Bert, was another matter. Nancy and Charlie Russell had their surprise dinner party with Edna Ellis and Bert Furnell and things went as planned. Bert and Edna's wedding took place at the church in Whitlash May 21, 1914 with Ms. John Murray Ellis (Effie), mother of the bride, playing piano for the ceremony. Edna's sister, Myrtle Mary Leach was her matron of honor, and Myrtle's husband, James Ray Leach, was best man.

Following the marriage, Bert and Edna lived with Della for four years and managed the Elephant Livery Stables in Great Falls. The business was a part of Matt Furnell's estate. In 1919 Bert went to work for Flowree Cattle Company and he and Edna lived on the ranch in the Augusta area. In 1920 Bert and Edna moved in with John and Effie Ellis in the Sweet Grass Hills where Bert began ranching with his father-in-law. John Ellis died in July of 1931 at age 68. He had lived and ranched in the Sweet Grass Hills 32 years. At the time of his passing, he had two grandchildren on the ranch, Matthew and Frances, Bert and (Babe) Edna's children.

CHAPTER 17

REMARKABLE CLAIMS

Charlie had given up the cowboy life in 1891which was about the time cattle herds had stopped trailing up from Texas and several of the cowboys were either settling down or looking to get a place of their own. Charlie was reasonably sturdy and robust, but he dealt with ailments, some of which were related to his appendix, for years. He likely ignored some of the aches when he was visiting, painting, or riding a horse out in the open air, but he did not favor horses that were green broke, or confrontations with man or beast. Con was a good partner for Charlie because he often threw caution to the wind when Charlie played it safe. Con sorts of welcomed a risky ride and taking a chance, even on a classy lady and a small ranch. Con says, *"Charlie used to come to the ranch quite often and enjoyed riding horseback, but I always had a hard time to convince him the horses were gentle".*

In May of 1904 Charlie came to the ranch to file a claim on some of the land bordering Con's spread. May 14th the pair had to ride from the cabin to Gold Butte, about fifteen miles horseback, where Land Commissioner McDowell had his office. Charlie would file a homestead claim on a 360-acre piece of land bordering the Lazy KY and sink an investment into the partnership so Con could have a few more cattle and maybe improve his bottom line.

Charlie says to Con; *"be sure to give me a gentle horse".* Con saddled up his and Charlie's mounts thinking they were both well broke horses. He hands Charlie his bridle reins then turns to mount his horse. Before

Con gets mounted, he hears a ruckus happening. When he gets aboard his horse, he turns to see what is happening. *"Charlie was down on his back with his foot fast in the stirrup and the horse was jumping and striking at him."* Con gets ahold of Charlie's horse's bridle while Charlie gets up and gives Con a chewing out saying, *"This is another one of them damn gentle horses you have been telling me about. Now I have got to ride fifteen miles with a hump in his back".* Charlie had lost his hat and his clothes were dirty. Charlie later tells Con every time he tried to hurry that horse; he would hump up like he was going to buck until Charlie pulled him back down to a walk.

Con and Charlie made it to the land office that was an addition to the northeast corner of Tony Feys' Saloon. Charlie filed his claim then they stepped out on the porch that overlooked Gold Butte looking south up Two-Bit Gulch. Note the land description below Charlie's signature. John Fey had filed on the land before Charlie once the land opened for settlement.

It was a nice day, and if it had not been for the fiasco Charlie had with his mount, he might have enjoyed a drink with the boys at the Gold Butte bar. Chas. E. Morris, photographer from Big Sandy, happened to be in Gold Butte on that day taking photos. C.J. McNamara was bartending for Tony Fey and had sold his homestead property in the Sweet Grass Hills to Fred Parsell. He invested in land at Big Sandy

where he built a large set of corrals and was holding horses for the government. It was the same time period that C.J. McNamara, Con Price, Charlie Russell, Bert Furnell, Dave Davis, Jim Turner, Dick Crawford, Matt Morgan, and a host of other cowboys brought a herd of horses from the Rocky Mountain Front to Big Sandy. They paid $4.00 a head for the horses and sold them to the Government for $15.00 each to be used as calvary mounts for the Boer War. Reports of a herd of 7,000 horses in a band that was a mile wide were in that roundup.

J.K Toole was serving his second term as Governor of Montana and C.J. McNamara was running for a position on the Democratic Central Committee in Big Sandy (Oct. 4, 1904 The Havre Herald). Whatever the occasion, C.J. McNamara (bartender), Con Price, Christopher Cummings, Thomas O'Laughlin, Fred Parent, Wilbur Parent, and Charles M. Russell stand on the outside of the bar to the north of Two-Bit Gulch May 14, 1904. Chas E. Morris had just moved his studio from Big Sandy to Chinook and had gotten married. He took a photo of the men on the deck of the Fey Saloon overlooking the Gulch. Charlie's a little ruffled with a spot on the left shoulder of his jacket and he is as far away from Con as he can get without leaving.

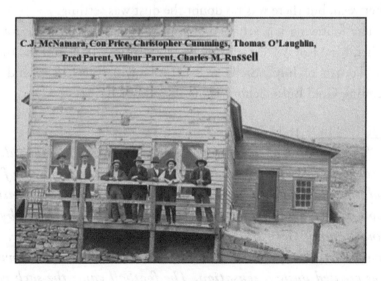

Photo by Chas E. Morris, Big Sandy. Courtesy to print from Pamela Morris

Thomas O'Laughlin was Fred Parent's brother-in-law and Wilbur's uncle. He was married to Fred Parent's sister, Margaret.

C.J. McNamara worked for George Byron, foreman for TL, along the Marias River range. The brand was owned by a group of investors from back east. McNamara bought the TL in 1889 and moved the outfit to Big Sandy. Although he was a bartender for Tony Fey for years, he maintained his interest in livestock and selling horses and cattle to Fort Assiniboine and other government contracts.

The old gang had all but deserted the once bustling town of Gold Butte. The Parents', Fred (father) and Wilber (son), had had their hand in building most of main street such as it was. Thomas O'Laughlin was a blacksmith. The town was on the decline by the time Charlie filed his claim. Instead of miners and single men, families had moved in and schools were becoming more important than saloons. The buffalo were all gone, but there were still a few Indians around the Hills. Settlers had started farming. The men were married and raising families, which meant churches and schools. It was getting hard to get enough hands together even for a game of faro. There were still big celebrations around the fourth of July in the summer and Christmas and occasional dances in between, but there was no doubt the dust was settling.

The following is a school assignment Stella Colvin wrote for her teacher, Mrs. Roy W. Parsell July 8. The year was 1899 and the theme was "Fourth of July". Stella was Effie Colvin Ellis's sister and was attending Gold Butte School at the Parsell ranch.

"FOURTH OF JULY":

"The morning of the Fourth dawned bright and beautiful. No clouds were to be seen in the sky. Every-body was preparing for a good time. There was a large crowd at the Gold Butte celebration, people came from miles around. The after-noon was opened by the grand Band of Gold Butte which furnished beautiful music. The horse races were splendid. The fat men and also the fat women's races created quite a sensation. The football game the sack races the children's race and biking contest was enjoyed very much. The evening opened with a grand Ball in the hall. The excellent music

was furnished by the Greatze orchestra. The ladies gowns were beautiful and airy. In the morning, the people departed with a smile and a good By. The day shall always be remembered as a pleasant one."

The Gold Butte school had burgeoned. Because of the harsh winters, school was in session during the summer. Stella came to the Sweet Grass Hills with her sister, Effie (Mrs. John) Ellis. The Ellis's had two young daughters, Myrtle and Edna. Edna Ellis was named after Effie's sister, Edna. Edna Colvin had married in Pleasanton, Kansas, and with her husband headed west to Oregon. Her husband had died and left Edna a widow. Once Effie had settled in the Sweet Grass Hills, she sent an invitation for her sister Edna to come and live with the John Ellis family and her sister Stella. Edna Colvin Taylor's nieces and sister, Myrtle and Edna Ellis and Stella Colvin, were frequently left at the cabin on the ranch alone while John and Effie were managing the store in Whitlash for T.P. Strode. Edna Colvin Taylor came to the Sweet Grass Hills around 1905 to see that the girls attended school and help her sister with ranch chores.

Edna Colvin Taylor would find more than gold in Gold Butte and shed her role as the widow Taylor. A smart young gentleman from Canada came to the Sweet Grass Hills looking for work and found young Edna Taylor mesmerizing. F.M. Mack arrived in Gold Butte around 1908. With his education and skills, Forrest Mack found work and was quickly engulfed in the community. Edna Colvin Taylor had plenty to do in the Sweet Grass Hills community. Her sisters and nieces kept her busy helping with chores and housekeeping. She also worked at both stores, Gold Butte and Whitlash, cleaning and stocking shelves. F.M. Mack was driving freight between the two towns and soon a romance sprung between the widow Taylor and F.M. Mack. Once Forrest and Edna married and set up their own household, Stella Colvin, Edna's sister lived with the Mack's. When Edna and F.M. Mack left the Hills, Stella Colvin left with them.

Forrest Marvin Mack was postmaster at Gold Butte for some years. Forest M. Mack was born September 1, 1886 to Roderick John and Cella Lamora Bidlack Mack in Cedar Rapids, Nebraska Territory. He

attended school in Rome City, Indiana, and then worked in a store (clerk) in Fayette, Ohio two years then deciding to head west on the Canadian Railroad using *"Homeseekers"* rate @ 1¢ per mile (Canadian funds). He traveled around the Great Lakes by way of Detroit and on to Edmonton, Alberta. Arriving in Edmonton he found work as a carpenter helping construct the Strathcona Hotel in 1906. When the Hotel was complete Forrest took the train to Cardston, Alberta where he found himself short of cash. There is a gap in the recounting of Mr. Mack's journey to the Sweet Grass Hills when he was *"short of cash"*. He had a *"draft"* and a *"Masonic"* friend *"cashed the draft"* and suggested F.M. take the train to Sweetgrass and try his luck in Gold Butte prospecting for gold or work at a ranch in the area. Both occupations were new to Forrest, but the possibilities were endless in his adventure into the west.

The brotherhood of *"Masons"* played a significant role in settling the west. In the late 1800's they were a fraternal organization that regulated the qualifications of stonemasons. They interacted with authorities and clients and had bank accounts for their organizations in almost every town. Most likely F.M. Mack became a member when he was working on the Hotel in Edmonton which gave him a link for networking in the regions where he traveled. The men were able to *'vouch'* for fellow *Masons* as to their legitimacy and craft. Thomas Strode was a Mason.

Women were not admitted to these fraternities at first, however, the conclusion of meetings included a formal dinner, or festive meal requiring a feminine touch. *"Eastern Star"* became the lady's side of the *"Masons"*. High school female teens had *"Rainbow Girls"* as an introduction to becoming a member of *"Eastern Star"* and the boys had *"DeMolay"*. Each of these four groups contributed greatly to the communities in their districts. Meetings and events gave the ladies and gentlemen an opportunity to dress up and follow strict decorum for a common cause which was mainly to support their fellow members and promote good will in communities. Through rain and sleet and piles of snow families made it to the *"Lodge"* meetings and worked their way up the *"Chairs"*. Forrest M. Mack met up with Bill Kent in Sweetgrass and the pair rented a team and wagon and headed to Gold Butte.

Forrest Mack hadn't been a cowboy, but he liked to dress the part,

so he had spent a good portion of his past earnings on his travel fare and clothes to blend in with those "*western cowboys*" he'd heard about. He arrived in Gold Butte wearing a "*Eastern Stetson*" or as some called it, a *derby*. The Gold Butte crowd was almost offended by this newcomer showing them so much respect and promptly knocked his *Stetson* to the floor and kicked it to pieces. According to his story, F.M. Mack "*donned an old western Stetson*" that "*someone*" gave him the rest of his years in the Sweet Grass Hills. They might have been a little rowdy to newcomers, but the bunch that hung around Gold Butte evidentially appreciated the fact that the stranger did not pull a knife or a gun on them for knocking off his hat. Maybe, if he was going to stay, he should at least have a hat to shade him up there in God's country. Forrest worked for Sam Aiken hauling hay with a four-horse team when he first arrived. He had never driven a team before, so that was impressive. He then worked for George Murray one summer.

F. M. Mack went to work as a clerk for Tony Fey in Gold Butte in 1908. As clerk in Gold Butte, he served as Postmaster. Being a bachelor, he was interested in all the settlers, miners, and hired men in the area and liked hearing the stories about how they came to the Hills and proved up their claims. One such story he repeated often was about Ralph Hatterly, a government man who was sent out from Washington D.C. to '*inspect*' a desert claim before issuing a deed for the property. Hatterly came into the store after spending "*a long day circling the top of a knoll three times looking for the headwaters of the irrigation ditch the claimant had dug as an improvement on the claim*." F.M. said there were many of those ditches all over the Sweet Grass Hills that "*never ran a drop of water*".

Edna Colvin Taylor and F.M. Mack were married in Long Beach California at the home of Lynn Stark. Stark sold his claim and livestock in the Sweet Grass Hills to T.P. Strode. He headed west to the ever-popular California coast. Before the Mack's returned from their honeymoon, T.P. Strode had decided to build his second Whitlash just a little west of Lynn Starks cabin at the base of Hawley Hill. Bob Whitlash, a prospector who moved into Lynn Starks cabin, was the first Postmaster when the application was approved. When F.M. and

Edna Mack returned to the Hills, John Ellis and F.M. Mack managed the store in the New Whitlash until it burned down. In 1913 Elmer Smith decided to close his business in Gold Butte. He hauled all the merchandise to Galata and put it in a freight car and shipped to Gilman. The railroad had rebuilt the line that year and had bypassed Gilman by a few miles. Elmer Smith's goods were purchased by F.M. Mack who hauled the freight carload of goods in a wagon to the town that had sprouted where the railroad had ended. Edna & F.M. Mack and Stella Colvin ran the general store in Augusta for many years.

Jim Whitlash was a gold miner who came to the Sweet Grass Hills to haul freight for Bourne/Hamilton at Hill, then beyond to Whitlash and Gold Butte. Whitlash moved into Lynn Stark's cabin at the base of Hawley Hill near where the present day Whitlash is located. Hamilton applied for the Post Office name of "Whitlash" for the stage stop north of Hill. Most of the gold had already been taken from the diggings around Gold Butte and Hill. Jim Whitlash heard about a new strike around Butte. He headed for the Richest Hill to prospect for gold leaving the newly formed "Whitlash" without a postmaster. There were a few newspapers reports of him buying drinks one Fourth of July for the entire crowd at a Butte Bar and mentions of small strikes, but he never returned to the Sweet Grass Hills.

Eva Strode (Melvin) took over the Post Office duties when Whitlash left, and T.P. Strode had sent the application to Washington for the name. Postal deliveries often took a side trip to Whitefish until postal codes were added to addresses. It is not a misnomer, but it is unique, and many prominent oil business elites have visited this town with the 'odd' title. Just as the Sweet Grass Hills are a memorable landscape, Whitlash remains in one's memory once visited. A small village at the end of a long road. The last town on the U.S. side of the International boundary.

The naming of coulees, claims, and homesteads often came from the original claimant or resident. Such is the case of "Bears Den" on East Butte. Claimants who came later inherited the name or remained obscure. Nancy Russell filed a desert claim next to Charlie's in 1908. Being the smart businesswoman that she was, Nancy doubled the size of the property in the Sweet Grass Hills owned by the Russell's because

a desert claim was 640 acres. There wasn't any need to spend time running an irrigation ditch on her West Butte holdings as it was sitting on a fresh water artesian spring. Charles Warner let that cat out of the bag in his book "**Old Coins of the Sweet Grass Hills and some shreds of wiregold**". The Great Falls Public Library has a copy of this grand book to check out. … *"But I came to know these rugged buttes, and the claims the Russell's filed.*

The artist had his choice, and did he quite gladly bear the blame; The scenery and the babbling brook, the same was true of Russell's art, his hobby, just a pleasant game;

But Nancy knew he held a winning hand, it was she who paved his way to fame.

Art was a gift his maker gave him, which he featured, though he rode or walked; This was proof that much he loved it, he modeled clay, the while he talked. While Price, in his own way an artist, too, was finding ranch life rather slow.

The Kicking Horse, a creek of constant flow, rolling hills, how right it seemed this place would do; The narrow valley, and the willow hedge, a cowboy's dream had here come true. Con kept in mind a site for permanent home, at which he had a second throw; It was a house of logs, both neat and roomy, his style of barn was modern too.

Charles had filed a claim a little higher, where the Stony Creek flowed crystal clear; Nancy filed on land as desert claim, which may one not knowing misconstrue, it was a legal deal with Uncle Sam, but what its name inferred was far from true."

Facts are stubborn things. The following newspaper postings reflect that both Nancy and Charlie filed Desert Land Claims. Charlie's on April 4 and Nancy's on June 27, 1908. Interestingly Nancy's claim references her as "*Claimant*" and Charlies' references "*He*". Even with the expanded property, Nancy, and Charlie did not complete proving up their filings and the property was sold at a sheriff's sale. The "second throw" cabin that is pictured with Charlie, Con, and friends in photos of 'the Lazy KY' sits in the yard of Chuck and Sally Clark as a testament to a moment in time as it was.

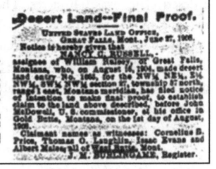

Charles Warner was a bachelor whose cabin was walking distance from the Price Lazy KY cabin. He was a kind man who wrote verse and sketched a little. Mostly he liked watching the antics of Con and Charlie along with nature's ever-changing portrait right outside his door. For a mind's eye view of the Sweet Grass Hills, a short visit to Chas Warner's *"Old Coins"* book will take you there.

One of Mr. Warner's verses mentions *"this young man with his derby"* being the *"oddest thing about the place"* with a recommendation that *"If you're gonna stick around, you better put that thing away."* Woven throughout his verses are clues to some of the stories included in this writing, some embellished, some somber events examined more closely by sentiment and wisdom that rises from the writer with integrity and concern. This reference of the *"derby"* is most likely F.M. Mack's arrival with his Stetson derby he so proudly purchased and found it to be a novelty to the cowboys in the area. The Stetson hat was one of the most popular styles of cowboy hats for years, possibly because of the quality indicated by X meaning the processing of beaver pelts for the brand. Beaver felt is waterproof and many times the cowboy used the hat to carry water or to water his dog or horse from his canteen. Usually a XXXX (4) or XXXXX (5) were considered top of the line. John B. Stetson Hat Company was founded by John Batterson Stetson in Philadelphia in 1865. The Company stopped making cowboy hats in 1971 due to a decline in demand and competition. Lead was used in the processing of the beaver plews which may have contributed to the decline in use. The term *"**mad as a hatter**"* rings true as over time it

has been proven that lead affects the neurological system. In addition to the use of lead to hold the beaver hairs together for forming hats it was used as a tacky agent to form roof tiles often used in wealthy homes roofing materials causing many a wealthy family mental dysfunction, especially in children who often had playrooms or bedrooms on the top floor or attic of their homes.

Barbara Berthelote and her friends often walked through Chas Werner and the Lazy KY yards on their way to an adventure. When the newspapers, books, and documents are gathered from 1880 to 1920 surrounding the Sweet Grass Hills in north central Montana they reflect a panoramic view of the west in transition from savage to statehood in condensed version. For the characters who played their parts, it must have seemed like fits and spurts of terror or grief between hours of tranquility and moments of sheer bliss. Even though the country was huge and sparsely populated, the communities were close knit in their celebrations and strife's.

There were 'Land Locators' who came out of thin air and set up land offices offering to 'save time in locating property' showing their clients (for a fee) choice location to homestead. Often the 'Land Locator' became lost on the open prairies and by the time the client had gone all the way to Fort Benton to file his claim, the promoter had disappeared with the fee leaving the homesteader to seek out his own claim. That was one advantage of having family in the area of the Sweet Grass Hills. Sometimes descriptions did not match the acreage, so locations had a way of moving. Even the Courthouse had rackets going on. When a claim was about to be filed, someone had always been there first. However, the clerk was always sure that the party ahead did not seem too interested and would relinquish the claim for a fee. "*The clerk would find out at lunch time.*" The excess fee was divided between the swindlers. Proving up the land was important, but building a cabin or digging a ditch often did not keep claim jumpers from moving in. Bachelors had the worst of this issue as they did not have a wife or children to "*hold down the fort*" if they were out working.

Frank Pugsley, son of David and Jane Pugsley, shared a claim jumper story. The Pugsley ranch was located near the site of the Baker Massacre

and a large portion of it is now under the waters of Lake Elwell, the lake formed when the Tiber Dam was created. This story was reprinted in the Shelby Promoter.

"One incident involving our claim on the Missouri River occurred as my brother and I, returning from a trip to town, found two men building a house of sorts between the horse corral and our house. Getting off our horses we began arguing with the men as to who had the first claim on the property. I could see Leonard was not making much headway and maybe because I was young and brash, I pulled off my coat and said, okay lets fight and let the best man win! That was all that was needed. They got on their horses and rode away and nothing more was heard of them.

Another time when I returned from some chore away from the ranch, I found that a man had driven a band of sheep through my alfalfa field and had completely ruined it. Being in a rage over this destruction I hauled him off his horse and knocked him down. After all these years I still remember my utter surprise at seeing him on the ground. Having gone that far I proceeded to give him a regular old-fashioned licking. The news of this squabble was bruited about the countryside and for several years no more claim jumpers bothered us.

A few years later, when Leonard and I had established our ranches, a cowboy in the employ of some cattlemen built a shack by a spring where we had a shearing shed. If we lost this spring our grazing area would have been sharply curtailed. In talking it over with my brother we decided to move the shack up the arroyo a couple of miles. Taking several men, a four-horse team and sled, we lifted the house on the sled and hauled it to some distance away. The cowboy came and asked what was the idea? Without much argument I kicked him, and he got on his horse and rode away. Contrary to public opinion, or at least in our part of the country, there were none of the range wars so dear to the Western pulp stories and movies. To back up your claim with a threat of a fist was usually sufficient."

Eva Strode Melvin captured some of the common antics in her article "**My most unforgettable characters**" published in the Shelby Promoter and Tribune of Shelby Thursday, August 21, 1969: *"Among "My Most Unforgettable Characters" are a periodic drinker, a great liar, and a stealer. They would drink for you, lie for you, all because they loved*

you." People don't change, they just become more of what they are. Often their offspring reflect the same values and traits as their parents and in a community that is topographically isolated and consists of third generations of the same families, this becomes obvious over time. The wild card is that sometimes there is nothing known of the previous generations of some who came to the Sweet Grass Hills and stayed. Charles Warner is one such man. If he hadn't authored a book little would be known of this gentleman. Mildred Trost of Brady, Montana wrote his biography in the first three pages of his book. Eva Strode Melvin shared bits and pieces of history of some of the people she knew and observed during her years growing up in the Hills. One most often written of was "Old George Jackson".

George Jackson worked for T.P. Strode most of his life and all of Eva's life in the Sweet Grass Hills. T.P. Strode was related, as a step brother-in-law. Thomas Strode died before George. Eva says, "*he was grief stricken at my father's death, that was probably why he went on his bats oftener.*" Eva was left to tend her father's ranch when T.P. died and George had worked there all her life, so she relied on him to supervise the other hired hands. When George would go to town and get so drunk, he could not make it home, she would go to Chester and consult with sheriff Dodds Keith as to his whereabouts. Such was the community that the sheriff would put George in a cell if he happened on him in a state of incoherence so George would have a safe place to "*sleep it off*". There were two George Jacksons in the Sweet Grass Hills. The one who worked for Strode was from Lancashire, England and when Eva moved to Great Falls, she invited George to live with her, which he did for about five years. The other worked for Fred Parsell on the north side of Middle (Gold) Butte. Eva says of "the other George (L.) Jackson "*was a shirt-tail relative of my father's. He was also a university graduate ... maybe that was why Mr. Parsell's sheep were so much better educated than ours.*"

In the article of unforgettable characters Eva mentions three who are "*characters*" throughout this book; Bert Furnell, Maurice Price, and Charlie Russell. It begins with a '*goat tail*' of which there were not many in the Sweet Grass Hills. Evidently a "*suave, dapper Frenchman*"

named Jing worked for T.P Strode and had left to work for a rancher at Box Elder. Jing sent Eva's brother Tommy a goat for his birthday one year. Strode's found out that he had stolen the goat from a circus in Malta (Valley County) and shipped it to Whitlash to Tommy. *"The circus held over a day hunting and the Law searched all over Malta and Valley County."* The goat had been part of the Circus Clowns act. It was trained to butt the clowns when they bent over sending them catapulting through the air into hilarious situations which entertained the crowd but was highly unpopular at the Strode ranch. Eva reports *"he ate the clothes off the line, poked holes in the screen doors and butted away at everyone and everything to draw attention to himself. It was worth your life to bend over."* In the section titled *"DASH FOR THE HORSE ..."* Eva relates *"One evening with the goat after him, Bert Furnell made a dash for his horse ... but the horse kept whirling away from Billy and Bert found himself in trouble."* Eva relays that Tommy finally traded his birthday present to Maurice Price for two geese. It may have been these two fine feathered birds whose remains made their way to the parcel F.M. Mack mailed for two fellers from the Gold Butte Post Office to the Lazy KY. For certain, Billy ended up as a hide left to dry on Maurice Price's barbed wire fence.

Eva goes on to tell of years later when she was a nurse in training in Great Falls when a friend of Charlie Russell was hospitalized for a broken hip. Mr. Speck had fallen off a coal wagon. Eva says, *"these men were about as witty as they come"* and *"they loved to kid the nurses and knew Jing better"* than she did. One day while she was tending to Mr. Speck, they were conversing about the picture Charlie had left with Mr. Speck of Billy, that goat *"old Jing"* had given Tommy. Eva remarked that the picture *"Riding the Goat"* was all wrong. She would know about Billy and his rack because she had decided to ride him one time and snubbed him to a post so he could not buck too hard or run too far. Billy had tipped his head back with his well-muscled neck and just about punched a hole through her thigh. As life is full of happenstances, Charlie Russell pops his head in the door of Mr. Specks hospital room just in time to hear this comment. Mr. Speck jumps on the opportunity to sink Eva

up to her neck in hot water with Kid Russell and his artistic prose. He tells Charlie; "*Eva doesn't like your picture. She says it's all wrong.*"

For Mr. Speck and Charlie Russell this was getting to be lots of fun; but for young Eva Strode it became an embarrassment. She felt she had to explain so she told Charlie "*if you had ridden our Billy Goat those horns would have been pointing DOWN drilling a hole in his legs not UP in the sky.*" Mr. Speck could not help himself. He smiles and looks to Charlie saying, "*maybe you had better ride and let her paint.*" Eva gets on with her nursing chores while Mr. Speck starts wailing to Charlie about the horrible pain he had during the night. It was so bad he couldn't sleep. Charlie, being concerned about his friend's comfort, steps out in the hall when Eva finishes up and asks her if there isn't "*something she could do*" to make "*Mr. Speck more comfortable at night?*" Eva, having experience with the lot of old-time characters, tells Charlie, "*your friend wiggles and squirms around too much in his cast because of all those liquid refreshments*" Mr. Russell "*brought along every day.*" Mr. Speck slept quietly all night after that conversation. It can be said that alcohol in the system expands corpuscles putting more pressure on the circulatory system, especially the lower extremities.

Eva Strode Melvin was one of four children of Thomas P. and Ella Strode. Anne, Tom, and Bill were Eva's siblings and if it weren't for Eva's articles in the Shelby Promotor little would be known of the everyday life at the Strode Stirrup Ranch besides what is written about the quality and variety of livestock T.P. Strode raised on his ranch. Thomas P. Strode and Ella were married sometime between 1888 and 1894. When T.P. Strode is mentioned in the Whitlash social column of the Chester news or Great Falls Tribune, if his wife was with him, she is referred to as Mrs. T.P. Strode, even in the column where T.P. went to town to get "*Mrs. T.P. Strode and their new baby from the hospital*" to take the family home to the ranch. Virginia Strode gave a donation to the "*Whitlash School*" and her name was entered in the ledger for the school, not Mrs. A.C. Strode, T.P. Strode's brother, A.C., and sister-in-law, Virginia. Ladies – not so important back then to distinguish. Credit was usually assigned the 'MAN'.

George L. Jackson's half-sister was Tom Strode's stepmother. George

Jackson was also related to T.P. Strode. Mrs. T.P. Strode (Ella) was George Jackson's sister. He lived and worked on the Strode Ranch until T.P died, and the ranch was sold. Mrs. Meldrum took care of Old George Jackson at Strode's on the ranch after T.P. died. He then went to Canada and stayed with a nephew for three years then moved to Great Falls with Eva for five years. Frank Sutton's mother, Elizabeth Bond, was Tom Strode's full sister. Frank Sutton was T.P. Strode's nephew. Morris Alexander was a relative to Strode and worked for Demarest's for a while.

There was another older gentleman, Mr. Moore, who lived with T.P. Strode his entire life. Mr. Moore was a good worker. He loved to see the animals eat and lost his job feeding as he almost foundered the horses and fattened the sheep and cattle beyond fit for stock shows. Eva mentions that her mother use to *"take him (Mr. Moore) by the arm and insist that he at least look at the tree"* when Mr. Moore would come and stand at the door of the living room Christmas Eve. He would come in and watch as the children opened their packages and as soon as he got his sack of candy he headed back to the bunkhouse; until he got older. Mr. Moore would sleep in the kitchen on a cot near the stove Ella Strode had placed there for him in his later years. Harrison Jackson Moore was possibly an estranged brother to Ella Strode. The following stories of Mr. Moore written by Eva Strode Melvin may shed a light on why much of Mr. Moore's heritage and early life was unknown.

Thursday, January 15, 1970 *"The Shelby Promoter and Tribune of Shelby"* carries another in a series of articles written by Eva Strode Melvin titled **"Mr. Moore: Unusual man, unusual past, infuriating person, yet likeable person"**. In this article Eva refers to this person as "Mr. Moore" and relates that out of respect for this man and his age her father told the Strode children to address him as "Mr.". A hint of Mr. Moore's beginnings is in this article:

*"**His wagon train, heading from "York State to the Oregon" predates others by approximately ten years. WITNESSED MASSACRE ... He ... around seven years old at the time ... hid back of a rock and witnessed the massacre and burning of the train. When he was driven out by thirst and hunger to try to "Ketch a**

fish," he was caught by other Indians. These later Indians raised him and it was from these beginnings that he advanced into the white man's world."

Eva goes on to describe Mr. Moore as *"slight in stature ... about five feet six or seven inches tall; blond and blue eyed, he must have been in sharp contrast to the Indian youngsters he had been raised with."* A hint to the possible or probable exposure to Mormonism comes under **"CONTRADICTED HISTORY"**. *"His experiences and opinions often contradicted history".* According to the books, **Jim Bridger** was an honest man, but *"Mr. Moore claimed he was a sharper and would **Skin ye outer yer pelts quicker'n scat gets he a chance**."* These two accounts give reason to believe that a young "Mr. Moore" was with a wagon train on the Oregon Trail.

Jim Bridger had an unusual relationship with Jedidiah Smith. Bridger was another person who grew up without parents and became a legend in the mid 1800's. Although Bridger did not espouse Mormonism, he spent a lot of time on the Oregon Trail guiding wagon trains of Mormons to Utah and Oregon and claimed to have been the first person to discover the Great Salt Lake in Utah, the same claim Jedidiah Smith espoused.

Ike Hawley came to the Sweet Grass Hills from Nevada. Mrs. Hawley came from Chicago and Lee Blevins and John Fromm came from Oregon. John and Mrs. John Blevens came from the Piegan Indian Reservation. These people are thought to have been related to Mr. Moore. Whether by blood or by adoption, or both, the implications are they all had a familiarity with each other before they arrived in the Sweet Grass Hills. Fromm and Hawley came to the Hills with a large herd of horses. Mr. Moore had arrived at his claim on Sage Creek with a small band of horses he brought from an Indian reservation in Oregon. Lee Blevins homesteaded next to Hawley and it was his cabin several people lived in, including Jim Whitlash, before finding their own land. At the time these men and families were arriving no one was keeping track because the Hills were technically still Indian lands and the U.S. Canadian border had not been surveyed. Many of these people could not read or write. They were intelligent and could converse

perhaps better than scholars of the day, but when they left their story disappeared with them. One name that passed through the Hills, Peter Albert, paid Kathy Foote $1.00 a lesson to teach him to write. Miss Foote's father, George B. Foote, was the first engineer in Helena. His sister married the first Episcopal Bishop of Montana, Leigh Richmond Brewer. Many of these settlers went to school, sometimes with their children, and often before they married. The Strode's hired governesses to tutor their children before there was a school in the Hills. They were one of the families who had a house large enough to offer rooms for staff.

In Liberty County Times, Chester, Montana December 20, 1906 under the **Whitlash Whittlings** column was this notice: "*Frank Larson has taken a position on T.P. Strode's ranch.*" A note found in the Ellis cabin before it was burned, written in German, reads: "*Hello dear Mamma, how are you doing? Here, I am learning, and I am understanding (a lot). And I can speak. But I have to take care of my body which is not so good.*" Written at the bottom of the note in English in block print: "*Frank Larson, Gold Butte.*" The note was translated by Achim (Joe) Garbe, Rheine, Germany, June 2020. The characters were difficult to identify as they were written in old German. It appeared that 'Frank' was proud that he was learning *English* and *writing* as his name and the name of the town were beautifully printed. At the end of this book there is a picture of young Frank Larson. He was a relative of the Smith, Kimble, Carroll, Ellis, Stott, Alvord, and Johnson family.

Some ranches hired tutors for their children and would hold classes at the store or vacant buildings if there was one available. Some school age children were sent to Havre to "*free*" school during the months school was in session prior to County organization of a school system. The reorganization of Choteau County was largely to form school districts to distribute state and federal dollars for education institutes. The first "West Butte" school in the Sweet Grass Hills was taught by Miss Mae Griesbach in 1904. Annie O'Laughlin had been teaching without pay until the community gathered up enough money to pay a teacher and offered the position to Mae. Gold Butte was experiencing an overload of students and the distance for some of the students was

becoming cumbersome. The adults agreed they would find the necessary funding and building for the West Butte school to become a reality. Joe Berthelote was the clerk of the Gold Butte District and he became the first clerk for O'Laughlin School.

Mae's father was the County Assessor for Choteau County in 1901. The Chester Signal of February 7, 1901 reported: *"Mae Griesbach of Fort Benton will teach the fifth and sixth grades, she has 26 pupils enrolled. The several school districts of Chouteau county have been apportioned the funds in the county treasury by the County Superintendent on the basis of $8.77 for each name on the annual census. The amounts due each district in this vicinity follows:*

Gold Butte ... $499.89; Whitlash ... $508.66; Marias ... $122.79; Chester ... $201.71; Beatrice ... $210.48; Alma ... $ 87.70.

Mae was paid $50.00 per month in one payment of two hundred dollars at the end of the four-month term. Half of her salary came from the Gold Butte District and the other half was raised by the people in the new district.

Born October 4, 1885, Mae was one of the many young schoolteachers who came to teach in the Hills then met and married spending the rest of her life in the Sweet Grass Hills community. She died in March of 1957.

"**Echoes from the Prairies**", a history of Toole County (1976), carries a story submitted by Mae G. Clark, the first 'paid' schoolteacher of the West Butte school. Mae is the Grandmother of Hardee, Jay, and Chuck Clark. The building was new, somewhat unfinished, and was later known as the cabin at the Lazy KY.

"The schoolhouse was a new frame shack between the Perkins place (now owned by Karl Nutters) and the Charles Farrell's place (now owned by Dave Thomas). At this, my first school there were no furnishings.

It contained a long table and two long benches for the pupils and a small table for the teacher. The floor was covered with fresh sawdust and shavings. There was a framed board about three feet by six standing against the wall with a partly used can of black paint and a used paint brush on the floor beside it.

Charles and Frank got on their saddle horses, rode up towards the hills

to the Charles Farrell place and brought back a chair for the teacher, a water pail and dipper, a comb and brush and a towel and a broom. They carried all this stuff on horseback.

There was a heating stove, but only one joint of pipe. The girls walked to a nearby coulee and found that the rest of the stove pipe had blown into the coulee, so the children all went after it. With the pipe assembled, the two Clark boys got the stove set up. This was quite a job for 14-year-old boys.

Then the broom and pail arrived. The boys carried water and helped the girls get the sawdust and shavings swept up and put in the stove for future kindling. The mothers had sent towels, so the girls washed the two windows.

While this was going on, I painted that smooth framed board, which they had put outside. The paint was "Carriage Black" and it made poor blackboard but out in the dry air it dried fast.

Rupert Clark and his brother went home and got a saw and a six foot two by four to use as a measure. When they returned, they remodeled the long table and benches by sawing it two or maybe four, inches off the legs. Their father, Hardee Clark had made them to fit himself and he was a very tall man.

There was no clock and none of us had a watch, but we ate when we were tired and hungry – then went back to work till we had the place in shape to hold school. The second day of school someone sent a clock and it stood on my table. I wound it at the end of each day. I had brought along in my overloaded valise a set of old eighth grade books for Montana Schools, a New Course of Study for Montana Public Schools and a Teacher's Manual for Cook County, Illinois.

The pupils had brought a set of fifth grade books for Montana, a Canadian primer, a first grade reader from King County, Washington, two sets of school books from Grant County, Kentucky, and seventh and eighth grade books from Lethbridge, Alberta. I also had a McGuffey's Fifth Eclectic Reader, a book I had never mastered. I must have had some idea that there might be a student who could. We did not get proper books nor a teacher's register till late in August, but we did hold school, and no one was ever tardy or absent."

That was quite a first day of school. Meanwhile over in Gold Butte

1895, Maude McDowell says, *"My father, John McDowell, had a store in Gold Butte. He also did freighting. My sister Myrtle helped in the store. If school was in session when he was away freighting, he would put a sign on the door saying,* [*"**If you want to buy anything go to the school and get Myrtle.**"*]

Myrtle would go back to the store and wait on the customer. If the customer was a miner paying gold dust, she would weigh it on the little gold dust scales. (One ounce was worth $18.00). The customer would leave and Myrtle would go back to school."

Mae Griesbach married Clint Clark, a brother to Senator William A. Clark (1900), December 31, 1913. The cabin where she first taught school was built by Bert Moles. About 1910 another school was erected. This was a one-room schoolhouse and Clint Clark hauled the lumber from Sweetgrass for this building. To get a new school district, ten students were needed to qualify. O'Laughlin School had exactly ten students the first year, with a little stretch of the imagination. There were three O'Laughlin children: Margaret, Jennie, and Peter. Three Clark children: Rupert and Ruye, twin boys and their younger brother, Frank, called *"Tuffy"*. Three Farrell children: Charles, called *"Babe"*, Kathleen, and their cousin, Don Farrell. Another cousin, Helen Wamsley, was living with the Farrell family. Don Farrell was not five years old, but his aunt told Mae that he *"wasn't six yet, but if she would enroll him as six, he would be the tenth pupil needed to get a new district."* A bit of fuzzy math, but a new district was in the process of being formed anyway. In the book, "**Echoes from the Prairies**" There is a photo of the 1910 O'Laughlin School with three children on the step: Ricky Schock, Gayle Mielkie, and Sharon Schock. This book can be viewed online or at the Montana State Historical Library in Helena.

South of the Hills along the Hi-line the town of Galata was growing. The ranchers in the Hills were trailing their herds of cattle and sheep to the stockyards at Galata to ship to Minneapolis or Chicago. In 1910 Dell T. Hales (Mrs. Frank Scales) came to Montana to homestead. She established her residence in a dugout intended for a *"chicken-house"* and taught the Galata School beginning in the fall of 1911.

"I was the first teacher. We had eight grades and there were 50 pupils. My wages were$75.00 and board was $25.00.

Some children walked cruel distances – first grade with older children – up to six miles per day. The Alsup children, Cecil and Ethel, had a long walk but trudged it willingly.

I remember that every child except two was born out of state. Before spring we had learned a lot about California, Idaho, Minnesota, Michigan, North and South Dakota, Virginia, Oregon, and perhaps other states that I do not now recall. We had listened to homesick boys and girls who loved to tell about their state back home. We started school in October in the back room of a feed store operated by Tom Williams and Douglas Parker. At Christmas we moved into the Galata church building. The Galata school building was finished in 1912.

The hardest thing that winter for me was the 25-mile ride on horseback after 4 p.m. on most weekends to my homestead. It was usually midnight when I rolled off that horse, often so cold and stiff that I was scarcely able to stand. The north star had been my guide.

I had not yet learned to wear jeans or overalls and why I didn't freeze to death is still a mystery." Newspaper clipping by Mrs. Frank Scalese (Dell T. Hales), date unknown.

The County Superintendent was in Fort Benton until 1912 when Choteau County separated to Hill County making Havre the County Seat. Gold Butte formed a board of trustees to handle all things school related and July 24, 1897. The School Board summoned W.A. Davis to their meeting and informed him the *"sale of liquor in his place of business near the schoolhouse was disturbing the school"*. Mr. Davis moved his *'tent'* establishment across the creek and a few feet west on the Gold Butte Road and built a *'wood'* building known as the *"**Bucket of Blood Saloon**"* to satisfy the citizens. Shortly after the new Saloon building was constructed, the board moved the school. Two schools sprouted. One in the West Butte community and one in the Whitlash Community. The times were changing.

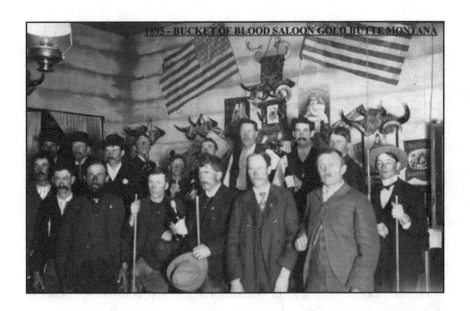

Photograph by Chas E. Morris. Note the buffalo horns flags and pictures on the wall. The gang with their pool cues and hats in hand most likely instructed by the photographer. From the back row left to right the persons identified are Arthur Gratez, Bob Reid, John Cameron, Bert Davis, Sam Aiken, Murray Ellis, Dave Davidson, Al Wolf, Bob Carroll, Wilber Parent. Front row, left to right; Bill Morely, Bill McLaughlin, Harry Miebauch, ?, Jack Dake, Tom O'Laughlin (Mrs. Parents brother) and Fred Parent.

Quite sure Wilbur Parent should have been in school if school was in session. This group was identified by Glenn Aiken, Claude Demarest, and Irvin Brown as best they could decern in 1988.

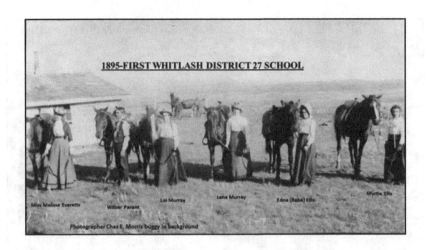

1895-FIRST WHITLASH DISTRICT 27 SCHOOL

Miss Melissa Everetts Loi Murray Lena Murray Edna (Babe) Ellis Myrtle Ellis

Wilber Parent

Photographer Chas E. Morris buggy in background

The first Whitlash schoolhouse was moved to the Laird District after one-year service near Fitzpatrick Lake at the southwest corner of the crossroads west of Whitlash at Strawberry and Gold Butte crossroad. Photograph of Harrington Spring School by Chas E. Morris.

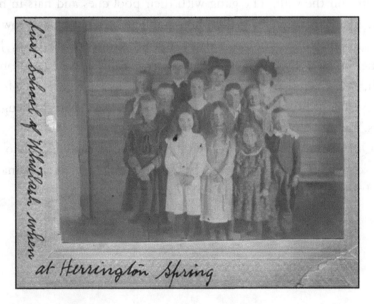

first-School of Whitlash when at Herrington Spring

Back row left to right; Alice Stratton, Miss Alvord (teacher), Loie and Lena Murray Second row: Bessie Brown, John Stratton, Amelia Brown, Johnnie Morgan, Howard Stratton Bottom row left to right: Letha Morgan, Golden Fitzpatrick, Mary Morgan, Archie Stratton.

Mary Morgan married Robert (Bob) H. Carroll October 14, 1926. She interviewed Chas E. Morris in September of 1937 for a series of stories published in the Montana weekly *The Great Falls News*. In Bill Morris's book about his father, "**True, Free Spirit.** Charles E. Morris Cowboy Photographer of the Old West", pages 128,129, and 130 repeat these stories. This friendship and connection are examples of the common thread knitting communities together sharing moments in time in photographs and written words.

Pleasant View / Valley School District 27 enrollment 1899 had grown from 12 students to 18. The School Board members were C.R. Keller, W.A. Carroll, and George Murray. Students taught by Fannie DeLacy were Agnes Carroll (Larson), Mamie Carroll, Lois (Loie) Murray (Mrs. Sam Aiken), Edna D. Ellis (Mrs. Albert (Bert) Furnell), Lena Murray (Mrs. E. Bauer), Lottie Amez Droz (Mrs. Harvey Price), Elmer Brown, Mary Fitzpatrick, Amelia Brown (Mrs. Harry Demarest), Ada N. Rowe, Edwin Sommer, Robert H. Carroll, Myrtle Ellis (Mrs. Jim Leach), Lynda Roch, Harold Brown, Ester M. Brown, Charlie Farrell, and Jessie Rowe.

It would take another 30 years before modern farming practices came into being and by that time so many of these early settlers and their families had simply abandoned their homesteads, sold their land, and moved on. The ones that remained had married some of these originals who were fortunate enough to have made it through the difficult years. All these beautiful faces in their frilly dresses and dress jackets are witness to how the community felt about the importance of education to their children. It was no small feat to assure their children attended school daily when it was in session.

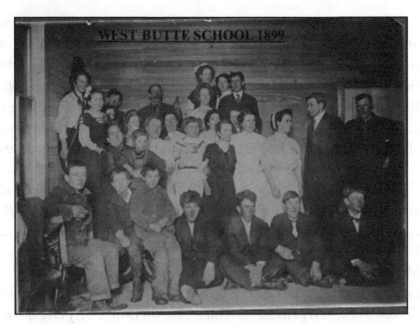

Photo by Chas E. Morris

The range of ages of the students gives an indication of who attended school. In this West Butte School photo, the desks have been moved to the edge of the room. On the left there is the side of the metal filigree inlay desk and the back of a school desk seat that served as the front of the desktop. The man with a moustache and fiddle (violin) at the back of the group may be Billy Sayers as he played the violin frequently for community dances. *"A one-man band"* reported to be *"quite a lively fiddle"*. The school may have been preparing for a dance over a weekend or evening celebrating the completion of the new building. It appears mothers are in the photo, but because of the slight showing of men, if it was a dance, it was early.

Looking at the group in the photo, the young men are most likely the Carroll's and Toole's. C.B. Toole had donated a two-acre piece of property and the community raised funds for the building's construction. The flood of youngsters to the once single male dominated population of Gold Butte is obvious. Reports were that there was usually a ratio of ten men for every girl at the dances.

School started out as a three-months term the first year Gold Butte

school was in session. By 1897 the term had increased to six-months with Nellie Neafus as the teacher. Nellie became a good friend to the niece of Mrs. John Umphrey, Jesse Rowe. Jim Fenton began courting Miss Neafus. Jim Fenton was a saloon owner in Gold Butte. Near the end of the school term Nellie became sick and died at the Jack McDowell home in October of 1897. She was buried across the creek from the school on the hillside. Jim Fenton sold his saloon and moved to Shelby, but he continued to travel to Gold Butte from Shelby for several years to put flowers on Nellies' grave.

Jesse Rowe was born March 9, 1887 and died September 30, 1902. Ada Rowe and her sister Jesse were living with the John Umphrey family. The two girls walked three miles to school during the months school was in session. Jesse would have been 15 years old when she died, and she died of pneumonia. The Umphrey's placed a stone on Jesse's grave which was placed next to Nellie Neafus across the road from the school on the sidehill at the mouth of Two-Bit Gulch. The stone had the following verse on it: *"Remember me as you pass by; As you are now so once was I; As I am now so you must be; Prepare for death and follow me"*

The verse was available on gravestones that could be ordered through Savage Mail Order Company. In the 1970's the stone was taken from the head of Jesse's grave. The thieves were never caught, but through word of mouth and newspaper pleas, the stone mysteriously reappeared at the head of Miss Rowe's grave next to Nellie Neafus on the hillside in Gold Butte. The placement of the graves for these two young women is most unusual because Gold Butte has a cemetery that sits atop a knoll overlooking Miners Coulee and West Butte.

Maude McDowell Toole was interviewed about the Gold Butte school(s) for the Shelby Promoter in June of 1964. She remembers the first school being a *"cabin with a board roof and logs chinked with mud. The floors were 12-inch boards. A stream of water ran right near the schoolhouse. We got it for the school in a bucket. We all drank out of the same dipper."* Bill Morley built the furniture such as it was. Desks that sat four students with a bench for seats. There were no library books, no blackboards, no globe, or maps. The students used slates and slate pencils (chalk). Students brought their lunches in five-pound lard pails.

Those who rode horseback used the saddle strings on the saddle to hold the lunch bucket. When they got to school their lunch was all crumbs. Edna and Myrtle Ellis rode horseback on one horse. Frank Fontaine rode nine miles to school. Edwin Sommers rode five miles. When the school moved to West Butte Miss Minnie Miebach taught the first term. Minnie left the school high and dry when she married Tom Farrell. Sarah MacHale was hired to finish out the term. Those schoolteachers were like honey to the bees. Robert Sisk Sr. from the Shelby area said, "*if it wasn't for the single schoolteachers the cowboys never would have gotten any smarter*". A sentiment often repeated. The competition was fierce for the single women who came to Montana territory. The Sisk Ranch was established in 1911 and is featured in Volume 15m, issue 6 of "Treasure State Lifestyles Montana".

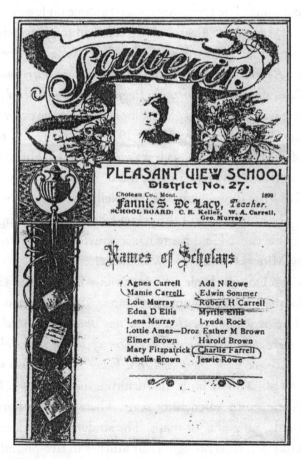

School census on July 18, 1895 was 41 between the ages of 6 and 21 and 28 under six. In August 1895, the trustees purchased a log cabin for $25.00 from Carl A. Whitmire. Miss Malissa Everett earned $40.00 per month. The District didn't have enough money available to pay her the full amount for three months, so they split the payments into $113.66 December 7, 1895 and $16.34 on January 11, 1896 when they had received their annual funds. The County Superintendent appointed the School Board: J.M. Wilcox, W.R. Bass, and H.F. Smith. By 1905 Choteau county showed the total of children of school age in Choteau county was 2,581. Chester had 28, Gold Butte - 74, Whitlash - 57, Marias - 32, Beatrice - 40, and Alma - 17. Havre was the largest district in the county with 637.

Beatrice School was also known as Willow Rounds School built in 1892. The name of the Post Office at Willow Rounds was Beatrice. Susie (Susan) Price Turner was the postmistress for as long as this Post Office existed, and she named it after an aunt, Beatrice Wasacha. The school was the first school *"on the Marias River"* meaning from Fort Benton to Conrad. The first teacher at this school was Kate Thompson (LeMasters). Following Miss Thompson in the teacher's position was Mr. Cartright. This information was taken from the Shelby Promoter and Tribune of Shelby Thursday, July 9, 1964 edition. Selections were taken from a 1959 letter from Mrs. Dorothy Hamaker of Valier, Mrs. Majell Peterson of Conrad, Mrs. Ed Pettigrew, and Mrs. John Wolfe, all who had attended the Willow Rounds school. Mrs. Ed Pettigrew (Mary Ellen Lynch) attended and returned to teach in 1902-03.

"The desks were homemade with slanted tops. The pupils sat on benches with the slanted desk in front of them. Each seated four or five pupils. The teacher's desk was a homemade table. There was a potbellied stove in the center of the room. There was a large clock on the wall.

There were blackboards but no library books and other equipment such as a globe or maps. The textbooks included the McGuffey readers.

There were 14 to 16 pupils in all grades from the first through the eighth. There was no playground equipment. Baseball was popular. The children also played such games as Run Sheep Run and London Bridge. Mrs. John Wolfe – then Madeline Wilson – was one of Mrs. Pettigrew's

pupils. When it was time for school to begin or the children were called in from recess, the teacher rang a large hand bell.

Most of the children rode horseback to school. In the winter they drove a sleigh. Some of the children came a long distance to school. The Wilkins children came six miles in a one horse two wheeled cart. Sometimes they came horseback.

Mrs. John Wolfe reported that her folks moved way down on the Marias River where there was no school, so she stayed with the Peter Hughes family and went to Willow Rounds School. The teacher also stayed with the Peter Hughes family. Mrs. Pettigrew and Peter Hughes were cousins. Ed Hughes was the first pupil of the Willow Rounds School to receive an eighth diploma. Mrs. Fannie Chenowith, county superintendent of schools for Teton County, awarded the diploma."

A few fun facts on early finances and teachers. Gold Butte's second School House was built by William Morley @ $250.00. The Material was purchased in Columbia Falls and a charge of $60.00 was paid for "hauling the material". The building material itself was $75.00 for an 18ft. X 24ft. building. George Beattie built the West Butte School for $150.00. November 18, 1899 the District received $30.00 for rent of the school building from D.O. Swelt. Swelt was possibly one of the Government men sent from Washington to approve claims so deeds might be issued. October 24, 1905 District 27, Choteau County paid $108.00 for two chimneys, 2 coal houses and painting Middle Butte and West Butte schoolhouses.

The Homestead Act provided for school sections of land which interestingly, were rarely used for housing the actual brick and mortar of school building(s). These Lands are known as '**Trusts**'. In 2020 they are managed by Trust Lands Management Division administers who manage the State trust timber, surface, and mineral resources for the benefit of the common schools and the other endowed institutions in Montana, under the direction of the State Board of Land Commissioners. The division is divided into four primary management programs: Agriculture and Grazing (including Recreational Use), Forest, Minerals, and Real Estate Management. 4.76 million acres are leased to over 9,000 farmers for cropland and rangeland.

Forest Management Bureau manages over 780,000 acres of forest land (of which there is some in the Sweet Grass Hills). Revenue from forested trust lands is mainly derived from the sale of forest products. Minerals Management Bureau, (MMB), is responsible for leasing, permitting, and managing approximately 5,301 oil and gas, metalliferous and non-metalliferous, coal, sand and gravel agreements on 2.1 million acres of the available 6.2 million acres of school trust lands and approximately 5,632 acres of other state-owned land throughout Montana.

Real Estate Management Bureau manages all activity on trust lands not classified as grazing, agriculture, or timber. These surface tracts are administered for the benefit of the trust through leasing, short-term licenses, land exchanges and sales, and through issuing right-of-way agreements. Most of these Bureaus were not in existence when Homesteaders were moving into Montana Territory. Even if they had been, no surveys had taken place. The diverse topography of Montana makes surveying a challenging task even today.

Even though the land had not been surveyed, the squatters, homesteaders, and miners who made dugouts, built cabins, or dug irrigation ditches were bound to their claims. Like Lewis and Clark and David Thompson, most of their claims were close to right, but occasionally they found that an adjacent claim overlapped property. One instance of this is a shed that still stands off Strawberry Road with the northwest corner sawed off. The shed was built as a pole barn sheep shelter by Arthur Ross as an improvement to prove up his land claim. It did not have a floor so it could not be moved. Peter Hughs, a miner who had steaked a claim next to Ross, had his claim surveyed and found that the northwest corner of that sheep shed was on his property. Most of the disputes in the Sweet Grass Hills were resolved with a trade or exchange of land use, but Hugh's was having none of that. He wanted all that was rightfully his and he sawed off the northwest corner of the shed. Arthur Ross put a support back in for the roof and the building remained protected from the wind in the shelter of Middle Butte. The Arthur Ross ranch was bought by Cliff Toole and sold to T.C. (Red) and Dorothy (Dot) Thompson Morris in 1937. Dot and Red hayed the meadow surrounding this shed.

Ironically, Red Morris died following a hay wagon accident moving his haying equipment to his home ranch. He was on the Strawberry Road and ran off a steep embankment July 21, 1984 with his bale wagon. Buster Brown found Red pinned under the bale wagon with sever lacerations. The lacerations created internal bleeding causing pressure on his heart. It was not determined if his heart attack occurred before or after his accident.

Red was born in Lindale, Texas and worked for Hope Engineering on a pipeline from Louisiana to Illinois. He came to Montana in 1930 working on a pipeline from Great Falls to Canada. He met and married Dot that same year. Dot and Red raised and showed registered Herford cattle. Dorothy Thompson Morris (Dot) was Robert Thompson's younger sister. Robert Thompson's wife Juanita, was the daughter of Murray and Myrtle Johnson.

June 18, 1901 a petition was filed to establish a county road from the point where the Chester and Gold Butte stage line leaves the county road to Gold Butte via Whitlash. John N. Dorsey, C.R. Keller and A.W. Merrifield were appointed to view the proposed road. This same day a petition was filed to establish a county road from a point near the iron-roofed shed belonging to C.R. Keller to the Whitlash post office was presented. Livingston Crihton, James E. Hamilton, and A.W. Merrifield were appointed to view the road. The iron-roofed shed had been the first Whitlash post office.

In September of 1901 T.P. Strode of Whitlash attended the Medicine Hat fair with Strode & Dorsey's show flock of Rambouillets. They exhibited several rams and five ewes. Some of their thoroughbred yearling rams weighed 175 pounds in show condition. October 10, 1906 the Liberty County Times reported *"Cupid has again been busy in the Hills and this time his victims were Miss Louise Murray, daughter of Mr. and Mrs. George Murray of Whitlash, and Samuel W. Aiken, popular young business man of Gold Butte. The young couple took the train Monday morning for Great Falls where the knot will be tied. The Signal wishes them a long and happy life."* The following weeks edition announced; *"Maurice C. Price and Louis Amez Droz welcomed baby girls to their homes in the Sweet Grass Hills. The stork made his visit on the same day."* In September,

a daughter was born to Mr. and Mrs. Wm. McDowell of Gold Butte. George Murray reported having raised 12,000 pounds of potatoes on a half-acre on his homestead in Middle Butte. Murray's garden was a short distance from the shed with the corner cut off by Peter Hughes. A.K. Prescott shipped 2,300 fat ewes to Chicago. Cattle and sheep were being shipped out of Galata and Chester to market in Chicago November of 1906. In June there were reports of grains being planted in the Hills and the hefty rains in the spring brought in a bumper crop that year. Things were booming even though there was little gold left.

Black gold was struck in 1902, not the liquid, but coal. *Two men discovered coal at West Butte when they noticed the diggings of a badger hole had chunks of coal; Teed Johnson and Fred Bent. The first coal was a rusty color, but when the shaft was sunk deeper, they found black coal. At 65 feet there was a vein 22 inches thick was found. The coal was found close to Fred Knoble's homestead cabin. It may have been on his land. Teed Johnson and Fred Bent sold the mine to O'Dells and they ran it until 1912.* Mrs. O'Dell sold 320 acres @ $20 an acre to McDermott's who owned and ran the coal mine until it closed in 1945.

The coal was bituminous, some of the best in Montana. This mine saved people from traveling to Lethbridge, Canada for coal and produced enough to ship outside of the area by rail from Sweetgrass. The mine employed 30 miners when it was in full operation and coal sold for $6.00 to $9.00 a ton.

Sometime in this flurry of activity in the Sweet Grass Hills before surveys and fences had marked property lines, old George Jackson from the T.P Strode ranch was called to Fort Benton District Court to testify in a dispute between Mr. Christianson and Mr. Sam (Aiken) over Mr. Sam's desert claim. *"Old George was subpoenaed much to his consternation."* This is another of Eva Strode Melvin's newspaper articles in the 1969 Shelby Promoter.

Both men were friends to George, and he did not have any skin in the game. The first day of the trial was routine in the morning but heated up in the afternoon. The argument centered on a garden and a ton of potatoes Mr. Sam said he had raised. The case seemed to be about wrapped up. There were only two witnesses yet to be heard, George

Jackson and another man. There was a short recess and when the trial resumed Old George was called to the stand.

Lawyer: *"Did you contract to build a reservoir for Mr. Christianson?"*

George: ***"Yes sir, I did."***

Lawyer: *"Did you contract and dig a ditch on Mr. Sam's desert claim?"*

George: ***"Yes sir, I did."***

Lawyer: *"Did the reservoir belonging to Mr. Christianson, fill with water?"*

George: ***"Yes sir, it was full."***

Lawyer: *"Was there any rainfall during this summer?"*

George: ***"No sir."***

Lawyer: *"Is it possible to raise a garden and a ton of potatoes without water?"*

George: ***"No sir."***

Lawyer: *"Did Mr. Sam raise a ton of potatoes?"*

George: ***"Yes sir, he raised a ton of potatoes."***

Lawyer: *"How could he have raised those potatoes without water?"*

Judge: **"The witness will please answer that question."**

George: ***"Well I'll tell you. I built the reservoir for Mr. Christianson and dug the ditch for Mr. Sam and Mr. Sam stole the water from Christianson's reservoir and watered his potatoes. Yes, he raised a ton of potatoes."***

The fact remained that Mr. Sam had raised those potatoes and therefore had fulfilled the legal requirement of the law on desert claims. Facts are stubborn things.

CHAPTER 18

GALLANT AUDACITY

Bert Furnell was just about finishing up high school in Great Falls in 1898 when his mother was settling Matt Furnell's estate. Bert was working at the Furnell ranch in Sun River, as well as adjacent ranches, but once he finished high school, he went to work at the Deer Creek Cattle Company & Spencer Cattle Company in Canada. Deer Creek Cattle Co. was owned by Frank Webster from Benton Harbor, Michigan. Benton Harbor and the City of St. Joseph (which is located across the St. Joseph River) are known as the *"Twin Cities"*. The city took its name for Thomas Hart Benton in 1865. Thomas Hart Benton was a Missouri Senator who helped Michigan achieve statehood in 1869, the year Benton Harbor organized as a village. Michigan opened for homesteading long before Montana and the 160 acres of homestead land supported small productive farms. Della Peek Furnell, Bert's mother, was from White Pigeon, Michigan just down the river from Benton Harbor. Anyone filing homestead claims in Michigan at that time had to travel to White Pigeon where the United States Land Office is the oldest surviving U.S. Land office in the state of Michigan. It's possible and most probable that Della Peek Furnell was related to, or at the very least, knew Frank Webster before he came to Montana.

Frank Webster had been on his ranch alone and his son, Henry Pike Webster, came to live with him and help with the ranch. Henry Webster was born in 1885 and was six years older than Bert Furnell. Possibly the Websters were related to the Peeks as there were numerous visits

from the time Della and Kate had arrived in Montana throughout their lives. Henry married Josephine Canary of Great Falls in 1917. Henry and Josephine met at the ranch in Alberta and lived on the Deer Creek Ranch for 11 years. When they left the ranch, they moved to Sweet Grass Montana and opened a mercantile business.

Spencer Cattle Company was a partnership of Thomas C. Pegg and Art Barton. This pair enjoyed a few years of above-average rainfall and land that was undefined. They prospered until the winter of 1906-07 when winter was without the accustomed chinook to their home ranch just north of the Sweet Grass Hills. The livestock strayed and they experienced significant stock losses. Pegg partnered with Pearl Jones near Coutts and later moved across the border into the United States operating a sheep and cattle ranch on the north side of West Butte. When WWI started in 1914 the enlistments and casualties combined to change profoundly the social character of the ranch country. Many of the large ranches dispersed and remained vacant for twenty years when homesteading began and the economy on both sides of the border improved.

Thomas Pegg attended Pillsbury Baptist College in Owatonna, Minnesota, an Independent fundamentalist Baptist college. Programs include degrees of Bachelor of Arts in Bible and Bachelor of Science degrees. He was known as the *"sort of"* preacher. His wife died on the ranch in 1947 and in 1948 he moved to Shelby where he had a feedlot until ill health forced him to retire. For a while, his ranch on West Butte was known as the "Company Ranch". He partnered with Harry Thompson who managed a second "Company Ranch" south of Whitlash. In addition to sheep and cattle the pair raised and sold registered Belgian horses. Remains of the house and corrals are still standing. The ranch yard was located where the Calvary Camp had been, south of Writing-On-Stone Park. Walter Clark had some spooky tales about the door flapping in the wind and an occasional cow being trapped in the house causing *'suspicious noises'* which gave the buildings a reputation of being haunted. It is rumored that Mrs. Pegg, who died on the ranch, is not resting in peace alone in the Sweet Grass Hills.

There was a lot of activity along the border near the Sweet Grass /

Aden port of entry and Bert Furnell was in the thick of it but unawares of everything that was happening. He was hauling freight and wrangling cattle, horses, and sheep from Shelby, Montana to Lethbridge, Alberta and the Rocky Mountain Front to the Sweet Grass Hills. Bert's uncle, Lee Ford, and his cousins would visit Bert at the Deer Creek Ranch and Bert would go with them on outings to Gold Butte looking for buffalo skulls and Indian artifacts. Occasionally they would go as far east as the Strode Ranch where they 'guttled' native trout in Bear Creek.

Guttling trout is like noodling catfish. Its catching fish with your bare hands. Bear Creek was the best creek for this sport as it was a step-over creek with under-washed banks. After stomping your feet and making a lot of noise to scare the fish under the banks you lie on your belly and reach under the bank until you feel a big fish go over your hand. Keep your hand still until the fish settles and gradually work up to its gills. Once you have griped the fish by the gills you throw it over your head far enough away from the creekbank, so it won't flop back in the creek and escape the frypan. Breed and Sage Creeks had fish too, but Bear Creek had the best under-washed banks for this sport.

Overnights in Gold Butte were common stops in the summer for the Ford's and Furnell. Gold Butte remained the center for travelers in the Sweet Grass Hills. With two boarding houses, a store, a stable, and four bars, there was always something happening. There were not a lot of houses in town as most of the business's housed their proprietor. The gold diggers had left the fringes full of holes leaving the gulch looking like a giant badger colony had harvested a colony of gophers and left a log or two over the hole in an effort of reclamation. Cap (Jack) Toole and Murray Johnson took advantage of those dugouts when they were courting Maude and Myrtle McDowell. Judge McDowell did not have time to research all those diggings when he was looking for his missing daughters and knew those young scallywags had been seen around town.

One old drunk stumbled into one of those holes and tried to save himself by wrapping his arms and legs around a log. A crowd of men gathered around and just stood there laughing and talking. Not one offered to help him. He begged and he swore. He cried and he prayed.

Finally, he gave out and bumped to the bottom with an unearthly scream. Only then did helping hands reach out. No doubt he needed a drink by the way he went staggering and swearing to the saloon. Bert asked his uncle, "*Why didn't anyone help him out.*" Lee replied, "*That old chump. The hole was only about four feet deep. He wasn't a foot from the bottom, and besides we had a bet on to see how long he would last.*"

Harvey Price was one of those cowboys who spent most of his free time and hard-earned money at the bars in Gold Butte. Harvey wasn't drinking to celebrate, he was aiming to escape, from what he did not know, but he would have a few spirits and started looking for a fight. Maybe Harvey was frustrated because he thought he couldn't dance or maybe he was too shy to talk to the ladies. Whatever it was, Harvey did not go to the dances to dance, he went to look for a fight. He gave Gold Butte and Whitlash a bad reputation. He would walk around the bar or Hall before he started throwing punches almost like he was looking for a way out or a way in. Eventually he would storm the door and offend the nearest bystander no matter their size, condition, or age. Without provocation he would throw a punch. That's not to say he always got the best of it. Often, he took a beating. Many times, he was gimpy for more than a month, but the lesson never took the fight out of him. Harvey's brother, Ernie Price, was a top-notch bronc rider. He seemed content to take his lickings on the back of spirited equine. Ernie made $50.00 per horse rode, which was big money in the day. It may have been sibling rivalry that made the Price men challenge their pain thresholds as they made their way through life.

Whitlash and Gold Butte started having 'rodeo's' on the 4th of July. There was never an arena, but Whitlash had a bucking chute and there were usually enough vehicles to form a surround making a 'sort of' enclosure. The pick-up men had to be well mounted to run down any of the broncs that broke out of the enclosure. It was crude, but it was the start of what would become one of Montana signature sports, rodeo. The events brought people from Canada, Havre, Great Falls, and all parts in between. With most of the west fenced in, cowboys would show their athletic ability riding broncs. The money was encouraging.

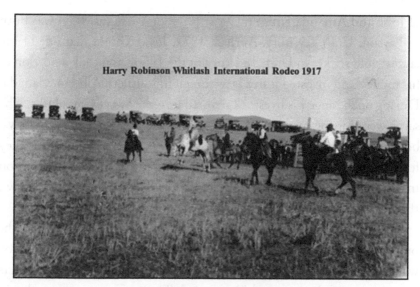

Pearl Alvord photograph

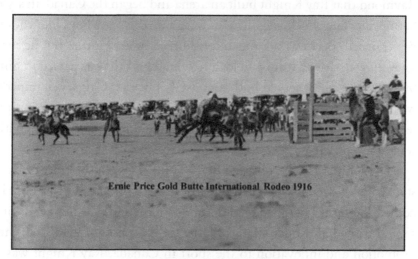

Pearl Alvord photograph

Rodeo's in Gold Butte and Whitlash were just bronc riding. The first complete rodeo with roping and barrel racing started July 4, 1888 in Prescott, Arizona. Cheyenne, Wyoming Frontier Days began in 1897. These were held with enclosed arenas and there was a charge. The first rodeo arena in the Sweet Grass Hills area was built by Raymond Knight in Raymond, Alberta, Canada in 1903. Raymond Knight was the son

of Jesse and Amanda Knight. Oscar Raymond Knight (Ray) was born in Payson, Utah Territory, April 8, 1872. Jesse Knight had one of the largest gold strikes in Utah Territory in the 1860's and took a portion of his money and invested it in a large ranch in southern Alberta, Canada. During open range his livestock roamed into the Sweet Grass Hills. The same went for the cattle in Montana. The line was blurred so cowboys, both north and south to the Marias River, just kept riding until they found what they were looking for. The first Canadian Day celebration in 1902, Ray held the "Raymond Stampede" in a vacant lot in the town that is his namesake.

Like the International Rodeo's in Whitlash and Gold Butte, the bucking horses were *"blindfolded and snubbed"*. Once the cowboy was mounted the blindfold and ropes were removed and the handlers stepped out of the way and "let er rip". The event was so popular in Raymond that Ray Knight built an arena and began the Canadian style Stampede. The chuck wagon races were added for cowboys like young Bert Furnell. Bert was not much for riding a bronc for fun, but he sure knew how to drive a team and load freight. This skill was passed to him by his father and it served both men well. The first Calgary Stampede was in 1910 with the Chuck Wagon Race, a unique and continuing feature. Raymond Knight coined the term "Stampede" for rodeo's with wagon race events.

The Knight ranch consisted of 400,000 acres (1,600 km²) of land stocked with over 15,000 head of cattle and 40,000 head of sheep. He coined the term "stampede" into a rodeo term and was inducted into several Canadian Rodeo Halls of fame for his roping skill, also for his promotion and innovation to the sport in Canada. Ray Knight was a prominent Latter-day Saint having completed a full-time proselytizing mission in England for The Church of Jesus Christ of Latter-day Saints. Ray came to Canada to manage his father's ranch. Knight was married to Isabell Smith in 1894 and together they had three children. Ray had five other children from his second marriage to Charlotte Maud Heninger.

John W. Bascom had a ranch in Vernal, Utah near Ray Knight's father Jesse Knight's ranch. John had been to Alberta with Jesse Knight

when he bought the Canadian property. His brother-in-law, Ike Lybbert, was working for Ray Knight as a blacksmith and farrier. Ike took care of shoeing all the ranch horses and did shoeing for the Canadian Mounties and U.S Calvary mounts. John Bascom's wife, Rachel Lybbert Bascom, died of breast cancer in 1912 leaving John with five children. In 1913 John came to work for Ray Knight's Butte ranch as manager.

In 1914 John Bascom's five children joined him traveling by train to Raymond, Alberta, Canada where John gathered them and took them to the Knight Ranch on Milk River Ridge. A year after their mother died the John and Rachel Bascom children, Raymond, Melvin, Earl, Alice, and Weldon Bascom, were taken to the train station in Price, Utah in a covered wagon. They loaded all their belongings into the wagon leaving their home in Vernal and made the weeklong journey to the railroad station. This was the first time any of them had ridden on a train and the Bascom brothers were wide-eyed waiting for a train hold-up or Indian raid. Neither happened, but the Bascom's had a good look at the country they traveled as they did not sleep a wink searching the sagebrush and rocks for shadows or movement.

Once John had his children with him, he found a place of his own at Wellington Station near New Dayton, Alberta in Warner County. The ranch was approximately 30 miles southeast of Lethbridge on the Old Man River along the Whoop-up Trail. New Dayton was named by the settlers who had come from Dayton, Ohio. It is a small hamlet between Warner and Stirling surrounded by numerous regional attractions that are well preserved and maintained as Park and Historic sites. John Bascom and his boys started the -B-3 (Bar B Bar 3) brand Ranch. Before they left the Knight ranch Charlie Russell came for a visit. Earl Bascom was seven years old, but he knew Charlie was a relative. Charlie had stayed in the bunkhouse and drew a sketch on the bunkhouse wall and the hired men told Earl the story of the mural. Charlie also finished a large oil painting of Ray Knight's favorite mount, "Blue Bird", roping a steer. Steer roping was Ray Knight's specialty skill and favorite hobby. John Brinkman from the Marias River Valley would judge these early roping contest on the Knight ranch and then the Raymond Stampede.

New Dayton is plated following the Plat of Zion model. The

collective Agricultural Villages of Stirling, Warner, and New Dayton are well preserved settlements with National Historic site's, museums, restored homes, Provincial Historic Site's, the Galt Historic Railway Park, and gateways to Waterton Lakes National Park, Cardston, Glacier National Park, and Writing-on-Stone Provincial Park. Writing-on-Stone is one of the large concentrations of rock art created by Plains People. The Devil's Coulee Dinosaur Heritage Museum features a Hadrosaur (duck-billed dinosaur) nest and embryo, ancient fossils, and dinosaur models. It is in Warner. North of Stirling is the restored 1890 North West Territories International Train Station from Coutts, Alberta, Canada and Sweetgrass, Montana, USA. This would be the Station where many of the people in this book purchased tickets or waited for rides when the International rail line was completed between Lethbridge and Great Falls.

John Bascom was a relative of Jedediah S. Smith and Charles M. Russell. His sons did not miss out on any of the genes of creativeness or adventure. Earl was the most outgoing and innovative, giving full credit for his interest in art to Charlie Russell and Fredrick Remington. Earl was like his cousins in having disdain for schooling, but credit to his single father, John Bascom, who had a school district transportation contract. He gave Earl the job of driving an old stagecoach pulled by a team of Bascom horses to transport students to and from school. Since there wasn't time to go home, unharness, and harness the team, Earl managed to take classes to fill the hours until the dismissal bell rang, and he loaded up his fellow students to deliver them home in the stage. He started that job when he was in the fourth grade (9 or 10 years old).

The Calgary Stampede began its annual celebration in 1910 and Ray Knight supplied livestock for the rodeo. He had started a rodeo production company with Addison (Ad) Day of Medicine Hat called the Knight and Day Stampede Company. Day, originally from Texas, was one of the founders, along with Guy Weadick, of the first Calgary Stampede. Knight recommended many of the judges for the event, including John Brinkman for the roping events. Another young bronc rider, Tom Gibson, was also in on the planning of that first Calgary

Stampede. By 1912 folks from all around Montana were taking the train from Helena, Great Falls, Shelby, and Sweet Grass to Calgary in early summer to see the "Stampede." Charlie and Nancy Russell were among the throng headed north and they had sent an invitation to Bert Furnell with a request that he pick up the Ellis family in the Sweet Grass Hills and bring them to the train the Russell's would be on.

Bert Furnell and Edna Ellis had been dating for about a year by this time and he had been stopping by the Ellis ranch for short visits when he had work in the Hills. Once he stopped by the school on a rainy day when he had a delivery at the store in Whitlash. He was dressed in his long yellow rain slicker and rain hood, looking pretty sad, and a little frightening. The teacher excused Edna and she visited with Bert in the school entry for a few minutes. When Bert left and Edna returned to the classroom the teacher made a remark about "Icabod Krane" appearing out of the rain. Edna didn't like that teacher for the remainder of the school term. Edna shared this story with her children, Francis and Matthew Furnell and they passed it along to this author.

Charlie and Nancy had sent a few other people invitations to the 1912 Stampede. Henry Webster of the Deer Creek Cattle Company where Bert Furnell worked, and Mrs. Art Barton. Bert Furnell picked up the Ellis family and they boarded the train at the Sweet Grass station. Mr. Webster and Mrs. Barton boarded at Warner. Nancy and Charlie were already on the train along with many of their friends and acquaintances. It was a well-known fact that Charlie Russell preferred riding a horse, or walking, to riding on the train. Nancy was always relieved when some of Charlie's 'cowboy' friends happened along because Charlie was very entertaining when he was comfortable with the company. Charlie was one part of the entourage featured at the Stampede. His painting, "**A Serious Predicament**", was used on posters advertising the September 2,3,4 and 5 events in 1912. Nancy told the ladies, Effie, Edna, and Myrtle Ellis and Mrs. Barton, that Charlie had received $40,000.00 for the painting to use on the poster. An eye-popping sum for art at that time. Mr. Webster started paying more attention to Charlie Russell once he realized the value of his work. Bert Furnell and Edna Ellis were so infatuated with each other and the events surrounding the Stampede

they barely were aware of the '*business*' being conducted by Charlie Russell biggest fan, Nancy Russell.

Guy Weadick knew Charlie and Nancy before the 1912 Stampede. Although given credit for the 1912 Stampede, the event itself was not totally Guy Weadick's invention, but having a Native American encampment along with the rodeo was. Indigenous peoples were not allowed to celebrate their cultures on their own reserves because of the Indian Act laws and regulations. Guy Weadick made a special agreement with the Canadian Government and the 1912 Calgary Stampede was one of the only places where they welcomed the Indians and Métis to celebrate their traditions publicly. An Indian Village was organized by volunteers on the Stampede's Indian Events Committee. The attendance of the 1912 Stampede was 80,000 + which was twice the population of Calgary. This addition of events may be why the Duke of Connaught (who was the Governor General of Canada at the time), his wife, Duchess of Connaught (Princess Louise Margaret), and their daughter, Princess Patricia attended the first of its kind exhibition.

Guy Weadick had visited Calgary in 1908 as a performer in the Miller Brothers' 101 Wild West Show. He left the city with visions of cowboys and Indians on the open range in their colorful attire and apparent wild lifestyles. He imagined a condensed version that could be seen by people in a grandstand. When he returned to Canada in the spring of 1912, he sought out E.L. Richardson, owner of the Calgary Hockey League, in search of financing such an event. Richardson was also the manager of the Calgary Stampede at that time. He introduced Weadick to prominent businessmen and local boosters, George Lane, Pat Burns, A.J. McLean, and A.E. Cross. This group of four were known as the Big Four. They gave Guy Weadick $100,000.00 and told him to present the "*greatest thing of its kind in the world*". There is no doubt that was the best investment these businessmen ever made, and Guy Weadick made it happen in a few short months which shows his organizational skills and charismatic charm. Possibly two attributes that attracted Grace Maud Bensel to Guy.

Grace was a part of the Cummins's Wild West Show and Indian

Congress. Hers' is a wondrous story. She was born in Montevideo, Minnesota. Her mother died while she was an infant and her father, C.D. Bensel, was a criminal lawyer and later a judge. She spent most of her young life on a Sioux Indian reservation where her grandfather was the government agent. When Grace began preforming in the Wild West shows as a trick rider and roper, she changed her name to Flores LaDue. She met Guy Weadick in Chicago where he was preforming for Miller Brothers 101 Wild West Show. They married in 1906.

Guy was born in 1885 in Rochester, New York. The son of a railway worker, Guy was a city kid who was fascinated with Buffalo Bill's Wild West Show and headed west when he was a teen to work on ranches. Living the life as a cowboy he developed a knack with rope twirling watching Will Rogers talk and preform. Along with rope skills he picked up storytelling to hold the attention of the audience, cowboys, and city slickers. He was tall and handsome, skills that served him well in vaudeville and in life. Guy Weadick was just the sort of young man to fit right in with Nancy Russell's' business plan for her husband's art, and it helped that he spoke the language of the artist. His wife, Flores, was an equal fit with her knowledge of Indians and skills as a horseback rider and roper. La Due died of heart failure in Phoenix Arizona in 1951. Nancy maintained her friendship with Florence until Nancy's death in 1940.

Calgary didn't have a Stampede in 1913. The following year, 1914, World War One began and the next Stampede took place in 1918 with the Indian encampment and all events. The following year, 1919, was the next BIG blockbuster Calgary Stampede. Known as the Victory Stampede because WWI was over, it was the second epic Stampede in Calgary. In addition to Grace Weadick, Marie Gibson was a second trick rider at this huge event. Marie had met Tom Gibson at the Great Northern Stampede in Havre, Montana in 1917. The two had married and were traveling the rodeo circuit together.

Great Falls Montana hosts an annual Western Art Show featuring C.M. Russell's Art and in 2019 the show featured the 1919 Calgary Stampede with a Centennial celebration. This annual event was

cancelled in 2020 due to coronavirus (COVID-19). This photo appeared in Signature Montana Magazine in an article by Thomas A. Petrie.

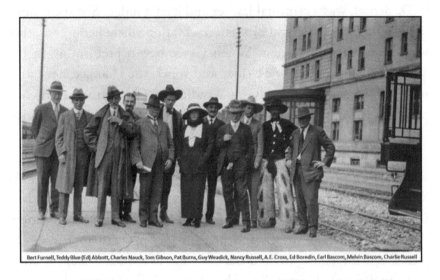

Bert Furnell, Teddy Blue (Ed) Abbott, Charles Nauck, Tom Gibson, Pat Burns, Guy Weadick, Nancy Russell, A.E. Cross, Ed Boredin, Earl Bascom, Melvin Bascom, Charlie Russell

When Charlie Russell had visited the Raymond Knight ranch after John Bascom's children came to live with him, the two remained in contact with each other as family and friends. A horse named "Dave" evidenced that. Monty had moved to higher pastures by 1904 and Charlie didn't trust just anyone to sell him a good horse. He did not ride as often, but when he did, he needed something very reliable with a great deal of sensibility. Knowing how to work a cow would be a good trait, but well broke and calm under all circumstances was the important criteria. John Bascom had Dave and gave him to Charlie to use after Monty got older. Con Price writes about "Dave" and the 3 hanging reverse E brand "Dave" packed, but he never really knew where he came from. It was a Canadian brand, and cattle were no longer free ranging. John Bascom had a small herd of cattle with a bar B bar 3 brand Con called the bar 8 bar 8, but most of the livestock packing the 3 hanging reverse E were horses the Bascoms kept for their personal use.

"Dave" was a common bay color, and it is hard to say what shade of bay he was to Charlie's eyes, but he knew that pony long after he had returned him to John Bascom. Charlie wrote his "Friend Con" after a

visit to the Lazy KY with a stop at Galata to have his horses shod on his way back to Great Falls- October 28, 1910, Great Falls Tribune: "*I spoke to Cap Toole and Tom Daley in front of the Mint in Great Falls. A Bay horse was tied in front of the Silver Dollar across the street with a skunk wagon all around him. The horse had his head down asleep. I told Cap and Tom the horse was Dave. They didn't believe me, so I showed them the three 'E' to prove it.*"

Jack knew the horse, but he also knew Charlie had not been riding for a few years and no one knew what happened to "Dave". Jack could not decern "Dave" from any of the other bays tied across the street. There is something about a brand that's more than the symbol when you get to know the animals. The placement, size, and how it shows up is unique to each critter. A brand becomes a part of the uniqueness of the animal. Charlie was probably standing across the street of the Mint waiting to see if any of his kinfolk came stumbling out when Jack Toole happened along. In his letter to Con he goes on to report that Johnny Lee died. In many of Charlie's letters to friends he mentions the friends who had crossed over to the great divide.

Here's a Chas E. Morris photo of Charlie on a sorrel horse with the 3 hanging reverse E brand. The horse is Sandy, identified in Con Prices's book in a photo with Charlie and Dave.

The Bascom boys, or as they became known – the Bronc busting Bascoms - were at the Victory Stampede in full cowboy attire ready to ride in the events and to greet Charlie and Nancy, and Bert Furnell in 1919. They knew Bert and worked with him at roundups and free time when they got together to break horses. Raymond Knight told the young cowboys in the area they could use any of the ranch horses he had to practice on. They did their best not to miss a chance on the worst of the bunch. Earl had started riding broncs when he was only three years old. He was inspired by the Utah cactus to stay mounted at an early age. While Earl and his brother Melvin were at the Stampede in 1919, they were recruited to work in a movie titled "The Calgary Stampede" the following year. Besides their own ability to ride, they happened to be handling Raymond Knights pair of golden palominos. The horses were named Bud and Goldie and they had gained Canadian fame as champion roman racing horses. Because of their color and calmness preforming at western events, the movie starring Hoot Gibson was their debut to acting. The movie released in 1924.

There were at least two other cowboys from open range days that made it to the 1919 Stampede and were in the highly publicized photo of Charlie and Nancy that year. "Teddy Blue" (Ed Abbott) and Charles Nauck from Sun River stand right of Bert Furnell as unidentified attendees at the left of the group in the photo. Earl and Melvin Bascom stand at the far right in the photo sandwiched behind Ed Borein and Charlie Russell on the end. This photograph is featured in "Charles M. Russell: Photographing the Legend" by Larry Len Peterson, page 185. Proceeds from this book benefit the Charles M. Russell Museum in Great Falls, Montana.

The Bascom boys were the youngest contestants at the 1919 Stampede. The pair were sitting behind the chutes waiting for their number to come up when one of the ring stewards tried to run them off. Earl had to explain that they were contestants so they would not get bounced out of the Stampede before they had a chance to win a piece of the $20,000.00 in prize money.

The 1912 Stampede was a muddy affair. It had rained for days

before and it was raining at the start of the events. The parade was a success as the sun found its way through the clouds to shine just long enough not to ruin the floats or the painted Indians. Events ran a bit behind schedule and the group of friends from the Sweet Grass Hills had time to discuss what was coming up. Bert Furnell tells the group, *"This next rider is Walt Whitney. He's an old timer who's never been bucked off"*. Charlie remarks, *"He surely must have been bucked off as a boy"*. The group waits as patiently as they can in the grandstand and the rain takes a short break. The announcer says, *"This next bronc rider is 46 years old and never been bucked off"*. All eyes are on the chute Walt exits on a twisting bronc.

Walt's got a smoking pipe in his mouth as he comes out. He proceeded to ride his horse to qualify, but as soon as the buzzer went off, he was promptly unloaded in the middle of a water puddle. Earl Bascom had followed Walt Whitney's career and admired him. He recanted some advice Walt gave him. Walt said, "if you want to succeed in rodeo, don't ever smoke or drink". Walt told Earl he stayed up all night partying before the finals at one rodeo. He said "the next day I didn't get bucked off. I fell asleep and just fell off".

Earl Bascom started building tack when he was a boy. Improvising any piece of leather into a usable saddle and figuring out bits and spurs welding and working metal. He held several patents on early rodeo equipment. Walt Whitney borrowed one of Earls' saddles he designed and made to ride in the rodeo at the Dempsey-Gibbons fight at Shelby, Montana. Shelby had such a big crowd in town for the fight that they held two rodeos. One at the east end of town where the rodeo arena was and the other at the west end of town in the arena where the fight was. Whitney won so much money at the east end rodeo they refused to let him ride at the other rodeo. It may have been that the promoters for the Dempsey-Gibbons realized how much money they had lost already and did not have any left for the rodeo riders.

Money or not, the show must go on. July 4, 1923 all roads lead to Shelby Montana. The heavyweight boxing championship match came to this small town in the Midwest because there was an

International Railroad crossing and folks from all directions could take the long ride on passenger trains to get to this event. And come they did. The travel planning was the only thing that was successful about the event. Unlike Guy Weadick's organization of the 1912 Calgary Stampede, the organizers of this championship boxing match knew little about feeding and housing large crowds of celebrating peoples. And yet, the championship boxing match remains a part of history. The Canadian and American communities continue to come together marking time each year with events that began more than a century ago on the plains of northern Montana and southern Alberta, Canada.

Singer / Songwriter, k.d. Lang, released a compact disc titled "Hymns of the 49th Parallel" in 2004 as reported in the Tuesday July 27 edition of USA TODAY. The release demonstrates the shared commonality that exists on invisible lines across Nations. Music and verse continue to demonstrate same interests of a diverse culture. Children's songs, church music, Irish limericks, and a good story, true or not, kept the cowboys entertained and the homesteaders from going crazy when the sun got hot and the work got hard, music lightened the load. N. Howard ("Jack") Thorp wrote "**Songs of the Cowboys**", a printed collection of cowboy songs with commentary and notes about the tunes and their histories from the late 1800's. His version of "*Sam Bass*" has most of the verses ever sung, except for the ones adlibbed along the trails. For sheet music readers he has the notes included. Worth the read. These collections are presently held by Butte – Silver Bow Public Archives, Butte, Montana given permission for use of the following pieces of music and verse.

A Poem, Dedicated to Charlie Russell, by Powder River Jack Lee.

✦ ✦ Trail's End ✦ ✦

I'm sittin' there in Charlie's home, an old friend from the range,
And gazin' on his pictures, with a feelin' sad and strange;
Familiar scenes of long ago—my soul within me stirred—
A moistened tear I brushed away, I'm ridin' with the herd.
Nancy's showin' Kitty Lee his model of a roan,
And left old Powder River with the paintin's all alone;
The golden, glowing prairies, the slick ears and the strays,
The cowdogs on the roundup and the tang of better days.

A waddy quirtin' down a bronc, in curls of yellow grass,
The travois and the Injun band, the lodge poles on the pass;
A ringy cow that's on the prod and prairie lights aflame,
So true and lifelike that it seemed I walked right through the frame.
It may be I was dozin' for I loped across the land,
And Charlie rode beside me with his trail rope in his hand;
A soft chinook was blowin' and somehow we wasn't old,
And the skies were tinged with crimson, and with purple, and with gold.

Just like all his paintin's of the scenes he knowed so well,
And by his hand describin' tales no tongue could ever tell;
He galloped on beside me with a kind and noble face,
A soul of immortality, a genius of his race.
The trail lay green and easy, and I knowed I was awake,
He said "Goodbye," and then I felt as tho' my heart would break;
And then we seemed to separate and somewhere from my side
He cantered 'round the trail herd and toward the Great Divide.

Was I asleep? none knows but God, somehow it was so strange
When Charlie Russell's spirit led me out across the range,
And left behind forever as his quirt around him twirled,
The hist'ry of the cowboy with his paintin's to the world.
I dallied on mah feelin's with my heartstrings achin' sore,
I snubbed mah bronc up easy with mah rawhide hackamore;
He waved back in the distance, and farewell he seemed to say,
And something died within me when his spirit rode away.

Nancy Russell's callin'—I awoke with sudden start—
I knowed I wasn't dreamin', there was sadness in my heart;
I thought of all the cowboys and of ranchers and the same
Who'd wipe away a tear drop when they mentioned Charlie's name.
The ways of God are strange indeed, I never will forget
That ride with Charlie Russell and it lingers with me yet;
There's some things we don't understand, but o'er me it has dawned—
A knowledge of his presence from the great and far beyond.

In silence there I pondered—he was greatest and the best—
And knew that God inspired his soul, this cowboy of the West.

"Trails End" can be found on the back cover of his book, "**Cowboy Wails and Cattle Trails of the wild west**" by *Powder River Jack & Kitty Lee's* Cowboy Song Book, With Music.

"This is part of an old song, slightly changed. I lost the other verses when one of my ranch buildings burned down at Palma, New Mexico, some years ago." Jack Thorp.

*"**Night-Herding Song**":*

Oh, slow up, dogies, quit your roving round, you have wandered and tramped all over the ground; Oh, graze along, dogies, and feed kinda slow, and don't forever be on the go, —Oh, move slow, dogies, move slow.

I have circle-herded, trail-herded, night-herded, and cross-herded, too, but to keep you together that's what I can't do; my horse is leg-weary and I'm awful tired, ...

This song expresses the feelings a night herder had tending a herd of horses or cattle on the open prairies. It was important to keep the horses as calm as possible because if either horse or cow spooked; a stampede of all the livestock followed.

A lot of people claimed to '*know*' Charlie, but few really did. A poem written by Powder River Jack Lee titled "**Trail's End**" sums up what one of Charlie's friends imagined when he had dinner with Nancy after Charlie had died. It is written in a dream state with all of Charlie's '*fixins*' surrounding him at Nancy's home in California. Jack and Kitty Lee have some of the greatest western songbooks in print. They were at the 1919 Calgary Stampede and remained friends with Nancy and Charlie Russell until each met their trails end.

CHAPTER 19

EXTENDED FAMILY

Montana's culture remains resolute. It's easy to see how communities came together during early settlement when looking at maps and transportation corridors. And though the roads run both ways, the river does not. Passenger train service only runs across the northern corridor with one train a day each direction. Highways running north and south are few as are highways running east and west. The majority of the paved road miles in Montana are two-lane even through winding mountain passes. There are stretches of highway that will not see 100 cars a day across them. The people who were bold enough to come to Montana Territory and set down roots were plenty glad to see other people. Time and again in books written of the years of pioneers the settlers say, *"the latch string is always out"*. That saying is another way of saying *"let yourself in"*, or *"you are always welcome"*, or *"mi casa es su casa"*. Company was always welcome and usually a visit included a meal or two and overnight lodging.

Those small cabins held a lot of people compared to the homes of today. It has been said that no matter which room was the largest in the home the people always gathered in the kitchen. In 2020 people found out that cooking, food, conversation, and company find comfort at the table. Charlie Russell joyfully received guests in his telephone pole cabin where he cooked, served, then conversed with friends in his studio with all the tools of his trade displayed around him on the walls and furniture. A theater and stage that enabled the audience a comfortable repose in the

presence of a master. Beginning with the menu which included "*bachelor bread, boiled beans, fried bacon, or if it was fall, maybe deer meat and coffee; dessert was dried apples.*" Charlie did all the cooking in his Dutch Oven and cast-iron fry pan while the guests inhaled the aromas of the food while feasting their eyes on the tack and artifacts displayed along with the paint and clay jars resting about the cabin. It would have been impossible to escape the mood. Nancy Russell tells about Charlie's delight of having his log cabin studio and how it came to be in her book, "**Good Medicine**". To her credit, Nancy Russell was wise beyond her years. Charlie may never have finished that log cabin if it hadn't been for some feminine wiles and her love of her husband and understanding of his love and empathy for the Indigenous peoples in their transitioning journey.

Charlie started his cabin with a collection of old telephone poles in the yard and felt the upscale neighborhood in the city wouldn't appreciate a shabby cabin stuck in the midst of the upscale architecture Paris Gibson had brought to Great Falls. Topping off his insecurities a neighbor remarked, "*What are you doing at your place Russell, building a corral?*" That cemented Charlie's thoughts, and since he wasn't enthusiastically invested in the construction of a building, he let that pile of logs sit and started piling up some rocks to shape a chimney and hearth. Nancy had a few friends who knew and understood her and Charlie, probably because they had experienced similar challenges early in their lives. A.J. Trigg was one such neighbor and he had had a few conversations with Nancy about Charlie's "project". Mr. Trigg came over one evening and said, "*Say, son, let's go see the new studio. The big stone fireplace looks good to me from the outside. Show me what it's like from the inside.*" After talking through his plans to someone who was genuinely interested, Charlie got his '*studio*' finished to the eternal joy of Nancy, Charlie, and all the visitors of the C.M. Russell Museum and Studio. Sometimes it's not what is said but how it is said. A little integrity and empathy go a long way.

The dinners Charlie and Nancy hosted in their homes were made for targeted audiences or celebratory impromptu affairs. Charlie believed, like the Apache Indians, that eating was a private matter. He had a respect for food that many people did not understand because they had never been hungry or seen people deprived of food they were promised.

When Nancy and Charlie took the train east or west, Nancy always dreaded how she was going to manage Charlie, especially at mealtime. He would not *"make up with new people"*. That was another factor that made their marriage successful. Each filled the others' shortfalls when necessary and did so with respect. Fortunately, on most of the long train trips there was somebody on the train who knew the Russell's and there are *no friends like old friends.*

On one train trip east, Mr. and Mrs. J.H. Carmichael boarded the train the Russell's were on. Charlie knew J.H from the Augusta area where he had one of the largest sheep ranches in the area. The Russell's invited the Carmichael's to have dinner with them in their compartment as Nancy had brought along a hamper with smoked fish Charlie had caught at Lake McDonald. Charlie had a table set and the Carmichael's enjoyed a delicious meal and Charlie enjoyed the compliments and company.

Nancy Russell's book has one letter Charlie wrote to Brother Van on March 20, 1918. World War I ended in November of 1918 and Charlie is writing to Brother Van to wish him a Happy Birthday because he isn't going to be able to attend the party. He recalls when he met Brother Van and it was way back when Charlie was with Jake Hoover. Jake and Charlie were at *"Babcocks ranch in Pigeye bason on the upper Judith"* with *"three pack horses loaded with deer and elk meat"*. The sketch on his letter to Brother Van is a herd of buffalo coming up from the river and there is a steamboat on the river. Charlie thought a lot about animals, particularly the buffalo and their breathtaking disappearance. The deer and elk meat was becoming scarce and Jake and Charlie sold the game to settlers and Calvary camps. When the buffalo disappeared, people began to think about food sources more. Hunting was not a sport; it was a livelihood.

The scarcity of game became an issue for everyone, including restaurants or boarding houses. Since Shelby became a major crossroads for the railroad, Dan Sullivan's hotel and restaurant was known far and wide to serve meat that often had a peculiar '*flavor*'. Close inspection often revealed it was bear. The recipe for bear meat is to get a piece of hardwood the size of the cut of meat and put the meat on the board. Place it in the oven and cook at a low temperature for five hours.

Remove from oven; throw out the meat and eat the board. Bear hair is special and great for fly tying. It floats; a small tuft added to the hook and fly adds to the lure. Bear stories and the consumption and use of bear hides and fat or grease seem to lead to humorous ends.

Tom Fontaine wrote a column for the Great Falls Tribune. In October of 1959 he wrote one Charlie Russell told of characters in the Sweet Grass Hills. Fontaine starts out by saying that Charlie told so many hair-raising yarns about the old west that he would often point up at the sun and say, *"That story, boys, is just as true as you see the sun up there"*. Hence Charlie's nickname, Sun. This tale was about Oleander Alexander and Alfred Bragg, two of the first settlers in the Sweet Grass Hills. Titled "Sun Irvin Tells A Bear Story":

"See that log house, log barn and corrals? Little creek running right through the place? Well, old Alexander lives there. Held that squatter's right since way back in 1884. Was the first settler in the Sweet Grass Hills. Came across the prairies in the early days right through Indian country all by himself and his family, his wife, Nancy; his daughter, Rosie, and a boy, Johnny. Came from Louisiana.

Everybody says Alexander is the biggest liar in these here hills. But I don't think so. He told me a story once that he was a fearsome old codger when he was mad. Well, you see that high bunch grass ridge on the other side of his place? It runs right up to the shoulder of the mountain there. Well, on the other side of the ridge is Breed Creek canyon. Old Bragg, an old prospector, used to live over there. He lived in his cabin at the head of the gulch all alone. At that time, everybody knew that there was a bear on this mountain. He was the only bear left in these hills.

Well, old Bragg came over the ridge to pay Alexander a visit one day, and he tells him about the bear. "He's right around there close to my cabin all the time", says Bragg. "Get your gun and come over. He's big and fat and you can get him easy." So Alexander went back with Bragg to his cabin and he killed the bear. Then he skinned it and dressed it out. "Well now, says old Bragg, "when you get home you cut all the fat off the carcass – there's a hundred pounds of it – and you render it out. It's just the finest stuff you ever used to fry shortening, too. And make sure to save a gallon of that bear oil to grease your harness with. It's just the best oil you ever used to soften leather."

So Alexander followed Bragg's instructions to a T. He greased his harness with the bear oil, till he had the leather nice and soft and pliable. Then Alexander had to haul a load of wood. He run his old flea-bitten grays into the barn — and that's when Alexander encountered troubles. To hear Alexander tell it: "I'm blamed if I could figure it out. That team never acted that way before. Every time I'd throw the harness on their backs, they'd buck it off. They just went mad, I tell you; yet I fought it out with them. They snorted and they faunched and they reared, till they broke down the stalls, and they pulled back and broke their halter ropes and smashed down the barn door and ran out on the prairie."

"You see, it didn't come to me right away. Bragg had jobbed me. It was that bear smell on the harness. I should of known that. A horse is mortally afraid of a bear. Anything that smells like bear sets a horse crazy, and that oil that I used on the harness smelled pretty strong. I can't say for why is a bear a hereditary enemy of the horse, maybe it's a natural fear, maybe it's imagination of the horse; Since the horse is a grass eater, he knows the bear is carnivorous, and he knows the bear would eat him; only the horse hates to think that he would be eaten by an animal that smells as foul as a bear."

"Well", says Alexander, "I was so mad that I rode over to Breed Creek Gulch and I finds old Bragg home all right in his cabin, and I gets him by the whiskers with my left hand and I pokes my gun barrel between his eyes and I pull the trigger." And old Bragg blast him, he never played a dirty trick on a neighbor again.

*"There was some derisive laughter and **Sun** pointed upward and said, "Boys, that's just as true as you see the sun up there!"*

Permission for use of this column piece was given by Grady Higgins, editor of The Great Falls Tribune, September 16, 2020. This piece is copied in its entirety because of the unique underlying facts of the piece. Alexander was Oleander Alexander. Bragg was Alfred Bragg, and Sun was Charles M. Russell.

The location of the "Bears Den" was over the ridge to the east of Bear Gulch in the Sweet Grass Hills. Alfred Bragg came to Montana with General Nelson Miles via Fort Assiniboine. They came up the Tongue River to Fort Buford, then on to Fort Benton. The Tongue River flows from Wyoming to southeastern Montana and empties into

the Yellowstone near Miles City. Bragg had been a Confederate soldier during the Civil War. When he retired from the military, he went to work for Conrad out of Fort Benton packing soldiers and supplies to the military camps in the Sweet Grass Hills. He made the first land claim using the Donation Land Claim Act of 1850 with script on Indian lands in Gold Butte (AKA squatters claim). He later sold to Rodney Barnes and Fredrick Parsell and took his earnings to East Butte filing on a 160-acre land claim on Sage Creek just north east of Bears Den and Mount Lebanon.

October 7, 1921 the Chester Reporter ran the story of Alfred G. Bragg's fatal accident helping a neighbor hauling hay. His neighbors did not know anything about Bragg's family as he was a quiet man always helping neighbors. He liked to work. He was driving a hay wagon for John Oswood onto a scale and the team bolted throwing Bragg from the load. He suffered a broken neck in the fall and died instantly. Oleander Alexander was Bragg's nearest neighbor and Bragg helped the Alexanders particularly during winter months when it was difficult to get around to get supplies. Both Bragg and Alexander were exceptional story tellers. They would rather laugh than complain and found comfort in sharing hardships especially events that spurred unbelievable tales. There was usually a shred of truth in the tale. Often: truth is stranger than fiction.

Alfred Bragg may have suffered from PTSD from his service in the Civil War. It is also possible that he was a relative of Captain Braxton Bragg the namesake of Fort Bragg in California. The timing may have been coincidental, but the Mullen Road was being built from Fort Benton to Ellensburg, Washington and the Railroad was looking at building a spur line to Gold Butte. Settlers were moving in and the demand for timber was on the rise.

Game was getting so scarce that by 1905 the State was paying $10.00 for wolves, $3.00 for coyotes, and $10.00 for mountain lions for bounty. The predatory animals were making out better than the Indians. The domestic sheep and cattle brought to Montana that struggled adjusting to the cold winters and often succumbed to the cold were a veritable smorgasbord for these animals. In the process of getting to the meat,

they would tear the hides to pieces so there was nothing to salvage for the losses. Sheep men in the Sweet Grass Hills spotted a white wolf that was killing their sheep, but they were unable to catch or kill him. John Oswood was making his living trapping in 1896 when these ranchers had some sheep that had been caught in a bog. It was winter and the sheep died before the ranchers could recover them, so they contacted John and he set some traps around the dead sheep and caught that white wolf. It wasn't long before the government contacted John Oswood and hired him as a government trapper for $200.00 a month.

John Oswood killed the last wolf in the Sweet Grass Hills in 1925. His son, Bernett J. Oswood, trapped in 1950's -1960's and caught several Canadian lynxes in the Hills. Lynx or bobcats continue to prowl the Hills but are rarely sighted. In A.W. Tinkham's Boundary Survey Commission report in September of 1853 he reported: "*The game was abundant; a large elk was shot in the earlier part of the day; antelope were more plentiful than we had before seen them; some black-tailed deer (mule deer) were seen, a big-horn, and occasionally a rabbit or hare crossed our path.*" Mrs. Dorothy Adams reported; "*In 1898 a mountain sheep was seen on Middle Butte by Robert Carrol. He tells of a fort like structure found there with a great pile of mountain sheep horns. How they got there or where they came from is a mystery.*" Another mystery of the Sweet Grass Hills, however it is well known that the Indians had several '*vision quest*' sites in the Hills and this may have been one.

Tinkham was on East Butte when he authored this report. This would have been the same Butte that Charlie told the bear story about and the approximate area where Bragg and Alexander homesteaded. The evidence of mountain sheep being abundant at one time remains evident by the sheep trails through the shale rock on all three Buttes. Camp Otis rested at the base of East Butte with Sharks Tooth to the southwest and where John Mix Stanley created his lithograph titled "Three Buttes" done in 1852-1855. A black and white picture of this art is in "**The Blackfeet Raiders of the Northwestern Plains**" by John C. Ewers captioned "*Piegan Indians hunting buffalo near the Sweet Grass Hills*". There are varying reports of the last stand of Buffalo and how and when it took place. This is a part of history rarely told; Northcentral

Montana from the Canadian line south to the Marias River and Birch Creek and approximately 50 miles east of the Sweet Grass Hills and west to the Continental Divide constituted the original Blackfoot Indian Reservation. A few settlers had made land claims according to the Donation Land Claim Act of 1850 (aka Donation Land Act). The act intended to promote homestead settlements in Oregon Territory. Since the boundary was not surveyed and Oregon Territory not yet defined a few 'squatters' made claims. Ranchers were using the Hills and parts beyond for open range grazing, but due to the annual roundups, buffalo became the main animals to graze the Sweet Grass Hills moving north due to the influx of people in the south. In 1873 a gigantic prairie fire swept across the Alberta plains and drove the buffalo south.

These volcanic protrusions known as the Sweet Grass Hills boast of a majestic view and each has its own unique minerals, rock formations and fauna. Outcroppings of rock on East Butte where Bears Den is located have a greater variety than on the other buttes. Syenite porphyry, narsarsukite, copper, and granite are just a few of the unique outcroppings found in the nine square mile area (flat) East Butte covers. Narsarsukite is reported to occur in only three known locations: Narssârssuk, Greenland, Sweet Grass Hills, MT., and Mont Saint-Hilaire, Canada. The narsarsukite found in the Sweet Grass Hills was documented by W.E. Ford (1909). The geology is unique enough that Will Steege sought the expertise of Charles E. Erdmann, a regional geologist for the U.S. Gelogical Survey, to find the perfect stone in the Sweet Grass Hills to mark the grave of Great Falls founder Paris Gibson. In the June 29, 1953 edition of the Great Falls Tribune there is a picture of Paris Gibson's seven-ton grave marker along with two photos of the Bear Tooth formation from where the stone was taken.

Carl Jeppeson, Liberty County Assessor, Chester, Montana, guided Charles Erdmann to Bear Tooth 90 miles north of Great Falls. Jeppeson commented; *"The early pioneers had to have some of the characteristics of this pre-historic rock formation to endure the hardships, the dangers and the uncertainties of hard-rock mining when travel was slow and cumbersome and the hazards of bringing in equipment, powder and fuse together with equipment; and the flour, sowbelly and dry beans with which to sustain*

life can only be surmised by present generations." Often these things are taken for '*granite*' today: pun intended. Pappin Construction Company brought the stone to the cemetery and Great Falls Transfer Company donated use of a big crane to set the rock in place. The Great Falls Cemetery Association employees fixed the cement foundation.

In 1874 the boundary line between U.S and Canada was surveyed jointly. On their way westward the engineers reported that they saw no buffalo until they were about 50 miles east of the Sweet Grass Hills. W.J. Twining, chief astronomer and engineer with the party, reported that he considered the Sweet Grass Hills the center of the vast herd. The Canadian herd that was driven across the line never returned to Canada and hundreds of Canadian Blackfoot Nations starved during the winter of 1874-1875.

Meanwhile traders at Fort Benton were urging the Indians to bring in more hides. In 1876 Baker and Brothers of Fort Benton shipped 75,000 hides. That was the peak year and in 1877 only 30,000 hides were shipped. That was the last shipment of hides to go down the Missouri. During the remainder of the 1870's the Indians were compelled to hunt stragglers, far and wide, for food. When the 1880's came, the trail of the last buffalo had disappeared from the prairie. [Great Falls Tribune 1961] 7,437 land patents were issued under the Donation Land Act.

The Donation Land Claim Act of 1850 law expired in late 1855, then the Yakama Native American War broke out in the Columbia Basin in 1856 and continued to 1858. Major Isaac I. Stevens was governor of Washington Territory and was attempting to rein in the Indians. The same was happening in Texas and Montana. The incoming emigrants and homesteaders added to the chaos which was exacerbated due to the diminishing supplies of food sources. Following the war in Washington Territory came the Civil War from 1861 to 1865. There were some 7,000+ people who came west to settle making land claims with the hopes of settling. What they had not anticipated when they committed to the long journey west was the Indigenous Peoples and animals not taking kindly to the cultural adjustments that were inevitable. Communication was problematic as American English evolved with the nation and the nation was comprised of Indigenous tribes who each spoke their own

language, and a melting pot of people from all around the world. Chief Joseph had it right when he said, *"The white people have too many chiefs. They do not understand each other. They do not all talk alike ..."*

The Grande Ronde River, located fifteen to twenty miles west of Wallowa Valley, was the favorite trading place of the Nez Perce and emigrants traveling the Oregon Trail. Much of the trading that occurred at this point was oxen or cattle for horses. Horses at this point had traversed from the east and were thoroughbred and work horses, or Arabian decent which had been captured in raids upon the Spanish settlements of California. These would be the horses that were the start of the American Wild Horse herd. Archaeological evidence shows that there were no vast herds of horses roaming the United States until they were brought to the continent. There have been occasional skeletons found, but not enough to support the fallacy that these feral animals are part of American Heritage. The herds that multiply in protected bands throughout the United States evolved because their forebearers were either turned out, escaped, or were clever enough to avoid capture. In 2020 the cost to the American taxpayer is more than $50,000,000.00 with most of the expense being used to feed and care for unadopted and unsold wild horses and burros. This information available through the U.S. Department of the Interior, Bureau of Land Management Wild Horse Program data. Perhaps there should be consideration for the 'wild slave' or 'savage Indians' throughout the United States. What could be done with fifty million dollars to each one of these groups of American Heritage - annually?

It took some time for the Indians to learn about the horse and its assets. The debate goes on about the intelligence of an equine, but for those who have spent time with the animals it is known that just like people they are individuals. One that can run like the wind might be looney as a distracted hornet. Since their instinct is fight or flight, they can either kill you or scare you to death if you don't savvy them. Charlie Russell learned that from the second set of ponies he owned. (He traded his first set for this pair). In his book, "**Trails Plowed Under**" Charlie has a story about *"The Ghost Horse"*. Whether the Indian who traded horses with Charlie for Monty told Charlie the story, or Charlie made it

up after getting to know his silent partner, it's the horse tale that gives a clue to his education of the difference in white man's ponies and Indian horses. First there was all the hardware thought to be a necessity for the cowboy. A blanket or robe was all the Indian needed to stay aboard a horse. Then there was the mount. White man mounts on the nearside. Indians mount on the offside. Monty had been ridden enough that he accepted the tack with caution, but that step up into the left side stirrup was awkward. The main characters in Charlie's story are *"Grey Beard"* who pays *"Bad Wound"* a Piegan Indian, forty-five silver dollars for the Paint and gave him to *"the boy"*. *"It was days before he would allow the boy to mount from the near side"* is all Charlie had to say about that. He had to **work** to earn Monty's trust as he learned was a good trait no matter the subject. So, Monty began teaching *"the boy"* about survival in the west. Monty had a five-year jump on Charlie in the wild west, and he had been a good study before this young white boy mounted him. This may be an indication of Jake Hoovers' generosity in Charlie's reference to "Grey Beard" and the forty-five silver dollars paid the Piegans' for the pinto pony.

Horses were a valuable resource for centuries around the world, until grass became more valuable than the animal and other means of covering rough terrain came into being. The fact remains that Indians were mostly territorial. They did little fighting or traveling because for centuries they didn't have the horse. It appears that there was little – if any - disease among Indigenous Tribes as there has been no evidence presented that would indicate plagues or other maladies before the horse appeared with riders from other continents. Charlie says in his book, *"Since Cortez brought them"*. He was talking about horses and went off into a run-on wolf or wolves and likens the wolf's wanderlust to that of a horse. Both travel in bands and both seem to like to travel. Horses seem curious to see what's over the next ridge or where might the grass be greener when they are not fenced. Horses are opportunistic and when you fence them in or pen them up, they wait for an opportunity to break up the monotony. When fences came into play on the open range, cattle pretty much stayed located even if the gate was left open. Not the horse. They seem to be able to tell when the gatepost is released even if

they are at the end of a ten-mile-wide pasture. They come stampeding toward that open gate like flies to a cow pie. The homesteaders were not accustomed to fences or herds of cattle or horses. Thirty head of cows and fifteen head of horses was a big farm back east. They did not see a need to close the gate, especially if they were coming back the same way. It became a problem. The newspapers started putting in requests for people to "*close the gate*" in the early 1900's. There were all sorts of things to learn by every person and every beast. It wasn't easy and it was not all fun, but it's a lifestyle that hasn't changed a lot except for the horse. Most of his work is performance or companion these days.

All cowboys remember their first horse. They usually remember their first buck off too. Sometimes they were one and the same, but usually as a lightweight kid the cowboy, or cowgirl, got away with their first ride without incident. Con Price, Johnny Healy, and Matt Morgan all knew horses, and all said, "*gentle hosses is all right, but give me a snaky one for a hard ride.*" These three men picked horses to fit the task at hand.

In Ken Robison's edition of the "**Life and Death on the Upper Missouri: The Frontier Sketches of Johnny Healy**" there is many adventures of rides Johnny took leaving his fate on the back of the horse he was mounted. In section 7 titled "Beyond the Frontier Sketches", Ken relays stories of heroic rides made in epic time on well bred, thoroughbred, or a tough little horse, revealing his credit to his silent partner.

Con Price doesn't write about one "special" horse in his book "Memories of Old Montana" published by the Highland Press, but he pays attention to their actions and reactions. He does mention one named "*Tony*". What Con remembered about this horse was: "*he was a good walker*". Many cowboys found that a good walking horse could cover territory at a smooth walk as most horses would at a ruff trot. The rider had a better day on a "*good walker*". In his book, Con has a story about him and a friend riding over to impress a girl one time and Charlie Russell writes about the same incident in his book, "Trails Plowed Under" which can be found online in Project Gutenberg Australia. Cons' is a delightful story, but Charlie's slightly embellished version gives a hint of Charlie's personal sentiment at that time.

The story goes that Con Price and Ed Rosser are riding in the Sweet

Grass Hills gathering stray horses. Rosser spots a cabin in a valley below the ridge where they are riding.

Rosser: *"There's women in that shack,"*

Price: *"What makes you think so?"*

Rosser: *"I see washin' on the line there a few days ago an' all the he-folks we know, when they do any washin', use the creek an' hang their clothes on the willers. But to make my belief a cinch bet, there's garments on that line that ain't worn by no he-people."*

Price: *"Well, I guess you're right. I remember a few weeks ago that nester told me he had a wife an' daughter comin' out from the States".*

Rosser: *"Wonder what the gal looks like?"*

Price: *"She's a good looker, judgin' from the photograph the old man shows me."*

This led into an event that tickled Charlie Russell. Charlie has a good idea that: *"In the days when this happens, women 're scarce, an' the few cowpunchers an' old mountain men that lived in this womanless land sure liked to see a white woman an' hear her voice".*

Price and Rosser try to figure an excuse to visit the cabin. They would look silly asking for a drink of water because the Hills are full of springs and there is a creek flowing past the front porch of the cabin.

Con is riding a colt that's a little high spirited. He tells Rosser he is going stick a spur to the shoulder of his pony to get the horse to jump then Con would fall off and act like he is hurt. They ride to within fifty yards of the cabin and Con puts his spurs to his horses' shoulder. The assault to the unsuspecting horse from his rider puts the horse into bronc mode. He unloads Con with a hop and a twist leaving him on the ground eating dust. The horse lopes away with his tail in the air unhindered by the reins Con left tied to the saddle horn.

Both men keep looking at the cabin window to see if anyone has an eye on their charade. There is no sign of an audience. The horse had left Con in the air and jumped out from under him. Con's journey to the ground was not interrupted and he hit harder than he intended. Act one was over. Rosser is stunned and jumps from his horse and runs over to where Con lay. Con could hardly move and needed help getting up and getting to the cabin.

Rosser forgot about his horse and left him with his reins dragging. His horse starts after Cons' with its head held to the side so as not to step on his reins. As the two cowboys' mounts disappear over the ridge, Rosser helps Con up, and together they hobble to the doorstep of the cabin. They give a rap, but they don't hear any footsteps or activity from inside.

The latch string is out indicating there isn't anyone inside, but visitors are welcome to enter. Rosser and Price enter the cabin as Con is needing a shady spot to recover from his buck off. Upon entering the pair can tell "it's a woman's camp". There are curtains on the window and flowers growing in a recycled tomato can sitting on the table where the sun hits them. As Price and Rosser survey the interior of the cabin with garments strewn about, they determine there are two ladies camped, but no one is home.

Con began facing the fact that he was not going to get sympathy from anyone, and it was going to be a long walk home with Rosser jobbing him all the way. It would be a ten-mile ride on horseback, and further on foot because of creek crossings and taking the low road to avoid climbing hills. All of that being more difficult with boots and spurs.

The men take inventory of what is available to eat. *"They locate some bacon, real light-bread an' dried apple pie"*. When they finish *"their feed they wash the dishes an' start on their sorrowful journey. Con laughs about it now, but Rosser says he never even smiled the day he walked. Rosser say's Con had no license to kick. He'd fought hosses all his life and"* won *"most of the fights. That day he"* threw *"the fight to the hoss. The hoss double-crossed him."*

There's a couple of differences in Con's version and Charlie's recap reflecting these cowboy friend's personal interpretation of the same event. The scarcity of *"white women"* and the eagerness to just *"hear her talk"*. Charlie had left St. Louis without much of a chance to socialize. His parents were slightly helicopter parents attempting to *"teach"* their son according to their standards. He hadn't had a chance to talk to very many *"white women"* and when he rose to the rank of a cowboy, where womanizing was an expectation and not an exception, he obliged the fact so as not to disappoint his peers. Sign language is a means of

communicating, but even Charlie recognized that each tribe used this method of communication in a limited setting. When he tells about his 'less than a year' marriage to an Indian, he says "*they*" learned how to communicate well enough so they could have some good fights. Aside from that, she could not cook, and they generally did not work as a team. When he said he was done with the arrangement she held the teepee flap open and bid Charlie farewell. The winter of 1886 was miserable, but those winter months of his marriage to an Indian were the worst. That was the winter Charlie learned that you could work with an Indian pony, but an Indian woman was another matter.

Matt Morgan, born Matthias Herman Morgan June 5, 1889, grew up in the Sweet Grass Hills. His father, Thomas (Tom) Francis Morgan, was a cousin of Thomas Francis Meagher. His mother was Edith Brinkman. The same Edith Louise Brinkman whose Black Walnut piano top ended up in the horse barn at the Thomas P. Strode ranch on East Butte in Bear Gulch, the daughter of Herman Brinkman. Matt's stepfather, Sam DeYoung, had two children when he married Edith. Alice and Gordon DeYoung.

Matt married Kathrine A. Foote June 20, 1912 in Butte. Kathrine was teaching school in Butte. Matt had built on to the Tom Morgan cabin by Kathrine's design. They lived in the house until 1920 when Matt became Under Sheriff in Chester. In the spring of 1928 Matt was the Roundup Foreman for the Chappel Brothers, Inc. The brand was the CBC and it included the entire Black Foot Indian Reservation in Montana and several Indian Reservations in numerous states. The inventory was approximately sixty thousand wild range horses and two hundred saddle horses with twelve wranglers under Matt Morgan's charge. The Chappel Brothers Inc. had a horse meat packing plant in Rockford, Illinois where they processed horse meat for foreign trade. Later Matt became a Collector of Customs, Horse Roundup Foreman for Bureau of Animal Industry on the Black Foot Indian Reservation, and Brands and Livestock Inspector along the Montana-Canadian border. He wrote reports for all these authorities in addition to writing several magazine and newspaper articles. After leaving Montana he was sent to the southern border at Sasabe, Arizona where he retired. Matt

was a busy guy between 1906 and 1918 attempting to get livestock sorted between the countries. It wasn't unusual for him to put in 100 miles a day on horseback, and for those days he needed a horse that had the stamina and temperament to make the run.

Because of the reports Matt Morgan had to write for his work, his writing often leads to minute specificity to the task at hand. As in his telling of a young, black, unbranded horse he encountered one day while riding a *"good filly chaser"* which translates to an *"Old Saddle Type, partly broke gelding that needed a lot of riding"*. This was the *"kind of horse"* Matt *"liked to be mounted on to chase wild horses"*. He was riding in the Eagle Creek area working for Ed Trommer. Eagle Creek heads in the Bears Paw Mountains and flows south entering the Missouri below Virgelle. In the days of open range, horses traveled hundreds of miles and the only means of identifying who owned the horse was by brands. This is one of the reasons the night herder for the horse herd during roundups in the fall was such an important job. In a cattle stampede cows would run short distances and if the herd broke up it was in small bunches in draws, then they would settle. Horses would scatter all directions and continued moving when they stopped running. They were put in a remuda with strange horses, they didn't locate. There wasn't a lead horse as with one stallion with a '*band*' of mares. Roundup remuda's were all broke cow horses, usually geldings, and losing any would leave the wranglers short of horsepower to get their job done. One reason the cowboy preferred geldings on a roundup is because a mare in the bunch would create havoc.

Dan Sullivan was one of Toole County's first pioneers. He married Louisa Jane Ranney in 1874 in Townsend and the family homesteaded 15 miles southwest of Shelby on the Marias River bottom in 1885. Dan and Jane had eleven children, seven survived and worked in the Hotel and Restaurant in Shelby or on the ranch working livestock. His sons, Fred, Flurry, and Mike were known as excellent horsemen as Sullivan's horses were a mixed bunch of saddle and work horses that were usually left until they were six years old before they were handled. Six years of open range made them wild, mature, and rank. Dan Sullivan was more of an entrepreneur than stockmen. He realized when he arrived on the

Marias that the farmers were going to need work horses and stockmen were going to need riding horses. He invested in a bank and started financing horses for the homesteaders building up a large herd that ranged from the Rocky Mountain Front to Havre and Lethbridge to the Marias. Flurry, Fred, and Mike would wrangle and break or train the horses as needed for their own use and for sale and the mares and stallions ran the open range. Every other year the Sullivan boys would round up as many of their branded horses, and any horses running with them, they could find. They would castrate the stud colts and brand everything that wasn't wearing a brand in the corrals. Taxes paid on all livestock in the days of open range was done on an estimated number of cattle, horses, and / or sheep, minus estimated losses and expenses. Since the area in central Montana on the northern border was the last to be surveyed, surveys of homesteads and ranches wasn't complete until the early 1900's. Open range meant tax free use of the land.

The following report was taken from the River Press of Fort Benton, 1901: *"J.M. Conway has returned from a trip to the western end of the state where he bought another shipment of horses, which he will sell on contract to the British Government for cavalry service in the South African campaign,* says the Billings Times.

Several Billings citizens are said to be making a small sized fortune out of their contracts. About 4,000 head of horses have been turned over to British representatives who have visited this city. Nearly all of the animals were shipped into Billings, coming from western Montana and Washington.

British purchasing agents report that they have purchased over 115,000 mules and horses in this country for shipment to South Africa, at a cost of some $15,000,000.00. Without wishing any harm to the Boers, the average owner of American horses and mules hopes for a continuance of pleasant business relations with the British government."

In 1906 Matt Morgan was working for an outfit called the Ace of Spades. The Ace of Spades was the front name of a large conglomerate based in Aurora, Illinois. Homesteaders were starting to leave Montana and sell their land, livestock, and brands. Matt did not know who he was working for, he only knew they wanted him to wrangle as many horses for the Lazy B hanging A brand as he could locate. This brand

had belonged to homesteaders who had left the area and sold the brand making the Ace of Spades the owners of any livestock wearing the brand. The Ace of Spades were the Chappel Brothers. They exported horse meat to foreign countries when they first started in business then expanded into the first canned dog food company in the United States. When World War I broke out the demand for the meat soared and their business doubled in size. By 1923 the business had moved to Rockford, Illinois where the brothers began marketing Ken-L-Ration dog food using the movie industry's star canine Rin Tin Tin as their marketing symbol. The Chappel's had to do a bit of politicking to transport their '*meat*' across State lines. Early in their marketing there was an outcry from the American people for selling '*horse*' meat for '*dog*' food. In 1928 the Chappel Brothers formed a new corporation called C.B.C. in Miles City, Montana. They leased a million and a half acres of rangeland in Wyoming and Montana. They had a ranch crew that rounded up horses and shipped them by train to Rockford. Many cattle ranchers welcomed the C.B.C. for culling the range horses. Range horses had become direct competition with beef cattle. Horses eat about ten times more than a cow does and even though the open range was being fenced there were enough unclaimed and unbranded horses running free to cause substantial damage to grasslands.

This time Matt was looking for horses wearing a Canadian brand. Lazy B hanging A horses should have been north of the railroad tracks and west of what is now Interstate 15. Matt met Flurry Sullivan driving a small bunch of saddle horses on the prairie near Dunkirk. Flurry told Matt he was looking for the Embleton Horse roundup camp. The Embleton's of Teton River near Fort Benton were quite a large horse outfit. Horses that normally were south of the railroad tracks had been run north of the railroad tracks by Horse Thieves. Flurry and Matt had seen some Canadian branded horses running with the small numbers of horses the two of them had seen in the two days they had been wrangling. This was an unusual situation as normally they would have come across large herds of the brands they were looking for. The two of them talked it over to come up with a plan to get a years' worth of work done in a couple of months. There weren't a lot of fences up yet, but at

the same time there were not many corrals big enough and tuff enough to hold the big herds of wild horses. Matt and Flurry decided to see if they could locate enough horse wranglers to cover a large quadrant of the State and Canada to corral and sort as many horses as they could to get an inventory.

Ad Day horses were mixed in with the herd that Flurry was trailing. Ad Day was from Medicine Hat, Canada: one of the partners in the Knight and Day rodeo stock business. Matt and Flurry had an indication that horses not usually running on the Marias range were going to be scattered throughout the area from the Rocky Mountain Front to Malta and from Lethbridge to the Marias and Missouri River. Flurry Sullivan figured he could get his brothers and a few more wranglers that he knew to work the south west range. This would be the range from the railroad tracks to Sun River south of Chester and west to the Rocky Mountain front. The Embleton Horse Outfit was working range horses north of the railroad tracks into Canada and east to Malta and west to the Sweet Grass Hills. Matt thought he would find most of the horses he was looking for in the northwest quadrant. This would include the Sweet Grass Hills into Canada as far north as Lethbridge and west to the Rocky Mountain Front then south to the railroad tracks.

The "Block" brand camp northwest of Galata was about fifteen miles from where Matt Morgan and Flurry Sullivan had met that day. Gilbert Embleton owned the block brand. The two men decided to see if Embleton and his men would agree to work together with Matt and Flurry. This would give them a central camp with good corrals to sort horses once they were gathered. Flurry and Matt took Flurry's small band of horses to a ranch north west of Galata. Embleton agreed to help with the round up and volunteered to be wagon boss. The next morning Matt headed to the Sweet Grass Hills to see about getting some of the ranchers who had ridden the range and were familiar with the brands in the quadrant he was heading up. Embleton set up camp while Flurry Sullivan went to town after grub. Matt got Con Price, Charlie Russell, Peter Wagner, Ed Trommer, Harvey Price, and the Carroll Brothers of Alum Coulee to help. Pete Wagner offered up a steer which was butchered so the camp had plenty of beef and biscuits

341

to keep them working. The Tingley brothers from Big Sandy, Jack Edwards, Bill Farrell, Orville Meranda and Bob Stirling had joined in the roundup covering the southeast quarter. That would cover the Bears Paw, Little Rockies, and Belt Mountains east to where Fort Peck Lake forms the Charles M. Russell National Wildlife Range, west to the railroad tracks from Havre to Great Falls and south of the Great Northern Hi-line track. The cowboys all gathered at Embleton's to pool their horses for wrangling.

The next morning Flurry ropes Matt a big bay gelding and tells Matt, *"If you can get away on him without him kicking or striking you, then keep him from bucking, he will carry you as long as any horse alive."* This remark coming from Flurry Sullivan meant that this was a real ridge runner - but **mean**. They headed out to ride about 125 miles in each direction with their assigned group covering about 15,625 square miles. The area they were riding was river breaks, hills, coulees, and some mountains. They would bring the horses into the best set of corrals located within their area then sort some brands and at the end of three days take them to their main camp and sort them again. Any no brands or horses that were not wanted were sold and the money was distributed to the homesteaders and business's that served food in the area where the horses had been running. Matt Morgan took a pass through the Marias River valley checking on a homestead that had a good set of corrals to see if it was still in good enough conditions to hold wild horses. He caught a glimpse of a black horse with a band of mares wearing the Canadian brand he was looking for. He chased the bunch for a while, but the lead black horse was too crafty. Checking on the abandoned homestead corrals, he met a friend who agreed to help him get the small band in the next day. That bay horse Flurry Sullivan had given Matt to ride that morning was everything Flurry said he was and was not showing any signs of fatigue. At the end of round-up Matt found out the horses name was 'Old Jiggers'. He saddled 'Old Jiggers' the following morning and went looking for the herd of mares the black horse was running with. His friend met him about halfway between his place and the corrals where they were planning to take the bunch. He took 'Old Jiggers' for a run at the herd and with help got them corralled.

The black wasn't just a good looker, he was smart too, but he was so full of hate his eyes were red with fury. He came at Matt with hooves flying, but Matt got a rope on him and tied up three legs. He pulled his tail, castrated, and branded him with the Lazy B hanging A and let him go. He figured he would pick the bunch up toward the end of the round up. He needed to head north to get with the rest of his wranglers and see what horses they could collect in their quadrant.

The cowboys got their round-up done and horses sorted and shipped. Any no brands or unclaimed horses were sold, and the money was distributed to the homesteaders and business's that served food in the area where the horses had been running. Matt Morgan did not see the black horse and the band of Canadian mares for several years. He was riding along the Marias River and caught a glimpse of the band wearing the Lazy B hanging A. Matt was still working for the Ace of Spades, but they were just one of the brands he rode for. He was wrangling and breaking any geldings he found and turning them over to their owners. At daylight one morning he waited at Cockrell Spring for the herd the black was in to come for water. The band came to the spring and Matt could see this was the same black colt he had handled years before. He looked like he had not had a hand on him and had only gotten older and meaner. He managed to get the horses corralled by himself and sorted the black from the rest of the herd. The black came at him again with his teeth barred and hooves flying. Matt got a rope on him and took him to the ground. Matt gave the horse a name this time. He called him '**Darky**'. He tied **Darky** up and "*trimmed his tail then put a hackamore on his head and rolled him into his F.A. Meanea, 14-P. double rig saddle and cinched him up good and tight as he lay on the ground*".

F.A. Meanea Saddlery began in the Gallatin & Gallup Saddlery in Cheyenne, Wyoming in 1867. Frank Meanea was the nephew of E.L. Gallatin. Gallatin joined his nephew in Cheyenne after selling his interest in the Denver Colorado Saddlery to Francis Gallup. The double rig is a front and rear cinch used by any cowboy who had occasion to use a rope. It keeps the back of the saddle from flipping up when the rope is dallied to the saddle horn.

*"Then I went to the corral, opened the outside gate wide, went back to where **Darky** lay, untied his feet and as he got onto his feet, I got up with him. For about a second, just sitting there on top of that beautiful big Black horse my thoughts were 'I am mounted on the greatest piece of horse flesh in this country.' Then – **Darky** started bucking. He bucked through the gate and out onto the big river bottom. Sure was a wicked bucking big wild horse and when I rode him back through that old corral gate again I was a very hungry boy for the sun was high in the sky, but **Darky** had been started on the way to being a broke saddle horse."*

Matt spent a summer camped on **Darky** and never lost his admiration of the horseflesh that he was. He never lost his hope that somehow the horse would learn a small amount of trust, but that never happened. Matt Morgan saw the Ace of Spades traders sell him as "a good horse to use to chase wild horses on, and that if he happened to be run to death on some wild chase, they figured that they had no loss". Matt wished for years after **Darky** that someone, even if it had not been him, would have worked with the horse when he was young. He had ridden a lot of spoiled horses, but **Darky** wasn't spoiled. He just had not met a human he felt he could trust.

In the spring of 1928 C.B.C. hired Matt Morgan as their Rep. By this time Matt knew who he was working for, but times were changing and wranglers who specialized in horses were becoming scarce. Property was fenced and motorized vehicles were becoming commonplace. There were still a lot of horses, but fewer wranglers and the open range where they roamed was usually marginal use land. At the peak of its production, Chappel packing plant had 600 employees.

One more horse tale by Matt Morgan; *"Tingleys had a wild bay Thoroughbred gelding on the range north of Lonesome Prairie Lake. He was about ten years old and had not been in any corral since he was a two-year-old. He was a bunch quitter, plenty big, very fast, smart, and knew his country. I took Mr. Wild Horse to the herd gathered and he ran right through the entire herd. He had a tail that dragged the ground and his mane hung below his knees and was all badly tangled up."* (Keep in mind, Matt Morgan was the man who pulled, or as he called it, trimmed his horse's tails before he ever got on them).

That night Matt was riding night herd and the horses broke and ran. Matt and William Vielleaux got them turned and settled and headed back toward camp. On the way back to camp in the dark his *"horse started acting spooked and kept gazing away into the darkness snorting right about the spot where the herd had spooked earlier."* Matt decided to take a closer look in the direction his horse's ears were pointing. There, tangled in his mane and tail, Tingley's Thoroughbred gelding lay on the ground. He must have been scratching his neck with his hind foot and got his hind foot hung up in that long mane then struggled and got his tail caught in the rest of the mess. Matt cut him loose by cutting one end of his mane off up close to the top of his neck. If Matt hadn't found him, he would have died there. As it was, he would fall when he tried to travel for a while, but he popped out of it after a few hours and took his place in the horse herd happy to be standing on his own four legs. The wild was all gone out of him that night. He had been tied tighter than a person could have tied him, and he did it himself. Recanting that story to fellow horse wranglers, Matt found out that a few of the other men had had similar experiences, but they didn't believe anyone would believe them, so they never told the tale of the horse's tail.

Horses were a big part of the cowboy life, in fact, the cowboy's life was often in the horses charge back in the day before motor vehicles and two-way radios. One of the first thing a person learns about a horse once they start spending time with them is that they will always take you home or to the last place they were fed oats. John Healy tells tales of *"falling asleep"* while his horse carries him down the trail. In his book **"The Way I Heard It"** Mike Rowe talks about Alan Hale Jr. at the beginning of his acting career. Hale was still working as a cowboy and he had an audition to get to but was running late with his ranch chores. He rode his horse to the highway and hitch-hiked a ride to Los Angeles. He just stepped off his horse and tied the reins to the saddle horn and swatted the horse in the butt to send him back in the direction of the stables. Mike says that was one thing he learned about horses: *"they always know where the stable is, especially around dinnertime."* Many lives were saved in the days of horses and buggies, by a horse's ability to head for home, or at least the nearest shelter, in blinding snow and

other adverse conditions when the person holding the reins could either no longer see or was unable to guide the horse. One such horse use to roam the streets of Great Falls shortly after WWI began.

It might be said that Charlie and Nancy Russell had a small part in this story because they brought Albert (Bert) Furnell and Edna (Babe) Ellis together for the first time at dinner in Charlie's log Cabin studio after he got it finished. Bert wasn't surprised to get an invitation from Nancy and Charlie for dinner because he grew up knowing Charlie, and Bert's mother, Della, had become good friends after Bert's father died. His sister, Florence was a good friend of Nancy's too. Nancy filled the sweet spot in the age spread between mother and daughter. A position greatly appreciated by all three ladies.

Charlie and Nancy Russell had been married for around 3 years when Con and Claudia married. Charlie had been busy in Great Falls settling he and his bride in a home and then working on his log cabin studio. Matt Furnell had fallen ill and died four months before the Russell's married in 1896 and Della Furnell went through the first estate dispute in the State of Montana shortly after Matt's death. Della and Nancy had met through the friendship of their respective husbands and when Matt Furnell died, Nancy became close with Della. Both ladies were in need of a close friend and their proximity of homes in Great Falls enabled them to be within walking distance of each other. It is difficult to say whether Della Furnell needed Nancy Russell more or the other way around in 1897 when the estate case was settled. Della had been unable to do much with and for her children. George (Ray) had a fainting spell the night after his father died and Della had sent him to Michigan to a sanitarium in hopes of finding a treatment as the doctors in Great Falls were unable to diagnose the problem. George Ray Furnell returned from Michigan with a diagnosis of Juvenile Diabetes and the day after he came back from Michigan Della enrolled her three children in Confirmation class at the Episcopalian Church. School was about to begin, and Ray seemed to be well enough to attend regular classes.

Albert (Bert) did not like school and was not fond of being in Great Falls. He wanted to remain on the ranch in Sun River. He had his aunt and uncle, the Ford's, and his cousins next door to help him maintain

the livestock. Sun River did have a school a few months in the fall so Bert attended classes at school in Sun River when they were offered. Bert's uncle, Lee, like to collect arrowheads and other Indian artifacts and buffalo skulls. The postmaster in Sun River, John J. Ellis, had relatives and friends in the Sweet Grass Hills and Lee would take 'the boys' with him on artifact excursions when they had the opportunity. There were always horses to round up and cattle to herd along the way and the ranches made space for overnighters, glad to have the help and the company. One of the ranches Lee frequented was Peter Wagner's. This is the ranch Con Price went to work for after Charlie got married and before Con married Claudia.

Florence had spent the summer at the ranch in Sun River and found a few friends in Sun River. She also found some joy in playing with the ranch animals but was delighted to go back home to Great Falls where she could attend school with her friends that fall. Nancy Russell had met Della and the Furnell family before Matt had died. Della and her sister Kate were welcoming and interested in Nancy because of their husband's friendship with Charlie. The timing for these ladies to meet was virtuous. Nancy knew little of the kind of life Della had led and Della needed a friend who was not needful and who could help her with her teenage daughter's hormonal blender.

For her 18 years, Nancy had learned about arduous work and great loss. She was just beginning to learn about great love and true friendships. Della had all the poise and elegance of sodality. Nancy had the initiative and fortitude to help Della with household chores while engaging with her debutante daughter. With Bert wanting to stay at the ranch in Sun River that fall, Della offered Nancy Russell Bert's place in the confirmation class opening she had enrolled her three children in. There was an opportunity for Nancy to belong to a sect and learn the orthodox standard with a mixed group of people who would not judge. Sadly, Ray fell into another coma the day following his last Confirmation class. Della kept Ray at home, but he didn't fully recover and spent the rest of his life in intermittent coma's and bedrest with very little interaction with the schoolmates until his passing May 13, 1903, seven years after his father's death. He was 19 years young. In addition

to her grief, Della again had an estate to settle. A mention that "Mr. and Mrs. J.H. Irwin moved into the Furnell house at 1517 Third Avenue North" was in the April 1904 Great Falls Tribune.

After the court heard the appellant case of the inheritance law argument on the probated Will of Matthew Furnell July 19, 1897, the court reversed their decision on the Inheritance Tax Law November 15, 1897:

51P.267 (Mont. 1897) Gelsthorpe vs. Furnell

*"The last Legislative assembly passed an act establishing an inheritance tax on all property which should pass by will or by interstate laws; the law also provided that the tax should be levied "**upon all estates which have been probated before, and shall be distributed after the passage and taking effect of this act**." All estates of less value than $7,500.00 were exempted from tax."*

Witnesses' at this action were Barbara E. Dunn and Gowan Ferguson.

When Della Furnell was put through these court actions, Lee Ford started branding his cattle with Kate Ford's brand. All the Ford ladies were given brands for livestock in 1886. Some of Furnell's friends, Cornelia Bull (Sr.) registered brands for his wife and Henry Wiegand added his wife and daughters' brand to his livestock markings. Kate Ford's brother-in-law added his wife and daughter's brands for horses and cattle at that time.

EB — Mrs. Cornelia Bull (SR)
c - L H

F — Mrs. N. Ford
c - L H

ᴜ — Mrs. Kate Ford
c - L S

W — Anna D. Ford
c - L S

Wⁿ — Lena Wiegand
c - L R, h - L T

W — Mrs. N. Ford
h - L T

CW — Caroline Wiegand
c - L H, h - L H

Ray's death caused Della to go through another estate case. Della Furnell remained active in the Episcopal Women's Home Missionary Society and supported her daughter's social life, but she closed her circle of friends to include her family and fellow Church members which include the Conrad's as W.G. Conrad was instrumental in the purchase of property and construction of the Episcopal Church building in Great Falls. With one sister being married to H.W. Stringfellow in Havre and another being married to Lee Ford in Sun River, her family was extensive. Her sister, Za, joined her sisters in Great Falls marrying Wallace Porter from Nova Scotia. Wallace A. Porter's brothers were commissioned to build the 10th Street Bridge in Great Falls in 1920. Wallace and Za had a homestead claim in the Hills where they ranched, and Wallace taught school in Gold Butte. One of his brothers had a stone and brick business in Sand Coulee, Jones & Porter Stone. King & Company Brick of Sand Coulee were cousins of the Porters. Thomas Strode's half-sister was married to a King who settled north of the Sweet Grass Hills in Canada. The Department of Transportation (DOT) set up camps near bridge constructions when they built Interstate 15. One of the larger camps was between Helena and Butte. The younger generation of Jones, Porter, and King went to work for the DOT and later settled in the Helena and Butte / Anaconda area.

Della remained active in the Great Falls community as she dealt with her grief and financial affairs. Her sisters visited often, and Della appreciated Nancy Russell's help with housekeeping, friendship, and bridge to the social gap that was widening between Della and her daughter. Nancy and Della worked together in WWI efforts through the Women's Division of the United World War Work. Nancy suffered bouts of depression. Shortly after WW I ended, Nancy Russell took the train to Minneapolis, Minnesota where she stayed at the home of Granville and Margaret Bennett, an Episcopal minister, and his wife. Charlie wrote Nancy frequently letting her know how much he missed her but reassured her he understood she needed the rest. (February 9, 1919)

Florence Furnell was frequently mentioned in the society page of the Great Falls newspapers. The March 21, 1901 edition reported she "*rode*

in a float in a parade" with *"Olive Ellis and Rachel Couch".* November 30, 1906 *"Florence Furnell, Miss Lina Cooper, Miss Louisa Leslie, Miss Edith Dunn and Miss Gretchen Stanford also served refreshments"* at the reception of Miss Ella B. Downing and Mr. Carroll B. McCulloh. *"Miss Josephine Conrad played the piano"* and *"Mrs. Evans and Mrs. Crowfoot served Punch."* The groom was Havre City Engineer, and the ceremony took place at the Episcopal Church in Great Falls with the reception taking place at the home of the bride's parents, 219 Third Avenue North.

The Havre Herald reported October 25, 1907: *"Miss Marguritte Wright went to Great Falls last evening, where she will be the guest of Miss Florence Furnell. Mrs. J.A. Wright and mother, Mrs. J.A. Sutherland, have returned from an extended visit and trip to California".* In the same edition is was reported *"**Brother Van returns from east ...**"* *" ...he attended the annual convention of the Women's Home Missionary society ... The general missionary committee of the Methodist Episcopal Church which met in Buffalo New York ..."*

Florence Furnell had her wedding the evening of June 15, 1910 with the ceremony and reception both held at the Furnell home, 1517 Third Avenue North, Great Falls. Her brother, Albert Matthew Furnell, walked her down the aisle to her waiting groom, Carlos Eugene Kumpe. The groom had taken confirmation classes with Florence and Ray Furnell, and Nancy Cooper Russell commencing in May of 1897. The Great Falls Tribune reported; *"to the trains of the Lohengrin wedding march, the bridal party entered the parlor, led by two little flower girls, Rachael Ford and Elizabeth Ann Irwin, who were daintily gowned in white and carried baskets of flowers. The bride and groom were met at a white altar by the Reverend J.L. Christler of the Havre Episcopal church, who performed the ceremony in the presence of 30 guests.*

During the ceremony Mrs. Lee M. Ford sang very sweetly "O Promise Me." The bride was a lovely picture in a gown of white liberty satin and carrying bride roses. She was attended by Miss Elizabeth Vaughn and Mr. Martin Kumpe, brother of the groom, acted as best. The ceremony was followed by a reception from 9 until 10, for a large number of friends of the young couple. Those receiving with Mr. and Mrs. Kumpe were Mrs.

Della Furnell, Mrs. Kumpe, Mr. and Mrs. McDonald, Mrs. Smith, Mrs. Porter, and Miss Vaughn. The groom's gift to the bride was a diamond and pearl necklace. Later Mr. and Mrs. Kumpe left for a wedding trip and upon their return will reside in Helena where the groom is stationed as state bank examiner. Both young people are well and favorably known here and have lived in Great Falls the greater part of their lives. The bride is one of the most popular society girls in the city and both young people have the best wishes of a host of friends. Those who witnessed the ceremony were Mr. and Mrs. Roy Clary, Dr. and Mrs. Irwin and family, Dr. and Mrs. Fergason, Mr. and Mrs. B.B. Kelly, Mr. and Mrs. McDonald, White Sulphur Springs. Mr. and Mrs. Lee M. Ford and daughter, R.S. Ford family, Mr. Robert Vaughn and Miss Vaughn, Mrs. J. J. Ellis, and Miss Ellis, Mrs. Porter and daughter, Miss Genevieve, Miss Jennie Porter, Mrs. Murray, Miss Grace Barrett, Mrs. Kumpe, Mrs. Furnell, Mr. Bert Furnell and Mr. Martin Kumpe."

Miss Ella B. Downing, Lena Cooper, Louisa Leslie, Edith Dunn, Gretchen Stanford, Olive Ellis, Rachel Couch, Elizabeth Vaughn, and Florence Furnell were among *"the most popular young society women in Great Falls"* at the turn of the century. Missing mention in many of the society events was Miss Minnie Conrad, daughter of Mr. and Mrs. W.G. Conrad. Minnie was selected by Governor J.K. Toole to christen the cruiser Montana in 1906. The Secretary of the Navy desired the Governor of Montana to select a person from the State to christen the ship built by Newport Shipbuilding launched December 15, 1906.

Charlie Russell and Bert Furnell always had stories to share. Bert rather looked forward to his trips to Great Falls so he could visit some of his Sun River friends and relatives. Since he was in Great Falls for his sisters' wedding, Charlie and Nancy invited him to dinner. The Russell's didn't have a reason to tell Bert they had also invited young Edna Ellis when Bert was extended the invitation. Their plan to play cupid for this young couple, just as the Roberts had for them, was equally successful. Albert (Bert) Furnell and Edna (Babe) Ellis were married May 21, 1914 in the Methodist Church, Whitlash. It was not the lavish ceremony that Bert's sister Florence enjoyed, but it was equally joyous and Edna's mother, Effie, played piano at both weddings. The

couple moved to Great Falls, then to Augusta, then to the Ellis ranch in the Sweet Grass Hills and lived their lives together raising their two children on the ranch where Babe grew up.

Their four years in Great Falls during World War I, Bert and Babe Furnell owned the Elephant Livery Stables, also known as Great Falls Stables, a subsidiary of Bailey and Dupree. Bert had trained one of his horses to go to the Furnell house when the horse was turned out in the city street. After Bert and Edna were married, the horse would answer Edna's beck and call and she would either harness and hitch, or saddle the horse and use it to do whatever chores she had to do around town, go home, feed him some oats and turn him loose. He would go back to the Stable unattended. He was a white horse named Richard and the folks around Great Falls came to know him well. It was impossible to distract him from his destination. The lure for Richard was the 'oats' at each end of the trip. The other horses at the stable were only fed oats once a day. Richard eventually was taken to the ranch in the Sweet Grass Hills and performed the same task between home and school when Matthew and Frances Furnell, Bert, and Babe's children, attended grade school in Whitlash. Richard lived to be 30 years old, which is 'old' for a horse. He did not come for oats one morning and Frances went to look for him. She found him tangled in barbed wire wrapped around his hooves. He had bled to death in the pasture. This incident is another example of why the ranchers were opposed to barbed wire.

Frances Elizabeth Furnell was born July 25, 1915. Her brother, Matthew Murray Furnell was born December 29, 1916. These two grandchildren lived with their grandmother in Great Falls as toddlers. Neither of them remembered very much about Grandma Della, except that she cleaned her closets a lot and whenever she was in a discussion that did not suit her, she would say: "Oh Whim wham". End of discussion. She did, however, believe she had the prettiest granddaughter in the world, and Buttrey's Department Store, the largest department store in Great Falls at that time, had an annual "Beautiful Baby" contest. The store displayed framed photos of all the babies entered in the contest in the windows and the public would vote on the most 'beautiful baby". Frances won the contest somewhere around 1916 – 1917. A feather in

Della's cap. Della needed the distraction of her granddaughter. Her son-in-law, Carlos E. Kumpe died October 1, 1917 of pneumonia. He was 37 years old. Florence and Carlos son, Carlos Kumpe Jr. was four years old when his father died. Carlos is buried in the Masonic section of White Sulfur Springs cemetery. Florence Kumpe died in 1984 in California and is also buried in the White Sulfur Springs cemetery.

Carlos Kumpe was survived by his wife, Florence, and son, Carlos, his mother, two brothers, one a captain in the regular army and a sister, Mrs. Fred McDonald of White Sulphur Springs. Mr. Kumpe was a member of the Masonic order. He belonged to the blue lodge and commandery at Great Falls and to the Algeria temple of Shriners in Helena. He also was a member of the Elks' lodge. He displayed keen interest in the work of the Helena Rifle club with which he was connected. During his residence in Butte he belonged to the Rocky Mountain Rifle club, twice world champions. Mr. Kumpe was a crack shot.

At one time Mr. Kumpe was superintendent of banks of Montana. He resigned this position to become vice president of the States Savings bank of Butte in 1912 and was connected with the bank until its failure a year or so later. Case study of the Gilman State Bank failure (1910-1923) written by Jeffrey L. Cunniff for his B.A from the University of Montana in 1970 can be found in the University of Montana files. The paper was approved by K. Ross Toole, Chairman of the Board of Examiners dated December 15, 1971. At the time of Carlos Kumpe's death he oversaw the Conrad estate having been employed by the Conrad banking interests in Great Falls prior to the time he became superintendent of banks.

Florence Furnell Kumpe's niece, Frances, never married and lived most of her life in the Sweet Grass Hills. She loved the outdoors and did not care for housekeeping or cooking chores. She loved riding and training horses, although she didn't have many. One of her horses she trained to kneel so she could easily mount. The reasons she thought of training her horse this trick is that she didn't have a saddle and used a blanket like the Indians to keep her legs from getting sweaty from the horses back. She finally saved up $48.00 and bought herself a saddle at Gold Butte.

Frances and her mother, Babe, milked cows and managed the stock cows during the seasons the men were farming. One time a cow pinned Frances against the wall when she was getting ready to milk her. Her mother saw what was happening and was able to get the cow distracted so Frances wasn't hurt. Another time Frances was taking some cream to the neighbors in a container strapped to her horse. When she arrived and delivered the cream it had all turned to butter. Frances also remembered when she was home alone one day and an Indian came to the house and rummaged through the kitchen looking for something, but Frances did not know what. She finally began setting flour, sugar, baking powder, and salt on the table. The Indian produced a small container and took some of the baking powder and smiled, bowed, and left. As a young girl she was sure she would be scalped, but all he wanted was baking powder.

Matthew Murray Furnell grew up on the ranch his grandad Ellis had settled. His personality favored the Furnell side of the family. He was quiet and polite and a good hand around livestock. Matt married Fey Davis in 1961 and they had three children: Antone Matthew born in 1967 and two daughters, Dorinda Ruth, and Jennifer. Matt and Fey's divorce was final December 24, 1978 and the families moved from the ranch. Frances said Fey took the $48.00 saddle with her when she left the Sweet Grass Hills.

Horse tales weave through the settling of the west in story and song. "She'll be riding six white horses when she comes" rings a line in "**She'll be Comin Round the Mountain**." Music and art are influential creative accomplishments that carried what appeared as anachronistic days into moments in time that changed lives forever. The breathtaking sunrises and sunsets. The rattlesnake that lay a strike away as a child fetched a bucket of water from the creek. The runaway pickup heading straight for a son or grandson as the old man watched from the top of the hill holding down his hat because the wind was so strong you couldn't hear the shouts of warning. That horse that is gone now but carried you over countless miles of wonder where no one had been before. In his book "**Originals – How Non-Conformists Move the World**", Adam Grant has a chart on Artistic hobbies and the

odds for Nobel Prize winners relative to typical scientists. The chances increase 2 times with music; playing an instrument, composing, or conducting. Arts: drawing, painting, printmaking, and sculpting increase the odds by 7 times. Crafts; woodworking, mechanics, electronics, glassblowing – 7.5 X greater. Writing: poetry, plays, novels, short stories, essays, or books. – 12 X greater. Performing; amateur actor, dancer, magician – 22 times greater. What are the odds of many of the cowboys and women of the west being pure genius? Many did all these things, and all did something. No matter the weather or mood, they participated. Even better, they left traces of what was. How they loved to make merry, share stories and quiet time, and work. They all worked, but the times remembered and shared were usually events where they worked as a group and accomplished remarkable things. Like the roundups, barn raisings, dances, and church. Any 'event' was never ordinary.

Songs of the past reflect the cowboys lament of not being able to conquer a bronc or a horse of a distinct color. "**Strawberry Roan**", "**Tennessee Stud**", "**Potonio**", "**Zebra Dunn**", "**Old Red**", and "**Little Joe the Wrangler**" are but a few of the ballads about horses. Yearnings for a way of life that appeared less stressful in "**Give Me A Home Where the Buffalo Roam**", "**Don't Fence Me In**", "**Buffalo Gals**", "**Dear Hearts and Gentle People**". And yet in reality as a people we have consistently moved away from those days. Can you imagine a nine-year-old girl teaching a thousand-pound horse how to kneel so she could put her blanket on its back and get on? That is more than innovation. It is brave, difficult, and fascinating that relationships develop between beings who share space and time.

For the first time in history, the United States asked its population to "*stay home*" or "*self-quarantine*" in 2020. It will be interesting to see in future the stories and books that come out of this experience for so many. Wini Barnett, a young lady born in 1926 to Edmund Edwin and Louisa Rachael Stott Allen, a resident at Marias Heritage Center when the pandemic was exposed and identified in Montana, said life didn't change much for her. Though she missed eating meals and occasional visits with the other residents, keeping her mind busy spending time

alone is a skill she has had since childhood. It was always her problem to "*keep busy*". When she was young there were plenty of chores to do, but she and her sisters enjoyed socializing with the people who came into their store to get mail, eat, or purchase goods. Wini says she and her sisters picnicked on East Butte near her grandparents' homestead, danced at the Community Hall after it was built in Whitlash. In Gold Butte or private homes before the hall was built. Her Grandpa Stott played several instruments by ear as he did not have sheet music. She and her sisters took piano lessons from Elsie Demarest, but she was not enthusiastic about learning to play an instrument. She sang. She said: "*I don't know if we were any good, but we sang.*"

Wini's mother, Louisa Allen Anderson's parents, Nettie Addie Alvord and Lester Allen Stott were both born in the United States. Nettie was born in Shurburn, Minnesota February 10, 1872. Lester Stott was born October 9, 1862 in Wisconsin. The couple married in Ceylon, Minnesota February 10, 1900 where Nettie was living at that time. Lester was a traveling Hawker (salesman or peddler) and musician. The couple met in Chicago at The **World's Columbian Exposition** in 1893. Lester was preforming and selling musical instruments. President Grover Cleveland pressed the button to signal the opening of the exposition commemorating the 400th anniversary of Columbus' landfall in '*the New World*'. The Stott family emigrated to South Dakota, traveling by wagon train in 1895. In 1902 the Stott's moved to the Sweet Grass Hills. Their homestead was located east of Hiram and Sarah Smith's ranch. They had a small band of goats that were wiped out by a band of coyotes or wolves and the Stott family moved to Whitlash. Louisa lived her entire life in Whitlash, Montana.

Edmund Edwin (Ted) Allen married Louisa Rachael Stott November 29, 1923. Her first two children, Evelyn Dorothy and Winifred Anne, were delivered with the help of Amelia Demarest providing the service of midwife, although she did not have formal training. Amelia Brown Demarest assisted the delivery of several babies in the Sweet Grass Hills. The requirements were a willingness to assist the labor, availability, and sufficient bedding to accommodate

a safe and sanitary delivery for mother and child. Amelia Demarest always had lots of linens. Evelyn was born January 24, 1925 and Wini was born September 10, 1926. When Wini was born the Doctor was called but did not arrive until twenty minutes after the baby had been delivered. In the spring of 1918 Ted Allen began construction on the home, post office, boarding house, library, and store building that would be Louisa's lifetime home. The building is still standing and displays pressed tin ceilings which were previously part of the Prairie Inn in Chester and were salvaged when the Inn was torn down. The safe Louisa had was from Bourne-Hamilton when they sold out and closed their post office and store in Hill.

Louisa and Ted Allen began their lives together living with her parents' in the tarpaper shack on the property where they, Ted Allen and Lester Stott, later built their home. Lester Stott was a multi-occupational entrepreneur with skills as a carpenter, shoemaker, and blacksmith in addition to hauling freight. He purchased a truck in 1914-15 for hauling potatoes and other fresh produce to Chester to market. Louisa and Ted were living in the basement of the tarpaper shack when the Armistice was signed ending World War One November 11, 1918. Armistice between Bulgaria, the Ottoman Empire, and the Austro-Hungarian Empire had been reached with Germany prior to the U.S. Armistice. When the large home, post-office, and boarding house was finished, the Stott's opened a store along with the other businesses. Louisa maintained the store until 1949 when Burnham Murray opened a store in Whitlash.

Both Louisa's parents enjoyed music and when they could afford to, they purchased the Church Organ that was in the old Whitlash (Pleasant View) schoolhouse which was half-way between Murray Johnson's place and Whitlash. Mrs. Leo Millis gave Louisa lessons on the organ even though she was a piano and schoolteacher; she could teach keyboarding. Millis's lived in Fred and George coulee and later moved to the Harold Brown place. Juanita and Florence Johnson were taking piano lessons from Mrs. Millis at the same time as Louisa and her sisters. Louisa Stott and Florence Johnson would ride together to

their weekly lessons, but Juanita Johnson wouldn't ride with her sister, so she went at a different time for her lessons.

Lester Stott and Ted Allen began building the Whitlash Community Hall in 1916. It was a challenge raising the funds with the war on and a few bad years building up to it. The crops were abundant, but the demand was great for all agricultural products. Lumber and building materials were scarce. Money (cash) was tight as most of the families in the Sweet Grass Hills were growing, creating a need for more schools and materials for instruction. Amazingly, the money was raised. The Hall was finished in 1918. It was a grand celebration that fourth of July. The men brought evergreens from all three Buttes and set up shaded seating on benches around the parking lot of the Hall. There were not so many vehicles at the time and the Fourth of July was warm, so the party flowed outdoors.

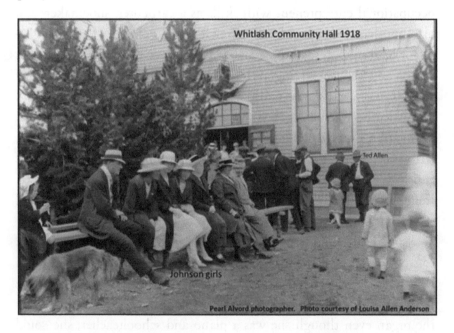

Whitlash Community Hall 1918

Ted Allen

Johnson girls

Pearl Alvord photographer. Photo courtesy of Louisa Allen Anderson

As the sun set on Whitlash the Fourth of July 1918, the party moved indoors. Hats came off and the dancing and celebration continued to the square dance calls of Murray Johnson under the Star and Striped banner boasting of the International crowds' patriotism. There were as

358

many Canadians as Americans attending the events in Whitlash. No alcohol consumption in the Hall and shortly after this event there began another fund-raising rush to finance an outhouse.

The Whitlash Community Hall was and is a spectacular achievement for this small village. Since it's construction it has served weddings, funerals, elections, conventions, roller skating parties, magic shows, dances, and hometown plays. The Arizona Cowboys performed in the fall of 1918 with complete credits listing of hometown talents, including set design and costumes. Had the advance promotors done a better job, its sure to have won some Oscars.

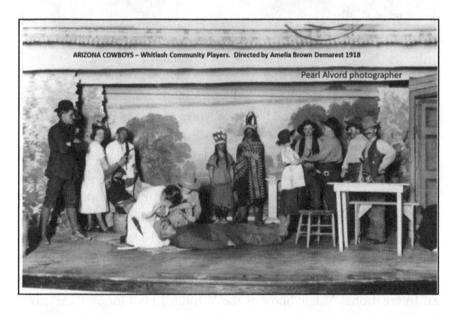

ARIZONA COWBOYS – Whitlash Community Players. Directed by Amelia Brown Demarest 1918

Pearl Alvord photographer

Amelia Brown Demarest directed the play, and she is at the front left with her face in her hands. Tom Strode lies dead on the floor in front of her and she is covering her face so the crowd would not see her laughing disguised as 'sobs' as her body shook. The actors standing from left to right: Harold Brown, Edna Nelson, Murray Johnson, Hanna Robinson (squaw), Harry Flynn (chief), Edris Jacobson, Jim Leach, Marion Parsell, Jim Robison, and Gordon Young. Kneeling to Amelia Demarest's left is Mary Morgan.

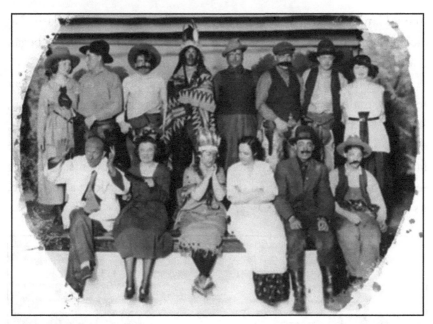

Pearl Alvord photographer. Photo courtesy of Louisa Allen Anderson.

If this acting group had been pressed to, they would have maintained social distancing and or worn masks. Fun is where it's made. Play your part well, others are watching. Amelia's great grandson continued with the family directing skills in Shelby when he attended High School. As a member of the Thespians and Speech and Drama Clubs, Marty directed such plays as: **"Alice in Wonderland"**, **"You're A Good Man Charlie Brown"**, **"Steele Magnolias"**, and others. He also performed an International Magic Show at the Whitlash Hall for Stolfa relatives from Czechoslovakia, Bowers from Canada, and the Dutch and Sioux family, Bob, Dicky, Ramona, Glenn, Miriam, and Christina Thompson from Whitlash.

The Christmas tree photo was taken by Pearl Alvord with his glass plate camera. It was 1919 and the large building constructed as post office, home, and mercantile in Whitlash is still standing in 2020. The mood of everyone was celebratory as this small community had celebrated erecting a Community Hall to accommodate dances and other events following the end of World War I on the Fourth of July in 1918. Lester Stott did most of the fundraising and carpenter work on both buildings. Nettie Alvord Stott, Lester's wife, had spent several years as postmistress in a tarpaper shack with the community coming and going all hours and days picking up their mail while her children slept in the basement. Paper chain decorations and coned shaped ornaments brighten up the boughs of this evergreen grown on East Butte. A doll bed, a toy car, and a box of needful things plus a few other gifts rest patiently in this grand setting overlooked by a shining star atop the tree. The copy of this glass plate photo is a rare artifact. Photographer

Pearl Alvord was the brother of Nettie Stott and uncle of Louisa Stott Allen Anderson.

Pearl Alvord was born July 6, 1879 in Sherbourne, Minnesota. He came to the Sweet Grass Hills in 1903 with his sister, Nettie. He was 24 years young and as many young men at that time, was looking for work. He had an interest in photography and had joined the fraternal benefit society, Modern Woodmen of America, in 1902. He had joined the Congregational church at Ceylon, Minnesota when he was 14 years old and remained a Christian his entire life but did not become a member of the Whitlash Presbyterian Church much to his sister and niece's antipathy. Nettie and Lester Stott and Louisa were all charter members of the Whitlash Presbyterian Evangelist Church formed in 1915. The first service was held at the home of Hettie Miller. Hettie was Harry S. Demarest's sister and had come to the community filing a homestead claim next to her brothers so she could sell the property to Harry once she received title.

Louisa Rachael Stott was born July 5, 1904. At that time, her parents had a small homestead cabin on Breed Creek on East Butte to the east of the Hiram Smith homestead. Lester Stott's sister Rose and her husband, Ed Thompson, and two of Ed's brothers, Arthur (Shorty), and Lester, had all filed homestead claims along Breed Creek. Arthur lived with Ed and Rose in a two-story house even though his claim was further east. Lester Thompson lived in a one room log cabin adjacent to the Stott's yard.

Lester and Nettie thought they would start their farm with a few milking goats and a large commercial garden. Lester had been a traveling salesman and was handy at marketing. He had also developed a skill at carpentry, blacksmithing, and shoe repair. Hiram Smith was building his corrals and outbuildings and eventually his house on his ranch one mile west of the Stott's. Lester worked for Hiram and lived close enough to his own place to get his own chores done. It seemed that Lester and Nettie had a good plan, but life has a way of humbling people. Wildlife in the Sweetgrass Hills were suffering a loss of grazing area and food sources due to the arrival of domestic animals and settlers. The deer and elk prematurely harvested the Stott's commercial garden and coyotes, or

wolves killed the goat herd. In addition to the loss of their farm income, Nettie and Lester lost their third and fourth born twin boys, Lester, and Allen. One died one week after birth and the other lived eleven months. There are two shallow divots at the edge of a hay meadow above Breed Creek a short distance from the outline of a foundation that has grown over. The twin boys are buried there. A beautiful resting place, but more than the young couple could bear. Nettie, Lester, and the Thompson families could not take any more heartbreak.

Arthur Thompson sold out to Strode. Ed, Rose, and Lester Thompson and the Stott's sold to Harry S. Demarest. The Stott's moved to a vacant tarpaper shack at the base of Hawley Hill where the first Whitlash post office had been. Nettie served as postmistress until 1928 when she relinquished her postmistress job to her daughter Louisa. Lester and Nettie moved to Chattaroy, Washington. Lester was in the process of building one more home for Nettie when he died in October of 1937. Nettie followed him April 21, 1946. Both are buried in Chattaroy.

Pearl Alvord was a welcome hand when he arrived in the Sweet Grass Hills. Most of the ranches were busy establishing their buildings and corrals, increasing their livestock range, and building fence. Pearl was one of the few young men who was not interested in being a cowboy. He began hauling freight from Chester to Gold Butte delivering mail along the route. Jacob Oswood had a spare place for him to sleep; in the bunkhouse on the ranch near where the old calvary camp was located on Corral Creek. Pearl camped there for a year helping Jacob. He then filed a homestead claim 14 miles north of Chester where he built a cabin. His freighting trips had acquainted him with the communities, and he took an interest when Jack McDowell had a talk with him in Gold Butte about putting in a telephone line to the Sweet Grass Hills. McDowell told Pearl to visit with his son-in-law, Murray Johnson. Murray was interested in a telephone cooperative for the Hills. With his interest in modern technology, Pearl's connection with Murray Johnson was a perfect fit. Murray had started promoting the idea of a telephone co-op and Tom Strode, Frank Laird, and Murray were raising the money getting people to sign up. Jack McDowell was elected president

of the newly formed telephone co-op. Murray Johnson and Pearl Alvord maintained the telephone poles and lines.

Hauling freight from Chester to Gold Butte in 1903 would have put Pearl Alvord right in the path of Chas E. Morris, the young newlywed cowboy photographer. There's circumstantial evidence in the way of unmarked photographs taken of the West Butte school, John Fey's new house, and the crew at the Bucket of Blood Saloon in Gold Butte indicating Chas E. Morris was indeed in the Sweet Grass Hills in 1903. There were several photos published in the Liberty County Times the summer of 1903 of Gold Butte, freight Jerkline between Chester and Whitlash, and the A.C. Strode Company Store in Chester. The Golden Anniversary issue of the Liberty County Times, Thursday, February 23, 1956 carries a reprint of a 1905 photo of Old Whitlash. The photographer is not identified, but research shows that Chas E. Morris and Pearl Alvord were the only two known photographers in the area with glass plate cameras.

Chas E. Morris took a lot of pictures before he went to school for photography in 1900. Pearl Alvord did not go to school for photography. He took pictures with his glass plate camera for his own enjoyment and didn't keep tally or mark them. After all these years of wind blowing over this black and white photo strewn trail, this author determined to track down Chas E. Morris. The collection of Pearl Alvord and Chas E. Morris photos is remarkable in likeness. Pamela Morris, granddaughter of Chas, and this author could only guess which photographer had taken which photos. One marker in the search is dates, which is why the newspaper prints and reprints are somewhat determinant. Pearl Alvord did not arrive until 1903. Chas E. Morris opened his studio in Chinook that same year. This is the period of overlap when it's possible, and even probably, that these two young men met and shared their interest and techniques in photographing the west at that moment in time.

Louisa Anderson, Pearl Alvord's niece, gave this author several photos. Some of the school photos in unmarked folders were taken before Pearl came to Montana. Pearl's sister, Nettie Alvord, married Lester Allen Stott, a traveling salesman (Hawker/ peddler) and musician, after eight years of courtship February 10, 1900 in Ceylon, Minnesota.

Nettie and Lester first met at The World Columbian Exposition, also known as the Chicago World's Fair, in 1893. Pearl and Nettie Alvord attended the event together. Being a hawker, Lester Stott was introduced to all the latest gadgetry and products that were innovative: like radio's and cameras. He also covered a large territory selling his wares and attended all events such as fairs and exhibitions. It is likely that one of the annual events he attended was the St. Louis Exposition or St Louis Expo, an annual agricultural and technical fair held in St. Louis Fairgrounds Park. It's also likely that from 1893 to 1903 Pearl Alvord attended this event annually.

Lester first saw the Sweet Grass Hills from a wagon train his family had taken from South Dakota to Kalispell in 1895. Things hadn't worked out in South Dakota and Lester came to help his parents relocate. Fascinated by these three islands on the prairie, Lester traveled to the Hills after his marriage to Nettie when she went back to Minnesota to visit her parents following the birth of their first child, Ray Alvord Stott, October 21, 1900. The couple had thought they would settle in the Kalispell Valley but changed their plans once Lester had visited the Hills.

Chas E. Morris was born in Glendale, Maryland June 29, 1876. When Chas was seven his mother Lily Jones Morris died. His father, William Morris, took his son and began a search for himself working at seasonal jobs in Virginia and New York. Chas recalled his father working in apple orchards around Rome, New York. He boarded at local boarding houses where Chas learned; 'when in Rome, do as the Romans do'. With no mother and his father working most of the time, Chas became an avid bookworm. Fortunately, he was able to keep up with his schooling. His father married again moving his family to Chattanooga, Tennessee where a stepsibling came into Chas life. By June of 1890, when Chas was fourteen, he had tired of reading about the west. His curiosity along with scholarly knowledge of cowboy life beckoned him to confidently take a few dollars, a bag of salt, and his father's loaded six-shooter heading west to experience the life he had read about. Walking away from his father's chosen family, Chas spent months working his way to Texas where he began his life as a cowboy.

His story can be found in "**True, Free Spirit**": Charles E. Morris, Cowboy Photographer of the Old West" by Bill Morris edited by Pamela Morris Larson, Charles Morris's son and granddaughter.

Happenstance is an intriguing element in life. In this telling of the tale, perhaps the common thread. Antony H. Fey Sr. was born in Rome, New York March 17, 1859. Antony (Tony) joined his brother Jake Fey on the W.C. Gillette Ranch in Dearborn country near Augusta in 1881. While living with his brother, Tony met and married Emma E. Noaks in 1890. In 1892 Antony and Emma Fey left the Dearborn and moved to the Sweet Grass Hills. They took up squatters claims that were later sold to Moltz and Cameron. Emma took a job cooking at a saloon, store, and hotel in Gold Butte. The store and Saloon where Emma Fey worked in Gold Butte was financed and owned by Whitmier & Co. of Shelby.

John Fey was born November 12, 1864 in Lewis County, New York, to Lewis and Kate Noll Fey. They had migrated from Germany. They were engaged in farming and dairy in New York State. John worked with his parents until coming to Montana when he was 21. He worked with his cousins, Tony and Jake, at the W.C. Gillete ranch until moving to his own place. John filed a 'squatters' claim in the Sweet Grass Hills in 1892 on West Butte. He later transferred his claim to Charles M. Russell May 14, 1904. 1886, the year John Fey came to the Sweet Grass Hills, was the winter Charles M. Russell sketched "Waiting for a Chinook" and John Grochon perished in a snowstorm on his way home from Gold Butte to his cabin on West Butte. John Fey married Rosa J. Blansfield of Good Hope, Illinois November 24, 1904. They met in Gold Butte while Rosa was serving a nursing assignment given her by Dr. Gordon Ferguson of Great Falls, Montana.

There were three saloons in Gold Butte by 1886. Mary Parent was managing the business where Emma Fey was working. Mary's husband, Fred, and son, Wilbur had built the building. John and Tony Fey formed a livestock partnership. Emma and Tony Fey made an offer to purchase the saloon and store where Emma was working as Gold Butte was expanding and Whitmier and his partners were investing in mining interests and divesting of their mercantile real estate.

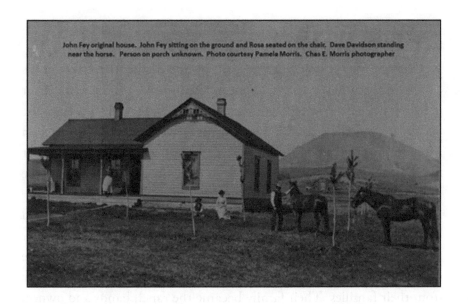

John Fey original house. John Fey sitting on the ground and Rosa seated on the chair. Dave Davidson standing near the horse. Person on porch unknown. Photo courtesy Pamela Morris. Chas E. Morris photographer

Here is where the saga delves into the unknown. Pearl Alvord arrived in the Sweet Grass Hills in 1903. Chas E. Morris had been to Gold Butte and Whitlash most probably as early as 1895. This is a guesstimate because of the 1895 photograph of the first Whitlash school. In what became a 'style'; the photograph sets up Miss Melissa Everetts and her students in a row each with their saddle horse reins in hand. In the background is the school building and a horse and wagon. Pearl Alvord was not in the Sweet Grass Hills at that time and there were no other known photographers in the area. The following year Whitlash school had moved to Harrington Spring school and the building that served the original Whitlash school was moved east becoming the Laird school.

Pictured in the Harrington Spring school is a young lady by the name of Mary Morgan. Mary would later become Mrs. Robert Carroll. Robert Carroll was a student at Gold Butte school or at the Parsell ranch when Hattie May Parsell taught students before a school district was formed in Gold Butte. Hattie had taught school before marrying Fredrick Parsell and was delighted to teach in her honeymoon cottage in the Sweet Grass Hills. Mary Morgan Carroll and her brother Matt Morgan are both mentioned in Bill Morris's book, "True, Free Spirit".

367

There are numerous photos of Matt Morgan throughout Bill Morris's book about his father and his journey from cowboy to photographer. As Chas E. Morris boldly walked out on the life he knew to find his calling in the unsettled west, he meandered his way to the Milk River in Montana territory following a cattle drive. Starting in Texas he worked his way the direction the big herds headed, north. Once north in Montana territory along the Milk River, Chas found work as a wrangler for the circle diamond north of Malta. Imagine, he was right in the heart of Granville Stuart's range.

Chas began working with people of all colors, nationalities, and backgrounds. What he found was he was not alone in seeking out adventure in the west. Most of the wranglers had followed the same trail he had getting to north central Montana. They had walked away from their families. Their family became the ranch hands and owners of the land and cattle they worked for. The 'boss' provided wages, room, board, and often transportation. The 'boss' of these outfits always noticed the hands that were educated because it was important that such men be put in positions to read and tally numbers and identify brands. With his interest in the new media of movies and film, Chas caught details and noticed the changes that were happening almost before his eyes, so he acquired a camera as he began thinking of having his own niche in life.

Chas was nicknamed "*Webster*" because compared to his colleagues he had a mastery of the English language. He was not interested in gambling, drinking, or smoking. He wasn't an outcast because, though still employed as a night wrangler, he loved to set up scenes to photograph and throw in stories about the setting. He added details making the subjects of the scene heroes for their mindfulness. He really wanted to capture those moments and share them with the world because he knew they would disappear as quickly as they had appeared to him. He was in the right place at the right time and Granville Stuart's son, Charley Stuart, latched on to Chas. Charley convinced "*Webster*" that he had a good eye for this photography thing that was taking the world by storm. Chas ordered all the supplies he could find in the catalog and began a self-study of how to take still photographs with a camera.

Glass (photographic) plates preceded photographic film. The light-sensitive emulsion of silver salts was coated on the glass plate which is typically thinner than common window glass. It is less likely to bend and distort like transparent plastic film. Glass plates are far superior to film for research imaging because they are extremely stable, especially in the wide field imaging. Wide field imaging and stability are two of the qualities of Chas E. Morris photographs that draw you into the moment in time. The widely published painting, "The Jerkline" by Charles M. Russell, is a great example of how freezing a moment in time with a photograph can help an artist examine all the elements and details needed to make the moment in time authentic. Chas E. Morris liked taking those wide angle and unusual angle shots with his glass plate equipment.

Glass plate photography faded from the market faster than the Indians and buffalo were driven from the open range. By the early years of the 20th century, plastic, a product that had been more expensive to produce than glass plates for photography, began to improve delivering better imagery. Not as exact as glass plate photos, but satisfactory and more convenient to transport. Glass plates were still widely used by the professional astronomical community. The most famous of these being the first Palomar Observatory Sky Survey (POSS) of the 1950's. POSS – 11 survey of the 1990's followed and the UK Schmidt survey of southern declinations Harvard College and Sonneberg maintain large archives of photographic plates, which are used primarily for historical research on variable stars.

Glass plate photography continued to be superior photography until digital Imaging improved and could outmatch glass plate results. Even the largest CCD formats (e.g., 8192 x 8192 pixels) do not have the detecting area resolution of most photographic plates. Modern survey cameras need to use large CCD arrays to obtain the same coverage. The photographs taken by Chas E. Morris and Pearl Alvord in the late 1800 and early 1900's are historic testaments depicting Montana as it was at that moment in time.

A collection of Chas E. Morris prints is on display at the Blaine County Museum, Chinook, Montana, the city where Chas and Helen

Morris had their studio. Chas made up his mind he was going to be a photographer, but before he had a talk about his plans with his foreman, Sam Miller, Chas began gathering photos amassing a large portfolio of real life on the open range. His last collection before heading for photography school Chas took documenting the sheep industry in Montana. The photos of a lone herder in a sheep wagon with a couple of dogs and a horse on the prairie with hundreds of sheep suggest the novel by William E. Eckerson, "A Monument to Loneliness". Chas doesn't have any pictures of those stone towers of varying shapes that pop up across the prairies. Some of these stone towers remain as testaments on the prairies and hilltops. Sheepherders built the markers for shade from the sun or shelter from blizzards; for landmarks to remind them where they were and where they were going; sometimes out of boredom for something to do. Indians used the monuments as lookout posts. A natural outcropping was embellished with a few more stones on a highpoint and turn in the road to Gold Butte from the north. The Indians used it for a look out to warn the early gold diggers if the military was coming. Eckerson paints pictures with his words of the sheep industry around Augusta from open range to fences. The following story is of one such monument that saved the life of Peter Miller the winter of 1892.

In the early afternoon in February a blizzard swept suddenly over the foothills of the Bears Paw's. Chris and Peter Miller thought they would hurry out to help their herder bring in their band of sheep to shelter. They put on their heavy coats and went out finding their way to the sheep and herder before blinding wind and snow engulfed them. Darkness came and Chris Miller's wife, fearing for the men, placed a candle in the window of their cabin in hopes it would guide her men home safe.

Peter Miller knew Mrs. Miller (Lillian) was home alone with their daughter and would be worried. He left the sheep, Chris, and the herder in a coulee that somewhat sheltered the group and headed the direction he thought was home. The familiar ridges and coulees had disappeared with the piles of snow and darkness. Peter was lost. He wandered until he came upon a pile of rocks stacked high by some herder passing a long

day away. Peter recognized the monument and worked his way along the top of the ridge. Finally, near desperation, he saw the light from the candle Lillian had placed in the window. He made it to the door. Too weak to pull the latch cord he fell against the cabin.

Mrs. Miller heard the noise. Hoping, yet not knowing what to expect, Mrs. Miller threw open the door and there was Peter, his face an ice mask with black holes for nose and mouth and open patches for eyes. Those sheep herders' monuments were important landmarks in Montana's vast territory. Great Falls Tribune, Sunday, December 7, 1958.

Chas E. Morris captured the era in photos. Most of his sheepherder photos are of large bands of sheep being tended by one or two herders and dogs. What can be seen in the photos are vast undistinguishable acres of prairie with an occasional hill or tree denoting an identifiable landscape.

Archives of preserved photographic plates are uncommon due to the requirement for preservation. Emulsion on the plate can deteriorate. Glass plate medium is prone to cracking if not stored correctly. The George Eastman Museum holds an extensive collection of photographic plates. The largest panorama on display made from glass plate photographs is on display in Sidney Australia Harbor. Charles Bayliss is the photographer of this spectacular black and white panorama constructed in 1875.

Chas E. Morris had invested most of his wages in his assemblage of his portfolio. By the time he brought his plan forward to Sam Miller he realized that if he wanted to continue with photography as a profession, he would have to advance his business sense as well as his craft. Sam Miller had kept his eye on 'Webster' and suggested Chas take the last cattle train hauling the M & M brand herd east where he could enroll in a business college over the winter months. Four winters later Chas E. Morris graduated from Toland Business University at LaCrosse, Wisconsin. His first winter in LaCrosse he met Helen Schroeder. Smitten by this young woman's beauty and charm, Chas kept a stream of written and photographic communications with Helen every summer when he was back on the range in Montana being a cowboy photographer. At the

end of his fourth winter term, he had won her heart. The spring of 1903 Mr. and Mrs. Chas E. Morris arrived in Montana bringing color to the images Chas had been producing. Helen Schroeder Morris not only fell in love with Chas; she learned the skill of processing, retouching, and coloring the glass plate negatives to perfection in the darkroom of the studio and the Morris photo shop on wheels. The pair became so skilled that by 1904 they won the award in the Hand-Tinted Photo class at the St Louis Exposition. The marriage was off to a great start.

"True, Free Spirit" has unique photos of Fort Assiniboine and American Indians in the pages of this wonderful book. This author's favorite picture is titled "All Dolled Up" on page 75. In the photo are four American Indian Women with parasols and beaded apparel with beaded headstalls, breast collars, and reins with Hudson Bay blankets draped across their laps in their saddles. This is a sight most likely un-replicated. A moment in time worth a thousand words.

Chas and Helen Morris were busy in 1903 and 1904 getting their collective lives started as a couple. Chas E. Morris was in the Sweet Grass Hills taking photos and it's possible Helen had returned to Iowa to have their first child. Pearl Alvord may have met Chas somewhere along their journey to Montana as Pearl showed up with a glass plate camera about the time Chas and Helen started their business in Chinook. Pearl did not have folders for his photos, and at least one of the photos taken in Gold Butte in 1904 has Chas E. Morris stamped on the back of its folder. Some of the other photos taken during that period in the Hills appear to have been removed from their folders for placing in albums or storage. The photo of the John Fey home is one such photo. The West Butte school photo and interior of the Bucket of Blood Saloon photo were in folders. It's possible that Pearl went with Chas (and Helen if she was along) and the men shared their passion for taking photos and techniques of shooting groups of people and livestock. Pictures Pearl Alvord took in 1918 and later in the Sweet Grass Hills and Chester area are very like Chas E. Morris photographs. Chas would have been the kind of person who would share his knowledge; especially to another cowboy who aspired to become a photographer and had a glass plate camera out on the range.

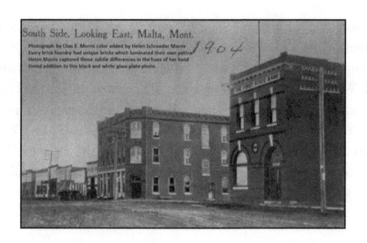

South Side, Looking East, Malta, Mont.

Photograph by Chas E. Morris color added by Helen Schroeder Morris. Every brick foundry had unique bricks which laminated their own patina. Helen Morris captured those subtle differences in the hues of her hand tinted addition to this black and white glass plate photo.

1904

In 1998 the movie "Pleasantville" came to the big screen beginning in black and white, transitioning to color as the characters began feeling emotions and experienced the impact of color on their perception of life. Just as Helen Morris hand tinted her husbands' photos, she added enlightened emotions to his once black and white life. Her perception and exact replication of hues in detail earned this couple a place in history of western photography. The black and white copy of main street in Malta was taken from "Treasure State Lifestyles Montana" Volume 14 Issue 12 in an article on page 39 titled "First State Bank of Malta". The bank provided the image and wrote the date 1904. In 'Lifestyles' the first two brick buildings are hand tinted brick giving their rich brown tones character. The bank was founded in 1903. The buildings have been resurfaced and no longer display the original brick and its variance in color, but the image is so well tinted it is easy to tell they were built with bricks from different kilns. The electric wire poles along the street indicate Malta was soon to have electricity if they didn't yet have it. Color and light would soon be infiltrating the once bland landscape. It wouldn't be long before streetlights and radios would extend days with light, news, and music at a switch any hour of the day or night.

Music and Art contribute greatly to our lives and our psyches. At times, the people in the Sweet Grass Hills may have been singing "Stone Soup" thinking of better times, but they were singing and thinking.

The wonderful Stone Soup song was written by Sheldon Silverstein has been made into a 15-minute children's play. The song and play are about starving soldiers entering a village where nobody is willing to share any food. With guile and creativity, the soldiers teach the villagers how to share and how to overcome their selfishness. Selfishness did not exist when it came to food and company in the Sweet Grass Hills. The latch strings were always out and somehow, even on the warmest days of summer, homemade ice cream finished up the meals at every gathering.

PART III

A SENSE OF THE WEST

OUTFITS, BREEDS, AND RECIPE'S

"If the latch string is out, knock twice. If no one answers the door, come on in."

These were the house rules in all seasons in the west before doorknobs and canned milk. If you were hungry, cold, hurt, or thirsty, if the latch string was out you made yourself to home. That wasn't to say you could rummage through a place and leave it a-strew. Dishes used needed to be washed and put away; but warming up and filling up were permitted and expected when travelers came to visit, home or not. Cupboards usually had dried goods. Beans, split peas, flour, sugar, salt, baking powder and soda. Molasses, honey, or syrup were usually somewhere in a pantry as pan cakes were a go to meal anytime. Many homesteaders had a milk cow and chickens which greatly expanded their larder. They had cream, milk, butter, and eggs, but milking the cow and gathering eggs were daily chores often left to the women and children. Along with the milk and eggs came the care of the animals. For many of the women, life on the prairie was a steep learning curve often without mentors or guidance of any kind. This may have been one of the reasons gatherings were so popular. Women could work together serving and sharing recipes and household tips learning from each other how to create a meal for twenty out of what was on hand.

A favorite for men of the west that remains today is sourdough. This

batter was probably a happy accident for someone who left a bowl of ingredients out overnight and had to use it the following day because there were no options or alternatives. The magic of sourdough is that each batter is unique in its flavor. It seems to pick up the mood of the day and incorporate it in its flavor, so it never gets '*old*'. The following is one recipe, certainly not the only. Often called '*bachelor bread*', this simple starter is a fun addition to almost any dumpling, bread, pancake, cake, or muffin. Fresh or dried fruit can be added in the mix or on the side to make a dessert.

'*The way to a man's heart is through his stomach*.' Even in the Twenty First Century, at brandings, roundups, hunting camps, and rodeo's, sourdough is still a favorite when it's time to eat. This starter will take you back to the day before the four-wheeler and automobile brought fast food to the campfire.

Using a quart-size fruit jar, dissolve 1 yeast cake (1 Tablespoon dry yeast or 1 pkg.), in ¼ cup of lukewarm water. Potato water is good, it adds nutrients and gives a flaky texture to the dough. Add 2 cups flour, 1 Tablespoon of sugar and 1 teaspoon of salt. Cover with a cloth and leave at room temperature overnight. This will have to be stirred down 2 or three times or it will run over. (The longer it stays at room temperature, the stronger the sour taste.) Replace cover and refrigerate until used.

This is your STARTER. Each time you use a portion of this you should replenish or feed it. 1 cup flour, 1 cup milk, 2 Tablespoons sugar. Stir. May be lumpy – that's okay. Some people feed with water instead of milk, but others report that milk makes the sponge 'sweeter'. Refrigerate or freeze if not used for a while. If it dries out some, just add water or milk and leave at room temperature and stir a few times in a day and watch it come back to life. Refrigerate and use as before.

Cowboys reported the cooks would mix bread or sourdough in the morning and let it rise or ripen on the trail all day. By the time they set up camp and got the fire started, the starter was ready to mix or the bread ready to shape and bake. With any luck your children can inherit your sourdough starter and begin a family tradition. There's a little magic in the fermenting process of sourdough that breaks down the

ingredients to enhance the digestive process. A cup of sourdough can be added to most cookie, cake, and bread recipes to add flavor and body to the mix. Once you have the starter you only need a small amount of the original to feed and start another sponge.

Here is a **Cowboy Coffee Cake** that will top off any meal:

1 cup flour; 1 cup starter; ½ cup sugar; 1 egg; 1 tsp. baking powder; 1/3 cup oil; ¼ tsp. baking soda; 1 cup raisins (soaked); ¼ tsp. salt; ½ cup nuts.

Mix dry ingredients in large bowl, flour, sugar, baking powder, baking soda, salt. Stir in starter, oil, egg, raisins, and nuts. Spread in greased iron skillet. Bake @ 350°for 35 min. or until toothpick comes out clean. Any dry fruit can be substituted for raisins and/or nuts. Top with powdered sugar or cinnamon sugar mixture.

Griddle Cakes: 1 cup starter; 1 cup flour; 2 ¼ tsp. baking powder; ¼ tsp. baking soda; ¼ tsp. salt; 1 egg; 2 TBSP. oil; ½ to ¾ cup milk.

Mix all ingredients. Add milk to desired thickness. ¼ cup batter per cake. Pour on hot skillet. When dough bubbles, flip and cook on other side. Top with **Cowboy Syrup**; 1 cup brown sugar; 1 cup sweet cream; 1 cup white Karo (simple) syrup. Bring to boil. Serve. May be used for ice cream topping. Keeps refrigerated for up to two weeks.

Just like any cook, the trail or camp cook had to multi-task. They usually had to find a campsite and set up their cook wagon and fire. They drove their own wagon and kept all foodstuffs clean, dry, and stored. If it was a long drive, there were usually two more wagons. One with wood for the fire and another to carry the bedrolls. Sometimes each wagon had a driver, but it was not unusual for the cook's wagon to have a consist with all three wagons pulled by two teams of bulls or horses. Either way, the cook was usually responsible for harnessing and hitching the teams and loading and unloading the wagon(s).

To add to the romance of cowboy life, bosses rarely had a clue about horses or cattle, and they didn't sleep or eat with their hands so they didn't care if the camp cook could cook or not as long as he filled the position, drove the wagon, and made coffee. Often the trail boss or rep had skin in the game and always knew horses, cattle, and a good hand. Cooks were a breed of their own. After the first herd of cattle made it

to Montana from Texas, it was not hard to get another crew together because word spread fast. Montana had grass and the best cooks in the country. Sourdough and steak with cornbread for breakfast and dried fruit in the evenings, sometimes baked in the sourdough biscuits or on a good day - pie. The coffee pot was on all day and they were generous with the Arbuckle. Texas trail hands started finding reasons to stay in Montana. Once oil was struck in Montana the Texas cowboys went to work on oilrigs. Montana cowboys and ranchers started doing business with Texas oil men. Transportation corridors continue to grow as industry and markets dictate economy.

Cattle are creatures of habit. They do not track like an elephant, but once one has broken trail the rest of the bunch tend to follow. With a longhorn, the males, whether bull or steers, herd the cows with their horns so keeping the cows moving in the right direction is a little easier if you can maintain control of the males. Sort of like a bar crowd. It wasn't long after the first herd of Texas longhorns came to the territory, herds of Texas longhorns were showing up in Montana in record time. Happy to reach grassland where they did not have to travel miles in a day to fill up, the longhorns were content until winter came to Montana. Their hide was thin, and hair didn't get winter growth. Unfortunately, they could not travel south fast enough through the heavy snows. The losses were devastating and increased the wolf and coyote population. Many of the large herds brought to Montana in the mid 1800's were financed by conglomerates who were seeking to start financial institutions in portions of the Territory that hadn't reached statehood. This gave a broader financing opportunity because of regulation(s). These well financed stockmen were able to recover from livestock losses by replacing and expanding their stock. Finding qualified rep's and cowboys was easy enough with all the men coming to Montana looking for gold and needing a paying job.

After a few hard winters, stock growers realized they would have to put up grass to feed the cattle on the months the snow covered the ground. They also began to close in on ranges and use geographic and topographic landmarks to define parameters. Cattle adjusted somewhat along with the 'cowboys' and as with evolution and diversity, herds of

all livestock became accustomed to frigid winter months with hair and hide that kept them warmer. For the sheep: after one year the quality of wool produced improved measurably. Texas longhorns have not been as prevalent on ranches in Montana because of their nomadic and thin hided nature. Longhorn bulls continue to be popular for breeding first year heifer production as the skull of a longhorn calf tends to be smaller allowing for a less complex delivery of a live calf. Red and Black angus as well as Herefords remain the most popular '*cross*' for meat production and handling. Several other breeds have proven to be hearty in the climate and are suited perfectly for limited pasture and ease of handling.

Another '*uniqueness*' of Montana is the diversity in terrain. Just as people were drawn to certain areas of the state from different countries of the globe, cattle adapt better if the range reflects similar aspects of where the breed was developed. Call it '*country of origin*' or '*ancestry*', breeds of animals carry traits just as people carry cultural traits that tend to be identifiable. An Arabian horse moves better on sand than other breeds largely because of the size of their bodies and hooves. Smaller bodies, shorter back, larger hooves. The animal doesn't sink into sand as readily as other animals might.

Suitability of animal to use and conditions translates to best adaptability and nutritional requirements. Montana's pristine air and water were and still are taken for granted as the population of animals and people continues to rise. The largest contributor to these assets, soil, is also taken for granted. There's a reason Montana produces the best barley in the world. There is a reason that once the soil was opened to agronomy the crops were remarkable. There is a reason livestock does well on Montana's native grasslands and grain crops produce superior end product. Challenge your taste buds to a 'bachelor bread' bake off with this biscuit recipe using Wheat Montana flour, unpasteurized organic cream, and eggs produced by free ranging chickens – all Montana products. Make the same batter with other comparable product and you be the judge of the flavor and quality.

Inspired by Effie Ellis and Ron Wehr's milk cow that was ranging on the ranch in the Sweet Grass Hills where Effie raised her family, here is a recipe for **EFFIE'S BISCUIT'S:**

2 cups of flour; 1 cup of cream; ½ tsp. salt; 1 egg; 4 teaspoons baking powder; 1 teaspoon sugar. Combine dry ingredients. Mix egg into cream and add to dry mix. Knead on floured surface 12 times. Pat out and cut or shape into rounds. Place on cookie sheet and bake at 425° for 20 or so minutes.

When on the roundups, the cooks often did not have eggs or cream and their biscuit recipe (can be used to make dumplings and steamed on top of stew) was more along the line of these ingredients – **BISCUITS:** 2 cups flour; 2 teaspoons baking powder; 1 teaspoon baking soda; 2 teaspoons sugar; 2 level tablespoons lard or Crisco; Water or milk to mix – mix should lumpy, slightly dry, not smooth. Steam for 20 minutes on stew or bake at 425° for 20 minutes.

Sourdough batter can be added to almost any baked dough. A quarter of a cup to one cup, depending on availability and size of recipe, it will add flavor. The following is a sourdough bread recipe that works well when camping because of the use of water rather than milk and no egg or other fresh ingredients necessary: **Sourdough Bread -** 1 cup sourdough starter; 5 ½ to 6 cups flour; 1 pkg. active dry yeast (1 TBSP.); 2 tsp. salt; 1 ½ cup warm water; 2 tsp. sugar; ½ tsp baking soda.

Let starter warm to ambient temperature in large mixing bowl (approximately 1 hour standing out). Dissolve yeast and sugar in warm water in large measuring container. Blend about 2 ½ cups flour, sourdough starter, salt, and baking soda. Mix in another 2 ½ cups of flour, add remaining flour gradually so as not to get dough too stiff. Place in greased bowl to rise. Flip dough over so the entire batter is covered with grease. Cover with damp cloth and leave to rise for 1 to 1 ½ hrs. Punch down dough and shape into two round loaves or place in two bread pans. Score tops and let rise. Bake at 400° for 35 to 40 minutes until tan on top and hollow when tapped. Raisins, craisins, dried or fresh chopped fruit can be kneaded into this batter before shaping, or the dough can be patted into two rectangle flats and sprinkled with cinnamon and sugar or other spices then rolled and let rise and baked as usual.

Another reason for the popularity of sourdough in days before air conditioning and freezers is the character of texture when the sliced

bread or biscuit dried. These tasty morsels became known a rusk and were packed for lunches and snacks. The preservation of eggs was often done by baking large batters of '*cookies*' when eggs were plentiful. Cookies will keep in crocks or barrels for weeks and make excellent take along snacks for hikes or horseback rides. Cookies take time to bake, which wasn't feasible for the roundup cooks, but for the families on the plains they were a staple for a sweet treat in case of company or fatigue. At the end of a long day, often a cup of tea and a '*biscuit*' or cookie would settle a tired soul for the night. A particularly nutritious cookie is the gingersnap. These tasty morsels have ginger, which is great for settling the digestive system, cloves, and cinnamon, two healthful micronutrients as old as Biblical travels. By varying the amounts and ingredients this dough was often made into a cake or gingerbread and served with lemon sauce for a dessert. Sometime the cookies were frosted or filled. However, they were served, they were a welcome treat for any occasion.

GINGERSNAPS: ¾ cup shortening; 1 cup sugar;_¼ cup molasses; 1beaten egg;_2 cups flour; ¼ tsp salt;_2 teaspoons soda; 1 teaspoon each, cinnamon, cloves, and ginger.

Cream shortening and sugar; add molasses and egg. Beat well. Sift dry ingredients; add to creamed mixture. Mix well. Roll in small balls, dip into additional sugar. Place 2 inches apart on cookie sheet. Bake at 350° to 375° for 10 to 12 minutes. For softer cookies, bake at lower temperature for shorter time. For crispy, higher temperature for longer time. These cookies store and ship well. With a little practice the dough can be rolled out and shaped into the parts needed to make a gingerbread house. Cut shapes, place crushed lifesavers in window openings, and bake like you would for cookies. Let cool for a minute before removing from cookie sheet.

GINGERBREAD & LEMON SAUCE: 1 ½ cup sifted flour; 1 tsp. baking powder;_¼ tsp. salt; 1 tsp. cinnamon;_½ tsp. baking soda; 1 tsp. ginger;_¼ tsp. cloves; ¼ cup sugar;_1 egg well beaten; ½ cup milk; ¼ cup oil or melted shortening; ½ cup molasses.

Sift all dry ingredients; add egg and milk and stir until smooth. Stir in oil/shortening and molasses; beat until smooth. Pour into greased

8-inch square pan or loaf pan. Bake 30 to 40 minutes at 350°. **Lemon sauce**; place ½ cup of sugar, 1 Tablespoon plus 2 teaspoons cornstarch in saucepan. Stir in 1 cup cold water and heat over medium heat stirring constantly until mixture thickens and boils. Boil and stir 1 minute; remove from heat. Stir in 2 Tablespoons butter and 1 Tablespoon grated lemon peel plus 1 Tablespoon lemon juice. Serve warm over gingerbread.

These easy to prepare treats were great for everyday pick-ups, but the spread of food for Holidays, like Christmas and Thanksgiving, were incredible considering they were cooked in wood stove ovens. Many of the women of the west cooked for more than their own family when they first came west. Wherever there was a crew, the women did the cooking. Often in their own kitchen for several hired men in addition to the family. If their home was big enough, rooms were rented out and meals were provided. This was the beginning of the cabin industry *"Bed and Breakfast"*. If it was not a roundup or thrashing crew, it may have turned into a dance and dances usually included midnight feeds with breakfast in the morning after dancing all night.

Here is one Thanksgiving that took place in Gold Butte at the Anthony Fey bar, store, and restaurant as told by Eva Strode Melvin in a 1970 Shelby Promotor story.

"Several four-runner sleds would meet in Whitlash and passengers would pack into the sleds and head to Gold Butte. The ladies wore skirts to the ankle and a few lucky girls would have formals. It was prudent to wear long handles, tops and bottoms, for the trip requiring a dressing down once arriving at their destination. The girls would take chafed raw legs any time before looking like a frump when the dancing started.

The three Pritchard girls came out in lovely chiffon formals one Thanksgiving looking like fairies, but it was kind of airy for fairies.

Even though the old potbellied stove had been doing its best all day, one could still see his breath ten feet away from it. Dave Thomas must have been proud of his future wife, Elizabeth, that night ... she was indeed beautiful.

The musicians most in demand were Mrs. Short and Lord Roberts, (Willard Robertson) and the Kinyons and Mrs. Berry, and don't think that Ethel couldn't belt out those old songs.

By midnight, we were all ravenously hungry. It was then that Mrs. Fey (Anthony Fey) crowned the event with her banquet ... such a feast. There was pumpkin pie loaded with heavy whipped cream, cookies, fruit cake, all kinds of jellies and home-made sweet or sour pickles and last but not least those real scratching chickens and turkeys baked to a turn. All for 35 cents.

We danced the whole night through until they played "Home Sweet Home" and "Good Night Ladies". We were fortunate to have Bill Herbert as our caller and he was an artist at it and also at teaching us other dances, minuets, and schottisches, square dances, three steps and the beautiful Viennese waltz."

"Those real scratching chickens" give a hint that there weren't gobs of fat on these birds, only succulent meat loaded with flavor and nutrients. If those birds could talk, they might have said, *"Now when I was a young chick, free range meant miles and miles of walking. There wasn't a waddler or dwaddler in our flock".* No meal was complete without homemade pickles. Canning was big and almost everything was canned including meat and fish. The one thing that wasn't canned was milk. Not until 1861 and what a blessing for the cowboys. Trying to get a cup of milk from an open range cow for coffee in camp is what led to the rodeo's wild cow milking contest. Cowboys did love milk in their coffee though. Most rural folks had a milk cow in the 1800's and early 1900's, but milking is time consuming and preparation or preservation of the milk also takes space and time, two commodities that were always in short supply.

With electricity, natural gas, freezers, and refrigeration meals got a little fancier. Many of the ladies in the Sweet Grass Hills competed at fairs with pies and canned goods and ladies' clubs began to form promoting the grains and beef they were producing. The 'CowBelles' were one such organization. They had an annual contest for recipes using 'beef'. The following is a recipe from Mary House, daughter of Sid and Delores House, second place winner in the 1977 CowBelles Cook-off, **Cheezy Beef Bake:** 4 ounces (3 cups) medium noodles; 1 ½ pounds ground beef; 2 cups tomato sauce; 1 teaspoon sugar; ½ teaspoon salt; ¼ teaspoon garlic salt; 1/8 teaspoon pepper; 1 8-oz. package cream cheese; ½ cup sour cream; 3 Tablespoons milk; 2 Tablespoons finely

chopped onion; 1- 10 oz. pkg. frozen chopped spinach; ½ cup cheddar cheese, shredded, cooked, and drained.

Cook and drain noodles. Brown meat and drain off fat. Add tomato sauce, sugar, salt, garlic salt, pepper, and noodles. Set aside. Stir together cream cheese, sour cream, milk, and onion. In a two-quart casserole, layer half the meat and noodle mixture, half the cream cheese mixture and the spinach, then the rest of the meat and noodle mixture. Cover and bake 40 minutes at 350°. Uncover, put remaining cheese mixture on top. Sprinkle with cheddar cheese. Bake ten minutes more, or until cheese has melted. Serves six or more."

It's apparent the change that occurred in cooking when what was termed *'modern conveniences'* and *'processed foods'* that were *'prepackaged'* hit the market. No calorie counting or consideration of cholesterol content. These changes along with the mode of transportation and the coming of electronic entertainment and communication led to a sedentary lifestyle creating a change in physical profiles throughout the world.

Canning produce was almost a necessity for farmers and ranchers. Grocery stores didn't carry a variety or amount of canned goods in the late 1800's. Canning was just about the only way of providing fruits and vegetables for nutritional meals. Tomatoes were another hit and homesteaders who had gardens with tomato plants soon found Montana soil could produce the fruit by the gallons. Often a tired cowboy would open a can of tomatoes and just break up a couple of slices of bread and make tomato soup. Hot or cold, it was a tasty, nutritious, and satisfying meal. Teddy Blue Abbott tells about working for the DHS and having Mrs. Granville Stuart and her daughters serving *'canned tomato's'* to the cowboys. He says it is one of the reasons he worked for the ranch. When he married Granville's daughter, Mary, and they had their own garden, he found out how to raise that red fruit and how much work it was to do it. Teddy Blue was never one to shy away from demanding work or a challenge.

There is a diverse collection of people in the Sweet Grass Hills' from its early settlers to present day. One reason is the fact that they rest on an International boundary. John James Morley, the gentleman

who helped with the construction of most of the buildings in Gold Butte, built coffins and school desks, and timbered mines throughout the area. He was from England. His wife, Bella Dixon, was working as a housekeeper for her brother, Thomas Dixon, in Gold Butte when she met and married John.

Thomas Dixon was with the North West Mounted Police and was stationed at Writing On Stone military camp in Canada. The camp had a laundry service that was owned and operated by Chinese. Some of the Chinese people worked at the coal mine on West Butte and lived in Gold Butte. The women and children did laundry, dishes, and food preparation for the boarding houses and ranches in the area.

Claude Demarest was a young lad around nine years old when his father, Harry, took him to Gold Butte one day and they went into the Bucket of Blood saloon where Harry got Claude a soda. Claude was watching some men play pool when a ruckus broke out and before Claude knew what was happening, a Chinaman with a long braid hanging down his back jumped up onto the pool table and whipped out a knife. The Chinaman said *I can split a hair in the air* as he wielded the knife and circled the pool tabletop. He looked pretty big to a nine-year-old who had never seen anyone like that before in his life.

There was only one black gentleman who lived in the Hills for a period of time. His name was Charlie Coleman. No one knew Charlie's age, but he had memories of his family being sold. Matt Morgan knew Charlie because he had a little store on Wild Horse Lake up in Canada at the time Matt was riding the border as a brand detective. Charlie was stationed at a military camp in the Sweet Grass Hills from Fort Assiniboine in Havre when he retired from the military. When Charlie closed his trade post on Wild Horse Lake he came to Montana and worked on oil wells in Verdigris Coulee and for Frank Smith on his farm for many years. When Charlie got old, he moved to Sweet Grass and later he died in a home in Billings Montana. He was thought to be around a hundred years old when he died.

Another black retired calvary trooper was Tom Manis. Matt Morgan put a notice in the Chester paper one year tying these two gentlemen together at a point in time:

"Lost, strayed or stolen from Marias Roundup Camp on Willow Creek in Canada, one dark colored cowboy, speaks fair English and remembers things that never happened. When last seen he was headed for the Wild Horse Lake. He is supposed to have in his possession tobacco to the value of $4 and one light bay horse branded Masonic emblem on left shoulder. Former range, the Sweet Grass Hills. A liberal reward will be paid for his delivery to the Marias Roundup at Malta or to Bert Orr at Whitlash, Montana.

The cowboys were out of tobacco. We gathered about all the money there was in camp and sent Tom Manis to Charley's little store at Wild Horse Lake, Canada, for tobacco. Tom was about a week getting the tobacco and catching up with the trail herd of cattle that we were trailing east to Valley county, Montana. Nigger Tom was not in any hurry to get back on the job where trailing a large herd and standing a night guard on them in the rain was a lot different from visiting around and riding the grub line.

The roundup crew had a mock funeral on Cherry Ridge near the Canadian line for Tom Manis (alias Nigger Tom). Then Tom arrived back at our roundup camp the same night with some smoking tobacco and plenty of excuses. There are pictures of that bunch of cowboys who were with the Marias roundup that were taken by C.E. Morris in Valley County. These cowboys are scattered far and wide and many of them have saddled a horse and ridden him over the Big Divide." Matt Morgan, April 1, 1955 "Montana Farmer-Stockman" magazine.

There is a lot of ground to cover in Montana. 147,040 square miles of country does not give the full story of acreage counting sidehills and mountains in the State. Many of the hills in Montana are covered with grasses perfect for horses, cattle, sheep, and wildlife. Coulees create shelter from the winds and collection points for snow providing excellent conditions for regrowth of vegetation. About half of the State is high desert with miles of prairie and ancient lakes and riverbeds with excellent soil for farming. When homesteaders first began arriving, the eastern parts of Montana looked good for agronomists. Layers of rocks buried beneath the sod were disguised by the grasses that were under grazed and undisturbed. The wild animals that grazed the range moved as they grazed leaving little evidence other than manure which

provided for other life cycles. Indians knew the land and hunted on some in the heat of summer retreating to the Mountains in winter for shelter and running water as they procured their spring and summer harvests and prepared furs and skins to keep warm and protect their feet in the coming months. The open water provided fish for food. Wild game would come to the mountains to forage in winter and drink in the flowing pools. No need to travel far to hunt. The game came to the Indian.

By the time Montana became a State every State and Territory had run their Indians off. With very few horses, the nomadic tribes escaped the savage assaults of the white settlers by moving west. The northern plains Indians came to Montana. When they arrived, they found the same thing the settlers found. The resources had been harvested and the acres were being raped of whatever nature offered for human survival. Indians, trappers, and politicians were aware of the threats mounting in the unsettled territory in North America, but emigrants were pouring in and a young Nation was unable to keep up with the population growth and cultural changes. The more European settlers arriving, the greater the threat to indigenous peoples. The emigrants knew how to farm; on the lands they came from. The Indians knew how to survive on the native lands. Ready or not, change came.

CHAPTER 21

EDUCATION ON LOCATION

Knowing the lay of the land was important to the cattlemen in the day of open range. The elements that can make or break a stockman are water, grass, and snow. That beautiful white stuff that melts and fills the lakes and rivers in the spring can wipe thousands of head of livestock out in one night. Con Price, Charlie Russell, Fred Parsell, Elmer Smith and T.P. Strode did not accidentally get lucky when they filed their land claims. They all had ridden and worked in the Sweet Grass Hills through at least three winters and summers. They knew where the water ran and how the snow piled up and where there was a natural windbreak formed when two ridges met making an eddy breaking the onslaught blast of cold to a diffused whirl. They witnessed what happened to the animals on the open range when they didn't know the lay of the land and remained in place as they froze, sometimes standing in snow that had drifted around them making it impossible to move. Texas Longhorn cattle were not native to Montana. The fact is that horses, cattle, hogs, and domestic sheep were all involuntary emigrants to the land leaving their instincts dumbfounded.

There was a reason some of the stockmen in the years between 1850 and 1900 prospered and a reason many failed. Credit can be given to finance and management, and it's true that these two factors played into the end results, but luck and flexibility, peasant skills, and persistence carried many of these cattle barons over the great divide. There were a vast number of early stockmen invested in Montana cattle who never set

391

foot in the Territory. Another group were businessmen like attorneys, military officers, or politicians. Very few were Stockgrowers by origin. The last three groups mentioned were politically connected.

Since the territory had not been surveyed there were no boundaries. Open range for stockowners was from Canada to Mexico and everywhere in between. Then there was the Morrill Land Grant College Act of 1862 drafted by Representative Justin S. Morrill of Vermont. This land grant intended to "*benefit the agricultural and mechanical arts*", granted each state 30,000 acres of western land "*to be distributed by each senator and representative*". There was also the "*and*" clause which included the funding and construction of "*colleges*". These institutes of higher learning were "*normal*" schools, and what would be more normal in Montana than mounting a band of cowboys and teaching them animal husbandry? Higher education isn't always classroom or institutional learning, it can be OJT (on the job training).

Forming a nation on the east coast of America had been a hard-fought journey. There wasn't a realization of size or content of what was being fought over west of the Missouri, but by all accounts, there were millions of acres of productive land waiting for a population to bring them to their potential. Thirteen colonies were already becoming some of the largest producers of goods in the world. Politicians were anxious to see the fruits of their land purchase and they began making offers to get a population to settle the west. The last place to fill their anxiety was Montana. Indians had been moved to the center of North America from the eastern side of the Missouri River, from the south and west by Spaniards, and south from Canada by the Métis, French, and English trappers. The military knew the challenge these indigenous people presented and were attempting to create a workable solution that would insure an ostensibly benevolent policy of imperialistic expansion.

There were a few major oversites in the founding fathers' campaign for eminent domain. Most notable were education and communication. The slaves brought to the new world were doing most of the agronomy and were not being educated nor given the opportunity to contribute the knowledge they had and were learning about production and product in the New World. The Indigenous Peoples (Indians) did not

communicate and had survival skills limited to natural resources. These two large groups were given no rights to participate in the making of this nation. Following the Civil War, the *'planters'* and politicians found they knew nothing of *'how to'* farm or *'how to'* motivate the slave population that was supposedly at once *'free'*. One solution was to *"give them 40 acres and a mule"* for the freedmen and their families. William Sherman's Special Field Orders, No. 15 (series 1865) was not that the freedmen would own the land, but they would *'farm'* it and bring it to production. No thought was given beyond this.

In Montana territory, where would the land come from? The answer was obvious to politicians of the day. The Indians. The rabid presumption that this manipulation of human beings was and is delusionary and disgusting. The superiority complex of a few men who could read and write and were *'elected'* to *'speak'* for the new nation, when more than half the population didn't *'speak'* the same language and didn't have a vote, was incredulous. Nonetheless, this forceable conversion perpetuated. Suppression: the conscious intentional exclusion from consciousness of a thought or feeling. Women, Indians, Métis, Oriental's, and People of color were kept from the polls, yet were expected to live within the *'laws'* presented by a handful of white men who were perpetuating disinformation. Perhaps not intentionally, however, no attempt was made for corrections as the absence of equity was exposed.

An interesting phenomenon about Indigenous North Americans is that no apparent facts indicate that they were seeking to advance their territories or lifestyles. They were seemingly content to *'maintain'* within their tribes. Other than homeopathic study of herbs and food procurement to see them through winter months, these Peoples were found to be in a primitive state when compared to Europeans, Orientals, South Americans, and Africans who arrived in the 1600's. Recent studies of DNA, specifically the Neanderthal gene, show variant levels of the Neanderthal gene and discovery of older fossils reveal another gene, Denisovans. A trait found to be indicative of Neanderthals is their ability to build on what they learn or a potential for innovation. Neanderthals tend to push beyond what they learn by observation

and trial and error. Once they learn to use a tool, they seek other objects to replicate the use. Once they replicate the use with a new tool, they seek to improve the use. It does not appear that the Indians of North America were demonstrating Neanderthal traits. Since the Denisovan DNA has only recently been found it will be interesting to see what they learn about the evolution of the human brain. Studies of the Neanderthal DNA indicate the brain developed (grew) due to consumption of protein in the diet, predominantly meat. If the studies are correct the Indigenous Peoples (Indians) should have been able to grasp the religious and agronomic lessons that were given them. Unless alcohol influences RNA to an extent it lessens the ability to reason or decern. Liquor, disease, and starvation are weapons that perhaps genesis cannot overcome.

After starving, demoralizing, and slaughtering the Indigenous Peoples, the U.S. Government sought to 'acculturate' Indians into mainstream 'American Protestant values'. Education, including the written and unwritten policy of refusing to allow Indians to use 'traditional names', as well as the policy of taking the children away from their families and sending them to boarding schools far away from their homes to educate them according to the white man's culture continued. This took approximately two generations of children away from their parents in a society that learned by locution. During the time the families were separated they were being told and taught that their entire culture should be erased, and the ways of the white emigrants must be adopted. Many of the children's parents were gone when the young adults were returned. The world they had known disappeared and they had to begin their adult lives unsure of what was or what was to come. The Indian Nations felt like *ghosts*. In somewhat of a living state unable to do anything of their own free will. They began a chant and dance brought to them by the Paiute of Nevada.

Jack Wilson, a Paiute shaman or holy man, was told by his father that all whites would be wiped out. His father, Tavibo, preached the message of his vision that the renewed earth would be lush and plentiful with game. All the Indians who had died before would return to life and be young again. The *"Dance of the Souls Departed"* was interpreted

by the whites as a call to war when in reality it was the overwhelming feeling of hopelessness and despair across all Indian reservations in the West that fueled the spread of the 'Ghost Dance'. Regardless of the intentions or reason, Indian agents, missionaries, and military became fearful of the frequency and intensity of the dancing.

Benjamin Harrison was President in 1890 when the "Ghost Dance" participants included all Indian Nations in Montana / Dakota Territories. On December 29, 1890 Major Whitside reported the Seventh Cavalry had in their possession four rapid -firing Hotchkiss guns that could fire almost one shell per second for a distance of several hundred yards. As the Indians were happily loading their wagons and travois for the final leg of their journey to Wounded Knee, Colonel Forsyth ordered all weapons be confiscated from the Indians. One Indian demanded payment for a rifle and in the ensuing struggle a shot was fired. The troops opened fire with the Hotchkiss guns as well as their regular Army-issue weapons. Hundreds of Indians were slaughtered with the Seventh Cavalry shouting "Remember the Little Big Horn, Remember Custer". The unprovoked massacre of hundreds of unarmed women and children by US troops at Wounded Knee in December of 1890 marked the end of the "Ghost Dance" and the perceived Sioux resistance.

The Blackfeet Indian Nations had less cause to fear starvation than sickness because of their prehistoric ancestors. They believed they were surrounded by supernatural powers protecting them from evil influences. These powers were believed to aid them in their undertakings. They resided in the skies and in the waters as well as on the land. Sun and thunder were the most powerful sky spirits. Beaver and otter were potent underwater spirits. Buffalo, bears, elk, horses, snakes, eagles, crows, and other birds were believed to be able to communicate powers to the Blackfeet. As these spirits began to disappear at the hand of white men, sickness became a deadly force. The Blackfeet turned to the human form sent by white Chiefs expressing pity for the Indian and a desire to give the Blackfeet *some of the black robes power*. Supernatural powers were given to **men** in *dreams*. The dream experience did not come to the men while they were sleeping but rather when they were on a vision quest which required a journey to a

higher elevation without food or water for several days. This was one of the reasons the Sweet Grass Hills were considered sacred by all Indians. They provided both a journey to be reached and an elevation to bring them closer to the sky *spirits*. Spirits would appear in the form of man and show certain objects that were sacred, how they should be made and cared for, and how to manipulate the objects to bring success to the Indian on his quest. The objects would be gathered into a *"medicine bundle"*. *Medicine bundles* were personal and the powers the bundle held could be transferred by the man who received his power from a spirit helper. If the bundle was stolen or taken from the original man who had been instructed by the spirit to gather the contents, the man could replace the bundle by gathering the items again. The power of the items and the bundle remained with the man even after death. Powers which had been transferred stayed with the person they were transferred to and remained with that person after their death.

This stereospecific enlightenment is in part the reason for Indians distrust of the *black robes* sent by white chiefs to **teach** Indians religion, education, animal husbandry, and agronomy. The black robes seemed to each have their own teachings. They were not presented in the same way. Inconsistency led the Indian to distrust the power in the teaching. Vision quest spirits gave instruction on body painting for protection, fighting, and success in hunting. The black robes discouraged body painting and instead encouraged clothes to cover the body. The Vision quest spirits gave the Indian songs to lure the needed guide when called upon by the brave. The black robes taught one song to all in tongues the Indian did not understand. It added to the confusion and distrust the Indians felt towards white people encroaching on the lands where they and their ancestors had lived forever as they knew it. Women were caught between wanting to keep faith and their nurturing assignment. Nature allows the female less of an opportunity for a creative career because their bodies are the incubator for the seed of all future human population. Physically and mentally, they were occupied with keeping their families, husbands, and fathers healthy and vibrant. As their culture was corrupted and invaded, the Indian woman's role began to change. Some became medicine women. Some were traded by their

husband or father to the white man for various goods and property in hopes that the integration would ease the mounting tension between the cultures.

Medicine women had to have lived a virtuous life always being true to her husband. She assumed this sacred role by making a solemn vow to the sun at a time of crisis in her family. She promised the sun that if her sick loved one should regain health, or her warrior son or husband returned home safely from a perilous raid she would undergo the sacrifice of serving as medicine woman in the sun dance of her tribe. This was a demanding role embedded with personal responsibility for the success of the ceremony. The ceremony itself required physical strength, wealth, and fasting. The success of the sun dance was solely the responsibility of Medicine Woman. Some years other virtuous women pledged to serve as medicine woman to the chief of each band and informed him of the woman's promise pledging themselves to serve a less demanding role of *"coming forward to the tongues"* assisting the medicine woman.

The Sun Dance was a gruesome event and as time passed and liquor was introduced to the Indians, it became a frightening spectacle which dismayed and disheartened the "Black Robe Medicine Men". Father Pierre Jean De Smet was the first Jesuit selected to an assignment in Montana territory. In 1840 he met the Flatheads and was impressed by the opportunities for missionary work in this virgin field. Among the Flatheads the First Roman Catholic mission in the great northwest was formed. On Christmas Day in the year 1841, the first Blackfoot Indian converts to Christianity were received in baptism by Father De Smet. Father De Smet did not realize that the Indians looked upon Christianity as a war medicine more powerful than any they previously had possessed. Competition among the Blackfeet tribes for the *"Black Robe's God"* power became fierce. September 15, 1846, Father De Smet held mass in a Piegan camp where more than two thousand lodges were assembled, including Piegans, Bloods, Northern Blackfeet, and Gros Ventres of the Plains, and Flatheads and Nez Percés from west of the Rockies.

The morning after the mass Father De Smet composed a chant for

the Piegans which he had translated into the Blackfoot language: "*God Almighty: Piegans are all his children. He is going to help us on earth: If you are good, he will save your soul.*" From a Blood Indian leader Father De Smet learned that there were already a number of baptized children in that tribe. He was told that some sixty children among the Northern Blackfeet had been baptized by a black Robe from Red River and that they wore crosses at their necks. Father Thibault had accepted an invitation from John Rowand, chief factor of the Hudson's Bay Company, to come to Fort Edmonton to serve the Cree and Half-blood residents in that vicinity years earlier. Father De Smet presumed these baptized children were from Fort Edmonton and had been displaced south. Confident he had achieved lasting peace between the Flatheads and Blackfeet, Father De Smet returned to St. Louis leaving Father Nicholas Point to continue missionary work among the Blackfoot tribes.

Father Nicholas Point, a French priest, worked diligently among the Blackfeet for eight months making his headquarters at Fort Lewis (Fort Benton), the American Fur Company's post on the Missouri. Father Point was a gifted artist as well as a zealous churchman. He baptized twenty-two Blackfoot children, then extended his labors to the camps of the hunting bands, spending several weeks in each. Through his skill in portraiture, he won the interest and friendship of the chiefs. He held daily classes in Christian doctrine for each of three groups – men, women, and children. With the help of an interpreter, he translated the ordinary prayers into Blackfoot and taught them to these groups so that they could recite them from memory. Father Point performed and recorded no fewer than 651 baptisms among the Blackfeet. All but 26 of that number were children. He found the prominent men unwilling to accept his criticisms of polygamous marriages. Young braves who were baptized expected they would immediately be "Great Men", and all expected they would be protected from disease and bodily harm. May 19, 1847 Father Nicholas Point returned to St. Louis down the Missouri. It was twelve years before the Jesuit's sent another "Black Robe Medicine Man" to Montana territory. Indians were becoming more confused about the significant differences between Roman Catholic

and Protestant doctrine and wondered why each sect competed with the other when the basis of belief was Christianity.

In 1859, Blackfoot Agent Alfred B. Vaughan, a Protestant, founded a Jesuit mission on the Teton River near present Choteau. It was moved several times in the next few years and abandoned in 1866 because of Blackfoot hostilities toward the whites. In 1875, Father Imoda, who had been associated with the mission since its founding, summed up its meager achievements with this report:

"Some two thousand have been baptized in the various bands, some marriages solemnized, and in a few isolated cases a slight impression made upon their religious convictions, but except these slight results, the state of religion among the Blackfeet is about where it was when they first came under the notice of white men."

Agent Alfred B. Vaughan became the Blackfeet Indian Agent in 1857. Fur trader, Charles Larpenteur, described Vaughan thusly:

"A jovial old fellow, who had a very fine paunch for brandy, and when he could not get brandy would take almost anything which would make him drunk. He was one who remained most of his time with his Indians, but what accounts for that is the fact that he had a pretty young squaw for a wife: and as he received many favors from the [American Fur] Company, his reports must have been in their favor." "Forty Years a Fur Trader, II," 417-18.

Contrary to Larpenteur's characterization of Vaughan, Vaughan's annual report of 1858 recommended the prohibition of trade in buffalo robes to prevent the ruthless slaughtering of more buffalo than the Indians needed for their subsistence. Such was the competition of the day. Had Vaughan's recommendation been followed the American Fur Company would have gone out of business twenty-five years earlier than it eventually did. Trappers and traders making their living in hides and furs would have been left out of the market and perhaps the events that came to pass could have been altered for the betterment of the Indian Nations. Although Vaughan was a Protestant, he expressed the belief that *"Catholic missionaries have always succeeded in gaining the Indians' hearts, in controlling their brutal outbreaks, and ameliorating their condition in every respect."* During his first year among the Blackfeet, Major Vaughan

examined the valley of the Missouri and its tributaries searching for the most promising site for the farm which was guaranteed the Indians by the 1855 treaty. With the advice of Father Hoecken and Major John Owen, whose years of experience among the Flathead Indian farmers west of the Rockies qualified them as the best agricultural experts in the region, he selected a site on Sun River some fifteen miles above its mouth. The 1859 crop was a disappointment because of drought, but 1860 brought wheat, corn and other vegetables of all kinds and varieties in quality and quantity. To ensure the fertility and productiveness would abound, Vaughan requested $2,500.00 for an irrigation system and $10,000.00 to purchase cattle. The request for monies to purchase cattle was denied.

When the Civil War broke out Major Vaughan had to be replaced as he was a Virginian, and there was no place in Montana territory for a potential southern sympathizer. For 18 months the Blackfeet Nation was without an Agent. Gad E. Upson replace Vaughan. William T. Hamilton, an outspoken Indian trader, scornfully wrote about Upson: *"He knew as much about an Indian as I did about the inhabitants of Jupiter."* ("The Council at Fort Benton," Forest and Stream, Vol. LXVIII, No. 17, 649). As conditions for the Blackfeet deteriorated the tension and competition between emigrants, Indians, and fur traders escalated. Indian tribes began stealing horses. The military and whites could not distinguish between the tribes. Innocent people were being killed for crimes committed on both sides. When ten bloody white corpses of woodcutters were found at the mouth of the Marias in 1865, Governor Edgerton called upon James Stuart to organize a volunteer force to chastise the Indians. It was discovered that the Blood Indians lead by Calf Shirt had withdrawn northward beyond the international boundary. The proposed campaign against the Indians was called off. The Indians called the international boundary "**Medicine Line**" because when they crossed it, they felt safe as the United States Government could not pursue them. That was good medicine.

Try as they did, the Jesuits could not begin to educate the Indigenous peoples. Communication was a problem. In 1872 a young vigorous lay preacher named William Wesley Van Orsdel arrived in Montana from

Gettysburg, Pennsylvania with a message of tolerance and interracial understanding among the whites. After discussing religion, sharing stories of the Old Testament, and singing songs with the Blackfoot, Brother Van, as he was affectionately called, determined that there was little that could be done for the Indians until the moral ideal and practices of their white neighbors improved.

Reverend William Westley Van Orsdel born March 20, 1848. Brother Van died in Great Falls Montana in December of 1919. He is buried in Forestale Cemetery, Prickly Pear Valley near Helena, Montana. Born on a farm near Gettysburg, Pennsylvania, his Dutch father died when he was only 10 years old. He lost his English mother two years later. The oldest of the Van Orsdel children, William chose to strike out on his own determining to find "a place where the souls of this world could find peace and rest". This young man had a square set jaw identifying him with inherent stubbornness from the 'Dutch' side of the family. That determination led the Dutch to form a nation from a bog in the ocean. Not a bad conclusion for such stubbornness. What some would consider a boondoggle is just another challenge to the Dutch. At 12 years old W.W. Van Orsdel headed for Titusville, Pennsylvania where Edwin Drake was working with Pennsylvania Rock Oil Company developing the oil refining business drilling for oil.

It was 1860 when William Van Orsdel arrived in Titusville. Drake had developed a new method of extracting oil from rock salt and the interest in the use of petroleum for lamp oil fuel had risen due to the decline in supply of whale oil. Samuel Kier, the son of Thomas and Mary Martin Kerr, was experimenting with 'Rock Oil' the product that had been fouling the Kier's salt wells. At first the Kier's salt wells were dumping the presumed worthless oil into the nearby Pennsylvania Main Line Canal, but Samuel saw an oil slick catch fire and began thinking about potential use for this byproduct.

Samuel Kier had founded Royer and Co. in 1838. This company was a canal boat operation that shipped coal between Pittsburgh and Philadelphia. He also owned interest in several coal mines, a brickyard, and a pottery factory. As an early entrepreneur he invested with Benjamin F. Jones and others in iron foundries in west central Pennsylvania

eventually forming the Jones and Laughlin Steel Company, one of the largest steel producers in America. When Kier began experimenting with the Rock Oil he needed someone to assist him with a method of extracting the oil from the ground. He formed the Pennsylvania Rock Oil Company with George Bissell, Jonathan Eveleth, and two other investors. Bissell and Eveleth were partners in the Wall Street law firm, Eveleth & Bissell. Eveleth was a direct descendant of early colonial families of Massachusetts, Joseph Eveleth, juror in the Salem Witch trial of John Proctor, and a second cousin of Theophilus Parsons, Chief Justice of the Supreme Judicial Court of Massachusetts. Bissell was the son of George Bissell, a fur trader who died when George was 12 years old. George was a graduate of Dartmouth and worked as a newspaper reporter and teacher before moving to New York and going into partnership with Eveleth in their law firm.

Seneca Oil Company hired Edwin Drake to investigate the oil deposits around Titusville, PA. in 1858. This conglomerate chose Edwin partly because he had free use of the rail and he was available. Financed by Seneca, Drake purchased a steam engine to drill for the oil in the manner of salt well drillers. The well was dug on an island on the Oil Creek which was largely gravel. It took time for the drillers to get through the layers of gravel and the well began caving in at 16 feet. Drake had the idea to drive a cast iron pipe in 10-foot jointed intervals into the ground. At 32 feet they struck bedrock. Drilling tools were lowered through the pipe and steam was used to drill through the bedrock. The drilling was slow at just three feet per day. By 1859 Drake was running out of money. His colleagues back in Connecticut gave up on finding oil by April of 1859. After spending $2,500.00, Drake was not willing to give up on his idea. He took out a personal loan for $500.00 to keep the operation going. On August 27, 1859 Drake had persevered and his drill bit had reached 69.5 feet when it hit a crevice. The men quit for the day.

The next morning Drake's driller, Billy Smith, investigated the hole in preparation for another day's work. He was surprised to see crude oil rising. Drake brought the oil to the surface with a hand pitcher pump and collected it in a bathtub. This began the first oil drilling field in

the United States. The beginning of the oil fields where William Van Orsdel began his independent journey.

William did not like working in the oil fields. His mind continued to drift to the far West where he envisioned mountain men, Indians, and pioneers. He wanted to meet these people and see the land. He quit the oil fields and started working in revival work. In 1872 he heard a chaplain named John McComb preach in a brilliant style. William Van Orsdel decided to emulate this Chaplain and he approached him and asked for advice. *"Go away out west, young man"*, advised McComb.

William lost no time in taking that advice. He went to Sioux City, Iowa and in June of 1872 boarded the steamboat *"**Far West**"* heading to Fort Benton. The boy did not have the $100.00 fare. Captain Coulson asked, *"Why are you going west?"* William Van Orsdel said, *"To try to help bring Christianity to the native Indians."* The young man was given passage with the condition that he would *"preach and sing a little and help with chores"* while on board. He saw two Indian Chiefs on board the steamer, *Sitting Bull* and *Rain-in-the-Face* boarded out of curiosity and looked around at one stop to load wood. That trip on the ***Far West*** took 17 days and 20 hours docking in Fort Benton July 1, 1872. Brother Van would remain in Montana from that day forward.

The Blackfeet opened their first school at the Teton River Agency. Progress of the Indian children was painfully slow. As their teacher could not speak their language, she used pictorial charts which were first explained to the white children and the half-bloods in English. The bilingual half-blood children explained them to the full bloods. A Blackfoot agent interested in showing the effectiveness of his school's teaching methods, reported, *"I held up my hat and the school as with one voice said 'hat'. Repeating the same with slate, pencil, book, pen and the pictures of dog, cat, horse, cow, etc"*. Evidence of progress in teaching the Indians white man's ways began. Where the Catholic Jesuits had held school previously, the Methodist were charged with the education on the Blackfoot Indian reservation.

By 1875 there were reports that the children were learning to wash and comb their hair before entering school. They were singing hymns *"with great taste and correctness."* Girls were receiving instruction

in cutting and sewing. Boys were very irregular in attendance and were being taught to milk cows, wash and comb their hair, and basic gardening skills.

In his poem, "**Lasting Footprints**" Chas. A. Shrewsbury writes of Charlie Russell and Brother Van as they both arrived in Montana about the same time and both spent years in Great Falls when the town was growing, and the century changed. ... *"Where the Crow fought with the Piegan -And the warring Black-feet dwell,-Lies the range that Russell rode-And Brother Van served well.-*

Dauntless men of kindred spirit-As through life's full course they ran,- Purses lean but ever open- For each loved his fellow man,-

Russell seeking high adventure-Made of life a gay romance,-Quite content to leave the future-To the laws of fate or chance.-

Brother Van sought not a fortune-Nor cared he for great acclaim,- He was here to spread the Gospel-In his Holy Maker's name.-

Two great men with different visions,- Each has given of his best,-Left his footprints in his passing-Deeply graven in the West."

Both 'men of the west' gave Montana their best. Both could tell stories that resonated with their audience. They had the greatest communication skill. They were both good listeners. In addition to these skills, they were observant and respectful of everything and everyone in their presence. Both were also acutely aware of the influences of environment and education on people – of all ages and cultures. January 5, 1914 Charlie Russell wrote on a drawing of an Indian warrior: *"This is the only real American He fought and died for his country today he has no vote, no country and is not a citizen but history will not forget him."* The note was written to Judge Pray of Great Falls.

Brother Van was unique in that his temple was anywhere or everywhere, whether alone or with somebody, and sometimes any living thing. Con Price mentions Charlie and Brother Van in his book saying Charlie wasn't a church goer, but he was a real Christian and *"one old time preacher"*, a Methodist by the name Van Orsdel, would hold services in *"cow country"* among the cowboys and *"cattle rustlers"*. Brother Van told his flock that *"if we would do as God wanted us to do, we wouldn't need a fast horse and a long rope"*. Evidentially Brother

Van had a way of playing to the crowd. He spoke the language. To the Indians, he drew, he signed, he sang. However, he could communicate and whatever he could use to be sure his audience understood.

Con and Charlie were visiting with Brother Van discussing religion and Charlie said *he didn't believe in so many branches of religion* and said he *thought the people should have a general roundup and make them all one.* Brother Van said, *"That's a fine idea, Charlie, and make it a Methodist."* He told Charlie and Con he was riding a horse outside Fort Benton on the downside of a freighter pulling a big hill. He followed along behind this fellow and the language he was using on those cattle was sure strong. He said the fellow called each steer by some religious name with an oath after it, such as Methodist, Baptist, Presbyterian, and so forth. When the bull whacker got to the top of the hill, Brother Van asked him *"what was the idea of giving those cattle such religious names".* The man said, *"It's appropriate. For instance, there is old Methodist – when I unyoke him he walks out a little distance and paws on the ground, gets down on his knees and balls and bellers just like a Methodist preacher. Then there is that old steer I call Baptist. If there's a water hole anywhere, he will find it and get into it and throw water all over himself – and old Bishop there, he leads all the other steers".*

Con relates a funeral service Brother Van preached over a young cowboy who died when his horse somersaulted over him and broke his neck. The boy didn't have any family and the funeral was held in a store with about twenty cowboys with their chaps and spurs on, all of them nursing hangovers from drowning out the memory of the boy getting killed the day before. Brother Van preached a forceful sermon that brought tears rolling down his cheeks. The cowboys were all sobered up with not one dry eye amongst them, that *"tough old bunch of waddies".* There were many young men who died in Montana with no one knowing their real names, family ties, or background. Cowboys were taken as the appeared and disappeared. Their best friend was whoever they rode with on a tuff day. That was one significant difference in the whites and the Indigenous peoples in the settling of Montana. When an Indian died, whether male, female, child or adult,

their family knew or heard about it because they were born and raised within a few miles of where they eventually died.

The family tie of Indians was part of the perceived polygamy before the white man introduced alcohol to the Indian. Women were revered, and the men took chances. The men challenged each other when they were young in games of chance. When horses came, they attempted to train them when they knew nothing of their temperament or what they might do with the horse. They were often killed in a riding accident. Others perished on hunting trips. If the man was married, another male in the family took the woman or widow in. If there was a family, they too became the wards of a grandfather, uncle, brother, or another '**man**'. A woman was not to be left without a man to provide for her. These people were starving. Trappers and traders always brought '*trade*' goods, including food, and women were scarce. The term '*Squaw Man*' was not intended as a derogatory definition, it was a '*fact*' that entitled the "*man*" full rights with the Indians and with Hudson Bay Company. When communication was a problem it did not enter consideration by either party. Assumptions of polygamy eliminated any queries. As time passed, it's possible the women didn't know the reasons they were living with another family. This was further exacerbated when the Indian children were taken from the families they knew and sent to '*boarding schools*' and the children of these mixed marriage arrangements were labeled '*half-breed*'.

It is easy to see how creative productions, whether art, song, or acting, can enhance communication and unite groups with a common thread. To see someone draw an image of a bear, buffalo, fish, or horse was like seeing a magician pull a rabbit out of a hat. It was magical to the Indian. These were images of good medicine to the Indian. Something they could keep, empowering them. Having a model made of wax or clay or carved was even more magical. These items were symbols that could be worn, carried, or displayed to demonstrate and denote purpose. Even the early teacher '*drew*' images to show an object as they taught the word for the objects name. The monotony of washing, sweeping, planting seeds, milking cows, and sewing did not seem so tedious when music was added with the chore. Sign language is a form or mime.

Acting or performing is similar to participation in a 'ceremony' giving a visual for a sermon or a story. Universal language has always used these tools or arts if you prefer. Sign talkers are readily understood. The vocabulary of signs is rich enough to permit strangers who understand scarcely a word of each other's speech to exchange information and ideas in meaningful silence for hours on end.

Women played an important part in settling the west. Sacajawea provided inestimable information to Lewis and Clark. Jane McManus Storm Cazneau (1807-1878) was the first female American Journalist and War Correspondent in the Mexican American-Texas Wars. Medicine Snake Woman, Blood Indian Princess, and wife of Alexander Culbertson helped Isaac I. Stevens secure the Lame Bull Treaty. August 1, 1853 the Stevens exploration party met Ms. and Mr. Culbertson at Old Fort Union. At that time Stevens was governor of Washington Territory and ex officio superintendent of Indian Affairs. He had secured Alexander Culbertson as special agent to introduce him to the Blackfeet Indians who were thought to be some of the most formidable and warlike Indians on the North American continent. Stevens had been assigned the triple responsibility of leading a railroad survey, governing a large, newly established territory of the United States, and inaugurating official negotiations with the Blackfeet Nation.

Following their meeting, Culbertson sent presents and tobacco to the Blackfoot chiefs with this message from Governor Stevens:

"I desire to meet you on the way and to assure you of the fatherly care and beneficence of the government. I wish to meet the Blackfoot in a general council at Fort Benton. Do not make war upon your neighbors. Remain at peace, and the Great Father will see that you do not lose by it."

Alexander Culbertson intended on leaving his wife at Fort Benton, but she insisted on going with him saying:

"My people are a good people but they are jealous and vindictive. I am afraid that they and the whites will not understand each other; but if I go, I may be able to explain things to them, and soothe them if they should be irritated. I know there is great danger; but, my husband, where you go, I will go, and where you die will I die." (Reports of the Commissioner of Indian Affairs, 1854, 196.)

Mrs. Culbertson was in constant communication with the Indians. She listened to what they said and reported it through her husband to Governor Stevens. Knowing her people's love of good stories, she entertained them with accounts of the whites she had seen in St. Louis. She described a fat woman she had seen exhibited, and sketched caricatures of the ladies of St. Louis. The Indian women delighted in her presentation and flocked around her watching with their faces beaming. She induced the Piegan band Chief Little Dog, her cousin, to accompany John Mix Stanley, the artist of the expedition, to the great camp near the Cypress Hills, to persuade their chiefs to come to Fort Benton to the council with the Governor. Stanley won the admiration of the Blackfeet by taking daguerreotype portraits of them. *"They were delighted and astonished to see their likeness produced by the direct action of the sun. They worship the sun, and they considered that Mr. Stanley was inspired by their divinity, and he thus became in their eyes a great medicine man."* (Stevens, "Narrative," PRR, XII, 104-105.)

On September 21, 1853 Governor Stevens met some thirty chiefs, braves, and warriors from the three Blackfoot tribes in council in a large room at the trading post of Fort Benton. The Indians were dressed in their finest clothing *"of softly prepared skins of deer, elk or antelope ... ornamented with beadwork."* They carried Northwest Company guns and bows and arrows. The Governor stressed the need for the Indians to make peace saying:

"Your Great Father has sent me to bear a message to you and all his other Children. It is, that he wishes you to live at peace with each other and the whites. He desires that you should be under his protection and partake equally with the Crows' and Assiniboine's of his bounty. Live in peace with all the neighboring Indians, protect all the whites passing through your country, and the Great Father will be your fast friend."

Chief Low Horn answered for the Piegans. He told Stevens that the chiefs could not restrain their young men. Their young men were wild, ambitious, and anxious to fill their places in the tribe being braves and chiefs. They wanted to win the favor of their young women by some brave act like bringing in scalps and horses to show their prowess. Chief Low Horn and the other chiefs said they could not speak for those of

their tribes who were not present. The council broke up and Governor Stevens distributed $600 worth of presents. The Indians *were greatly pleased.*

The Indians had been truthful and forthcoming to Stevens about what their abilities to commit to only the things they, not their peoples, had the ability to control. Stevens left with a complete feeling of success. He believed the Indians to be his "fast friends" and the Indians disposition towards all whites would be unquestionably friendly. White man *may travel through this country in perfect safety* was his opinion. Stevens continued west with his railroad explorations leaving his assistant James Doty with three men in Fort Benton to explore Mullin Pass. Doty was to collect information about and take census of the Blackfoot Indians. Doty visited the Indian winter camps on the Marias and Milk rivers and made the first known physical measurements of several hundred adult males yielding an average height of about five feet, eleven inches. Doty determined the Blackfoot population to be four tribes, Bloods, Blackfeet, South Piegan, and North Piegan. The North Piegan spent the summer in the north and traded with Hudson Bay Company on the Saskatchewan and the South Piegans who summered south of the international border and traded only with the Americans on the Missouri.

Doty may have been the sharpest tool Stevens had to leave behind, but he certainly lost the big picture to minutia. In the spring of 1854, he explored the Blackfoot country following the eastern base of the Rockies northward from Sun River past the Teton to the upper tributaries of the Marias, Milk, and Belly rivers. He located Marias Pass and followed it for several miles but failed to reach the summit. He also collected and preserved 320 varieties of flowers found in and near Blackfoot country. His collection would have been an immense value to botanists if his instructions to carry the specimens forward down the Missouri had been followed. Instead, the collection became moldy and useless because he did not follow up to see that it was done. This mentality did not instill confidence in the Indians towards the Great White Chief. He may have deterred some of the chiefs from making war on their enemies, but other chiefs and many young warriors said, *"This is the last winter*

we can go to war, next summer the white soldiers will stop us, let us steal this winter all the horses we can." And so, they did.

The council that was planned for the summer of 1854 was postponed due to Governor Stevens duties. Stevens had hoped to secure a route through the Rockies for the Great Northern before the Pacific railroad could join the Central Pacific linking the East and West Coasts of America. Because of Doty's inability to identify Marias Pass, Jefferson Davis Secretary of War, favored the southern railroad route and ordered the northern survey discontinued. James Hill continued with his own initiative and finance. Dismayed that the northern railroad line would not transpire as planned, Stevens set about organizing a treaty council securing $10,000.00 appropriation. Stevens had white man's visions of what Montana could be if the land potential were changed from warlike and nomadic to peaceable and agricultural. He relayed his sentiments to Alexander Culbertson who responded to Stevens:

"As to Agricultural operations they are not to be thought of as long as Game is abundant. Indians will not work unless their necessities compel them – it is beneath their dignity – and it is evident the day is far off when the Blackfeet will turn the Sward into the Ploughshare and make the wilderness bud and blossom like the Rose."

In the spring of that year George Manypenny, commissioner of Indian Affairs, was aware of the government's plan to *"gradually reclaim the Indians from a nomadic life"* and to *"encourage them to settle in permanent homes and obtain their sustenance by agriculture and other pursuits of civilized life"*. Manypenny stressed that the major objective of a treaty should be the establishment of permanent peace *"with all the most numerous and warlike tribes in that remote region of country"*. Alfred Cumming, superintendent of Indian Affairs from St. Louis, was named commissioner for the United States for the proposed meeting. Cumming opposed Stevens opinion that the Blackfoot Indian's future was in farming. He looked at farms as a philanthropist. In the end, Stevens philosophy prevailed.

Prior to Alfred Cumming, David D. Mitchell was superintendent of Indian Affairs in St. Louis. He had recommended the government call a council with all the Plains tribes living between the Missouri River

and Texas to make formal arrangements to indemnify the Indians for their losses and to define intertribal boundaries. Mitchel pointed out that *"the boundaries dividing the different tribes have never been settled or defined; this is the fruitful source of many of their bloody strife's; and can only be removed by mutual concessions, sanctioned by the Government of the United States"*.

May 26, 1851 Mitchell was authorized to hold a council with the **"Indian tribes of the Prairies"**. He instructed his former colleague in the American Fur Company, Alexander Culbertson, to select delegations from all the Upper Missouri tribes. Word reached Culbertson at Fort Union too late to permit him to obtain delegates from the Blackfoot and Gros Ventres tribes. Culbertson was able to assemble delegates from the Assiniboine, Hidatsa, Mandan, and Arikara to accompany him to Fort Laramie. The Treaty of Fort Laramie was signed defining the lands that would be Blackfoot Country. A formal description of this portion of the Blackfoot country appears on the sheepskin copy of the Treaty of Fort Laramie, preserved in the National Archives in Washington. The treaty was signed by prominent chiefs of two tribe's hostile to the Blackfeet, as well as by two white men who were their *'old friends'*. D.D. Mitchell, the senior United States commissioner at the council, Alexander Culbertson, husband of a Blood Indian, and Father De Smet, who prepared the official map on which the tribal boundaries agreed upon at the treaty were indicated. There were no tribal delegates from any of the Blackfoot tribes at the Fort Laramie council. Their interests were protected by intelligent, knowledgeable, and sympathetic white men.

In the period of time from October 4, 1854 to September 27, 1855 the Fort Benton Journal reported no fewer than forty-eight outward bound or return war parties which stopped by Fort Benton. Some had as many as thirteen men: others were smaller. There were many other war expeditions during that period which did not pass near Fort Benton. On his way to the council east of the Rockies, Governor Stevens passed through the Flathead where the Flathead and Pend d'Oreille tribes west of the Rockies complained of the frequent Blackfoot attacks on their camps during the two winters that had passed. Father Hoecken, their

priest, reported that the Blackfeet had *"committed more depredations than ever"* during the spring of 1855.

The council set to be held in Fort Benton was moved to the north bank of the Judith River just below the mouth because the boats bringing the presents upriver from St. Louis were delayed and the presents were to be given to the Indians immediately after the conclusion of the council. Gustavus Sohon simply portrayed the semi-circular rows of principal chiefs in front with lesser chiefs behind and the other Indians to the rear gathered facing a canvas-covered arbor in a large grove of cottonwood trees. Governor Stevens spoke following the distribution of tobacco as tokens of friendship among the Chiefs of the tribes' present.

*"**We want** to establish you in your country on farms. **We want** you to have cattle and raise crops. **We want** your children to be taught, and **we want** you to send word to your Great Father **through us** where you want your farms to be, and what schools and mills and shops **you want.***

***This country is your home**. It will remain your home and **as I told** the Western Indians **we hoped** through the long winters, by and bye, the Blackfeet would not be obliged to live on **poor Buffalo Meat** but would have domestic Cattle for food. **We want** them to have Cattle.*

You know the Buffalo will not continue forever. Get farms and cattle in time."

Somewhere in the beginning of the speech, perhaps the first *"**We want**"* the Indians became confused. They did not comprehend what a farm, school, mill, or shop was nor did they understand the comparison of Buffalo meat to cattle for food. Stevens continued explaining in the first two articles that there would be perpetual peace between the United States and the Indians party to the treaty, as well as intertribal peace among those tribes and with **all** neighboring tribes. The third article defined "The Blackfoot Nation" as the territory outlined in the Fort Laramie treaty. This land *"shall be a common hunting-ground for ninety-nine years, where all the nations, tribes and bands of Indians, parties to this treaty, may enjoy equal and uninterrupted privileges of hunting, fishing and gathering fruit, grazing animals, curing meat and dressing robes."* But no tribe would be permitted to establish permanent villages

412

or exercise exclusive rights within ten miles of the northern line of this common ground.

Articles IV and V described exclusive Blackfoot Nation territory. The boundaries were drawn on a map and shown to the chiefs. Alexander, the Pend d'Oreille chief, objected to the provision prohibiting his tribe from hunting on the plains north of the Musselshell River. He asserted his ancestral right to hunt in that region, saying, "A long time ago our people used to hunt about the Three Buttes [Sweet Grass Hills] and the Blackfeet lived far north." Little Dog, the Piegan chief, was inclined to let Alexander have his wish. This was the first 'push back' Stevens had roused from the Indians. With his arrogant babble producing some 'pictures' in map form, the Indians were beginning to understand some of what the chatter was about. Stevens began to explain that the numbers of peoples in each tribe varied and the smaller populations would receive a smaller area where the larger tribes would receive more.

Chief Alexander stood fast on his desire to hunt on the plains in the territory assigned to the Blackfoot tribes. His fellow chief, Big Canoe, War Chief of the Piegan, questioned the basic concept of tribal boundaries, saying, "I thought our roads would be all over this country. Now you tell us different. Supposing that we do stick together and do make a peace ... Now you tell me not to step over that way. I have a mind to go there." Stevens made a big mistake in presenting a map. Now the Indians knew what he was talking about. The land they knew and hunted. Lame Bull, the head chief, spoke and said his people did not write this treaty. Alexander remained silent. Commissioner Stevens wisely recessed the proceedings until the next day.

The following day the Treaty continued to skew all things 'white' in favor of United States citizens which the Indians thought included them. They did not realize that Indians, Blacks, and women were not Citizens. Really, they had no say in any agreements of property considered the United States of America. The Government would expend $20,000.00 to these "forever free ... citizens of the United States". Another annual payment of $15,000.00 of "useful goods and provisions would be given the four tribes of "The Blackfoot Nation" for a period of ten years. These goods and provisions would establish instruction in agricultural

413

and mechanical pursuits, educating their children, and in any other respect promoting their civilization and Christianization. Compared to what and according to whom? No one asked that question. Provisions excluded the use of intoxicating liquor with the promise to withhold annuities to anyone abusing this provision. The treaty was obligatory from the date hereof, and upon the United States as soon as the same shall be ratified by the President and Senate.

Lame Bull and Seen-From-Afar expressed some concerns, but ultimately placed their mark (X) on the Treaty. The gifts that were to be given immediately following the signing of the Treaty were piled high on the council ground. They served as a constant reminder to the Indian negotiators of the happy prospects ahead. When the last Indian had signed the gifts were distributed. They included blankets, cotton prints, sugar, coffee, rice, flour, and strange white men's foods. The Indians threw the food in the air and were amused to see it fall to the ground and cover the grass with its fine powder. They emptied the quantities of sugar into a stream and eagerly drank the sweetened water. They cooked huge batches of rice until their kettles overflowed with the odd, sticky foodstuff. They did not care for the taste of the coffee and eventually sold it to the white traders. No one thought to tell them to roast and grind the raw beans to mix with hot water. Six days later Commissioner Cumming headed back to St. Louis and the following morning Governor Stevens set out the opposite direction. Stevens reported that the signing of the Blackfeet Treaty October 17, 1855 "*succeeded to our entire satisfaction, and indeed, beyond our most sanguine expectations*". The Treaty was forwarded to Washington, ratified by the Senate on April 15, 1856, and proclaimed by the president of the United States 10 days later.

Lame Bull, also known as Lone Chief, was head chief of the Piegan tribe. Seen-From-Afar was chief of the Blood Indians. Each of these chiefs led a band. Lame Bull's band was the Hard-Top Knots Band numbering about 100 lodges by Stanley's estimations in 1853. Presbyterian Reverend Mackey met Lame Bull at the mouth of the Judith River in mid-September of 1856 where they awaited the annual shipment of annuities due the Indians under the terms of the treaty.

Mackey asked Lame Bull if he would permit white men and women to establish a mission among his people and after consulting the other chiefs that night Lame Bull agreed to allow the mission. The full reply Lame Bull gave Reverend Mackey would indicate that Lame Bull regarded 'white men' as friends and an understanding of their God as a Great Spirit. It also indicates that the white superiority inference was beginning to cause the chief to question the Indian way of life:

"We are satisfied that white men are our friends, if they were not they would not go to the trouble of sending us so many valuable presents each year. We desire them to come and teach us the Great Spirit and tell us plenty of good things. When we catch a wild animal on the prairie and attempt to tame him we sometimes find it very hard. It may take a long time and a great deal of patience but almost any animal can be tamed by kindness and perseverance. We have been running wild on the prairie and now we want the white sons and daughters of our Great Father to come to our country and tame us ... We have a fine country and we are not ashamed to have white men come and see it."

Lame Bull didn't imagine that *"kindness and perseverance"* were not part of the equation his *"white friends"* had in mind to 'tame the savages'. Time marches on and leadership changes. The following year, 1857, Lame Bull's Hard Top Knots band was hunting buffalo near the Sweetgrass Hills. In the dust of the chase Lame Bull's horse was attacked by an enraged buffalo bull. The bull rolled the horse over its rider and Lame Bull's ribs were crushed and his neck broken. He died instantly befitting his name at the mercy of a bull buffalo. The Indians say they buried Lame Bull on a platform inside his lodge and twenty of his horses were killed for his use in the afterworld. The white man's story is that the body of this great chief was taken to Fort Benton and buried there. He was thought to be about 60 years old when he died.

Many of the other Piegan band chiefs who placed their marks on the 1855 treaty died equally violent deaths. Big Snake (rattlesnake), chief of the Small Brittle Fat Band, loud-mouthed-announcer in the tribal summer encampment and prominent war leader, was killed in a battle with the Cree Indians near the Cypress Hills in 1858. Little Dog, Governor Stevens' favorite chief of the Black Patched Moccasins

Band and successor to Lame Bull as head chief of the Hard-Top Knots', was murdered by his own people in 1866. Middle Sitter (also known as Many Horses), chief of the Never Laughs Band was killed by the Gros Ventres' in 1866. Mountain Chief, second in rank among the Piegan chiefs in 1858 and successor to Little Dog as head chief of the tribe, was shot and killed (possibly by mistake) by another Blackfoot Indian in 1872. Seen-From-Afar, the Blood chief and chief of the Fish Eaters' band, was the brother-in-law of Alexander Culbertson, died in the smallpox epidemic of 1869. Calf Shirt, chief of the Quarrelers Band was murdered by whisky traders a few years after the smallpox epidemic.

In all the treaty was signed by fifty-nine prominent leaders of eight different tribes gathered at this most important intertribal treaty signing held on the northwestern plains. The combined population was estimated at around 12,000 occupying a vast area in present Montana and the Canadian provinces of Alberta and Saskatchewan. As time passed the Treaty became known as Lame Bull's treaty. Lame Bull advocated for this agreement and did not live to see what the full meaning of the agreement was to the 'white man'. The "*fine country*" he wished for the "*white man to come and see*" changed in two decades beyond his recognition.

John Mix Stanley's lithograph of the Piegan Indians hunting buffalo near the Sweet Grass Hills is near the location where Lame Bull died. Albert Bierstadt made a painting titled "The last Buffalo" in 1888. His setting is west of the Sweet Grass Hills with a similar background as Charlie Russell's "When law Dulls the Edge of Chance" and O.C. Seltzer's "Outpost" background appears to have the north side of East Butte in the Sweet Grass Hills as it's background. Bierstadt and Russell's paintings backgrounds are painted north of Babb near the Chief Mountain Port of entry south of Cardston, Alberta, Canada. The photo on the back cover of this book was taken by Dean Hellinger, May 4, 2020, 9:08 P.M. It shows the area southwest of East Butte. Sharkstooth Butte is centered in the photo. The military encampment and head of Sage Creek located in the saddle between Sharkstooth and East Butte. The photo is near where Lame Bull was buffalo hunting when he was fatally injured.

CHAPTER 22

ELOQUENT RETROSPECT

Gold Butte is the perfect setting for the saying, "all that glitters isn't gold". The real riches that make or break a community, town, or home are the people. What they do with themselves and the resources around them are what make a difference or change. This small little village set on the northernmost part of central Montana had dozens of infinitely famous people pass through. Among the few who were born in Gold Butte and died in the same community in the 21st century was the daughter of Martin and Elsie Kopplin Weidemann, Norma Jean Weidemann. Norma lived in Gold Butte where her parents ran the Mercantile store until 1941. Norma was born October 13, 1920 in Great Falls, Montana. Norma married Melvin Wehr, May 21, 1940. At that time, her parents decided to move to Shelby. Gold Butte had dwindled, and the mercantile business had turned into more of a service for the community than a profitable business. Norma and Melvin took over the store, but business was slow. Gold Butte began as a tent city with Indians and miners in dugouts and tents with the gold keeping a steady flow of people coming into the area. About the time gold ran out (except for small findings) a coal mine was discovered on West Butte bringing in another steady stream of people waiting to fill their wagons or find work. Gold Mining companies came in again, but the crews did not live in Gold Butte. They drove from Shelby and dredged employing a few locals, but no mother lode was discovered and the digging soon ceased leaving the hills pitted, scared, and littered with equipment.

Then black gold was discovered. Oil became the next stampede. In between and during all the activity settlers were leaving the Hills, many being bought out and large livestock ranches were taking shape in place of the small farms. Farming was burgeoning as the lowlands were very productive and tractors had replaced teams and plows. Automobiles were common and gas was affordable. People were 'driving' to town for their supplies and the only store left in the Sweet Grass Hills was serving as a meeting place and post office. Norma was expecting her first child and wanted to stay in Gold Butte one last Christmas, but the winter was too harsh. Melvin and Norma closed the store in Gold Butte leaving the town abandoned and moved to Shelby to live with her parents for the remainder of the winter. Norma delivered her first child, Ronnie Wehr, December 30, 1941. Melvin Wehr died June 25, 1942 in a vehicle accident in Wyoming. He was operating an oil truck around a sharp curve when his vehicle veered out of control and his neck was broken in the accident.

Norma didn't return to Gold Butte right away. She remained in Shelby for a few years with her parents. She had graduated from Shelby High School in 1937. She began working in Shelby Schools' administration as secretary for Norman Wampler for two terms, Norma managed as a single mother with her son, Ronnie. When her son was old enough, she went to work cooking and helping ranches in Toole and Liberty Counties. Ronnie Wehr's fraternal grandparents, Harold and Pearl Wehr, lived in Shelby. Harold was a barber and had his own shop. Norma Weidemann Wehr married Jim Wood March 9, 1946.

Jim was born in Burlington, North Dakota February 28, 1910. His family was living in Idaho in 1918 where his father died in the flu epidemic. His mother, Margaret, was left with five children when she became a widow. Unable to manage on her own she took her family to Saskatchewan where her in-laws lived. The arrangement was not satisfactory, and she moved to the Sweet Grass Hills where her mother, Bertha Loehr, and brother, August lived. Jim Wood was nine years old at that time.

Jim was born in Burlington, North Dakota February 28, 1910. His family was living in Idaho in 1918 where his father died in the flu

epidemic. His mother, Margaret, was left with five children when she became a widow. Unable to manage on her own she took her family to Saskatchewan where her in-laws lived. The arrangement was not satisfactory, and she moved to the Sweet Grass Hills where her mother, Bertha Loehr, and brother, August lived. Jim Wood was nine years old at that time.

Margaret Wood taught school in Liberty County. She met and married Clarence McDaniel in 1924. Together, Clarence and Margaret had six children making 11 children for Margaret. The McDaniel's took in borders as Margaret's first family grew and left home. She worked as postmistress at Hill when she retired from teaching. Jim Wood finished his High Schooling at normal school in Havre. Following graduation, he worked as a ranch hand until joining the army during World War II. When Jim was discharged from the Army, he went to work for Mrs Lydia Roke and her nephew, Amez Droz at their ranch on East Butte.

In 1944 Jim Wood and Norma Wehr were both working for the Prescott's in the Sweet Grass Hills. Norma was cooking for the ranch hands. Prescott's had a ranch north of Havre where Norma, Jim, and Ronnie lived their first year together. The following year they worked at a ranch in Giltedge, a small-town northeast of Lewistown. In 1947 they bought the Louis Beer ranch in the Sweet Grass Hills. The ranch was the original Joe Berthelotte homestead and had belonged to Riley Robinson before Louis Beer bought it. Norma and Jim's son, Jon, and his wife, Janice Bozarth Wood continue to live on ranch where Jim and Norma are both buried.

Ron Wehr had relatives living in Rudyard and Chester that he didn't know. A 1909 newspaper mentions a "Jacob Wehr": *"Jacob Wehr, one of the first to file on land near Chester, arrived recently from Odessa, Washington with his family and has erected a building on his claim just southwest of town. Mr. Wehr intends to engage in the contracting business at an early date."* December of 1909 the Liberty County Times reports: *"Jacob Wehr, contractor, started a force of men to work on the sidewalks Tuesday morning."* 1912 Local column reported: *"Jake Wehr and family went over to Inverness this morning to spend the day with relatives."* In 1913 the "Locals" column reported: *"Jake Wehr returned Tuesday from a*

trip to Canada and says he is going there to live." 1915 paper states: *"Mr. Wehr, the Ford dealer at Inverness, was in town Sunday"*. There were two other Wehr's in the Sweet Grass Hills, Walter Wehr and Elsie Wehr Demarest. Walter was a bachelor all his life. He came to the Hills from Minot, North Dakota to teach school in Whitlash and then was called to duty when WWII broke out. Elsie, his sister, came to replace him as schoolteacher.

Elsie lived in the Hills the remainder of her life. She married Claude Smith Demarest (no relation to Hiram Smith). Claude and Elsie Demarest had two children, Auvern Demarest Dieffenbach and Douglas Wehr Demarest. Douglas remains on the ranch his grandfather, Harry Smith Demarest homesteaded. Harry married Ameila Brown, the fourth daughter of John and Mary Brown. Harry and Ameila raised a family of four in the Sweet Grass Hills. Mable Demarest Iverson (wife of Carl), Helen Demarest Weber, Claude S. Demarest, and Lucille Demarest Ritter (wife of Clarence). Douglas W. Demarest married Roberta Larson Dobrovolny. Roberta brought a daughter, Paula, to the marriage. Doug and Roberta have two children: Marty, who remains on the ranch north of Whitlash with his father, and Crystal D. Demarest who married Matt Enneberg. The Enneberg's have two sons, Carter and Caige, living in the Kevin-Sunburst area in 2020. Paula, daughter of Roberta A. Demarest married Dolan Hull. Paula brought two sons to her union, Reid, and Rylan Broadhurst. The Hulls are raising their family of four, Tyson, Tatum, Timber, and Teagan, in Chester.

It is easy to see how communities grow. The above is a sampling of relatives expanding and it leaves out the extended families of the people mentioned. The Sweet Grass Hills is one of the most isolated and insulated communities in the world, yet it has seen the ranches and farms change ownership and families that had three generations grow up in the community then disappear. In a strange fashion, the ebb and flow of life then begins to flow back. In the last decade, the grandsons of two families, Bill Schafer and Virginia Johnson Ratzberg have moved back to the Sweet Grass Hills and are ranching and farming much as their grandparents did. John Brown, that grand old blacksmith in Gold Butte, has a great great grandson on his homestead north of Whitlash.

John's grandson, Buster Brown, married Helen Sisk, granddaughter of Robert Sisk. The Brown ranch yard is divided by Breed Creek into two counties. The barn is in Liberty County and the house is in Toole. The Indians were still coming to the Brown Ranch to harvest sweet grass for their ceremonial use in the 1950's. Janette Tomsheck Brown harvested the grass and made braids for gifts. She knew the best locations to send the Indians to for gathering. She allowed them to go on their own once describing where the largest growth would be found. She did not think the Indigenous peoples would need instructions on harvest, but after a few years she noticed the sweet grass was disappearing from the locations where she had sent them. What she noticed was in their desire to gather as much as they could the Indians had pulled much of the rhizomes from the ground with the base of the grass causing a loss in reproduction. Compounded with global warming and a decrease in the water flow on Breed Creek, the sweet grass meadows on the Brown Ranch have nearly disappeared. Sweet grass is still growing in its organic state in the Sweet Grass Hills, but not in the abundance it once did.

The Clark families are still on West Butte as are Berthelote's, Rankin's, and Nutter's taking care of their fragile landscapes with tender stewardship of their livestock and crops. Most of the Fey's and Christian's have left, but some of the first families of the Sweet Grass Hills, like Parsell's, Thompsons, Wood, Demarest, and Eide's remain. Grand and Great Grands are raising their families on ranches their families have owned for more than a century. T.P. Strode left the Hills and his relatives sold out and left. Hawley's, Smith's, Murray's, Pritchitt's, Hicks, Furnell, and Lakey's have all disappeared from the Sweet Grass Hills. Stratton, Thompson, Demarest, and Brown are still ranching with their homes located on Breed Creek. Wickhams' have their ranch near Sharkstooth where the calvary camp was located on East Butte. Nestled at the south side of Middle Butte on the flat is the Eide ranch. Lester Eide walked to the top of East Butte at least once a year as long as he could. He says: *"There's a coffee can with a lid that holds paper and pencil up there and I'm going to climb up there and sign that paper every year as long as I can."* Lester's grandson is following his

grandad's trail ranching along with his parents, Les and Jackie Eide, in the shadow of the 'slipper' on Gold Butte.

No doubt these pages have left out some important people, but trails plowed under are hard to track. Charlie Russell found a corner of the world that was as close to the wild west as he could get in his lifetime and put a lot of what he saw down on canvas, wood, paper, and bark. Some of what he got down was in sand and became part of that trail. There are still a few folks that make a trip up to Gold Butte (or what was Gold Butte) and look over the cemetery with its majestic view to the west. If they know how to, and there's water in the gulch, they might pull out an old gold pan and see if they can flush out a few flakes of placer gold. Oh yes, there's still gold in Gold Butte, but she is hanging on to it tightly. Black gold is still flowing, but new fields have been well drilled. The coal mine closed almost a hundred years ago and there has not been a need for it with natural gas and electricity abundant.

Karl Jeppesen was the Field Deputy Assessor in Chester as the town transitioned from Choteau, Hill, then Liberty County. December 30, 1951 he wrote an article for the Liberty County Times: "Reminisces Nearly a Half Century of Local Historical Events". Covering the territory and time period evaluating land values gave Mr. Jeppesen an intimate knowledge of the transitioning taking place for families and land use. Jeppesen says:

"In 1913 and 1914 a lot of new settlers, mostly young people, flocked into the area north of the Marias river some distance south of Joplin, Inverness and, Rudyard. Here appeared to be a real opportunity; 160 acres in a formerly restricted area, of choice land, mostly free of rock, and gently sloping to the south. A potential and very promising irrigation area and water from a dam, tentatively decided to be built near the Brinkman ranch, was an immediate prospect." Karl goes on to say that 1914 was disappointing and 1915 started out very dry. World War I was in full swing and there was a demand worldwide for foodstuffs. In May it started to rain saving the crops. Crops were good and prices were better. A few crops were hailed out, but overall, with the high prices, the farmers did well. 1916 was exceptionally good followed by 1917 which

was dry followed by 1918 which was drier. There was no government relief. Many men left their families and went to work in other states.

Liberty County was bonded for $125,000.00 in order to provide seed loans for the farmers. During these years Karl was doing his assessing from the back of a horse. People would allow him to stay with them and their families while he rested. They fed and sheltered his horse. If his horse were too tired, they would loan him a horse that he could swap back on his return trip home. He says he was heartbroken to see people lose their lifelong savings, ambitions, and hopes lost by nature's whim. Meals became meager. New clothing was not in evidence, yet they gave the most humble and sincere thanks for their blessings. Their unquestioned honesty, their willingness to assist and to help their neighbors, their deepest concern for their families and especially their thankfulness for blessing upon their children and upon the community now readily discernable, and which the second and present generation might safely build. These were and are the 'good old folks and days'. The values and determination have persisted.

Karl talks about the equipment that was used. Large steam outfits. Some large unwieldy Runleys and Hart Parrs. "*They were too cumbersome and costly for general work*". By 1925 some smaller tractors like the Waterloo made an appearance. The coming of the John Deere, the 15-30 and Big Brother made things "*really hum*". Unfortunately, many of the original settlers had abandoned their land due to the adverse conditions. Tax deeds allowed tens of thousands of acres of land to be sold for as little as fifty cents to $1.00 an acre. "*Loan companies encouraged young farmers to purchase land with favorable terms. This generation appeared to have a natural instinct to repair and put into working condition tractors of any kind which they had purchased at a low cost*". Karl was retiring from his position and said this about the people he had served: "*I am grateful to the people of Liberty County. The farmers, the ranchers, the housewives and the businessmen. For the trust and confidence they have placed in me in trying to work out a just and equitable distribution of our tax burden, mounting to millions of dollars based upon property valuation. This evidence of faith, honesty and integrity of the fathers and mothers of the past I can readily discern in their sons and daughters, and it has left an*

indelible imprint upon their minds and character they themselves may not fully appreciate".

Larry Gill, head of the Montana Livestock Association in the 50's wrote the Shelby Promoter August 24, 1950: *"Only high in the foothills and down on the river breaks do you find grass as it used to be. Don't look for cattle or sheep, don't look for a farmhouse with a few dairy cows and a few hogs and a few chickens on this great flat land area. In the wintertime don't even look for families for miles on end. The operators now raise wheat. They live in Cutbank or Kalispell or Los Angeles during five months of the year. In the summertime they drive out from town, plant their crops, harvest them in the fall and are gone. Not all of them of course, but of the 250 odd farms in the eight-mile strip along the east border of Glacier county, more than half are estimated to be off-the-farm operated. Independently owned farms and ranches on the Blackfeet reservation in western Glacier county are much more generally a home for the family that operates the ranch, as are in the units in the Sweet Grass Hills."*

Sometimes the tie that binds can only be found in snippets of information collected and pieced like a giant jigsaw puzzle. Many of the snippets of lives can be harvested from conversation at reunions or dances. The Toole County Old-timers Association reported in the Thursday November 8, 1951 edition of the Shelby Promoter a list of people from the original 106 members who attended the annual gathering: **F.A. Sullivan**, native Montanan, 1872; Mr. and Mrs. J.C. Kiehlbauch and **J.C. Clark**, who came to Montana in 1889; Mary A. Slavin, 1890; **Mrs. J.C Clark**, 1886; **Sylvan Murray**, 1883; Elmer Bonathan, 1888; Thomas Connelly, 1885; Mrs. W.B. Martin, 1887; Mrs. G.D. Thomas, 1895; **T.H. Daley**, 1887; **Mrs. Maude Crockford**, 1882; Guy Young, 1881; Ed Pettigrew, native; **Mrs. Frank Larson,** 1897; **Bert Furnell**, 1885; **Mrs. Bert Furnell**, 1897; M.O. Connolly; 1883; Carl A. Erickson, 1897; and Tom Crayon, 1888. These residents first gathering was held October 19, 1928. Eligibility required 25 years residence in the state of Montana. Bert Furnell put his arrival in 1885, and that's not wrong, it's just that he was born in Great Falls that year. Mrs. Bert Furnell is **Edna Ellis Furnell**. The group discussed *"picnics from the Marias river to Toole's grove to Pratt's canyon. Turner ranch was*

a favorite spot". James C. Turner gave a parcel of land to Toole county to be designated as a park and the marker is along Highway #2 on the south side of the Highway going to Lake Elwell. The Great Falls Tribune ran a note in a 1950 newspaper fifty years ago column: "*The GN moved the Galata stockyards at Lothair to Willow Creek*" (1900). Lothair has deteriorated and most of the buildings, elevators, and remnants of stockyards have disappeared from the skyline of the Hi-Line yet continues to rest along the bank of Willow Creek.

Brother Van held service at the Methodist Church in Chester in May of 1915. This was the last service Brother gave in Chester. Pastoral Tenure in the Methodist Episcopal Church and the numerous appointments of ministers of the Pittsburgh and Erie Conference during the nineteenth century are accounted for by the limitation on ministerial tenure in one appointment that prevailed in the Methodist Episcopal Church. Until 1864 the allowable period in an appointment was two years. This was increased to three years from 1864 to 1888, and five years from 1888 to 1900. In 1900 limitations was removed.

Miss Lucy Cook, the first child born in the town of Gold Butte April 28, 1886, died June 13, 1967 in Shelby. She suffered a stroke while visiting her sister, Ruth McDermott, in the Sweet Grass Hills. Four years prior to Lucy Cook's birth, James H. Morley reported in his diary that it had been cold and windy in Alder Gulch. Above Morley's claim in Pine Grove, another diarist, John W. Grannis, noted in his diary he had taken $23 in gold from his Highland claim.

The first First Lady of Montana, Lily Toole, daughter of Brigadier General William Stark Rosecrans, married Joseph Kemp Toole May 5, 1890. It is not known by this author if Lily was related to the Stark brothers of the Sweet Grass Hills, but there is a distinct possibility that they were related. Lily was from a devoutly Catholic family. She had an uncle on her fathers' side who was a Catholic bishop and three siblings who entered the religious life. Lily and Joseph had a small, private wedding at the parsonage of St. Matthew's Church in Washington, D.C. Governor Toole was not a Roman Catholic, and there was not time to obtain the dispensation required for a wedding in the Catholic Church. The service was informal. Lily wore a dark green traveling

dress trimmed with elaborate black braiding and a black straw turban embellished with ribbons and velvet. Her father and two friends were the only guests. After a brief seaside honeymoon, the newlyweds were at home in Helena at 102 S. Rodney Street. Lily planted an apple tree for each of her three sons in the yard at the Governor's mansion and lilacs around the parameter to remind her of Ohio. Her oldest son, Rosencrans, died of diphtheria when he was only seven. In the Sunday June 26, 2016 publication of the Great Falls Tribune, it is reported that two of the apple trees are still living. It is not known which of the sequenced apple trees died.

In the previous chapters some of the early settlers to Montana arriving by Steamboat were Matt and Della Furnell and Della's sister Kate Peek. Sharing a cabin on the boat with Kate was Fanny Iliff. Matt Furnell's first wife, Kate Dunn, was Thomas Dunn's sister. Kate Dunn Furnell died February 21, 1879 giving birth to her son who also died on that date. They share a grave in the Sun River Cemetery. Matt and Della were married in Michigan in 1883.

Thomas Dunn was born in Canada, however, his parents moved to Racine Wisconsin when he was a babe in arms. Both his parents died when Thomas was small, and he was placed with a family that raised him. He was ambitious and set out on his own with a 'prairie schooner' headed for Pike's Peak, Colorado during the gold rush in that region. When the Civil War broke out, he enlisted in the 2nd Colorado Cavalry and served three years. Later he went to Texas and drove one of the first herds of Texas longhorns to Montana.

Thomas Dunn married Mattie Iliff May 18, 1880. They settled in Sun River and remained in Montana in the cattle business until 1885. In 1886 Thomas and his wife moved to Fresno, California where they engaged in ranching. In 1888 they purchased eighty acres of vineyard near Malaga which they planted to Muscat grapes. For fifteen years they owned and operated this ranch.

Mattie Iliff Dunn was a native of Cincinnati, Ohio, but was raised in Illinois. Together Mattie and Thomas Dunn raised five children. When they moved to California they began investing in ranches and city properties. In 1890 they bought a 40-acre vineyard southwest of

Fowler; they invested in the City of Fresno real estate and built the Dunn Bock on J Street. They also bought the business block at 827 I Street. In addition to this development, Thomas and Mattie owned a business block at Sanger.

Mattie died January 2, 1913 and Thomas died June 11, 1916 in Fresno. Their daughter, Mattie I. married Arthur Perkins: stockholder, director, and manager of Barrett-Hicks Hardware Company of Fresno; William F. became district manager for the Associated Oil Company, Fresno. Lieut. Thomas M. became a career military man with the United States Army; Lillian S. became the wife of Edward M. Voigt of Fresno; Herbert I. joined the military in Field Artillery. LT.S.A., served as an Aviation Observer overseas. He was a student at Stanford University and attended the first officers' training school at the Presidio, San Francisco, receiving his commission.

While devoting his energies to business and developing his interests, Thomas Dunn was ever a willing worker for the good of his community and served the public with the same devotion to duty that he gave to his personal affairs. He was a member of the board of trustees of the City of Fresno under the new city charter, from the Eighth Ward, and served four years in that capacity. Thomas Dunn also served as park commissioner under Mayor Chester Rowell, and in all other work for the advancement of Fresno City and county. He was a prominent and well posted Mason and stood high in his lodge. Thomas Dunn was a candidate for mayor of Fresno but withdrew in favor of Chester Rowell.

He was a member of Atlanta Post, G.A.R., at Fresno, taking an active interest in all its affairs showing sympathetic spirit and loyalty by always attending the funerals of its members. In the cause of temperance, he was an active worker, but was said not to be radical. Thomas and Mattie Dunn's son, Herbert I., was the only child of theirs born in Fresno.

The G.A. R. or Grand Army of the Republic was a fraternal organization composed of veterans of the Union Army, Navy, Marines, and U.S. Revenue Cutter Service who served in the American Civil War. This was one of the first organized advocacy groups in American politics, supporting voting rights for black veterans, promoting patriotic education, helping to make Memorial Day a national holiday, lobbying

the United States Congress to establish regular veterans' pensions, and supporting Republican political candidates. It was succeeded by the Sons of Union Veterans of the Civil War (SUVCW), composed of male descendants of Union Army and Union Navy veterans.

Although an overwhelmingly male organization, the GAR is known to have had at least two women who were members: Kady Brownell and Sarah Emma Edmonds. Sarah Edmonds served in the 2nd Michigan Infantry as a disguised man named Franklin Thompson from May 1861 to April 1863. In 1882 she collected affidavits from former comrades to petition for a veteran's pension which she received in July of 1884. Edmonds was only a member for a brief period as she died September 5, 1898. She was given a funeral with military honors when she was reburied in Houston in 1901. The GAR formally dissolved in 1956 after the death of the last member.

CHAPTER 23

♫ I WAS LOOKING BACK TO SEE

♫I was looking back to see if you were looking back to see if I was looking back to see♫ if you were looking back at me ...

Looking back at how it was makes fun with looking forward. When you look at what others have persevered with fewer tools, getting on with life gains a new perspective. Decide. If it turns out to be the wrong decision, change direction. Challenging yourself to be uncomfortable for a moment in time engages and embeds the mind because you must focus. It is being present, the state of mind every cowboy or girl has put themselves into when they mounted a horse or nurtured a newborn calf in a blizzard. If you were not doing that, you would be doing something else. There are lots more folks who deserve a 'look back' at. This will be a short round up of a few and a tale or two to boot.

It appears that the search for a mother lode of gold made men, and a few women, lose their minds looking. They stampeded here and there wherever there was a hint. Like fishermen in a canoe on a quiet lake, they paddle back and forth casting their hook ten minutes after the fish jumped in that spot. Maybe it was still there, it just did not take the bait. Eventually you paddle back to shore and give it a try another day.

One such character found gold in the Little Rockies yet left this world penniless. Oliver Peter Zortman came to Montana in 1888 chasing the gold lure. He is one of the few who left the Little Rockies with a

small fortune in gold. Some of it he earned from other miners running a cyanide mill. When he left the city named after him, Zortman, he went to Chinook and joined the Masons. He was living in Chinook about the same era that Charlie Russell hung up his spurs and spent a winter in Sugarbeeters country. Sugarbeeters are the Chinook High School Sports mascot in honor of the Sugar Beet factory that was once the pride of the city.

Charles M. Russell gives 1888 as the year he spent with the "Blood Indians" (Piegan) learning to speak Piegan, sign language, and Indian ways from Piegan chief, "Sleeping Thunder" in his sketchy recants of his life before Nancy. That is the same period the Canadian and U.S. Governments were seriously working to move the Indians out of the Sweet Grass Hills and the largest Piegan encampment was in the Sweet Grass Hills. It was also the year Fredrick Remington was in the Sweet Grass Hills. Enough settlers had arrived in Montana to create an uncomfortable position for the Governments. Farmers from the east had identified that "*the best farmland was Indian land*". The Oregon Indian Treaty Act directed the negotiation of treaties for "*the extinguishment of their claims to lands lying west of the Cascade Mountains*" and, if practical, "*for their removal east of said mountains. Indians may have land rights, but WE WILL adjust them through treaties dictated* **on our terms***. Western Oregon is for white settlers, NOT Indians.*" By pushing the Indians on the west coast east of the Cascades and Rockies several of the tribes settling in Idaho, Washington and Oregon were moved to the east face of the Rockies and central Montana.

This began the migration of the Nez Perce Indians from the Wallowa Valley and the Trail of Courage by Chief Joseph or Joseph the Younger. Before him, his father led the Nez Perce and he was called Chief Joseph. When the transition of leadership for the tribe began, to distinguish the two, one was "Older", and one was "Younger". The final battle of the "*Trail of Courage*" for the Nez Perce took place in the Bears Paw Mountains south of Chinook. The battlefield is marked and can be viewed much as it was with plaques describing the battle. The famous words Chief Joseph spoke: "*Tell General Howard I know his heart. What he told me before, I have it in my heart. I am tired of fighting. Our chiefs are*

killed; Looking Glass is dead, Too-hul-hul-sote is dead. The old men are all dead. It is the young men who say yes or no. He who led on the young men is dead. It is cold, and we have no blankets; the little children are freezing to death. My people, some of them, have run away to the hills, and have no blankets, no food. No one knows where they are – perhaps freezing to death. I want to have time to look for my children, to see how many I can find. Maybe I shall find them among the dead. **Hear me, my chiefs! I am tired; my heart is sick and sad. From where the sun now stands, I will fight no more forever."**

Charlie Russell was back in Judith Basin in the fall of 1888 and 1889. After the 1889 roundup he went to work for the DHS on the Milk and Marias Rivers. Tom Daley was DHS Rep at that time living in Shelby. Charlie wintered in Chinook with some of the DHS line riders. He said it was one of the worst winters he spent in Montana. Sleeping in all their clothes at night and still near freezing. One of the bright spots was the train that came through and stopped daily at the Chinook depot. Traveling both east and west, the passenger train stopped, and people would get off and share news or pick up the Chinook newspaper. Charlie was at the depot almost every train to see who was passing through. One day he decides to stir things up a bit and as the train is about to pull out from the station he hollers; *"Look here, Chief Joseph breaks out!"* as he holds up the newspaper. Someone hollers back over the noise of the train wheels rolling: *"Where did he break out?"* Charlie hollers back: *"Everywhere, from his head to his feet he's covered."* Even though Chief Joseph had said: **"I will fight no more forever"** he was a clever chief and his trail from Wallowa Valley to the Bears Paw Mountains was strewn with United States military bodies. Chief Joseph and Louis Riel were the last two great leaders in the battle of the Indigenous peoples of North America and both of their trails ended in Montana leaving a temporal cast on the cowboys and emigrants coming west. Charlie made a pile of sketches that winter on napkins and anything else he could sketch on at the Mint in Chinook. That was about the same winter Oliver Peter Zortman had joined the Masons after leaving the Little Rockies.

Before the Glacial Period, what is referred to as the Flaxville Plain

embraced all the Great Plains except several mountains that rose above it. The Sweet Grass Hills, Bears Paw, Little Rockies, Highwood, Moccasin, Judith, Big Snowy and Crazy Mountains. The amount of uplift which caused the erosion by which Flaxville Plain is formed is measured by the vertical distance between the ancient plain or terrace known as the Cypress Plain. (Named from the Cypress Hills in Canada). Elevation of the land caused streams to erode and dissect the surface. Cherry Patch Ridge north of Harlem is a remnant of the high ancient plain. The most extensive remnants of the Flaxville Plain are high-level prairies north of the Missouri River in northeastern Blaine County, and in Valley, Daniels, and Roosevelt counties. A great uplifting and folding of rocks and massive beds of molten rock create these uplifts.

One of the larger uplifted areas of Central Montana is the Sweet Grass Arch. This uplift embraces a large area from around Great Falls to the International Boundary. It includes the Sweet Grass Hills and the Little Belt Mountains, the Highwoods, Bears Paw, Little Rockies, Judith, and Moccasins. This Arch is the reason so many mountains can be seen from several points when driving through north central Montana and southern Alberta, Canada. Area known as the "Golden Triangle" is largely composed of glacial-till soil or 'drift'. The soil produces excellent wheat and other grain crops and because of its scant and uncertain rainfall has recently realized the perfect conditions for pulse crops such as peas, lentils, and other legumes.

These irregularities in the formations of the area are some of the reasons the scatterings of gold are unpredictable and often shallow, much like the temporary resting place of Oliver Peter Zortman. If he had not joined the Masons in Chinook, he may have remained in a hand-dug paupers grave in Big Timber where he died of cancer in 1933. As it is, On August 27, 2005, a vintage hearse carried the pine box to the Zortman Cemetery with the remains of Oliver Peter Zortman. Relatives and most of the citizens of this Hamlet nestled in the Little Rockies gathered to pay final farewell to Oliver. The leather-bound records of the Big Timber Masonic Lodge led to the discovery of Zortman's unmarked temporary resting place.

Before gold was discovered in the Little Rockies or the Sweet Grass

Hills, James Brown and Joseph Kipp were civilian employees working for the government as interpreters, guides, and moving overland freight from Fort Shaw to Fort Benton. From 1865 to 1890 these two men were paid $150.00 a month to do various tasks for the government on both sides of the International boundary. John J. Roe & Company engaged in overland freighting and employed James Brown as their administrator. Brown engaged several subcontractors, and the service became known as the "Diamond R". Almost everyone having a wagon hauled freight for the Diamond R. In the fall Diamond R hauled south to Fort Ellis. In 1866 Louis Rivet of the North West Fur Company established Fort Hawley, a trading post for the River Crow with A.F. Hawley in charge. In 1868 James (Kootnai) Brown married Sarah Bull, daughter of Chief Melting Marrow (Bull and Bird Sailing the Way), in Fort Benton in an 'Indian Custom wedding'. In 1888-89 the marriage was blessed by a Priest at Holy Family Mission. This blessing was an important part of the politics of the day to accept the children of these marriages as *citizens*. Shortly after the marriage was blessed Brown homesteaded on a ranch at 8 Mile Spring near Fort Benton. At this time Brown and Kipp were organizing the sale of cattle to the military for providing the Indians with meat. The trappers and traders were stealing the cattle before they could be delivered to the Indians leaving the Indians to starve. There was little either the military or Indians could do as no laws governed the trappers and traders and identification of the rustlers was difficult.

In the winter of 1869, sixty head of cattle were lost and Brown and Kipp were sent to search for the cattle. It was December and a severe winter storm was raging. Kipp and Brown took several men and horses to travel north into Canada to look for the missing cattle. Reports were coming into Fort Benton that people attempting to travel the Whoop-Up Trail were being found frozen. In an amazing feat, Kipp and Brown returned to Benton with the 60 head of cattle and all their men. 20 of their horses had frozen in the storm at their encampment, but they managed to survive returning when the storm abated February 18, 1870. Credit was given these two men for their knowledge of the territory and their ability to direct their men in improvising shelter for themselves and their animals. Kipp and Brown erected two trading

posts, Fort Kipp on Old Man River in Canada, and another in High River. Because of their persistence in seeing to it that they could retrieve cattle for the military and get the beef to the Indians, these men were respected by both the white men and the Indians.

In 1890 Brown moved to Choteau where he assisted in teaching farming to the Blackfeet Nation at Old Agency until 1893 when he purchased a 1000-acre ranch on the South Fork of the Milk River. Both Kipp and Brown spent time in the Sweet Grass Hills as liaisons between the military, Indians, and Metis. They were constantly conflicted by the fur traders, Hudson Bay Company in the north and North West Company in the United States, but they earnestly made an attempt to deliver goods designated to the Indians and keep the emigrants and homesteaders safe. A slippery slope requiring mental and physical prowess and a knowledge of the territory and multi-cultural inhabitants.

Fort Assiniboine was built in 1879 south of Havre following Custer's battle at the Little Big Horn River and the rise of tension growing with the Indians and Métis. Louis Riel was well known throughout the Northwest territory to exert wide influence on the Cree tribe and other Indians in general. After the capture of Riel, Cree Indians poured into the territory of Montana in large bands. Colonel Elmer S. Otis was placed in charge of Fort Assiniboine. The telegraph came into existence and a line was expediently built from Washington D.C. to Fort Assiniboine to keep Colonel Otis apprised of Riel's movements and the notorious Cree Chief, Little Poplar, who for some years had been the terror of the border. Colonel Otis was inhibited from attacking Little Poplar and at the same time charged with inviting him to "*quit the country*". The soldiers at the Fort were largely young and inexperienced men. They nervously kept watch wondering what they would or could do should Little Poplar attack the Fort. A half-breed named James Ward killed the Chief near the Fort and caused great confusion for the Colonel and Washington as to what should be done with James Ward and the remains of Chief Poplar. Ward was released and allowed to leave the section. Chief Poplar's remains were exhumed and examined by Assistant Surgeon Woodruff with the skull being sent to Washington D.C. to the anthropological society in an attempt to satisfy the Indians.

The winter of 1886-87 was severe and an unusual number of renegade Cree from across the Canadian line had camped near the Assiniboine post waiting for word of their fate with the loss of their leader. Famine and pestilence made inroads to the encampment and the Indians were eating their dogs to appease their pangs of hunger. There were no appropriation or authority to feed the Cree, but the commanding officer issued stores at his personal risk. Colonel Otis forged through a good deal of red tape and was finally able to have his act of kindness approved and was relieved from personal liability for the supplies issued. This act possibly gave Colonel Otis enough respect from the Indians to prevent any physical confrontations from the Cree over the loss of Chief Little Poplar.

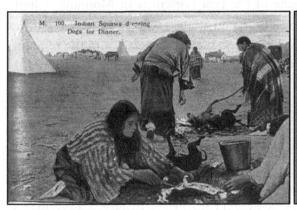
M. 100. Indian Squaws dressing Dogs for Dinner.

Photo by Chas E. Morris. Permission for use by Pamela Morris

During 1887-88-89 an unusual number of foreign Indians and half breeds about Belknap and Bear Paw Mountains evoked some apprehension around the Fort, but no physical disputes erupted. The "Ghost Dance" craze affected all the Indians along the border. A large garrison from Fort Assiniboine was sent eastward and the military force at Fort Peck was greatly strengthened. Military outposts were set up in the Sweet Grass Hills as the Piegan, Blood, and Blackfeet had all moved south from Alberta following a gigantic prairie fire in 1873 that drove the buffalo south never to return to the southern plains of Alberta. Indians were starving each winter and smallpox was ravaging bands leaving the Blackfoot Nations devastated.

This was the state of the '*savage Indians*' when Charlie Russell arrived in Montana Territory in 1880-81. He saw some of it in Judith Basin by the scarcity of wild game and the Indians he encountered but spending a winter walking '*in their moccasins*' Charles M. Russell found that his soul was incandescent to the nature of the Indigenous peoples. They filled him with character and gave him a taste of something everlasting that filled his senses, inspiring a fullness and realization of self.

It was with this spirit that Charlie approached his marriage, friendships, art, and life daily. Sometimes he had to get away from the city to just be, and his favorite mode of travel was his horse, Monty. Monty died in 1904 so Charlie did not have him by the time he partnered with Con in the Lazy KY, but he remained interested in horses and Con was one of the best horsemen in Montana. Charlie knew how hard making a living on a ranch was if you were the owner and hired hand. It gave Charlie a place to get away from the trappings of the city. The Lazy KY cabin with the creek running nearby and the picturesque landscape just outside the door. There was no need to go anywhere for inspiration. It came with each sunrise and sunset. Charlie could just show up unexpected whenever he got away from his studio and Con was always happy to see him.

They had about fifty head of mares at the ranch that were Mustang or Grade stock which made some tough saddle horses that weren't much to look at. Con thought he would look for a better grade stallion to improve their herd. He contacted Jake Dehart who told Con he had "*a fine stallion to sell.*" Con went to look at the horse and said: "*He was a terrible looking sight. He had been neglected, was sick and badly run down. His legs were swelled up almost as big as his body. He hadn't shed his winter coat of hair and looked like anything but a horse. Dehart showed me the registered papers of the horse and they were O.K., in fact, he was an imported horse and of fine breeding. I didn't know whether I could save the horse or not. Looked like he might die any time, so I told Dehart I would trade him a bunch of horses for the stud.*"

Con set a date for Dehart to come and look at his bunch of horses for the trade and gathered his Mustangs to see what he could do. When he looked at the Lazy KY bunch, he thought they looked pretty tough,

but thinking about the shape the stud was in; Con began culling out the worst ones for Dehart. He put the rest of the bunch out of site and when Dehart showed up, he said: *"My God, I thought you had better horses than those things. Where are the rest of your horses?"* Con told him that was all he had. Dehart was in a bad spot because he had a lot of money tied up in the stud, but he knew the horse was not looking too good. It was 'take the bunch of junk or no trade', so Dehart took the deal.

Charlie came up from Great Falls to see how things were going and found nobody home shortly after Con got his new stud. The stud was standing in the corral and Con was out riding the range after cattle. When Con got home, Charlie was peering through the corral poles. Charlie says, *"Where did you get that mountain of beauty?"* Con tells Charlie about the trade and Charlie says: *"Well, he is sure a good sleeper. I watched him for an hour in the corral; he never moved an ear."* Charlie said Dehart must have got Con drunk when he made that trade. Con told Charlie if he would have seen what he traded for him he would think Dehart was the one that was drunk.

Con doctored the horse and brought him out of his sickness and thought he produced some of the best colts in the country at the time. He later sold him for $500.00. Con made out on the back side of the trade too. He asked Dehart if he wanted Con to 'vent' the brands on the horses and Dehart said not to bother. Dehart turned the bunch loose on the open range about 20 miles from the Lazy KY and most of them found their way back home on the range mixed with the horses they'd been running with. Some folks had bought horses from Dehart and fussed and threatened Con with court action, but they couldn't do anything because Dehart didn't have the brand 'vented' and there was no way of telling which horses were his. Con figured eventually he got that stallion for nothing.

Con Price said about the way he knew Charlie: *"He loved nature and the West and was Western from the soles of his feet to the top of his head and had the finest principle and the greatest philosophy I ever knew in anybody."* They must have been a pair to draw too because Con Price is spoken highly of, especially by Matt Morgan. Matt Morgan worked with many cowboys along the Montana Canadian border country and whenever

he had his pick of who to ride with, he made sure Con Price was in the mix. He even convinced Con to work for the government for a short time before the International Boundary was established.

Captain John Mullan and Isaac Stevens may have delayed the development of Great Falls for twenty years by recommending the Mullen Road be constructed from Fort Benton to Walla Walla Washington bypassing the Falls. Paris Gibson is credited with establishing the city of Great Falls and he holds nothing back in crediting James Hill for financing and promotion of Great Falls. Once the railroad line was completed from the Great Northern line to Helena, the building of the city began and the core of what is Great Falls was built in a ten years' time. Considering many of the original buildings were brick and lumber, this is an amazing feat as there are no forests in proximity. In 1910 a power line was constructed connecting the power from Great Falls to Fort Peck for the construction of the longest dam on the Missouri.

The main architect for Great Falls was George Shanley. Architecture is eclectic throughout the city of Great Falls and a visit to the History Museum offers a map and brochure for a walk through the Historic District guiding the way through the impressive structures. One of the most impressive religious buildings is the massive 1901-1907 St. Anne's Cathedral. This is a stone building, designed in the Gothic Revival style of turreted bell tower, buttressing and rose windows. Windows are arched, as are some of the gables. The interior of the Cathedral is rich in decorative elements highlighted with gold paint and displays the original lamps and fixtures. In proximity is the 1906 Church of the Incarnation. This two-story buttressed primary building is in the late English Gothic Revival style having a three-story collegiate type tower with arched windows and gabled stone porch entrances. This church is located at 600 Third Avenue North. The property, lots 1,2, and 3 in block 255 was purchased by W.G. Conrad from Brown Brothers company of New York and the deed was placed in the offering in September of 1902. Mr. Conrad was a Virginian, and the gift carried the stipulation that buildings were to be placed in a manner to leave the corner lot vacant for a park, thusly following the pattern of Virginia Churches.

The construction of the Montana Central Railroad spur line

employed over 8,000 men using 7,000 horses. By 1887 the population of Great Falls was 1200. Great Falls was designated as the county seat of Cascade County giving the impetus required for Townsite Company to forge ahead with a promotional campaign to attract prospective residents and businesses. The forerunner to the Chamber of Commerce – The Board of Trade - sent circular flyers to sheep men, offering the reduced shipping, and holding rates available in Great Falls. Railroad advertisements raved about the excellent opportunities to be found in farming the plains surrounding Great Falls.

The advertising campaign attracted major industrial interests as well. Montana Smelting and Refinery Company, financed by eastern capitalists, constructed a silver smelter on the Missouri River's west side. One year later, the Boston and Montana Consolidated Copper and Silver Mining Company built a smelting operation utilizing waterpower from the Black Eagle Falls Dam, built by the Townsite Company. Population soared to over 10,000 by 1893. Success of the community appeared to be bright until the national monetary crisis, the Panic of '93', temporarily stalled economic growth. Increased production of silver worldwide, the gold-based economic system, repeal of the Sherman Act and closure of banks crushed silver mining and smelting activities in the west drastically affecting the railroad industry. The B & M Smelter was eventually forced to close, and Hill's Manitoba railway system struggled with railway workers striking against pay cut to less than $40.00 per month.

Even before the panic of '93' labor unions had begun creating frictions. Families who had homesteaded throughout Montana and experienced one or two harsh winters and dry summers had left their homesteads and moved to larger towns to find work. Accustomed to demanding work and little pay, the established workers began to form Unions and began terrorizing workers who would not join the Unions. These disputes caused people to exodus seeking employment where they would not incur harassment, however Unions were becoming a fact in all big business. By 1910 the economy in largely agricultural oriented Montana suffered from depression. Union workers had caused higher prices for equipment and seed. Prices were low for produce. Drought

like conditions and overworked soil began to take their toll. Banks failed reflecting the severity of the times. Approximately two million acres in the state dropped from agricultural production between 1919 and 1925 as eleven thousand farms were abandoned. Extreme weather conditions and the inflated cost of production combined to break the backs of many. This, coupled with depressed copper prices on the world market, produced a rapid decline of the economy of Great Falls.

When one considers a single person's lifetime, it may appear to trudge along with a few spikes of interest and end with a quiet ceremony leaving a small indentation on the face of the earth, marked or unmarked. If that person's life is chronicled with all the decisions and experiences had in a lifetime along with the people and politics that played a part in their life, it becomes quite a story. Possibly a story that should be written or maybe has been written. The following tune and photograph give credence to lives well lived and how a handful of people can build a community. ♪Enjoy Yourself – It's Later Than You Think! ♫

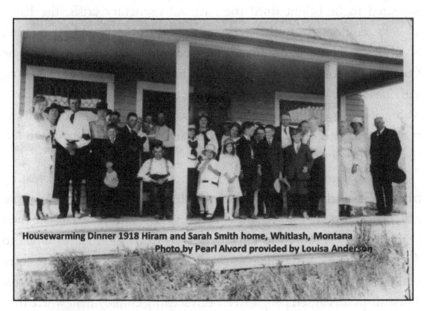

Housewarming Dinner 1918 Hiram and Sarah Smith home, Whitlash, Montana
Photo by Pearl Alvord provided by Louisa Anderson

Pictured in this photo taken Hiram and Sarah Smith's housewarming; Tillie Oswood, working there, Agnes Larson, Frank Larson, Young Frank Larson, Myrtle Johnson Sr., Harry Robinson, ?, Floyd Umphrey,

Mrs. George Murray, George Murray holding Glenn Aiken, Young George, Mary Cathrine Murray, Juanita Johnson, Florence Johnson, Paul Murray, ?, Edith Aiken, Bobby Carroll, Arch Carroll, Verna Johnson, Mrs. Arch Carroll, Mrs. Kemble-Murray J.'s mother, Mrs. Hiram Smith(Sara), Nan Murray, Tim Murray, two little girls in front are Virginia Johnson and Ruth Murray. Hiram Smith, Murray and Vowers Johnson missed dinner because they went fishing. They had their priorities straight.

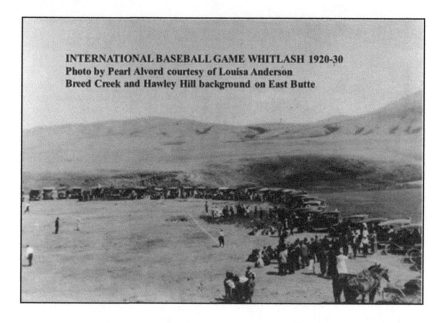

INTERNATIONAL BASEBALL GAME WHITLASH 1920-30
Photo by Pearl Alvord courtesy of Louisa Anderson
Breed Creek and Hawley Hill background on East Butte

<u>TAKE ME OUT TO THE INTERNATIONAL BALL GAME.</u>

This baseball field was used by the Whitlash school to host invitational interschool ball games until the school closed in 2014.

CHAPTER 24

PICTURE THESE MEMORIES

History is recorded almost moment to moment with today's technological tools. The retrospect of this deluge of information may be that much of it was misinterpreted or dissimulated. Disinformation? Maybe. The stories in this writing were largely found in newspapers and local history books which can now be accessed online, and a collection of personal newspaper clippings and photos from a century past. The fact is that no matter how you gather information, some of it can be incorrect. As time passes, our memory and the perception of a moment in time converts, dims, or is replaced by love, loss, and life. Time marches on waiting for no one. The closest we can come to recapturing a moment in time accurately is with a photograph, yet even a photo does not tell the whole story. Like a rock perched on a hill appears to be a permanent fixture, a photo carries a story of an unseen journey. This is how this book came to be. A journey in time gathering facts, photos, and stories of places and people who have left a trace of who they were, where they traveled, and how they managed on the path they took.

One fact remains true for everyone; there will be an end. The end came for Paris Gibson December 16, 1920. Born July 1, 1830 in Brownfield, Maine, Gibson served Montana as a State Senator from 1901 to 1905. Gibson was a Democrat. Politics and Politicians in Montana have always reflected the duplicity of the state's population and terrain. This characteristic is not exclusive to Montana, but the land area, topography, and sparse population seems to favor independent

thinking and perseverance. As with many of the great entrepreneurs of the era, when Paris Gibson died, much of what he incubated died with him. It seems the opportunity of maintaining an empire was lost on the ensuing generations due to adjustments in politics and finance. Gibson left his mark on Great Falls and that will remain for perpetuity as will the grave and stone denoting his final resting place at Highland Cemetery in Great Falls, Montana.

If stones could talk, Paris Gibson's memorial rock would tell of its journey from the Sweet Grass Hills to Great Falls and how it was splintered from the Bears Tooth formation. Gibson saw the falls in 1882 and determined that here was where he wanted to spend his life. The wonderment of the moving water over the rocks of Great Falls engulfed his mind and energized his spirit. So enthusiastic was he that he determined to find finance for the dream he imagined. For generations to come there are photographs and memories saluting Paris Gibson.

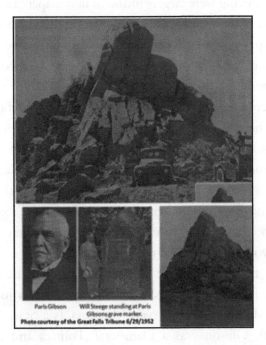

Paris Gibson Will Steege standing at Paris
Gibsons grave marker.
Photo courtesy of the Great Falls Tribune 6/29/1952

Two trucks moved the rock to the cemetery. The trucks were donated by Floyd Pappin & Son and the Pappin Construction Company. Great Falls business community came together donating all the time and labor

needed for this monument. Great Falls Transfer Company donated use of the crane to set the rock in place. Great Falls Cemetery Association employees fixed the cement foundation. Henry John, Great Falls stone mason, interrupted preparations for a trip to Sweden to face the rock to hold the plaque donated and installed by the Anaconda Copper Mining Company. Payne & Croxford Monument Company paid for expenses of the stone cutting and Croxford's mortuary donated rough boxes for the new graves. The unveiling ceremony saw the site decorated with beautiful floral arrangements donated by the Great Falls Florists Association.

Chas E. Morris photographed north central Montana from 1891 until he died May 16, 1938. Charles Edward Morris was born June 29, 1876 in Maryland. He sojourned to Montana trailing a cattle herd from Texas to Wyoming and eventually north to the Marias River Valley. Brinkman and Morgan's were long standing cowboys well known along the Marias River Valley, Havre, Chinook, Fort Benton, Malta, Shelby, and Chester. Cattle roundups would have had at least one of the Morgan boys riding with the crew. Chas Morris most likely rode with them and became fast friends with Matt Morgan and C.J. McNamara.

Matt Morgan was born June 5, 1889, 13 years younger than Chas, but his growing years were shaped by generations of educated and resolute cowboys. He was a top hand by the time he was nine years old. His father had died and his mother, Edith Brinkman had moved back to her parents' home on the Marias. John Brinkman, Edith's father, wasted no time in teaching his grandsons about livestock and demanding work. Sam DeYoung was a widowed ranch hand working for a ranch near the Brinkman's homestead. Sam DeYoung married Edith Brinkman Morgan. The DeYoung family with the Morgan children moved to the Sweet Grass Hills. It was through an article in the Montana Stockgrowers Magazine this author found who the photographer was on the roundup crew with Charles M. Russell in a widely circulated photo.

The story ran in several newspapers with the same round up crew in the photo with no credit to the photographer. It was about one of the cowboys taking the crews money to get some tobacco during a rainy

spell. This fellow took the money and an extended time getting back to the crew, so Matt Morgan decided to run an ad offering a reward for information leading to his whereabouts. The cowboys name was Tom Manis, also known as "Nigger Tom". The rain stopped and the cowboy returned with the tobacco for the crew, so the whole country was in on the joke. Matt says "C.E. Morris in Valley County" was the photographer. That is the trail this author found to follow.

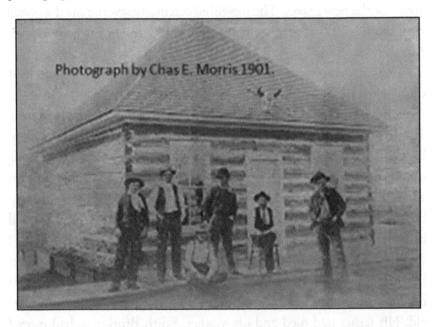

Photograph by Chas E. Morris 1901.

The men pictured above were not identified, however, it appears to be the Morgan brothers. Matt Morgan on the far left. Possibly a 25-year young Chas E. Morris standing in between Matt and Ed Morgan. Sam DeYoung, stepfather of the Morgan boys, standing to the far right, Grandfather John Brinkman, the Morgan boys' grandfather, sitting cross legged on the porch and C.J. McNamara seated in the chair. This photo was published in the Big Sky Journal, winter 2017 issue in a story written by Brian D'Ambrosio. The story chronicled Chas E. Morris glass plate photographs and his photographic journey in north central Montana. This would be the first photograph identified as a Chas E. Morris photo. Chas would have started his advanced education the prior winter. He perhaps took this photo to see how much he learned

about his craft. This group of men shared a mutual interest in the art of the cowboy.

The following Chas E. Morris round up photograph from Ambrosio's article has some very distinctive faces. Teddy Blue Abbott is standing fifth from the left and Charley Stuart is seated cross legged on the ground. Teddy Blue is Granville Stuarts son-in-law, married to his daughter Mary. Charley is Granville Stuarts son, brother of Mary Abbott. These two would be riding for the DHS. Two younger men minding their own business are by the rear wheel of the chuck wagon, one standing facing left and the other seated below him facing right may be Tommy Smith facing left and Matt Morgan facing right. Chas E. Morris photographed these two young wranglers frequently. That appears to be Chas seated on the ground with the thigh-high boots on to the right foreground in front of these two younger men. C.J. McNamara is seated on a stool third from the left.

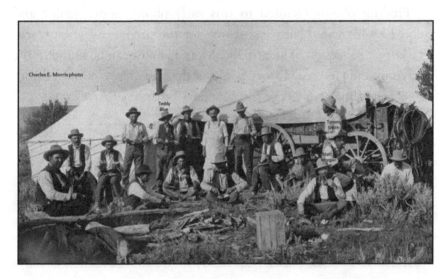

Charles E. Morris photo

A thorough search of "True, Free Spirit" would reveal the names of many more of these cowboys. The cowboy to the left of Teddy Blue may be Bert Furnell. Bert would fit the time, age, and profile of this wrangler. Its possibly Tom Manis is seated on the ground in front of Bert Furnell. The winter 2017 issue of the Big Sky Journal in a photo placed on the index page of two cowboys watering a herd of mixed

breed cattle in a lake. The cowboys and location are not identified. This photo is not in the main story, but it has a story. The cattle are in good shape and there is everything from Longhorns to Shorthorns and everything in between. Some are standing in the water. The cattle are spread across the picture until they appear as small dots on the horizon. It is obvious that the cattle are enjoying a drink as they stand in the water or at the edge of the lake facing each other or tossing their heads to the side knocking flies off their backs or scratching an itch. Easy to see a cool drink of water was a welcome respite after a dusty day's drive.

The winter of 1906-07 was treacherous for the livestock along the Hi-Line followed by a flood along the Marias and Milk Rivers in 1908. The flood swept through Chinook obliterating Helen and Chas Morris's photographs in their studio. Following the devastation, the Morris family moved to Great Falls opening a business on Central Avenue.

Finding photos credited to this early photographic genius and colored by his wife Helen is a search for the needle in the haystack. The largest collection of identifiable Morris photos can be found in the Museums and County History books of the area. The County History books are online courtesy of the Montana Institute of Arts.

Helen Schroeder and Charles E. Morris are both buried in the Highland Cemetery in Great Falls. The photo below was used as the Marquee for A.K. Yerks poem, "Nothing Like Montana". This may be the only photo of the last great horse roundup in Montana. Charlie M. Russell, Matt Morgan, Con Price, Teddy Blue Abbott, Charley Stuart, Tommy Smith, Robert Carroll, C.J. McNamara, Bert Furnell, and a

host of other cowboys rode on this horse round up. The photo is taken between Cut Bank and Kevin heading from the Rockies east below the Rim. The people who saw this string of cowboys and horses said the horse herd stretched "a mile wide" moving across the plains. It is a spectacular site and Chas E. Morris was there to capture this moment in time.

By most accounts, this horse roundup is one of the last roundups Charles M. Russell participated in. Chas E. Morris took photographs of Con Price and Charlie Russell at the Lazy KY about the same year this photo was taken. Con has a photo in his book, "Trails I Rode", of Charlie standing in between two horses, Sandy and Dave.

Con says he didn't know where Charlie got Dave, but he was a good horse for Charlie. He was smart, could work cows, and was a good walker. Dave looks all like Nee-náh, Charlie's bay gelding that he is shown with in photos in front of the Studio cabin in Great Falls. Both were bay geldings with small snips of white on their lip and a few white hairs on the sworl between their eyes with portions of their rear pasterns white. A view of Nee-náh's right hip would reveal if he was a brother, or possibly, Dave.

The photo of Charlie on Sandy in Chapter 18 of this book shows the broad side of Sandy facing right. On Sandy's hip is a large 3 hanging reverse E brand. Jack Toole mentions the 3E brand and Dave in newspaper articles from the early 1900's and Charlie mentions Dave and the 3E brand in a letter to Con in the book "Good Medicine: The Illustrated Letters of Charles M. Russell". Chas E. Morris took all the photos mentioned. It is possible that Charlie Russell went up to Canada to the Bascom's, Knight, or Webster ranch and got a couple of GOOD

horses for this last roundup. He wasn't going to take Con's word for a quiet ride, and he didn't feel like taking a risk. These ranches in Canada were still open range and only a half-day ride away from the Lazy KY.

Charles M. Russell was not prone to complain, but his love for riding a horse had taken its toll on his body. Coupled with the stress of toxin buildup from a dysfunctional appendix for many years, his heart had been challenged. In 1925 he started spending more time laid up in a hospital than he did doing anything else. Chas Morris's sons were in business with their father in Great Falls and they had transitioned from stationary (mainly post cards), sweets, and magazines to sporting goods. Hildore C. Eklund opened a photography studio in Great Falls and had the following story and photographs in the Great Falls Tribune January 15, 1956.

Hildore Eklund had arrived in Great Falls in 1909 just about the time the Morris's left Chinook and came to Great Falls. Eklund had seen Charlie Russell at the Mint sitting in a booth playing checkers with another man. He didn't know Charlie, but he asked a man at the bar about the artist who had painted the pictures in the Mint and the man pointed Charles M. Russell out to Hildore.

Interested in photography, Hildore started shadowing Chas E. Morris and Charlie Russell watching Morris as he photographed Charlie's paintings. Morris had gained Charlie's trust over years of riding the same range with him and then photographing him and his art. He cautioned Hildore about Charlie not warming up to strangers. Eklund names *"Morrison"* in the article. Hildore says Russell was getting comfortable working with Eklund when he heard Charlie was very sick and Nancy and Charlie were at the Mayo Clinic in Rochester, Minn. Hildore was surprised to see Charles M. Russell *"walking near his studio one day"*. The idea struck Hildore that he might get Charlie to pose for a studio photo as he had seen him at the Mint years before; seated at a table with his elbow on the table and his hand to his face.

He asked Charlie if he would come to his studio *"the following day to sit for a portrait"*. *"Charlie appeared at the Studio on Saturday dressed in a dark grey striped suit. It was an Indian summer day and Charlie was feeling and looking good."* With his glass plate camera, he created a double exposure

photograph of Charles Marion Russell playing a game of checkers with himself. With half of the photographic plate covered, Eklund says he "*had Russell sit at one side of the table bearing the checkerboard*". He exposed this half of the plate, then masked the exposed portion. He then had Russell move to the opposite side of the table and exposed that half of the plate. A black background in the center of the picture helped to conceal the line where the two halves were joined.

Eklund says "*Charlie passed away a few days later and eight days later the Tribune phoned and inquired*" if Hildore C. Eklund had a recent photo of Charles M. Russell for the write up in the paper. The following year Young Boy, a Cree Indian who was a close friend of Charles M. Russell came to H.C. Eklund and asked if he would take a photo of him at Charlie's last resting place in Highland Cemetery. Eklund took an Artists prerogative and inserted the face of Charles M. Russell looking down at Young Boy visiting the grave site. He also inserted a bubble indicating what he thought Young Boy was thinking at the time. There are disparities in the story and photo that would lead this author to be suspect that there was some photo shopping done on these interesting images. It took Eklund thirty years to bring these photographs to light.

Montanans tend to make newcomers to the big sky feel like they are never really part of the community because they "*weren't born here*". Most of the men who settled Montana "*weren't born here.*" Edwin and Bruce Toole, Mike Mansfield, Charlie Russell, Con Price, Chas E. Morris, Teddy Blue Abbott, Granville Stuart, Jack McDowell, T.P. Strode, Harry Demarest, Thomas Francis Meager, Solomon Abbott, etc. … Perhaps it is not where you start but where you finish that determines your connection to the land.

Chris and Henry Miller are another couple of brothers who *were not born in Montana* but ended their days here. The brothers were in their teens when they came to Montana from Iowa in 1892. In 1958 they sold one of the nation's largest ranches to Wellington D. Rankin, a Helena attorney, making Rankin one of the largest individual landowners in the nation. That title now resides with Bill Gates in 2020. The ranch address for this story was Chinook. It ran from the Bears Paw Mountains to the Canadian border. Ranken purchased 126,000 acres of deeded land and 218,000 acres of lease which carried through to the terms of the lease.

One of the earliest purchases of the Miller Brothers was the Peoples Creek ranch in the shadow of the Bear Paw Mountains. They purchased the ranch from squaw-men who sold out to move with their wives to the Fort Belknap Indian reservation. Indians did not want the work of proving up their claims and the Miller Brothers were able to file on land that had been filed on in previous years but had not been proved up. They had six months to start residence after receiving allotment papers from the general land office. Since they purchased adjacent claims, they only needed to set up one residence. The general land office was many months behind in making allotments at that time which gave the Miller brothers time to amass more adjacent claims. At that time, the land was not surveyed therefore property tax free for several years. Now why didn't the natives of Montana get that same deal? Born and raised, numerous generations.

Perhaps a mark delineating ownership would have helped the Indian. A brand or landmark showing boundaries and ownership may have worked if such definition had been introduced. Unable to find any stories about how the Native American felt when they saw herds of cattle coming to their territory wearing interesting markings burned into the hide. Ears and necks with notches that were obviously cut in synchronous fashion. Never had they seen a buffalo, deer, or antelope with such marks. They had to wonder what these pictures on the animals meant. Even more curious because they were not familiar with the animals.

The first brands recorded in Montana followed the first brand law which became effective in 1865. All original records in the first eleven pages of the original brand book carried no date. All original records were handwritten by the clerk of the supreme court, Montana Territory. To define animals that were branded then sold or traded to new owners, a system called venting which required additional marks altering the original brand or a new brand at a different location on the animal. In either of these instances, the original brand certification had to transfer with the animal so when an animal was sold the paperwork of ownership followed the animal. These practices required brand inspection in a brief period, hence the formation of the Montana Livestock Commission and appointment of brand inspectors.

Numerous brands on an animal indicated something odd about the animal. If it was a good producer or good ride, why had it changed ownership so many times? Horses especially became known by the brand or brands they wore. Brands were also large in the early days of cattle ranching so they could be read from quite a distance away. Today's brands are generally small concise markings, sometimes in 'freeze brand' which allows the hair to grow back into the hide in white. Branding irons have also improved over time. Early branding irons had to have long handles to keep the end cool enough to touch stretching far from the lapping flames of a wood fire. There was a lot of pride in 'riding for' the DHS, Square and Compass, IX, F, Circle, XIT, Bug, Two-Dot, and Ox-yoke brands as everyone knew they were BIG cattle outfits and the bosses or owners were reasonably trustworthy. If a cowboy riding for one of these brands got into trouble, the 'boss' would usually cover any damages and make repairs. The 'wranglers' were fiercely loyal to the brand they rode for and took pride in their appearance when they were in public.

Brands today are usually inherited. Passed down for generations, they must be renewed or re-recorded with a fee as dictated by State law. They are indexed and currently available online. Anyone wishing to research a brand can go online and see the enormous number of figures, numbers, letters, and symbols used in each State. Brands are registered to specific livestock on specific location so multiple owners of a brand will have a different location or animal carrying the same brand registered to (example) horse, left shoulder, and cow right rib. Another ranch might have the same brand with different assigned livestock and location of brand. Records show where the animal is located now that pastures are enclosed by fence. There are still 'open range' grazing and annual roundups to sort out brands. These opportunities and locations are rare and brand owners record the numbers of animal released into the open range land. Losses are recorded when the animals are sorted at the end of grazing season. To the cowboy and rancher, a brand is a work of art. There is a tendency to mark everything with a brand. Pickups, signs, barn doors, saddles, and stationary. Doodling while on the phone or on bar napkins often displays a brand denoting 'the artist'. All in a day's work for the cowboy.

Before 1896 brands in Montana were all owned / registered to men. Until the Inheritance law was passed in Montana, homesteaders had not considered property divisions between husband and wife. For the most part there were not that many large land and livestock owners who were husband and wife. Large herds were owned by conglomerates who were bankers, lawyers, politicians, and businessmen. The few that did have livestock in Montana were single or married to Indian women, therefore their wives were counted as 'property' subject to the same rule of law.

Thankfully, some things have improved when it comes to the rule of law. Change does not happen without an impetus. Throughout North American history some of the most persistent characters to have brought about change have been women. Quite an amazing feat considering women were not given the '**right**' to vote until August 18, 1920 when the 19th amendment was ratified. Well, some women gained the right to vote in 1920. White women could vote, but continued to be challenged in many ways to discourage them from voting.

In 1896 the National Association of Colored Women (Black), formed. Colored women (black) had an association yet were unable to gain the right to vote until 1965. Black and Latino men and women were given the right to vote through the "Voting Rights Act" signed into law by President Lyndon Johnson.

As with all language, the law has their own distinguished stereospecificity. Color (black) being specifically written left out all other (colors). Indian women were given the right to vote with the Indian Citizenship Act of 1924 and Chinese women were given the right to vote through the Magnuson Act of 1943.

Now there is a little backtracking to do in the women's rights to vote laws. Until 1962 all "Indians not taxed" in New Mexico could not vote until 1962 when the President's Committee on Civil Rights overturned this State law. In 1975 the Voting Rights Act was amended to protect the "language of minority citizens". In 1984 the Voting Accessibility for the Elderly and Handicapped Act passed. When you see these dates and laws simplified and outlined, it's easy to recognize there is still work to be done. Rest assured, working at getting laws updated or changed in anyway is like doing housework in a corral dust blizzard.

There are people who persist at righting wrongs when they find themselves in an impossible situation. One such person is Pamela June Morris, the granddaughter of Chas E. and Helen S. Morris. She found herself in an unbelievable situation involving domestic violence and brought about positive change to this area of Montana State law. The case centered on the language as many disputes do. In 1977 a woman could not testify against her husband in a domestic dispute. The first 'language' element in the case would be 'husband' as in married. The law(s), both Federal and State, have undergone numerous changes in verbiage regarding this legally sanctioned Act due to a rise in non-married domestic violence cases. This one took place over two decades in the State of Montana. Jurisdiction is also a factor when litigating.

Memory can be a 'learned' practice, or a nagging demon that haunts future behavior with emotional triggers. A picture can sometimes dispel the demon by taking away the sound, smell, and action of the moment in time. Written words may omit or distort events and emotions according to the readers interpretation. Nothing replaces being in the moment yet seeing a picture and reading a name or story gives opportunity to examine facts to better understand what a moment in time was about.

The photo in this book of Charles M. Russell and Charley Stuart on the Montana prairie dismounted and sitting cross legged passing a peace pipe between them is one example of 'what's in a picture'. Once we know the names of the people or place in a photo it gives us an idea of 'when' the photo was taken. What the people are wearing also gives us clues. Charlie Russell has a blanket across his lap in this photo and that same blanket is used in a photo called "The Cowboys Call" on page 14 of Bill Morris's book, "True, Free Spirit. Charles E. Morris Cowboy Photographer of the Old West". Those cowboys in the photo have a blanket spread out by a wagon in what looks like the Marias River Breaks playing a card game (poker). That blanket is a 'prop' Chas used in his early photography days to add dimension and interest to his photography. The horses and approximate age of Charlie and Charley in the photo help determine the year the photo was taken. Monty died in 1904. Charlie was said to have quit wrangling for the most part around 1892. Charley Stuart's horse is wearing a western saddle. The

same saddle he is riding on page 18 of "True, Free Spirit", and the horse looks similar, but not exact, in both photos so they are probably from the same stud, mare, or both.

The horse on page 18 of "True, Free Spirit" is wearing a circle brand on his left hip or thigh. There could be a dot in the center of the circle giving a clue to what outfit the horse was from that Charley Stuart was riding.

Pamela June Morris edited the book, "True, Free Spirit" for her father, Bill Morris. She had an opportunity to see the moments in time her grandfather captured even though he had died before she came to know of his work. Working with her father on 'his' project was challenging for Pamela as her life was busy and her father wanted her to put the book in order of his preferences, using her skills, with information he gave her on the subject matter. It was a "do as I say, not as I do" task at an inopportune time, but Pamela did her father's bidding.

What we keep and what we let go are necessary choices everyone makes all through their life. Intense emotional experiences are difficult to divest – perhaps impossible. Remarkable are the people who often change their perspective of negative experiences and take an error in judgement to change the outcome. Pamela's father, Bill Morris, admitted in his book that he was not close to his father, Chas E. Morris. Cowboys weren't cool in Bill Morris's generation. Guns and sporting equipment had undergone a revolution and the Morris brothers had progressed their parent's stationary and sweet shop into a large Sporting Goods store in Great Falls. Finding their own niche, their parent's camera equipment and photos were tucked away for safe keeping.

Pamela's domestic violence case was behind her and this authors belief is that every journey in life prepares us for out next adventure. I believe this was true for Pamela as her challenge with State laws and the odd turns the law can take in courts proved to be perplexing. Working on her father's project was a way to appease her father's need to make a statement of his pride in his father's work. It also gave Pamela a means to explore her grandparents and her father's life.

Spousal testimony prevented a wife from testifying against her husband at the domestic violence trial. The only other witnesses were

minors in Pamela's custody. This rule of law was supposedly enacted *"in order to preserve the then-existing marriage"*. The spousal testimonial privilege operated to keep a spouse off the stand altogether in a case involving the other spouse. The wife was the *"property of the husband"*. 1970's readers!! Not so long ago.

Along the journey Pamela took she realized her own "free spirit" and that being true to herself and her family was the only way she could effectively create positive change for herself and her children. Pamela's position in 1976-1977 was that she was in her second marriage with two young boys, a husband who had extreme emotional instability, and an ex-husband who was the father of her two boys and had relinquished custody of the children to Pamela. The boys were minors, and she was their voice in court.

Being a stepchild is another of those unknown categories of being. Who is the boss? It is an undefined position with unassigned rights. Particularly difficult when you are a young boy who loves both parents and would do whatever was in your power to protect your parents.

Pamela had the help of Senator Pat Regean and a little serendipity from her sons. She had been assaulted by her husband. After striking her, he ripped the phone cord from the wall. To protect their mother the boys jumped to action; Eric ran to the neighbors to phone for the police while 13-year-old David tried to hold off his stepfather getting knocked out in the process.

Pamela, her legal representative, and other activists throughout Montana proposed three domestic violence bills to the Montana legislature:

1. To revise tort immunity laws to exclude child and/or spousal abuse.
2. To establish a governor-appointed domestic violence task force.
3. To add $10 fee to marriage license applications to be used to fund domestic violence prevention and safe houses.

All three bills passed, signed by the Governor, becoming law in Montana. One of the first States to have such legislation.

During the interlude(s) between court dates, appearances, and hearings Pamela enrolled at Eastern Montana College in Billings in graduate studies toward a master's degree in counseling. Her sons, Eric and David kept busy; Eric babysitting, and David signed up for summer gymnastics and art programs. David came home with a cast on his hand and wrist one day and Pamela was beside herself until her told her it was just an art project. All the kids in class had one. A few weeks later Pamela came home to David with a cast on his hand, thumbs up AGAIN. She asked if they were still doing the same thing in art class. David replied that; "No, this one is for real. I broke it in gym class". The reaction to the real break was buffered with the fake cast weeks earlier.

The day finally came when Pamela and her sons drove to Helena to testify before the House and Senate committee hearings on the proposed bills. The hearing on the tort immunity exception was crucial. Three "victims" testified; Pamela's sons watched from the sidelines, David with the thumbs up cast on his hand clearly visible.

Here is where a picture is worth a million words, even if it is just a snapshot in time. When the Montana lawmakers saw this young man who had intervened in his stepfather's abuse of his mother only to get himself knocked out, with a cast on his arm in testament to the abuse, how could they oppose such legislation? Obviously, they could not.

In 2020 Eric Larson is an Attorney-at-Law who has chosen public service over personal wealth, thereby significantly furthering legal protections for citizens. David Larson has excelled in martial arts and cross-fit programs while pioneering/engineering complicated computer programs. Pamela June Morris has legally changed her name to her original family name and continues to explore her life and family heritage. Offering suggestions and queries that take her and this author deeper into the life of Chas E. Morris and his great grand offspring. Marriage and communicative privilege begin and end. Families continue.

Looking back this author would like to share one more story of a moment in time. I attended first and second grades of school in Cut Bank, Montana. My best friend and closest neighbor was Bart Urgens. He was my brother's age; one-year ahead of me in school. My dad worked at the refinery in Cut Bank and he received a phone call from

his father in North Dakota asking him to return to North Dakota to work the farm dad had grown up on. When school was out, we packed and moved to Ross, North Dakota and I didn't hear from or see Bart for years.

I lived in Seattle for a few years and Dad and my stepmother, Ginger, came out to visit. They wanted to go to Anacortes to visit Cora Urgens, Bart's mother. I thought it would be great to see Bart and his brother Allen again after all the years, but neither of the boys were there when we visited Cora.

I made arrangements over the phone a few weeks later to meet Bart at a supper club south of Bellingham not realizing that I really didn't have a clue of what he looked like after all that time had passed. I knew what kind of car he drove and thought "how hard will it be to recognize this old friend.

I spent about an hour looking at people and faces in the supper club before deciding to call Cora to ask what Bart was wearing. I had spotted his car in the parking lot, so I knew he was there. I had looked right at the person Cora described but did not recognize anything about him. He must not have recognized me either, because I had walked by his table numerous times.

Approaching Bart with the phone, I told him he had a call from his mother and Cora told him who was handing him the phone. We laughed. He hung up the phone and gave me a hug and said, "When did you get so pretty?". I laughed and said, "I always was, when did you turn into an Indian?" He laughed again and said: "The day you left Cut Bank".

The realization of that remark struck me hard as I began to realize that Bart was always an Indian. As a child I had grown up in a neighborhood surrounded by boys, most of them Indian. They were my equals and my friends. Until that moment I had not imagined what it would be like to be treated any different. I also realized in that moment in time my common thread with Bart was friendship.

HAPPY TRAILS TO YOU.

BIBLIOGRAPHY

<http://bigsky journal.com/images-west-charles-e-morris/>

<http://www.britannica.com> February 12, 2004

<https://www.cartermuseum.org/remmington-and-russell/> accessed November 12, 2019

<https://digital.nls.uk/histories-of-scottish-families/archive> accessed October 14, 2019

<https://www.doi.gov › bureaus> accessed July 2, 2018

<https://en.wikipedia.org/wiki/M%C3%A9dard_des_Groseilliers> accessed March 14, 2006

<https://en.wikipedia.org/wiki/Pierre-Esprit_Radisson> accessed June 14, 2005

<https://en.wikipedia.org/wiki/Ren%C3%A9-Robert_Cavelier,_Sieur_de_La_Salle> accessed February 22, 2020

<https://en.wikipedia.org/wiki/New_France> accessed June 24, 2019

<https://sv.findagrave.com/memorial/201042488/alfred-b-hamilton> accessed March 12, 2020

<https://www.historytoday.com> accessed February 5, 2020

<https://humanorigins.si.edu/evidence/genetics/ancient-dna-and-neanderthals/interbreeding> accessed April 9, 2020

<http://library.usask.ca/northwest//background/riel.htm> accessed 1/14/99

<https://www.mackinacparks.com/more-info/history/individual-site-histories/colonial-michilimackinac-history/> accessed February 16, 2020

<https://mtmemory.org/digital/collection> accessed August 16, 2020

<https://muse.jhu.edu/article/406907> Project MUSE – Jane McManus Storm Cazneau, 1807-1878. Reviewed 8/14/2020

<https://npgallery.nps.gov> National Register of Historic Places> accessed January 12, 2020

<http://www.npshistory.com/publications/badl/hrs> accessed May 15, 2016

<http://www.nationmaster.com/encyclopedia/United.States.Department.of.the.Interior> accessed March 14, 2003

<https://scholarworks.umt.edu/etd/3353> accessed January 13, 2020

<https://en.wikipedia.org/wiki/Theodosia_Burr_Alston accessed April 18>. 2020

<http://www.tpl-lib.wa.us/cgi-win/disastr2.exe/smuggling1.crime%5Csmuggle>

<https://itax.tylertech.com/cascademt/> 2016

<http://www.watertoninfo.com/r/history2.html>

Abell, Sam. "C.M. Russell's West". Thomarson-Grant, Inc., Charlottesville, Virginia, 1987.

Alvord, Pearl. Photographs of Sweet Grass Hills community, 1895 - 1936

Anderson, Louisa Stott Allen. Interview, Pearl Alvord photos, family history, 1983

Berry, Gerald L. "The Whoop-Up Trail".

Christian, Lorene. Interview, scrap book, photos, and newspaper collection 1986.

Clark, Hardee. Marias Vet Clinic, Shelby, Montana: August 14, 2020

Davis, Lee. Son of Ruth Stott Davis, niece of Pearl Alvord.

D'Ambrosio, Brian. Big Sky Journal, winter 2017 issue.

Demarest, Marty, and Elsie. School and Post Office records of the Sweet Grass Hills.

Dumont, Willard. Hills' Happenings, Edition 5: Heritage Association of Cypress Hills.

Echoes from the Prairies. Prairie Homemakers Home Extension Club and Jayhawker Ridge Home Extension Club. Published by The Shelby Promoter 1976, John Kavanagh, Editor. Available online.

Ellingrene, John David. MSU Masters' Thesis 1971

Episcopal Church of the Incarnation, Great Falls, Montana, records 1880-1905. Sara Quay assistant, access 2018

Ewers, J.C. (1958). The Blackfeet: Raiders on the Northwestern Plains. Norman, OK: University of Oklahoma Press.

Fey, Albert. Interview October 2016.

Fontaine, Tom, "Sun Irvin Tells A Bear Story", Great Falls Tribune, Sun Irvin column, October 1959.

Fort Benton Record. Columns, stories, obituaries, marriage, birth and burial records.

Furnell, Francis. Interview, 1979

Furnell, Matt and Fey. Interview 1984.

Gardner, David. Miscellaneous records of the General Services Administration National Archives and Records Service, Washington D.C.

Gill, Larry. Reply communication to Matt Furnell, Whitlash, MT. Montana Stockgrower Brand and Livestock Office, Montana State.

Glenbow Library and Archives now with the University of Calgary, Alberta, Canada.

Good, Hope. "Treasure State Lifestyles Montana" monthly magazine. Hope Good editor.

Griffin, Megan Jenison. Jane McManus Storm Cazneau, 1807-1878; Legacy: A Journal of American Women Writers, Volume 27, Number 2, 1010. University of Nebraska Press

Gold, D. (1934). The intelligence and achievement of Blackfeet Indians. Unpublished thesis, Montana State University, Missoula.

Goulet, George and Terry. "The Metis. Memorable Events and Memorable Personalities". FabJob Inc., 19 Horizon View Court, Calgary, Alberta T3Z3M5. 1933, Acknowledgements 2006.

Great Falls Tribune, various articles and column stories. Grady Higgins, Editor, 2020.

Greene, Lieutenant Francis Vinton: Journal of 1874; "***Down the Missouri by Mackinaw Boat***"

"*Harrow Photos – History of the Hills & Saunders Photographic Collection*". *Harrow School. Archived from the original on 17 April 2009. Retrieved 8 February 2016.*

Havre Daily News, various articles, and columns.

Haywood, Carl W., "Sometimes Only Horses to Eat". David Thompson "The Salish House Period 1807-1812. Rockman Trading Post, Inc. 2008.

Helena Weekly Herald, Helena, Montana

Hellinger, Dean. Front and back cover photographs. Devon Montana, 2020.

"*Holtermann panorama*" *(PDF). National Gallery of Australia. Retrieved 24 March 2016.*

Kavanagh, LeAnne. Editor, Shelby Promoter and Cut Bank Pioneer Press. Stories and articles.

Kipp, D. & Fisher, J. (1992). Transitions (film). Bozeman: Native Voices Television Workshop, Montana State University.

Leckie, Robert (1998). The Wars of America. Castle Books. p. 537. ISBN 0-7858-0914-7.

Lee, Powder River Jack and Kitty Lee, (Song Book with music). Copy 1934, Mckee Printing & Publishing Company, Butte, Montana.

Malcomson, Jeff. Photograph Archives Manager, Montana Historical Society, P.O. Box 201201 / N. Roberts, Helena, MT 59620. > (406)444-0261 <montanahistoricalsociety.org>

Malone, Michael P., Roeder, Richard B., Lang, William L. "A History of Two Centuries" University of Washington Press: Seattle and London. Copyright 1976.

Melvin, Eva Strode. Newspaper columnist. Shelby Promoter, Great Falls Tribune, Liberty County Times, and Pioneer Press.

Morris, Bill. "True, Free Spirit, Charles E. Morris cowboy Photographer of the Old West". Published by Advanced Litho Printing of Great Falls, Montana.

Morris, Chas E. Photographer, northern Montana. 1890-1920

Morris, Pamela June. Granddaughter of Chas E. Morris, daughter of Bill Morris, editor of "True, Free Spirit".

Nicholas, Lisa. "Ranching in Beaverhead County 1863 – 1960, Transition Through Three Generations". Scholar works from the University of Montana.

Odegard, Ben. Platt of Whitlash and interview 1977.

Parsell, Robert. Interview 1981

Petrie, Thomas A. "Return to Calgary: Charles M. Russell and the 1919 Victory Stampede".

Peterson, Larry Len. "Charles M. Russell; Photographing the Legend" page 185.

Price, Con Memories of Old Montana. The Highland Press, Hollywood 28, California 1945

<u>Progressive Men of the State of Montana</u> by A.W. Bowen & Co. Release Date: November 20, 2017 [eBook #56016] The Project Gutenberg

Renner, Ginger. "<u>C.M. Russell's West</u>" Introduction, Thomarson-Grant, Inc., Charlottesville, Virginia, 1987.

Richmond, Jennifer. Museum Specialist Archivist. St Joseph, Michigan. March 2020.

<u>River Press, Fort Benton Montana,</u> various articles.

Russell, Charles M. <u>Trails Plowed Under</u>. Doubleday, Doran and Co., Garden City, New York, 1944.

Russell, Charles M. "<u>Rawhide Rawlins Stories</u>". Trails End Publishing Co., Pasadena, California 1946.

Russell, Nancy C. "<u>Behind Every Man: The Story of Nancy Cooper Russell</u>".

Russell, Nancy C. "<u>Good Medicine, The Illustrated Letters</u>". Doubleday and Co., Inc., Garden City, New York, 1929 -1930.

Robison, Ken. <u>Historical Fort Benton Facing Down Danger: Fort Benton Men in the Nez Perce War – Part 3</u> accessed August 9, 2019

Robison, Ken. "<u>LIFE AND DEATH ON THE UPPER MISSOURI: THE FRONTIER SKETCHES OF JOHNNY HEALY</u>" Overholser Historical Research Center Fort Benton, Montana 2013.

Shaw, Mrs. Frank and Thelma Warrington: through the Montana Historical Society "<u>The History of Montana 1739-1885</u>" carries the topic of the "Sweet Grass Hills Mines" page 493

<u>Shelby Promoter</u>, various articles.

Shrewsbury, Chas. A. <u>Lasting Footprints.</u> The Montana Stockgrower March 15, 1955. Written for M.V. Davey, former Montana rancher from Rock Falls, Illinois, loaned to Montana Stockgrower Magazine.

Sievert, Ken and Ellen. "<u>A Cultural Landscape Study of the Sweetgrass Hills Area</u>", for Montana State Historic Preservation Office, August 1989.

SIG. Signature Montana Magazine. 2019 Volume 12 – Issue 3 page 32. David F. Leray Publisher. Hayley Lenington-Leray editor.

"<u>State of the Arts</u>" Sept / Oct 2004 issue.

Stewart, Joan Parsell and Lance. Parsell stories and photo.

Stratton, Joanna A., "<u>Pioneer Women</u>" copyright 1981.

Smith, Helena Huntington. "<u>We Pointed Them North recollections of a cowpuncher.</u>". Farrar & Rinehart, Inc. Copyright 1939. Assigned 1954 to the University of Oklahoma Press, Publishing Division of the University, Norman.

Strahorn, Robert E. "<u>Montana and Yellowstone National Park</u>"

<u>Toole County Backgrounds.</u> Compiled by Shelby History Group of the Montana Institute of Arts, 1958. Available online.

"<u>Treasure State Lifestyles Montana</u>". Hope Good, publisher / executive editor.

Toole, K. Ross, <u>Montana An Uncommon Land</u>. Norman, university of Oklahoma Press 1959.

Tretter, Laura. Technical Services Librarian, Montana Historical Society. August 2020.

Waggoner, Curley Bear. Great Falls Library presentation. 1997

Wehr, Ron and Toni Cochran Wehr. Recalls of Melvin Wehr and Norma Wood, Gold Butte and Willow Rounds.

Welch, James and Paul Stekler. "Killing Custer". W.W. Norton & Company – New York, London. Copyright 1994. Bibliographical references and index of North American Wars 1866 – 1895.

West, H. B. (1959). "Starvation winter of the Blackfeet". Montana The Magazine of Western History, 9(1)

Western Pennsylvania Conference of The United Methodist Church 1784-2010. Commission on Archives & History October 15, 2010.

White, George. State of the Arts periodical. September/October 2004 issue.

Willard, Daniel E. Montana, the geological story. The Science Press Printing Company, Lancaster, Pennsylvania, 1935.

WIKIPEDIA
Bascom, Earl W. accessed July 16, 2019.
Gallatin, Albert accessed April 18, 2020
Jumel, Eliza accessed May 14, 2020
New Dayton, accessed May 21, 2020
Raymond Alberta Canada, accessed July 20, 2019
Raymond Stampede, accessed July 21, 2019
Remington, Frederic, accessed July 17, 2019
Series: Photographs of American Military Activities, Record Group III: Records of the Office of
Chief Signal Officer 1860-1985. Information only included in this manuscript.

AUTHOR'S INTRODUCTION

Roberta is unique in this twenty-first century with her experiences and exposure to many of the traditional things that make this country what it has become. Born in a small town in North Dakota and raised by parents that were divorced when she was a small girl has provided her with some real-life experiences: Her deep interest in horses, her education, the desire to succeed and the ability to provide for her family.

Attending a one room country school during her elementary years and three different schools during her high school years has given Roberta a broad scope of relationships, many of which she still has today. She continued to college to receive her associate degree and later returned to college to get her bachelor's degree in 2003 with a major in business and minor in diesel.

Her father served in the United States Navy during World War II marrying his childhood sweetheart before shipping out on the USS Harlequin May of 1945. Her parents lost two children after her brother and Roberta were born which was devastating to their family. Unable to continue together, her parents divorced. These events at an early age introduced complexities and new life experiences for Roberta. Her dad remarried: an indigenous woman who helped raise Roberta and her brother introducing them to a different ethnic culture. Her father and stepmother took in foster children, always indigenous, eventually adopting two indigenous children.

Roberta spent her summers with her birth mother in Montana and winters in North Dakota on the family farm with her dad and stepmother until her Sophomore year of High School. While living

on her grandparents' homestead in North Dakota she helped with milking cows, feeding chickens and other livestock and herding cattle. She attended a country school until the seventh grade when the school systems reorganized closing most of the rural schools. During the fall and spring, she rode horseback to school. Once the schools reorganized, she rode bus 22 miles to Stanley, changing buses in Ross on the way to and from school. Her summer months were spent with her mother helping with chores and riding the Fort Peck Lake breaks rounding up cattle with her stepfather. She learned horsemanship skills at a youthful age. The T-Rex and other prehistoric relics hadn't been unearthed in the area at that time, but ranches were still operating much as they had in the early 1900's, working livestock with horses on range that was sparsely fenced. No running water or electricity at the line-camps, which suited this cowgirl's interests at the time. Sometimes on the open range in a sheep wagon she shared hard boiled eggs and sardines with crackers with the round up crew before heading out on a fifty-mile ride making a wide circle looking for cattle. All in a day's work.

After getting her associates degree at Northern Montana College she married and moved to Seattle with her husband and daughter Paula. After living in Seattle for a few years her marriage ended in divorce and she decided to return to Montana and start her own business. During the next years she remarried. She was blessed with two more children, Marty and Crystal. Married to a rancher for twenty-two years with responsibilities for partnering in a large cattle ranch in the Sweet Grass Hills gave her the privilege of raising her children in rural Montana while breeding and training registered quarter horses. A lifestyle that was glamorous from the outside but entailed long hours of hard but rewarding work.

The Sweet Grass Hills are one of the most historical areas of Montana. They sit on an international boundary rising above the simi-arid farmland with their free-flowing freshwater streams flowing all four directions. Her children attended a country school just as she had, and she was able to work and train her horses on cattle sharing her equestrian skills with her children. There were

472

many days when 10 riders rode out of the ranch yard all on horses she had trained. The children exhibited their horse(s) and dogs at open shows and fairs each summer winning awards and learning stewardship and citizenship skills in 4-H while Roberta served as a leader for 18 years.

When her youngest daughter, Crystal, graduated from High School and left for New Zealand with the International Agriculture Exchange Association, Roberta wanted to spend time traveling and enjoying life beyond the ranch. The concept was not unanimous, and the marriage ended. Roberta then moved to Great Falls, Montana and restarted her life with an eight hour a day, five days a week job for which she received a salary and days off, a unique concept to her. She worked as a Certified Nurses Aid (CNA) for more than a year then took a position as Director of an Alzheimer's Unit in an extended care facility. She also successfully ran for a position on the first Great Falls Neighborhood Council and the Great Falls Civic Center Board. In 1998 Roberta gave up her two civic posts and changed her CNA activities to home health care taking a position caring for a rancher and his wife in north central Montana.

During her commutes between Great Falls and Turner she met the manager of General Electric Transportation Systems in Havre, Montana. Al Beute had been assigned to reopen the Burlington Northern locomotive maintenance shop in Havre. The acquaintance developed into a relationship and the couple married. Roberta sold her home in Great Falls and moved to Havre enrolling in college. Her husband retired and the couple built a new home in Great Falls where they currently reside.

Over the course of her years, Roberta has continued to write and develop her many skills. She had the opportunity to interview people in the area north of the Missouri River and east of the Rocky Mountain Front working for the U.S. Census Bureau for the American Community Survey. This large territory required that she traverse the region on monthly assignments allowing her time to visit old acquaintances on her off-duty time. It also enabled her to know the backroads of this vast rural portion of Montana and see the changes

that have occurred in her lifetime. She found most of the farmers and ranchers were anxious to share stories of their life in Montana and the changes they had witnessed over time. This book, "<u>As It Was; A Common Thread</u>", is a compilation of the stories and people who are a part of the generations of people who settled Montana and continue to raise their families in Big Sky country.

By Albert E. Beute